THE ART OF THE BATTLEREALM

MARVEL CONTEST OF CHAMPIONS

ISBN: 9781785659553

Published by Titan Books
A division of Titan Publishing Group Ltd.
144 Southwark St.
London
SE1 0UP

First edition: December 2018
10 9 8 7 6 5 4 3 2 1

To receive advance information, news, competitions, and exclusive offers online,
please sign up for the Titan newsletter on our website: www.titanbooks.com

Did you enjoy this book? We love to hear from our readers.
Please e-mail us at: readerfeedback@titanemail.com or write to Reader
Feedback at the above address.

A CIP catalogue record for this title is available from the British Library.

Printed and bound in China.

MARVEL PUBLISHING
Jeff Youngquist, VP Production & Special Projects
Caitlin O'Connell, Assistant Editor, Special Projects
Jeff Reingold, Manager, Licensed Publishing
Sven Larsen, Director, Licensed Publishing
David Gabriel, Svp Print, Sales & Marketing
C.B. Cebulski, Editor in Chief
Joe Quesada, Chief Creative Officer
Dan Buckley, President, Marvel Entertainment

THE ART OF THE BATTLEREALM

PAUL DAVIES

TITAN BOOKS

CONTENTS

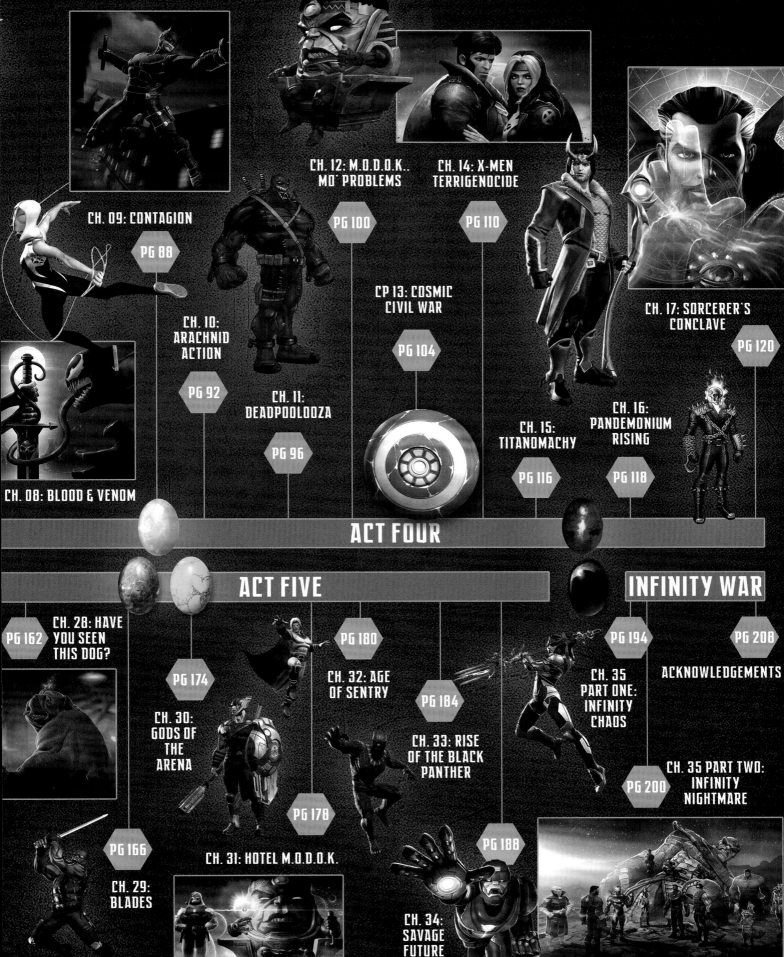

FOREWORD

BY GABRIEL FRIZZERA

Back in 2013, when I first learned we were in talks with Marvel to develop a new game, I sat in a room of our office in Vancouver for a preliminary brainstorm with my coworkers Cuz Parry and Tim Molyneux. We looked at each other with giddiness and said, "This is Marvel, we can't screw this up!" We didn't know if the project was moving forward, but we felt compelled to meet about the enticing possibilities. I realized at that moment that they were like me: people with Marvel lore indelibly etched in their brains, and a profound love for this fictional universe.

I still remember my first Marvel comic. I was vacationing with my parents in a small fisherman's village in my home state in Brazil, bored out of my mind, when I happened upon a local newsstand. They had almost nothing except a couple of local newspapers, and a solitary comic book. The cover featured a grizzled man with spiky hair, shielding a woman behind his body. Behind them was a large poster with many other heroes, with the labels "apprehended" or "slain." And the man had sharp claws coming out of his hands!

It was of course the now classic 'The Uncanny X-Men #141,' the first part of the seminal the two-part *Days of Future Past* by Chris Claremont and John Byrne. I bought that issue and read it many times over that summer. My ten-year-old mind was blown by the dystopian darkness of that story. Was that allowed? Weren't Super Heroes colorful, happy characters that always won? Can they get old and die like that?

To seal the deal, at that time Brazilian versions of Marvel comics had three or four different stories per issue, so along with the X-Men, I got introduced to material such as Alpha Flight, Daredevil (during the 'Born Again' run), Master of Kung Fu, Cloak and Dagger, Rom the Spaceknight, and even reruns of Jack Kirby's best years at Marvel. I was hopelessly hooked. I wanted not only to read all those amazing stories, but also create them professionally, which to a Brazilian kid in the 80s sounded as distant as becoming an astronaut.

Fast forward as we were sitting in that meeting room, writing a humongous list of characters that we'd love to have in the yet-to-be-official project. "Moon Knight? M.O.D.O.K.? I love them! But they'll never let us put those guys in the game!" We chuckled, but kept adding characters even more obscure. We had no idea of the thrill ride that was ahead of us, and that even our most feverish Marvel dreams would be surpassed by the reality of this juggernaut called *Marvel Contest of Champions*.

Four years later, we're still fuelled by the same giddy passion that moved us that day. And I'm sure that won't change until the last Champion standing raises the ISO-Sphere in triumph over the Battlerealm's skies.

THIS SPREAD: Early concept art for *Marvel Contest of Champions*.

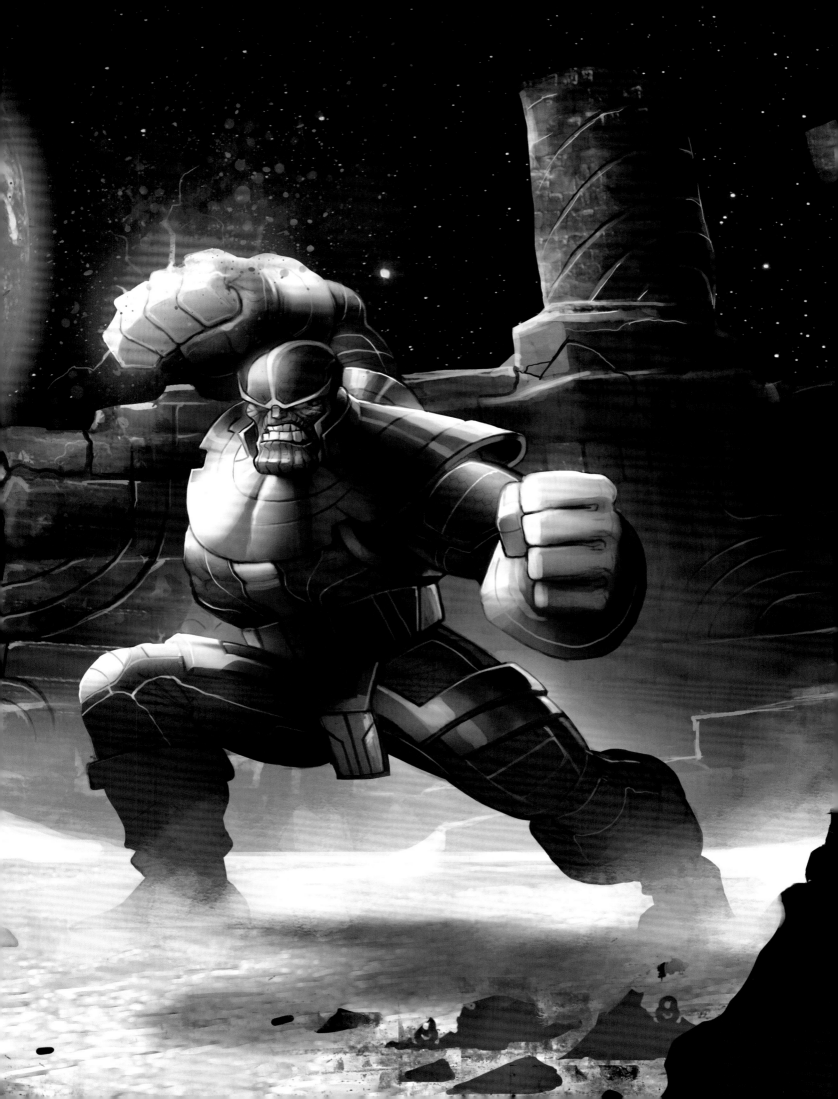

ENTER THE ELDERS

Welcome to *Marvel Contest of Champions*! The stunning mobile game made by Marvel fans for Marvel fans combines the spirit of the Grandmaster with the mindset of the Collector to create the ideal platform for discovering Champions from all across the Marvel Multiverse.

Although inspired by the 1982 limited comic book series *Marvel Super Hero Contest of Champions,* the story of *Marvel Contest of Champions* has its own strong identity and deep meaning.

The 80s original, written by Mark Gruenwald with art from John Romita Jr. and Bob Layton, was ground-breaking in its mash-up premise. It pitted Super Hero against Super Hero, including characters we never expected to see share the same dimension in the Marvel Multiverse.

When it came to formulating the ideas for *Marvel Contest of Champions*, the video game,

Marvel Games recommended veteran writer Sam Humphries to the Kabam team, brainstorming an entirely new scenario with the Collector at its center, expanding the one-on-one fighting concept further to suit an ever-evolving, event driven experience like nothing anyone had seen before.

It was also a writing task that was unfamiliar to Humphries. "I was used to traditional storytelling structures built around pages, issues, story arcs," he says. "One of the biggest opportunities was being able to speak directly to the player. It's a great technique for making them feel immersed in the drama. As much as the mediums differ, I was thrilled and inspired to find that the fundamentals are the same. Character, emotion, tension and release, motivation, cliffhangers...these are all things that great comic books and video games have in common—things that make both so addictive!"

Remarkably, this led to the 2015 *Marvel Contest of Champions* ten-issue comic book series, bringing to life Kabam's Battlerealm via the words of Al Ewing, and the art of Paco Medina, Juan Vlasco, Rhoald Marcellius, David Curiel, and more, with letterer Joe Sabino. As Marvel Games' Executive Creative Director, Bill Rosemann, deftly puts it: "Art imitating (digital) life, imitating art, imitating (digital) life!"

Passionate to explore this new dimension, Kabam Art Director Gabriel Frizzera and Marvel artist Luke Ross collaborated on something unique for 2018. *The Young Elders Tale* sheds light on Battlerealm history, a new avenue of storytelling for *Marvel Contest of Champions*.

"The Elders of the Universe have always been treated superficially in the mainstream Marvel Universe," says Frizzera. "They have always been either personifications of high concepts, or unidimensional cosmic villains used as foils for the heroes. But since the Collector and Grandmaster are recurring characters of our game, we had the chance to write them continuously in our stories for the best part of the last three years.

"We ended up developing a more nuanced understanding of their personalities and relationship. I personally became very interested in exploring their past, and how they chose their singular obsessions. It dawned on me that they would be like regular human beings: the distorted, sometimes disfigured product of the bad choices of their youth, but on a much larger scale. I thought it would be fun to tell that story and weave it into the origin of the Battlerealm."

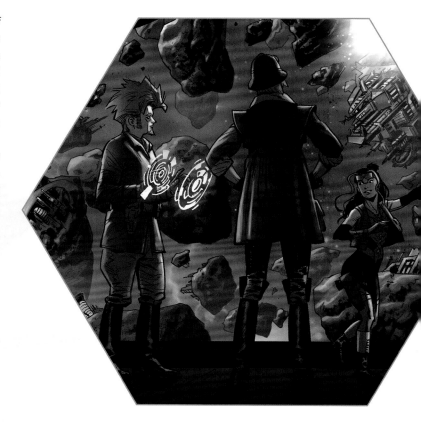

THIS SPREAD: [ABOVE] The Young Collector and the Young Grandmaster with Carina from *The Young Elders Tale* comic. [RIGHT] The Battleworld in formaton, with the ISO-Sphere at its core.

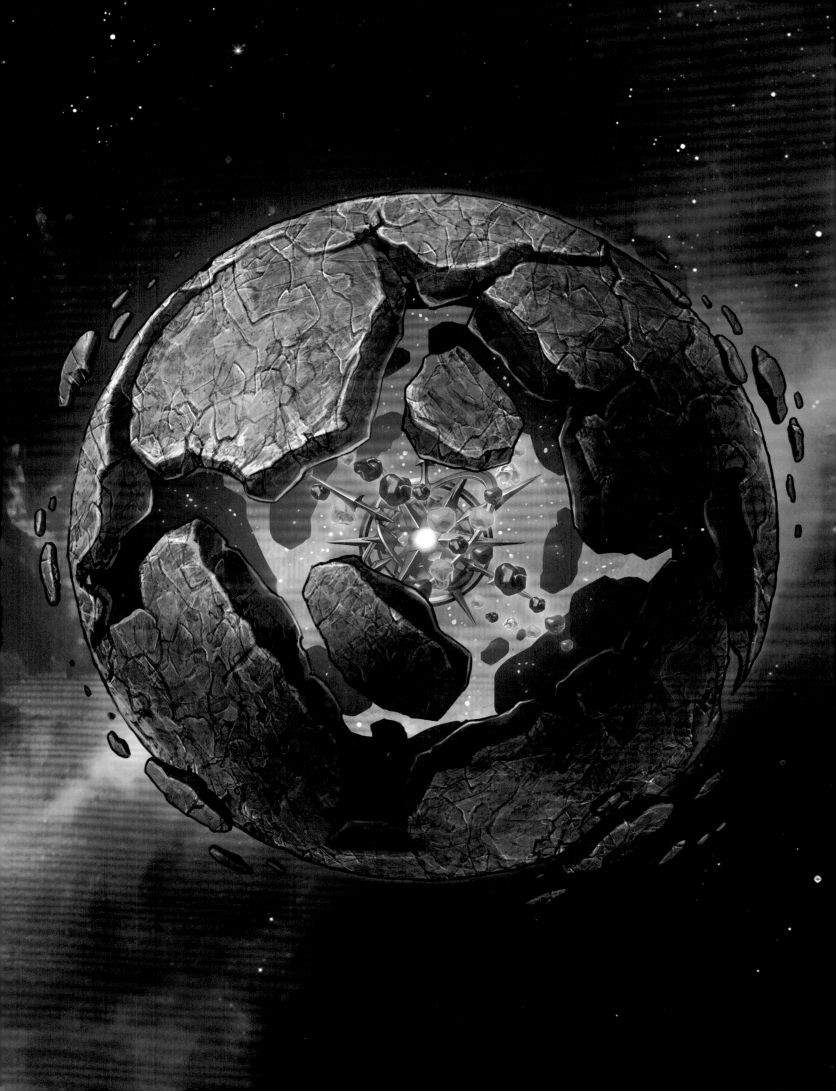

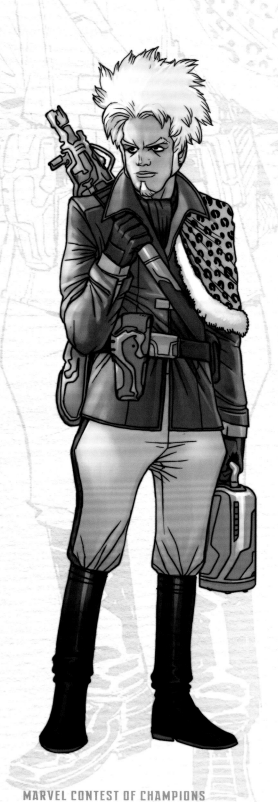

> ## "I WANTED A CLASSIC COMIC BOOK FEEL TO THE STORY."
>
> GABRIEL FRIZZERA,
> KABAM ART DIRECTOR

BROTHERS FOR LIFE

The *Young Elders* introduces the relationship between the Collector and Grandmaster, when they were both young men, establishing their Elder 'thing' (a.k.a. single defining pursuit). It is a tale of tragedy, involving the fate of the Collector's daughter Carina, the ultimate price paid for her "venturing into the unknown." To accomplish this delicate storytelling mission, Gabriel Frizzera enlisted the help of fellow countryman Luke Ross, whose work he has always respected.

"Luke is one of the best-known comic artists from Brazil, one of the people that inspired a whole generation of artists to follow their dreams," Frizzera imparts. "We had met before in conventions, and I was always trying to work with him on something. When I wrote the Young Elders story, I thought that would be a perfect occasion to invite Luke to participate. I wanted a classic comic book feel to the story, and Luke has an effortless style that matched the story very well. I was very happy when he agreed to participate."

Inside of relatively few scenes, compared to full-length comic books, the Young Elders story accomplishes much in its portrayal of estrangement across a mind-blowing passage of time. The imagery is unforgettable, owing to Ross' interpretations of Frizzera's poignant vision.

"I was especially pleased with the change in style between the early pages, when the two Elders are young and naive, and the end, when they're older and bitter," Frizzera explains. "Luke managed to slowly transform the art from a 'Silver Age,' cleaner style, to a more detailed, 'dirty' look to depict the changes in psychology of the main characters.

"I also love the way he drew the scene with the dying Celestial. That one had a pretty complex description in the script, a sprawling view of a cosmic god partly fused to a planet, spewing crystals from his guts. He managed to create an impressive scene in the vein of Jack Kirby's splash pages from Marvel's classics."

YOUNG COLLECTOR: (LEFT) Taneleer Tivan has not yet considered his true vocation, too busy raising a beloved daughter.

YOUNG GRANDMASTER: (RIGHT) En Dwi Gast feels betrayed, and had a thousand lifetimes to consider the consequences.

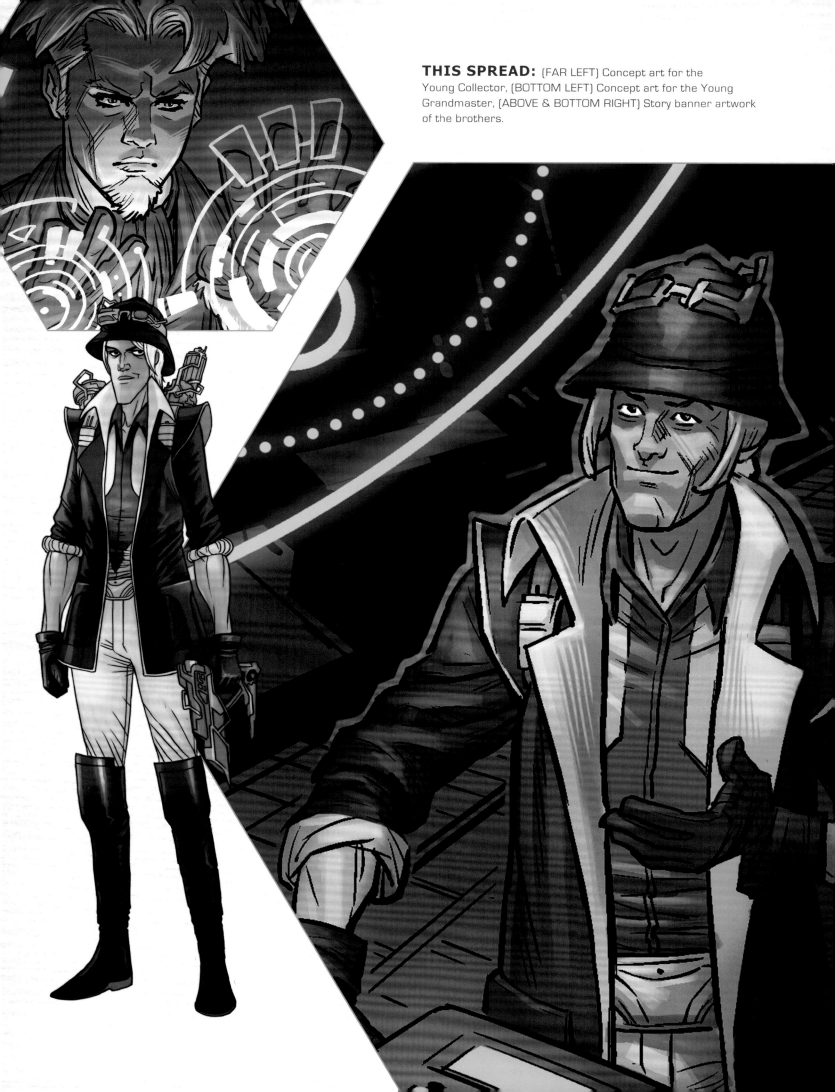

THIS SPREAD: (FAR LEFT) Concept art for the Young Collector, (BOTTOM LEFT) Concept art for the Young Grandmaster, (ABOVE & BOTTOM RIGHT) Story banner artwork of the brothers.

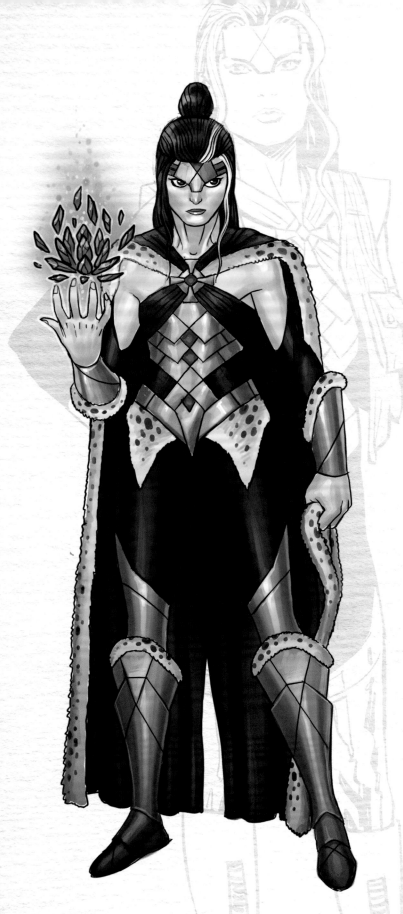

LIMITLESS PERSPECTIVES

The Frizzera-Ross collaboration won't be the last we see of talented creators being brought on board to expand the *Marvel Contest of Champions* universe.

"Each generation grows up knowing these characters inside out but decodes their stories through their own unique prism," Frizzera says. "I'm no different: Marvel is like a second language to me, and my personal history molds my unique idea of this universe into interesting shapes.

"I have a strong humanist interest in these characters and what makes them tick, not only in the personal level, but in the context of a larger world. The Contest of Champions for me is a cosmic-level social experiment where these characters can interact in interesting ways and evolve together.

"For me it's so much more than simply Super Heroes fighting. I feel very fortunate that we can tell this story as one continuous epic, and that Marvel believes in our perspective enough to foster our flights of fancy."

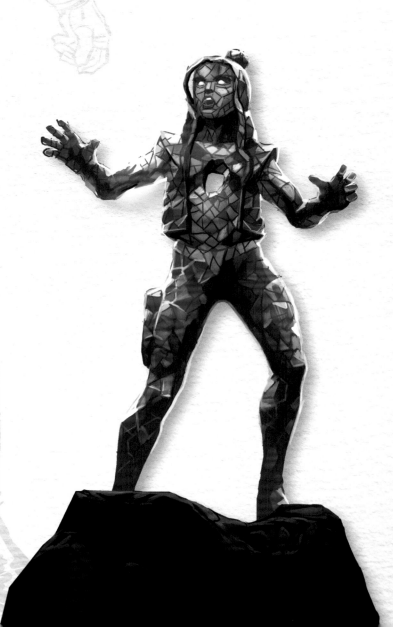

CARINA: [THIS PAGE] Represented as Taneleer's endearingly precocious daughter, during the brief time we spend with her.

NEXT PAGE: Pages from *The Young Elders Tale* comic.

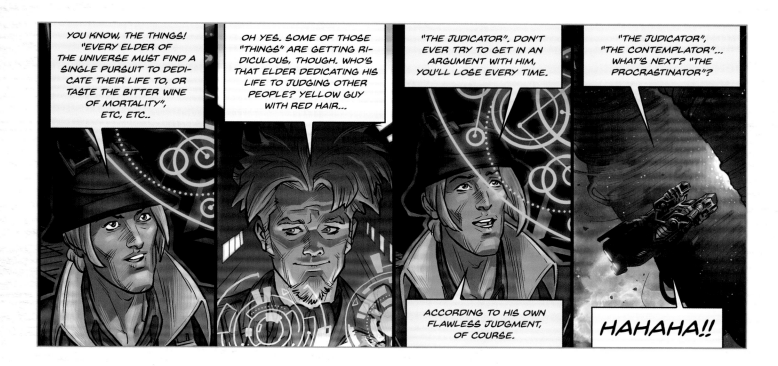

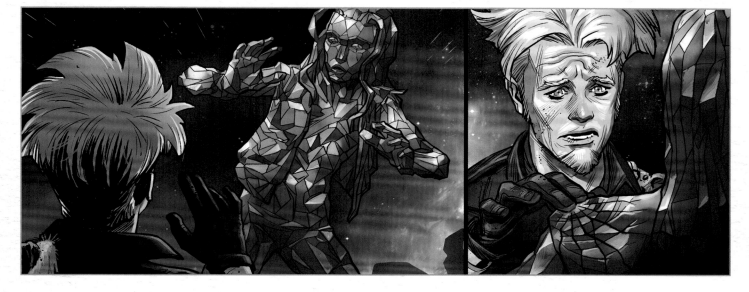

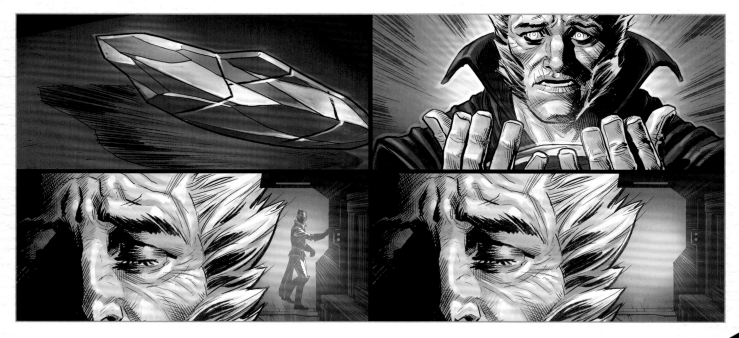

THE MAKING OF A MULTIVERSE

More than 100,000,000 fans of *Marvel Contest of Champions* know exactly what the Battlerealm is. The story of how it came into being has been kept in a dark, cavernous vault...until now.

"[Our studio] had a reputation for 'getting' IPs'" says Creative Director at Kabam, Chris "Cuz" Parry. "We were known for making high fidelity games that looked beautiful and were true to the product." This made Kabam an ideal fit for a fighting game that Marvel had in mind.

Among the early ideas that Parry and his team at Kabam suggested was something based on *Marvel Super Heroes Secret Wars*, a twelve-issue comic book series, in which the Beyonder, as Parry summarizes, "took a bunch of heroes and villains and put them all on a planet and said 'fight to the death!'"

Unfortunately Marvel already had plans for *Secret Wars* around that time.

"We still needed a concept where all these people would come together and fight," recalls Parry. "We thought Iron Man may fight Captain America, when does that happen?! There was a limited run series called *Marvel Super Hero Contest of Champions*, and that was exactly the scenario."

Parry and Gabriel Frizzera took Marvel's story as inspiration, "Let's jam about the Collector taking over a Contest of Champions—make it grounded in a nexus of the universe where all universes collide." With the Collector firmly established as the central super-powerful force, it became a "no-brainer" for a game. The aim would be to "Collect people, go and fight," says Parry.

"As Gabriel always talks about: 'Why are there multiple Summoners? Why are there millions of versions of Captain America?' Well, because we're in this crazy place that the Elders created for their own amusement, and that also is the secret source of great power."

Sam Humphries shares many good memories with the Kabam team talking about character and story, and how to capture the Marvel magic in a video game. "My favorite contribution was deciding on the Collector as the 'host' of the game," says Humphries. "He brought so much scale and power to the proceedings, he really made it feel epic. Plus, he's a blast to write. He got a lot of the best lines."

Before the Collector began capturing heroes from across the Marvel Multiverse for the purpose of his grim battle royal, inviting Summoners to challenge Kang the Conqueror, this hidden sector of the galaxy was a perfect mystery to Marvel Games and Kabam.

The premise from Kabam Vancouver was beautiful in its simplicity, deadly in its endless allure. The Collector is capturing heroes to take part in a battle royal, taking place in the mysterious Battlerealm, described by Kabam as, "a patchwork of floating planet fragments containing sections of iconic Marvel locations from past, present, and future."

The feel, according to Humphries, was ideal. "I don't remember if they told me the tone first—but it was exactly what I was going to suggest," says Humphries. "Fun, bombastic, and epic, built around real character depth. A game that makes you want to stand up and cheer every time you win."

And that, True Believers, is how *Marvel Contest of Champions* was born.

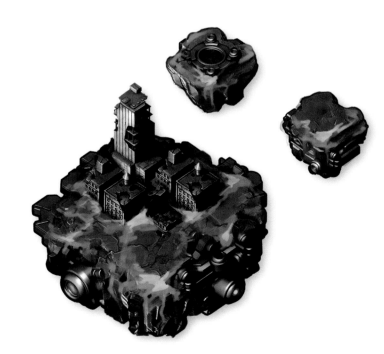

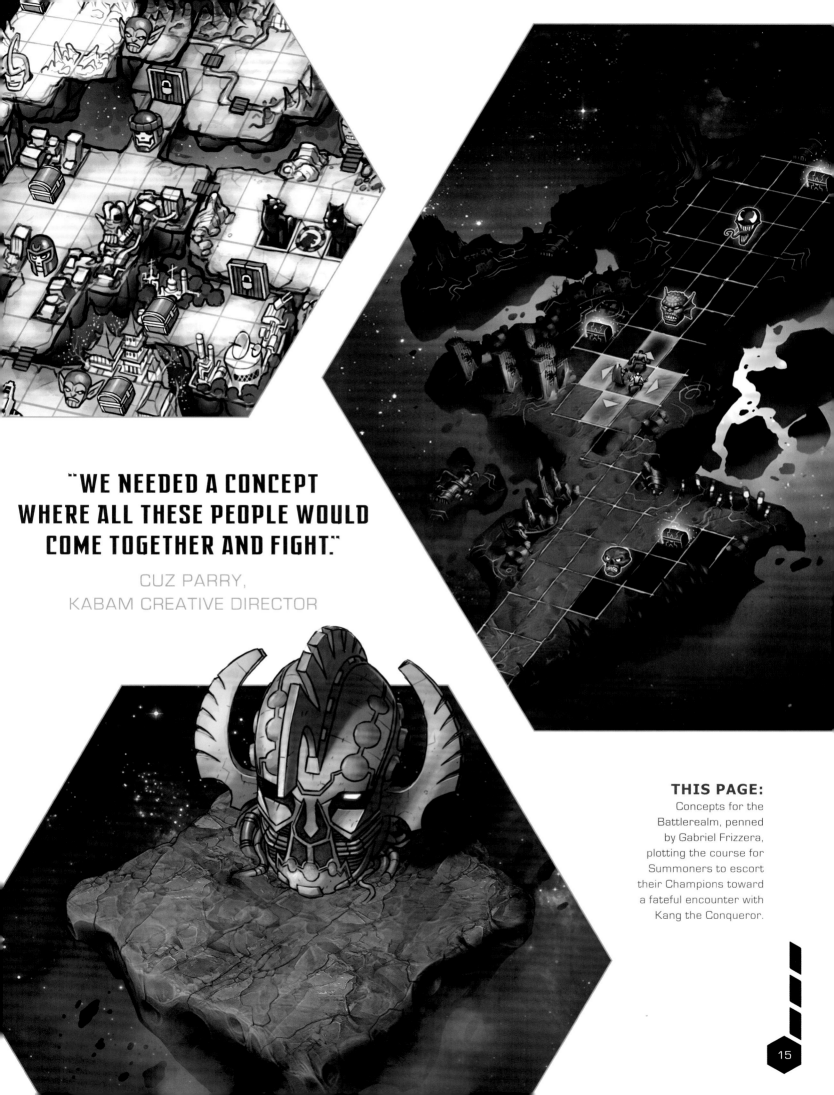

"WE NEEDED A CONCEPT WHERE ALL THESE PEOPLE WOULD COME TOGETHER AND FIGHT."

CUZ PARRY,
KABAM CREATIVE DIRECTOR

THIS PAGE:
Concepts for the Battlerealm, penned by Gabriel Frizzera, plotting the course for Summoners to escort their Champions toward a fateful encounter with Kang the Conqueror.

THE KNOWN BATTLEREALM

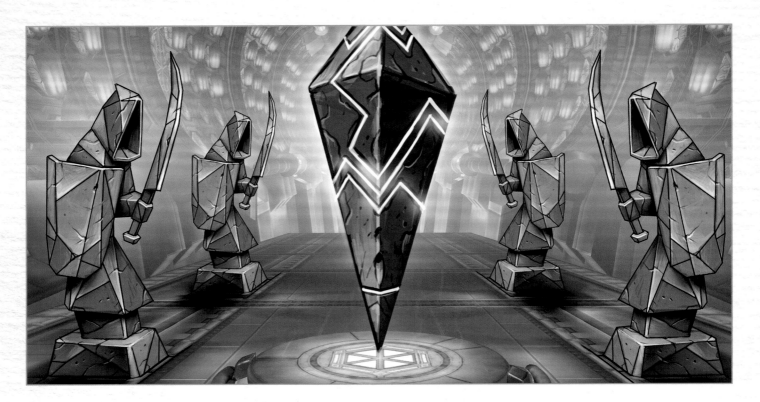

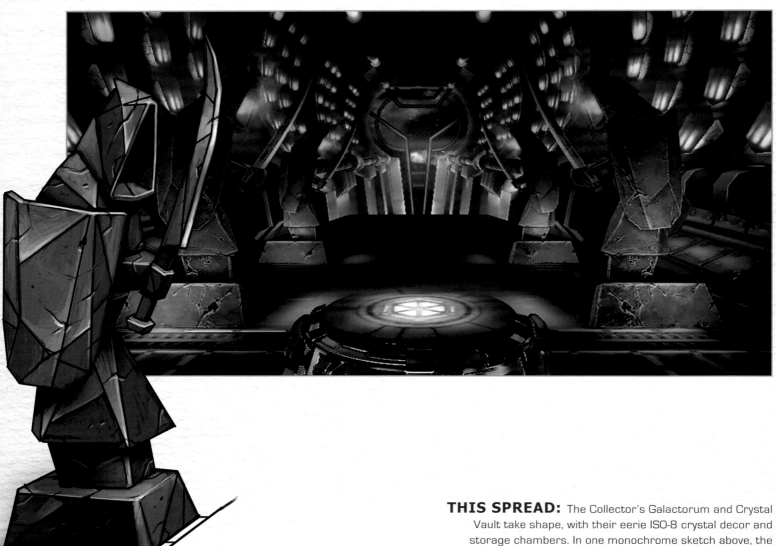

THIS SPREAD: The Collector's Galactorum and Crystal Vault take shape, with their eerie ISO-8 crystal decor and storage chambers. In one monochrome sketch above, the prized ISO-Sphere dominates the scene.

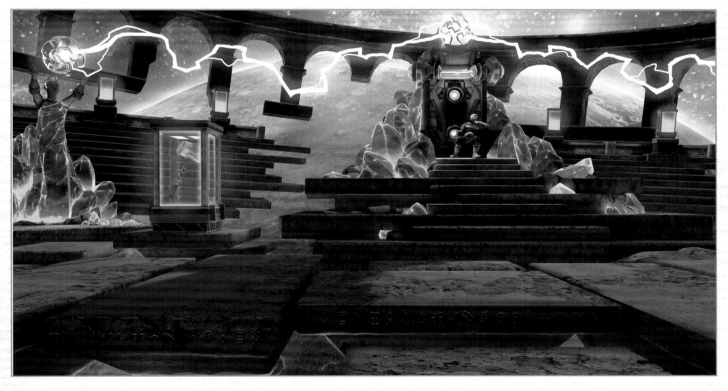

NEXT SPREAD: Iconic Marvel locations from the past, present, and future provide the testing grounds for the Collector's Contest of Champions. They include the Blue Area of the Moon, the S.H.I.E.L.D. Helicarrier, and the volcanic Savage Land.

After arriving at the Battlerealm concept, Gabriel Frizzera and his artists needed to envisage the manner of location that an immortal being—the Elder known as the Collector—would construct with a specific purpose in mind, surrounding an impressive throne.

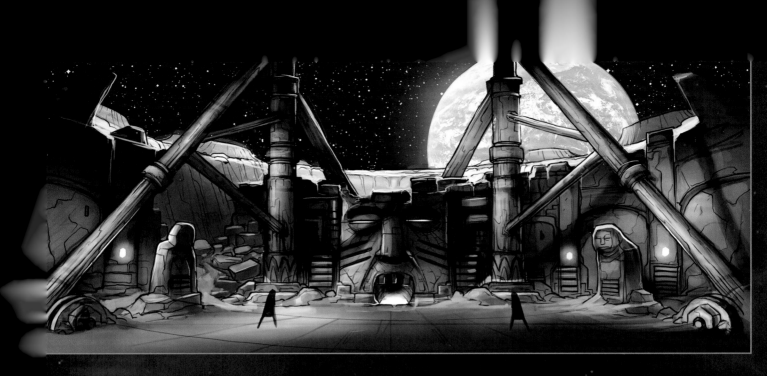

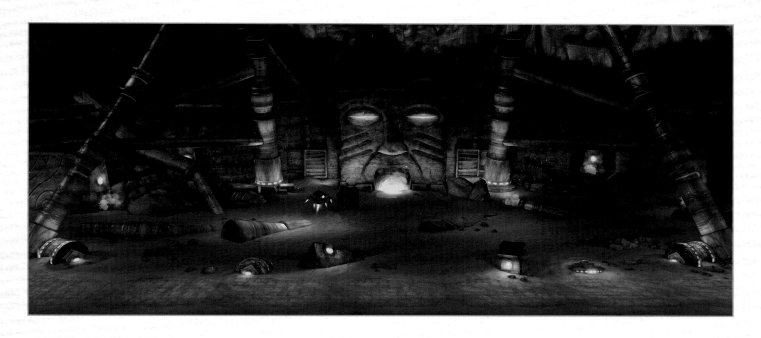

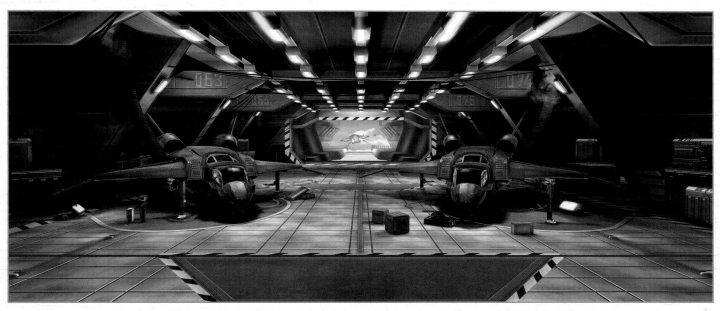

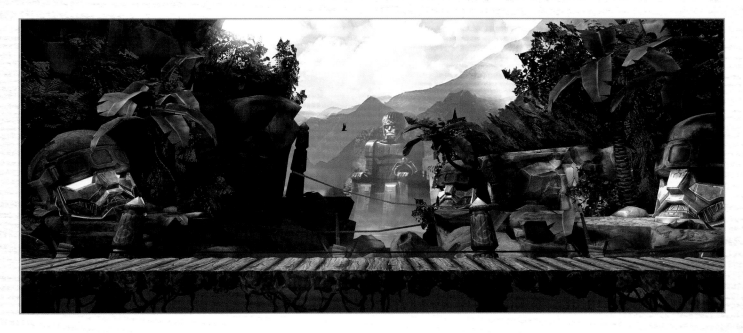

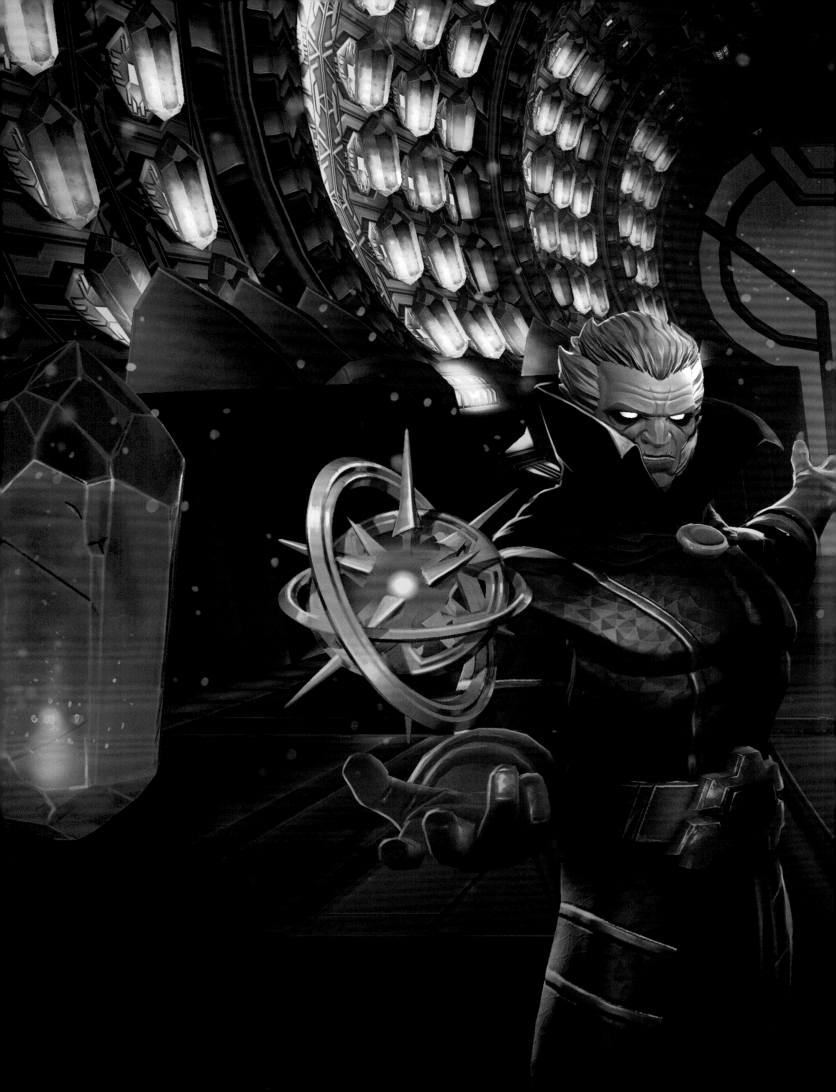

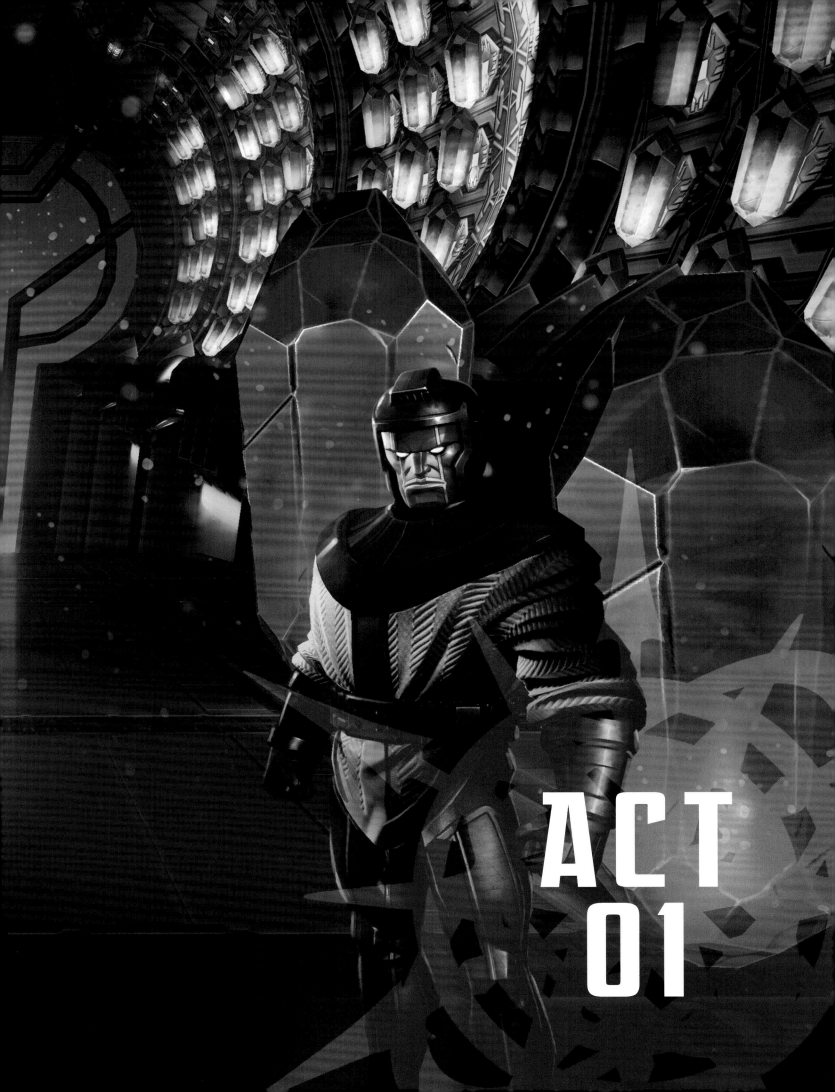

ACT
01

CHALLENGE THE CONQUEROR

CHAPTER ONE

But why would our favorite heroes and villains agree to fight their famous allies in the first place? In Marvel, there is always a reason. This was something that was carefully established between Marvel and Kabam.

"In Act 1, things are really all about setting up characters and contextualizing their actions. We had to explain things like the ISO-Sphere, the ISO-Spell, the Summoner, and the range of Marvel heroes at their disposal," explains Cuz Parry, Creative Director at Kabam. "We worked with Sam Humphries, an amazing Marvel writer, to add depth to the characters while still establishing the player's role in the story as the Summoner. There's a ton of groundwork that needs to be covered to establish some narrative structure for the gameplay, so a writer like Sam who has a reputation for top-notch characterization was the perfect choice. He helped us craft a lot of exposition while packing a ton of personality into every line of dialogue."

Summoners are each granted five Champions from a starting roster of twenty-five

that we shall meet in this chapter. Their abilities are divided across six classes: Science, Mutant, Cosmic, Mystic, Skill, and Tech. Summoners will notice that synergies between characters are hugely beneficial too. The Collector sure knows how to keep things interesting, having captured Champions that include heroes from the Avengers, Guardians of the Galaxy, Inhumans and oh, Deadpool's in here too (if you're lucky enough to crack the right crystal).

"Our fans are excited, but also skeptical about new games," says Marvel New Media Vice President and Creative Executive Ryan Penagos. "They want their favorite characters, they want their favorite storylines, and they want cool things. One of the greatest qualities of *Marvel Contest of Champions* is that it provides so much that hits so many different levels of Marvel fandom. At launch we had Spider-Man, we had Wolverine. Summoners could play as Winter Soldier, or Juggernaut... and Juggernaut was not a character you normally played in a lot of games. Giving fans the ability to play their favorites was the best hook for many."

In Act 1, we are shocked to learn that our beloved heroes are being mind-controlled to fight each other, including those that would be allies in their own universe. Summoners—the role eagerly accepted by millions of players worldwide—are chosen by the Collector to compete in a cosmic Contest of Champions against Kang the Conqueror. Win, and the Collector promises Summoners "untold power" in the form of the ISO-Sphere; a shard of pure ISO-8, a unique Battlerealm substance that augments or creates new super abilities. Lose, and they enter the Elder's collection "permanently." To make a dire situation even worse, Kang vows to destroy planet Earth when (not if) he proves victorious!

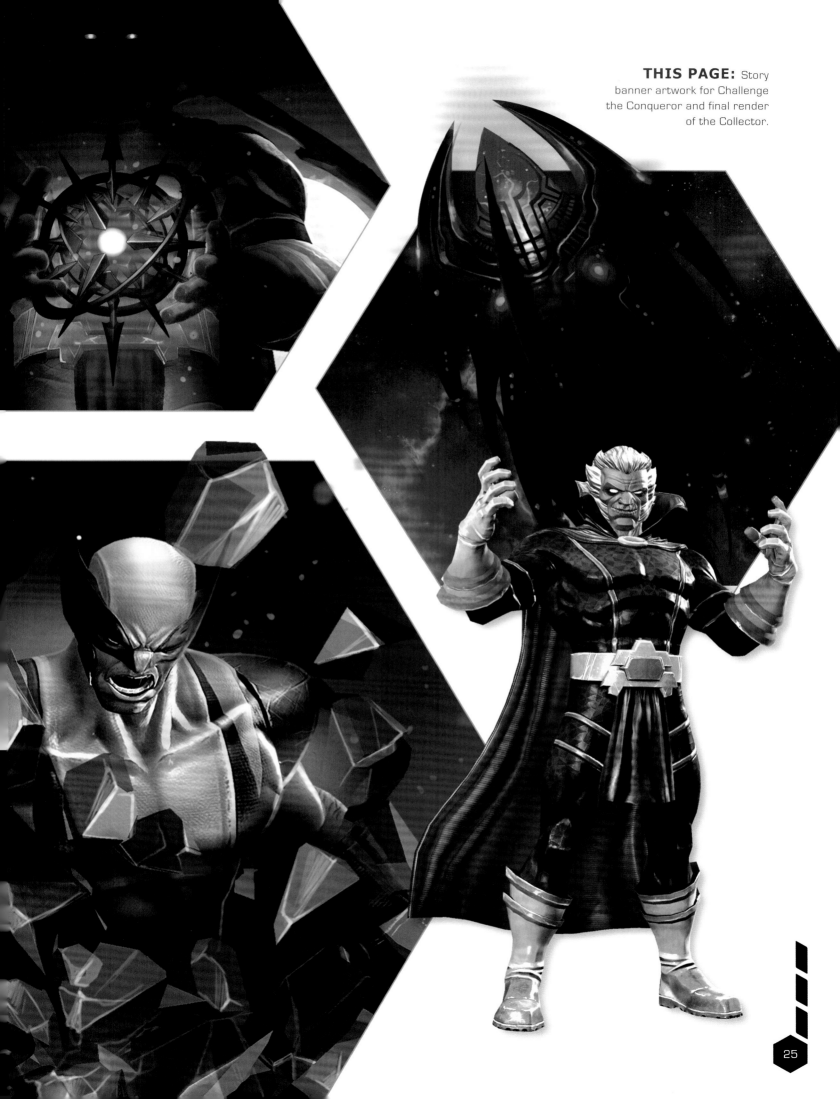

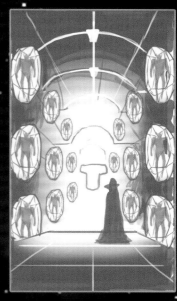
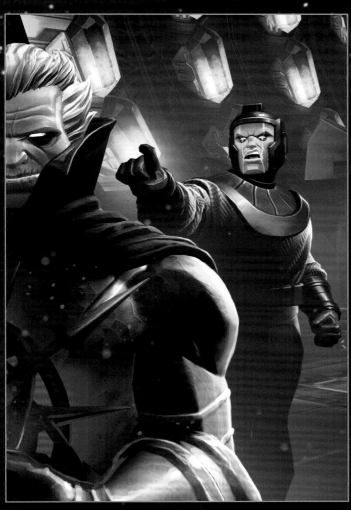
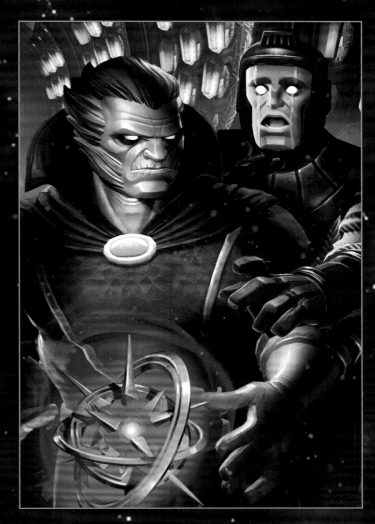

THIS PAGE: Storyboard for Challenge the Conqueror.

THE COLLECTOR

The Collector discovers early on that even the 'immortals' can become dispirited to the point of death. This drives his great motivation to acquire and preserve specimens of flora and fauna from across the known universe, so that in the event of their all-encompassing destruction—which the Collector has foreseen—the Elder might reintroduce every species, great and small, and light the way for their futures.

In *Marvel Contest of Champions*, Summoners initially perceive the Collector as the ultimate antagonist as the organizer of the sinister competition against Kang the Conqueror. His desire to collect lifeforms and artifacts appears crazed and out of control, but the true sponsor of The Contest lurks in the shadows. The Collector becomes the Summoner's determined ally.

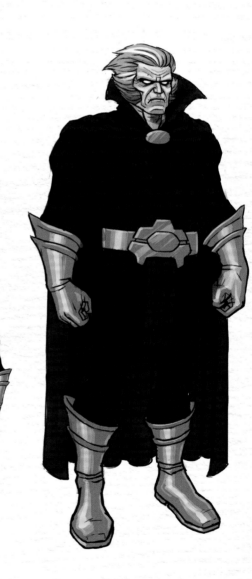

THIS PAGE: (LEFT) Final render of the Collector. (RIGHT) Concept art for the Collector.

KANG THE CONQUEROR

Kang is the Summoner's primary opponent in The Contest of Champions. Traumatized during childhood, challenged by mind-boggling journeys throughout time, Kang is most accustomed to winning, having conquered entire civilizations and founded technologically advanced nations with terrifying armies. The Contest of Champions is like child's play to Kang who views victory as an inevitability. However, all Summoners are bound by the rules of The Contest, leaving Kang open to deception and ultimately his defeat. Not all Champions agree to do Kang's bidding; the Battlerealm exists in a place beyond even his range of influence. An Alliance is eventually formed against Kang, and the megalomaniac proudly goes down fighting, betrayed by one Champion in particular. While this is very far from being the end of the story, Kang officially bows out.

THIS PAGE: [LEFT] Concept art for Kang the Conqueror. [RIGHT] Final render of Kang the Conqueror.

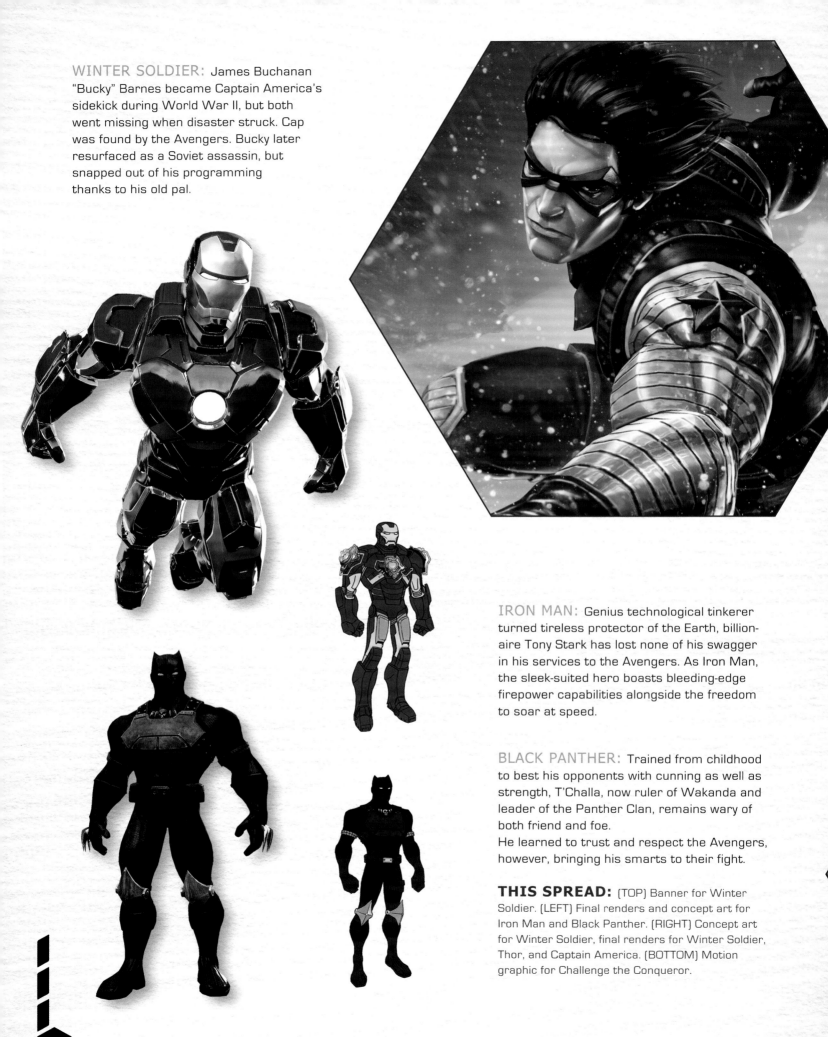

WINTER SOLDIER: James Buchanan "Bucky" Barnes became Captain America's sidekick during World War II, but both went missing when disaster struck. Cap was found by the Avengers. Bucky later resurfaced as a Soviet assassin, but snapped out of his programming thanks to his old pal.

IRON MAN: Genius technological tinkerer turned tireless protector of the Earth, billionaire Tony Stark has lost none of his swagger in his services to the Avengers. As Iron Man, the sleek-suited hero boasts bleeding-edge firepower capabilities alongside the freedom to soar at speed.

BLACK PANTHER: Trained from childhood to best his opponents with cunning as well as strength, T'Challa, now ruler of Wakanda and leader of the Panther Clan, remains wary of both friend and foe.
He learned to trust and respect the Avengers, however, bringing his smarts to their fight.

THIS SPREAD: (TOP) Banner for Winter Soldier. (LEFT) Final renders and concept art for Iron Man and Black Panther. (RIGHT) Concept art for Winter Soldier, final renders for Winter Soldier, Thor, and Captain America. (BOTTOM) Motion graphic for Challenge the Conqueror.

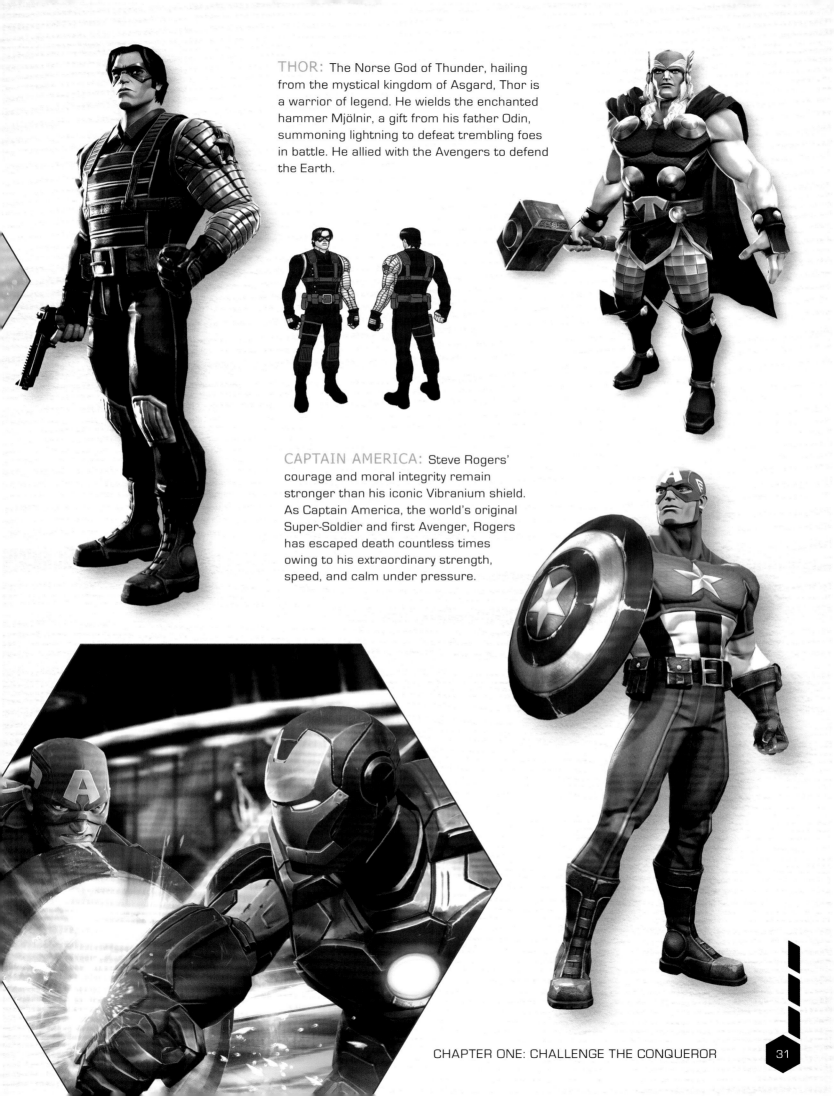

THOR: The Norse God of Thunder, hailing from the mystical kingdom of Asgard, Thor is a warrior of legend. He wields the enchanted hammer Mjölnir, a gift from his father Odin, summoning lightning to defeat trembling foes in battle. He allied with the Avengers to defend the Earth.

CAPTAIN AMERICA: Steve Rogers' courage and moral integrity remain stronger than his iconic Vibranium shield. As Captain America, the world's original Super-Soldier and first Avenger, Rogers has escaped death countless times owing to his extraordinary strength, speed, and calm under pressure.

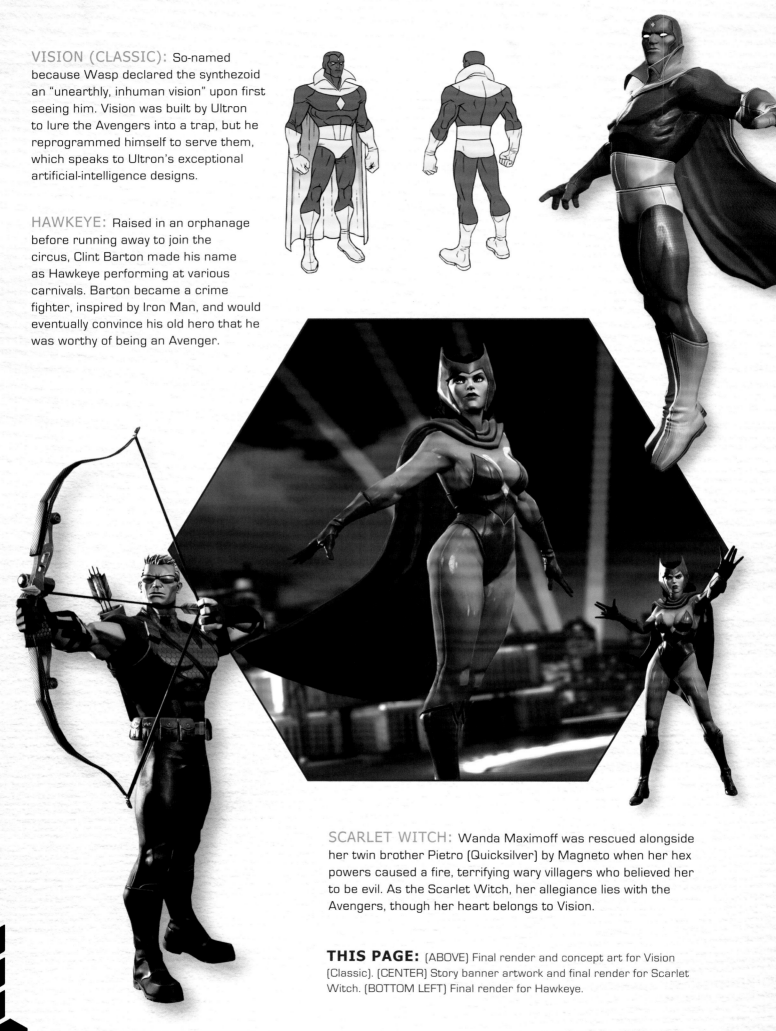

VISION (CLASSIC): So-named because Wasp declared the synthezoid an "unearthly, inhuman vision" upon first seeing him. Vision was built by Ultron to lure the Avengers into a trap, but he reprogrammed himself to serve them, which speaks to Ultron's exceptional artificial-intelligence designs.

HAWKEYE: Raised in an orphanage before running away to join the circus, Clint Barton made his name as Hawkeye performing at various carnivals. Barton became a crime fighter, inspired by Iron Man, and would eventually convince his old hero that he was worthy of being an Avenger.

SCARLET WITCH: Wanda Maximoff was rescued alongside her twin brother Pietro (Quicksilver) by Magneto when her hex powers caused a fire, terrifying wary villagers who believed her to be evil. As the Scarlet Witch, her allegiance lies with the Avengers, though her heart belongs to Vision.

THIS PAGE: [ABOVE] Final render and concept art for Vision (Classic). [CENTER] Story banner artwork and final render for Scarlet Witch. [BOTTOM LEFT] Final render for Hawkeye.

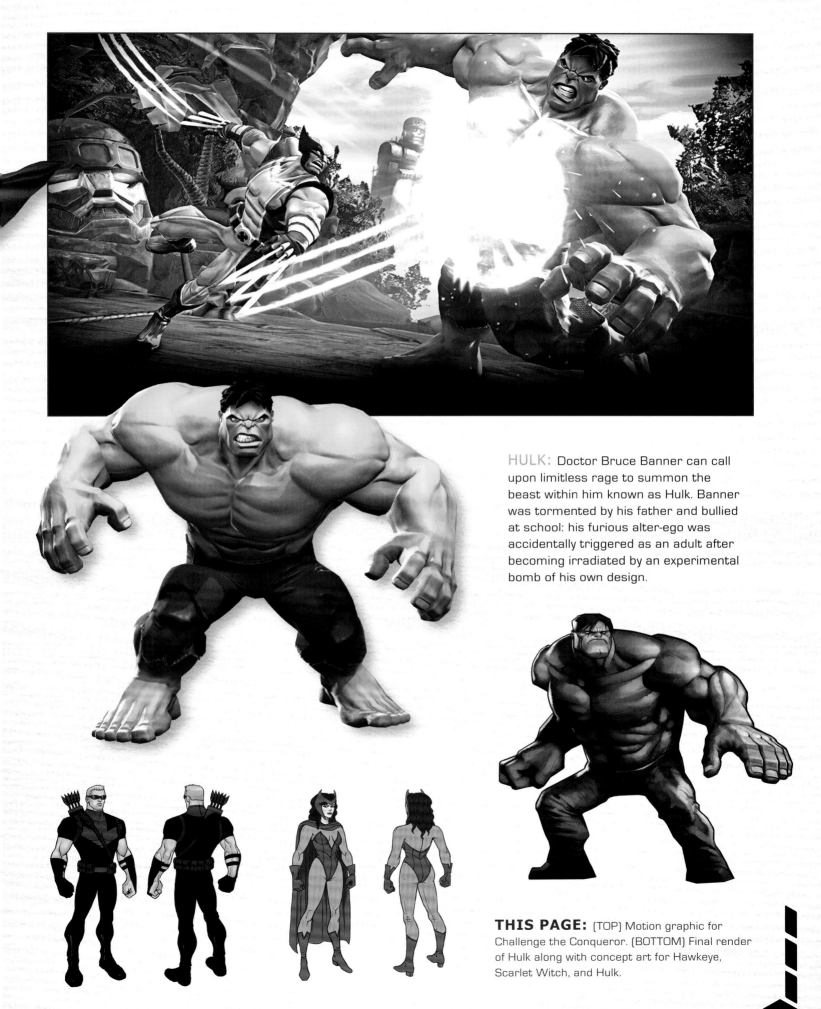

HULK: Doctor Bruce Banner can call upon limitless rage to summon the beast within him known as Hulk. Banner was tormented by his father and bullied at school: his furious alter-ego was accidentally triggered as an adult after becoming irradiated by an experimental bomb of his own design.

THIS PAGE: [TOP] Motion graphic for Challenge the Conqueror. (BOTTOM) Final render of Hulk along with concept art for Hawkeye, Scarlet Witch, and Hulk.

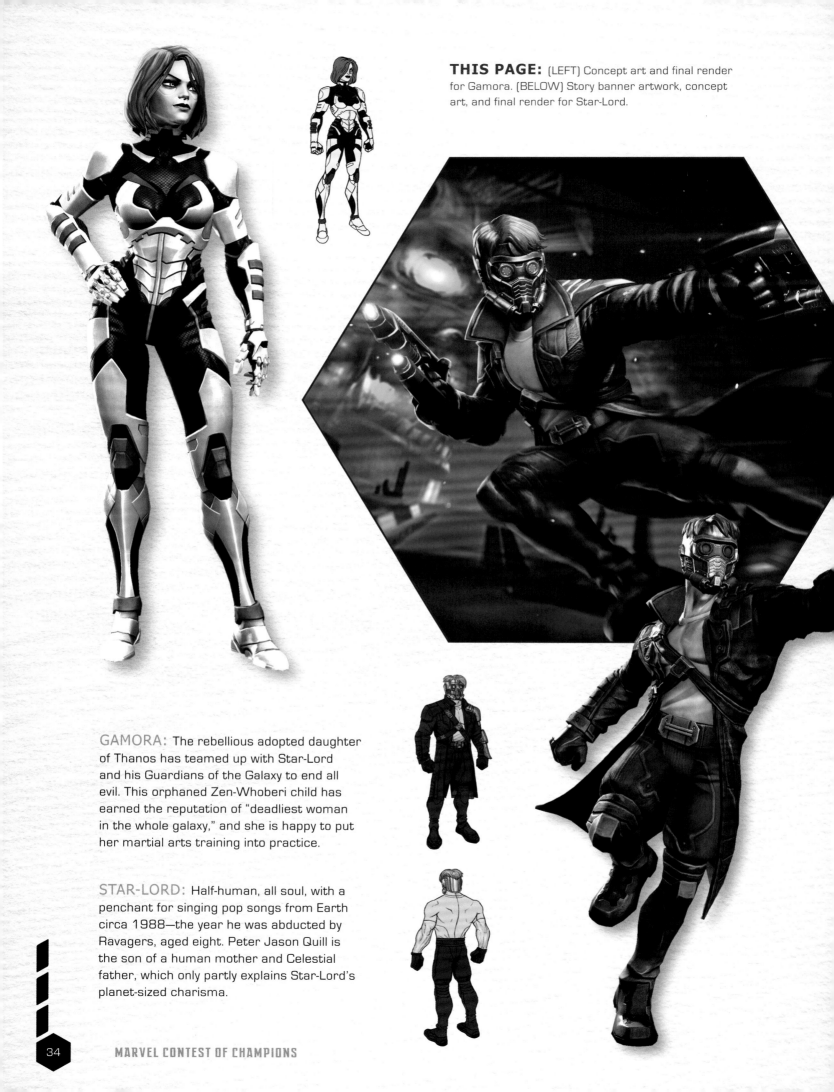

THIS PAGE: (LEFT) Concept art and final render for Gamora. (BELOW) Story banner artwork, concept art, and final render for Star-Lord.

GAMORA: The rebellious adopted daughter of Thanos has teamed up with Star-Lord and his Guardians of the Galaxy to end all evil. This orphaned Zen-Whoberi child has earned the reputation of "deadliest woman in the whole galaxy," and she is happy to put her martial arts training into practice.

STAR-LORD: Half-human, all soul, with a penchant for singing pop songs from Earth circa 1988—the year he was abducted by Ravagers, aged eight. Peter Jason Quill is the son of a human mother and Celestial father, which only partly explains Star-Lord's planet-sized charisma.

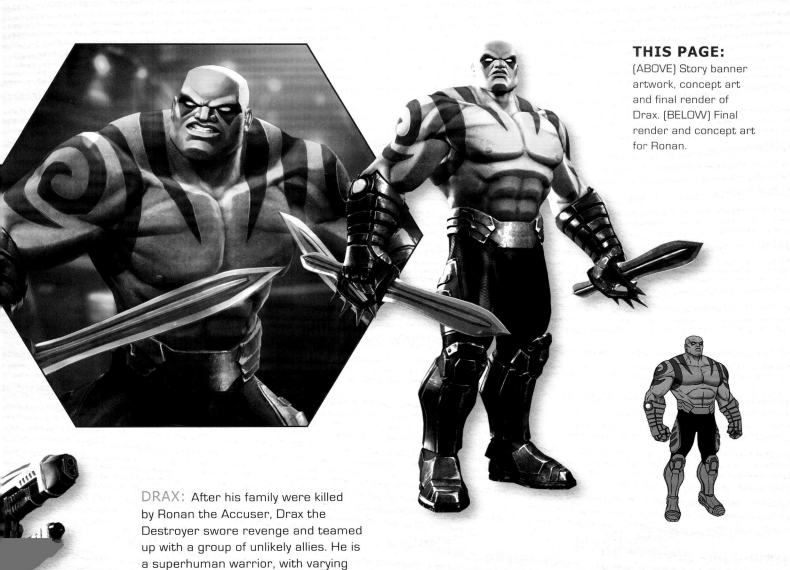

DRAX: After his family were killed by Ronan the Accuser, Drax the Destroyer swore revenge and teamed up with a group of unlikely allies. He is a superhuman warrior, with varying degrees of power versus intelligence.

RONAN: Ronan the Accuser is the ultimate champion of justice. As Supreme Accuser of the Kree Empire, he is judge, jury, and executioner. When his hammer falls, your fate will be decided.

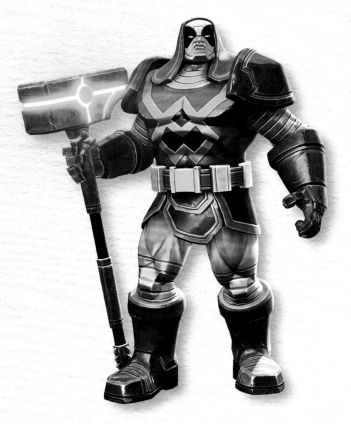

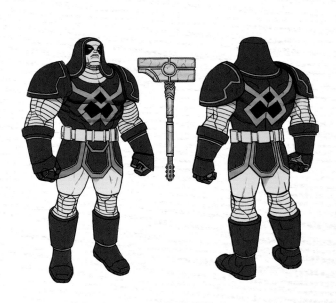

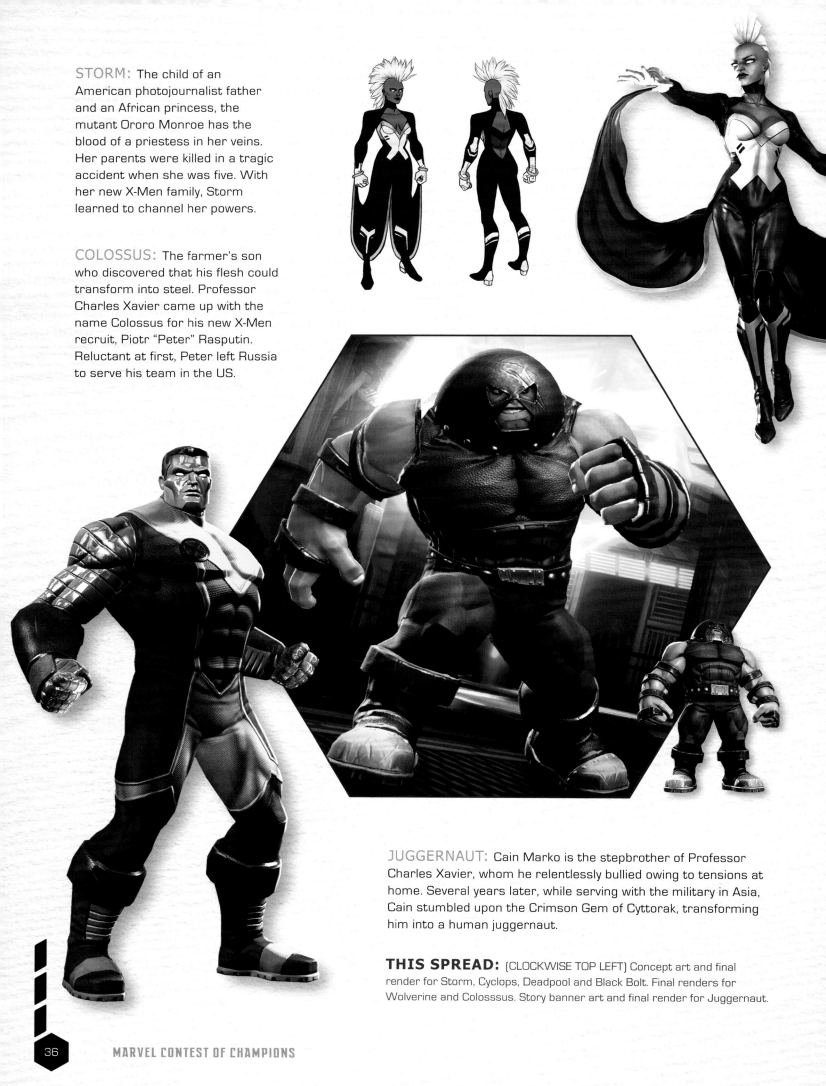

STORM: The child of an American photojournalist father and an African princess, the mutant Ororo Monroe has the blood of a priestess in her veins. Her parents were killed in a tragic accident when she was five. With her new X-Men family, Storm learned to channel her powers.

COLOSSUS: The farmer's son who discovered that his flesh could transform into steel. Professor Charles Xavier came up with the name Colossus for his new X-Men recruit, Piotr "Peter" Rasputin. Reluctant at first, Peter left Russia to serve his team in the US.

JUGGERNAUT: Cain Marko is the stepbrother of Professor Charles Xavier, whom he relentlessly bullied owing to tensions at home. Several years later, while serving with the military in Asia, Cain stumbled upon the Crimson Gem of Cyttorak, transforming him into a human juggernaut.

THIS SPREAD: (CLOCKWISE TOP LEFT) Concept art and final render for Storm, Cyclops, Deadpool and Black Bolt. Final renders for Wolverine and Colosssus. Story banner art and final render for Juggernaut.

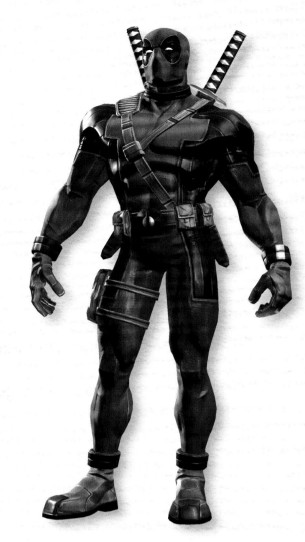

CYCLOPS (NEW XAVIER SCHOOL): A corrupted Scott Summers murders Professor Xavier, and forms an alliance with Magneto and Magik. Together they liberate mutants and build a new team, but soon realize that the after effects of Phoenix Force are far from done messing with their volatile super abilities.

DEADPOOL! *Clearly these guys can't write a decent Super Hero bio, so here's where I fit in with Contest of Chumps: So... I'm awesome. I took my name from something horrible. I have huge guns to save time learning moves that only get me killed. I should be your first pick!*

WOLVERINE: Weaponized through a process that bonded Adamantium to his skeleton and mutant claws, the man calling himself Logan has an uncertain past owing to messed up memory implants. Wolverine is fearless, unnaturally swift to heal, and counts Hulk among his fiercest rivals.

BLACK BOLT: The Inhuman child of Attilan royalty was imprisoned until the age of nineteen, owing to quasi-sonic powers beyond the youngster's control. Black Bolt's ability to cause mass destruction using the sound of his voice is owed to his own parents' mutagenic experiments before his birth.

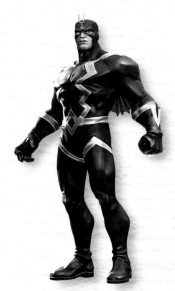

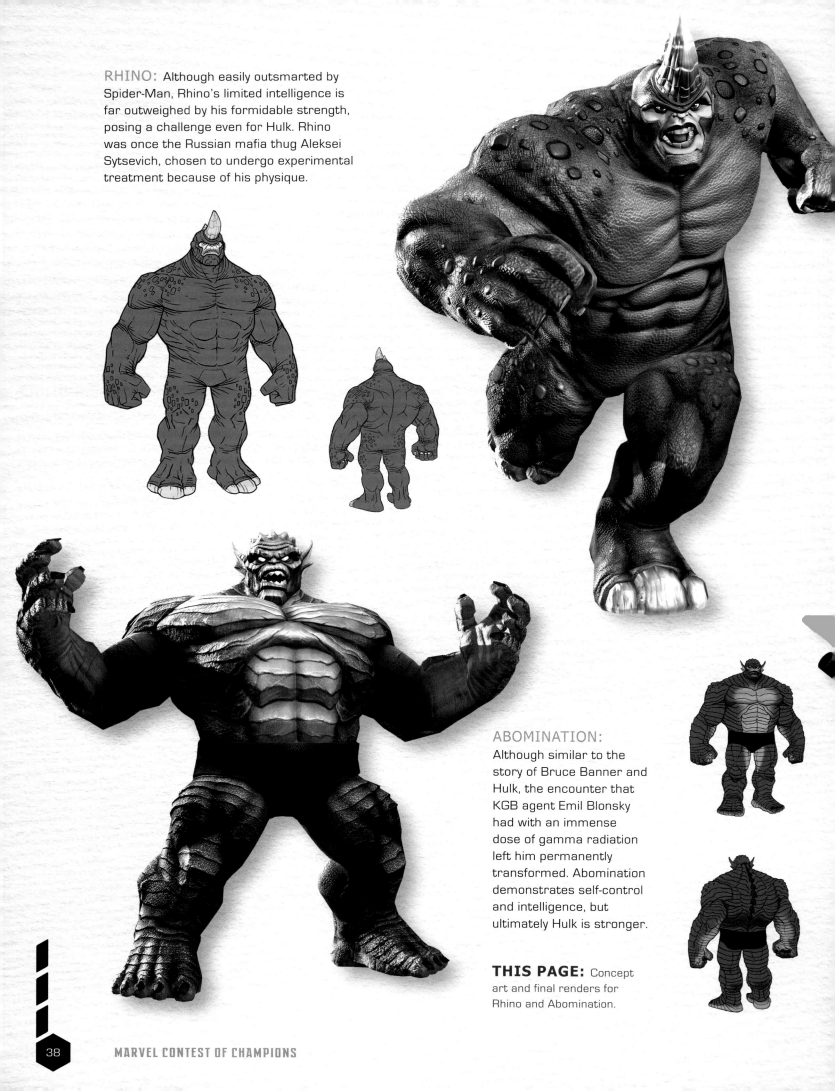

RHINO: Although easily outsmarted by Spider-Man, Rhino's limited intelligence is far outweighed by his formidable strength, posing a challenge even for Hulk. Rhino was once the Russian mafia thug Aleksei Sytsevich, chosen to undergo experimental treatment because of his physique.

ABOMINATION: Although similar to the story of Bruce Banner and Hulk, the encounter that KGB agent Emil Blonsky had with an immense dose of gamma radiation left him permanently transformed. Abomination demonstrates self-control and intelligence, but ultimately Hulk is stronger.

THIS PAGE: Concept art and final renders for Rhino and Abomination.

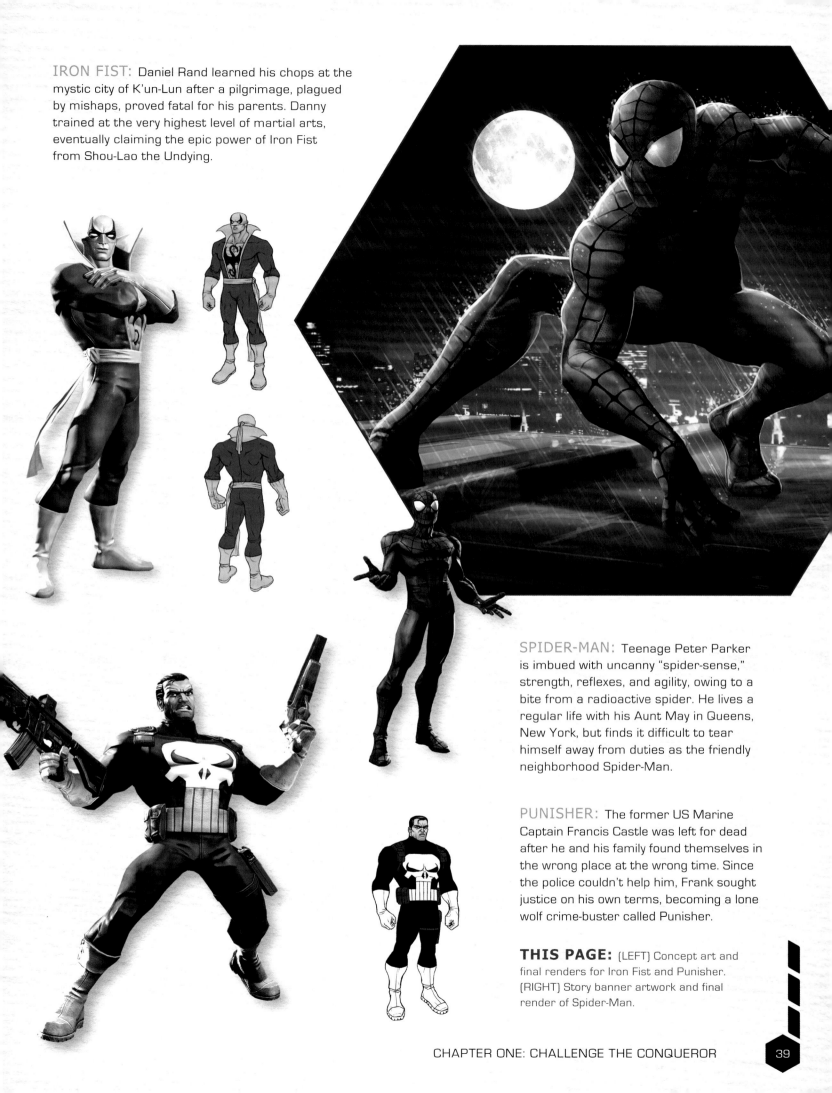

IRON FIST: Daniel Rand learned his chops at the mystic city of K'un-Lun after a pilgrimage, plagued by mishaps, proved fatal for his parents. Danny trained at the very highest level of martial arts, eventually claiming the epic power of Iron Fist from Shou-Lao the Undying.

SPIDER-MAN: Teenage Peter Parker is imbued with uncanny "spider-sense," strength, reflexes, and agility, owing to a bite from a radioactive spider. He lives a regular life with his Aunt May in Queens, New York, but finds it difficult to tear himself away from duties as the friendly neighborhood Spider-Man.

PUNISHER: The former US Marine Captain Francis Castle was left for dead after he and his family found themselves in the wrong place at the wrong time. Since the police couldn't help him, Frank sought justice on his own terms, becoming a lone wolf crime-buster called Punisher.

THIS PAGE: (LEFT) Concept art and final renders for Iron Fist and Punisher. (RIGHT) Story banner artwork and final render of Spider-Man.

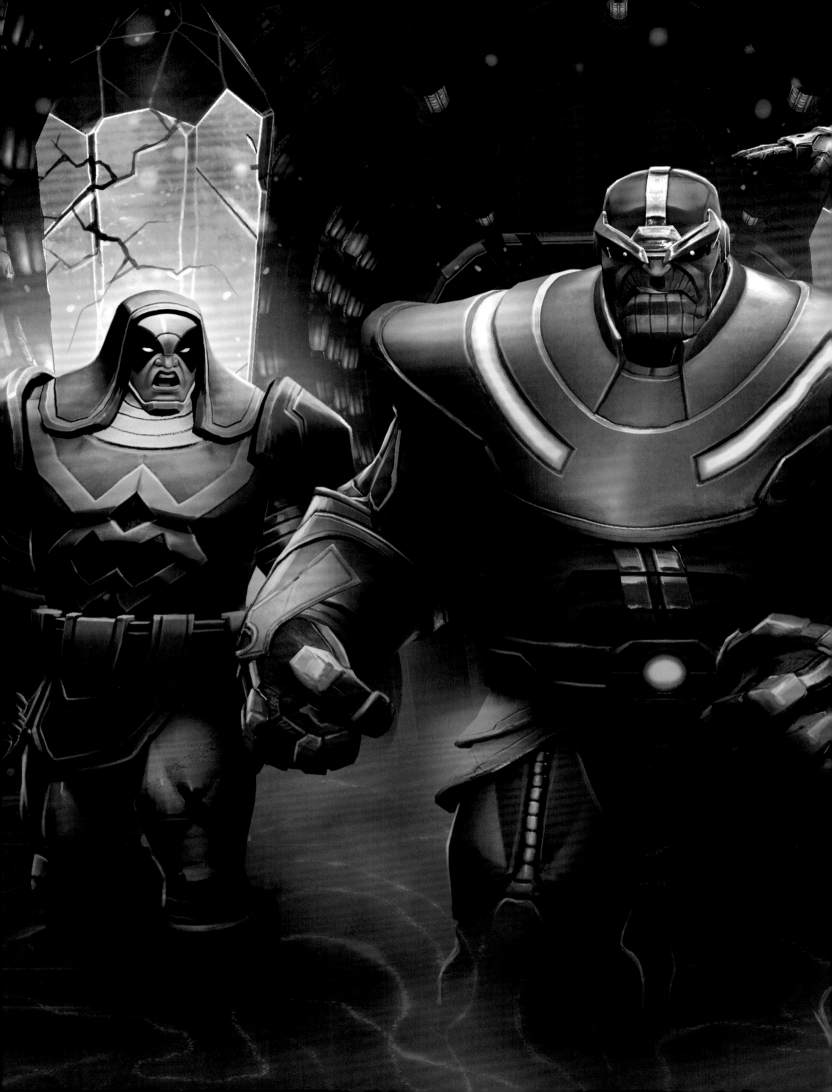

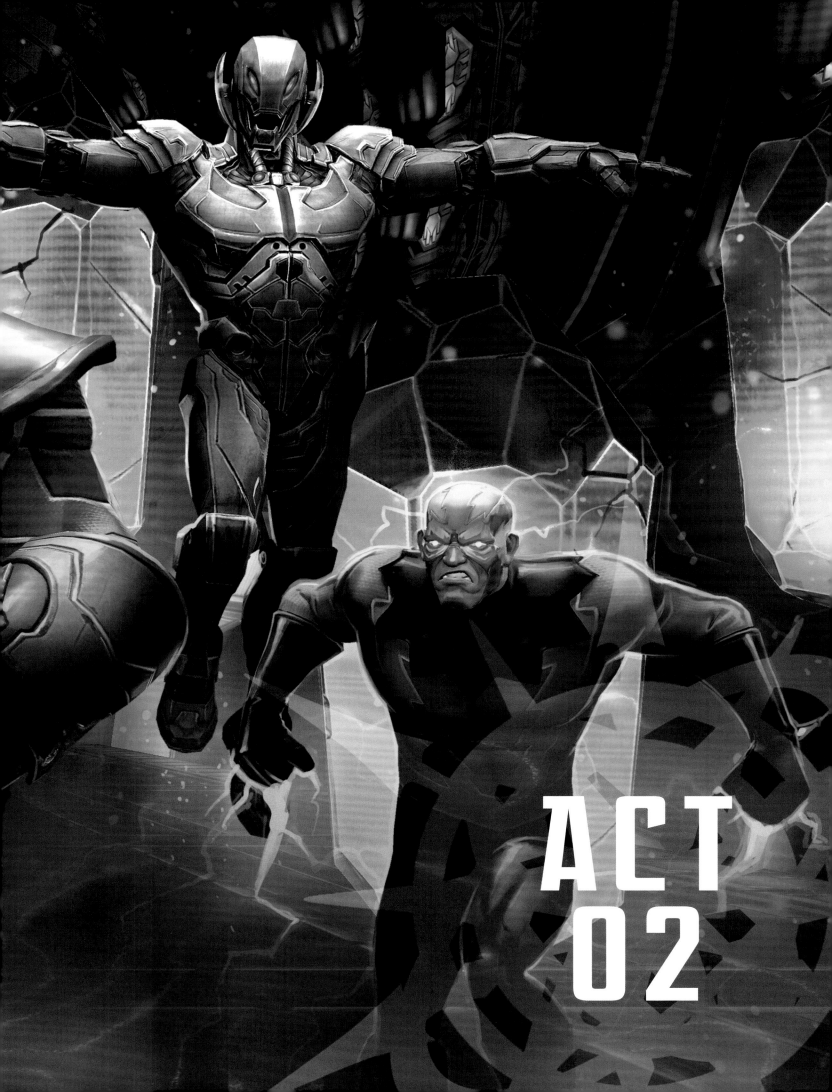

ACT
02

BATTLEREALM REVELATIONS
CHAPTER TWO

At the center of this game is a story eloquently established on Marvel lore that fans love. But with the audience having formed a safe idea of the *Marvel Contest of Champions* agenda, it was Kabam's great pleasure to immediately begin messing with those expectations. Not all Champions summoned like to play by the rules, and especially not the Mad Titan Thanos.

"Once the setup of the gameplay is out of the way, Act 1 really builds Kang up as your primary antagonist," Kabam's Quest Designer Scott Bradford says. "The structure of our story begins deliberately simply: Kang is your adversary. This premise lets us keep things familiar when we want, but makes wrinkles to the adversarial relationship more impactful. Wrinkles like the arrival of Thanos, for example. When he gets there he's not fond of all the secrets, and starts making demands only the Mad Titan could get away with making. Suddenly, our seemingly straightforward concept of Summoner vs. Kang has added a third player,

all while the secrets of the Battlerealm start to slowly reveal."

One way in which the Kabam team was eager to deliver precisely on a promise was through dynamic representation of Marvel Super Heroes and Villains. Fans leaving multiplex movie theaters full of excitement could use the game to fulfil the dream of executing superhuman powers. Tying in closely with what Marvel is doing across all its entertainment platforms has played a major role from the earliest collaborative meetings.

The close collaboration between Marvel and Kabam "helps us with powers and moves," says Cuz Parry. "People get really excited to see if something happens in the movie—like there's one big scene where somebody does this awesome special move—they'll find that effect in-game. I know that with *Doctor Strange* we worked with Marvel to ensure that our version of Doctor Strange, or characters from *Doctor Strange*, matched with what the characters did in the movie."

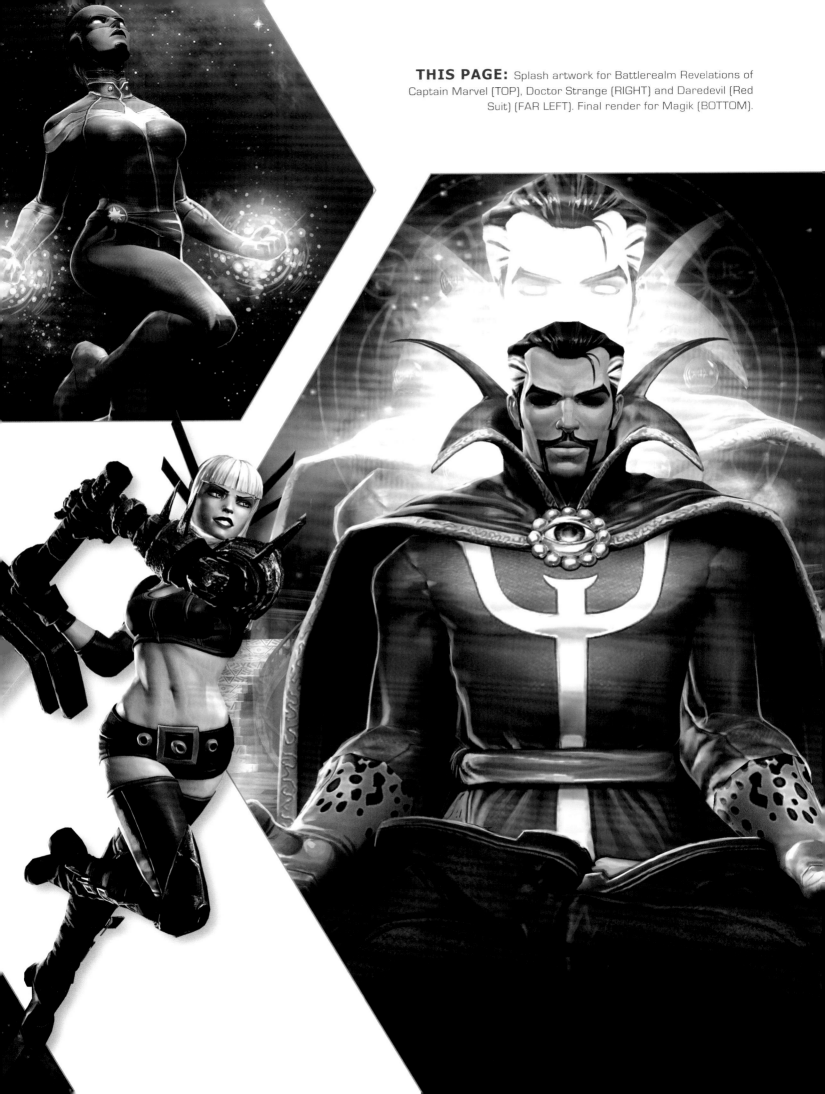

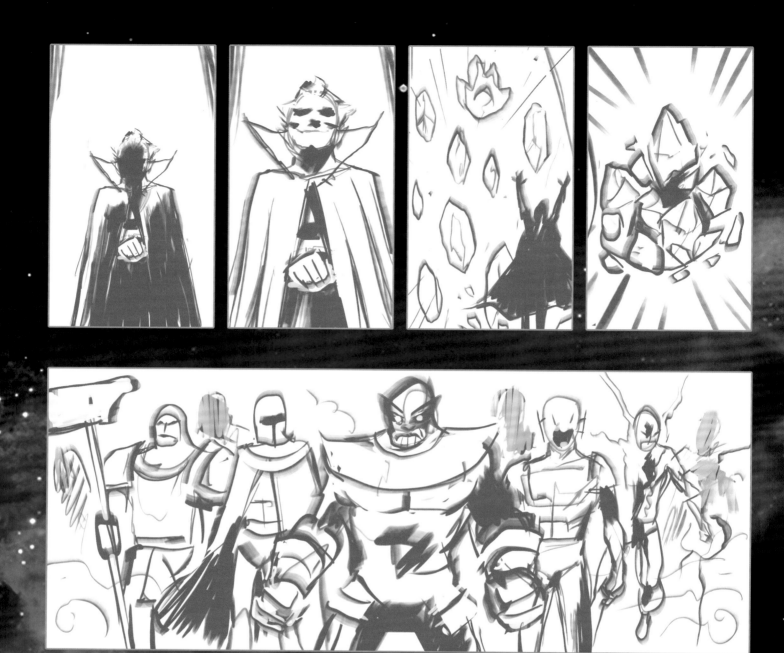

THIS PAGE: Storyboard for Battlerealm Revelations.

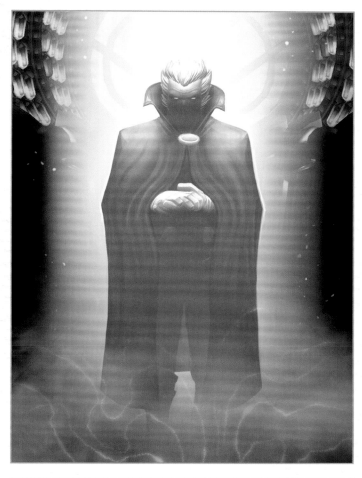

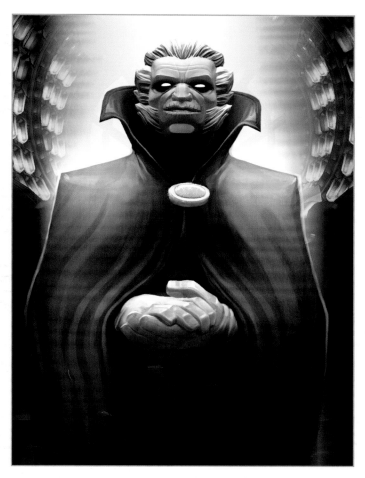

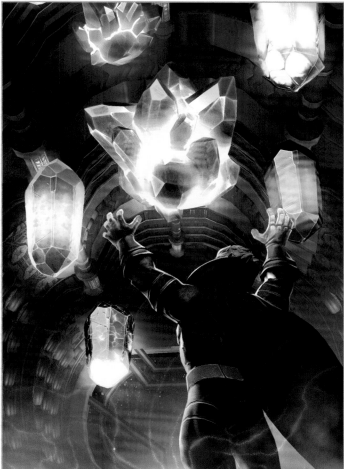

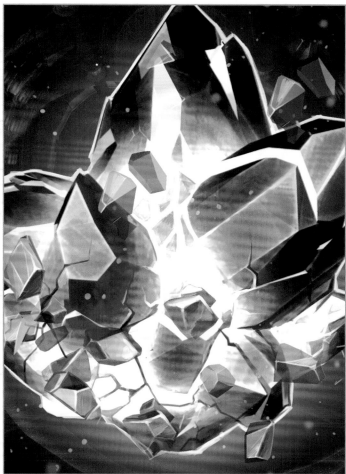

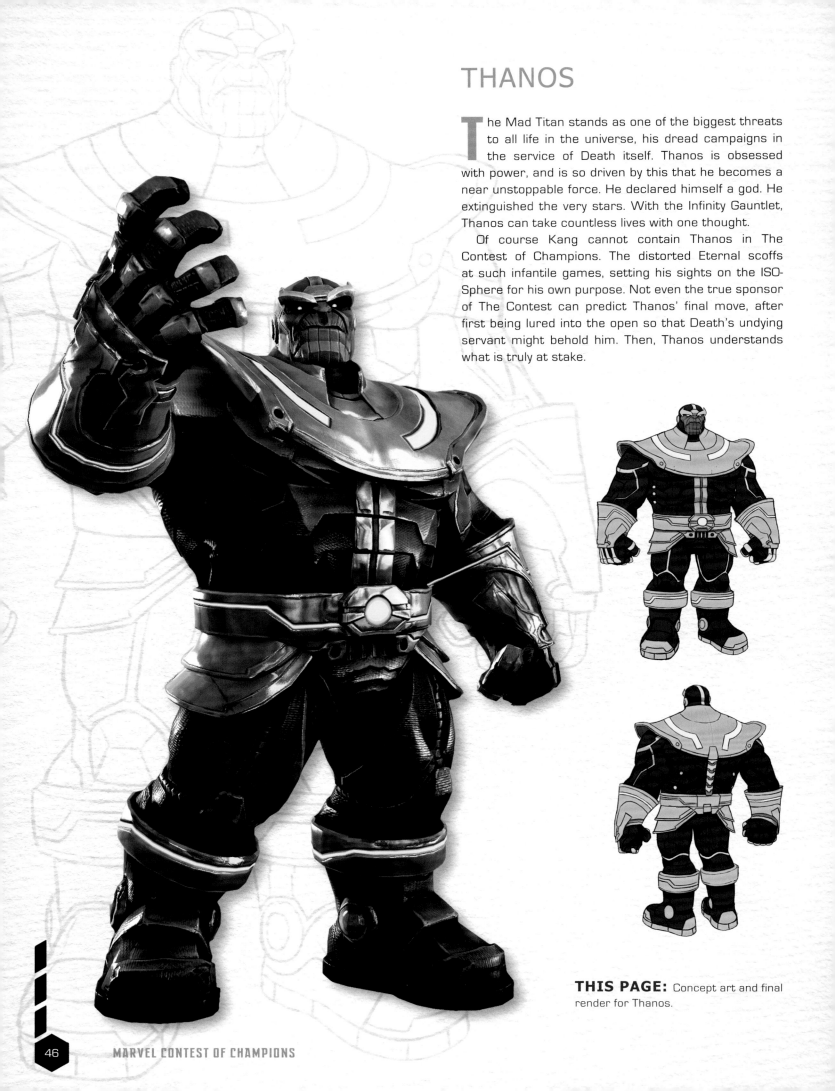

THANOS

The Mad Titan stands as one of the biggest threats to all life in the universe, his dread campaigns in the service of Death itself. Thanos is obsessed with power, and is so driven by this that he becomes a near unstoppable force. He declared himself a god. He extinguished the very stars. With the Infinity Gauntlet, Thanos can take countless lives with one thought.

Of course Kang cannot contain Thanos in The Contest of Champions. The distorted Eternal scoffs at such infantile games, setting his sights on the ISO-Sphere for his own purpose. Not even the true sponsor of The Contest can predict Thanos' final move, after first being lured into the open so that Death's undying servant might behold him. Then, Thanos understands what is truly at stake.

THIS PAGE: Concept art and final render for Thanos.

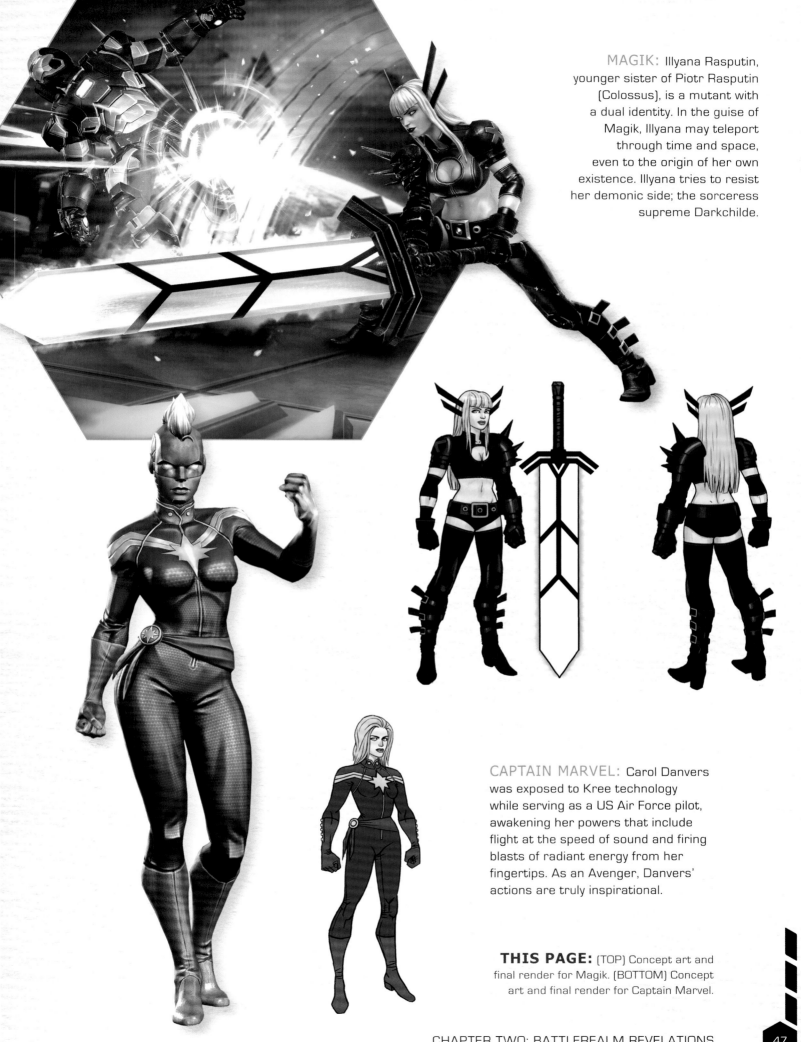

MAGIK: Illyana Rasputin, younger sister of Piotr Rasputin (Colossus), is a mutant with a dual identity. In the guise of Magik, Illyana may teleport through time and space, even to the origin of her own existence. Illyana tries to resist her demonic side; the sorceress supreme Darkchilde.

CAPTAIN MARVEL: Carol Danvers was exposed to Kree technology while serving as a US Air Force pilot, awakening her powers that include flight at the speed of sound and firing blasts of radiant energy from her fingertips. As an Avenger, Danvers' actions are truly inspirational.

THIS PAGE: (TOP) Concept art and final render for Magik. (BOTTOM) Concept art and final render for Captain Marvel.

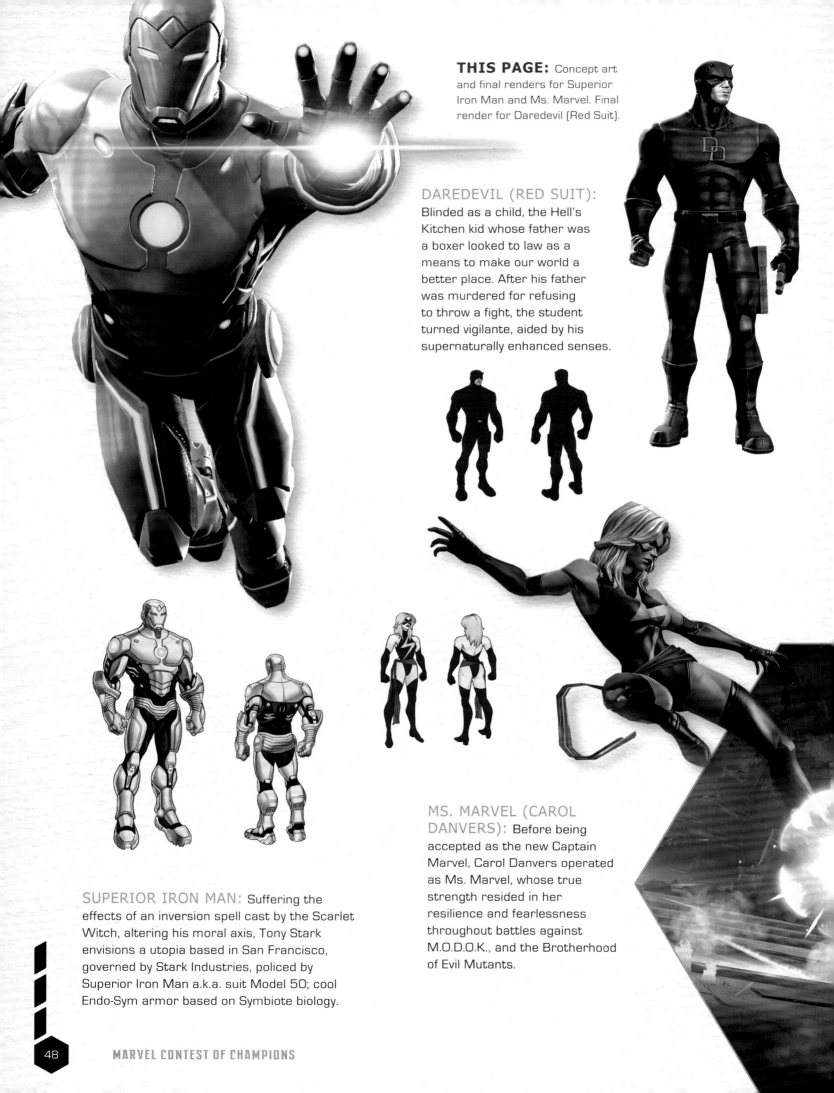

THIS PAGE: Concept art and final renders for Superior Iron Man and Ms. Marvel. Final render for Daredevil (Red Suit).

DAREDEVIL (RED SUIT): Blinded as a child, the Hell's Kitchen kid whose father was a boxer looked to law as a means to make our world a better place. After his father was murdered for refusing to throw a fight, the student turned vigilante, aided by his supernaturally enhanced senses.

SUPERIOR IRON MAN: Suffering the effects of an inversion spell cast by the Scarlet Witch, altering his moral axis, Tony Stark envisions a utopia based in San Francisco, governed by Stark Industries, policed by Superior Iron Man a.k.a. suit Model 50; cool Endo-Sym armor based on Symbiote biology.

MS. MARVEL (CAROL DANVERS): Before being accepted as the new Captain Marvel, Carol Danvers operated as Ms. Marvel, whose true strength resided in her resilience and fearlessness throughout battles against M.O.D.O.K., and the Brotherhood of Evil Mutants.

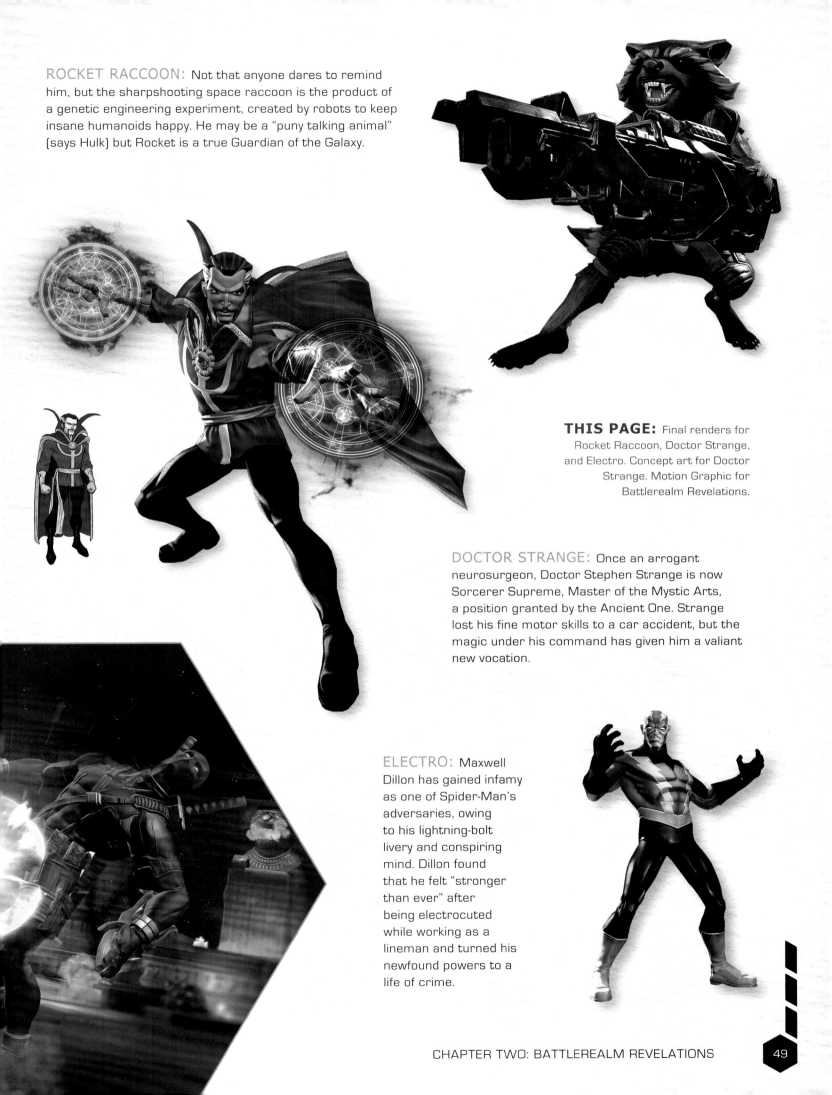

ROCKET RACCOON: Not that anyone dares to remind him, but the sharpshooting space raccoon is the product of a genetic engineering experiment, created by robots to keep insane humanoids happy. He may be a "puny talking animal" (says Hulk) but Rocket is a true Guardian of the Galaxy.

THIS PAGE: Final renders for Rocket Raccoon, Doctor Strange, and Electro. Concept art for Doctor Strange. Motion Graphic for Battlerealm Revelations.

DOCTOR STRANGE: Once an arrogant neurosurgeon, Doctor Stephen Strange is now Sorcerer Supreme, Master of the Mystic Arts, a position granted by the Ancient One. Strange lost his fine motor skills to a car accident, but the magic under his command has given him a valiant new vocation.

ELECTRO: Maxwell Dillon has gained infamy as one of Spider-Man's adversaries, owing to his lightning-bolt livery and conspiring mind. Dillon found that he felt "stronger than ever" after being electrocuted while working as a lineman and turned his newfound powers to a life of crime.

ACT
03

SURRENDER TO THE CONTEST
CHAPTER THREE

The game always requires new villains, but that can sometimes be a challenge. Some of the more obvious choices were quickly discarded. Then the Marvel/Kabam team hit on an idea that felt right: Maestro.

Maestro was a revelation for Marvel Games Executive Creative Director, Bill Rosemann. "One early fun memory of working on the game was when I was transitioning to relocate out to California to join the Marvel Games team full time," Rosemann says. "I received a phone call from my friend Sam Humphries, who was working with the Kabam writing team on the game's story structure. We had previously discussed bringing in the Grandmaster, the Collector's archrival in the original *Contest of Champions* comic book limited series, but Sam wanted to unveil a surprise in the form of Maestro, the infamous future evil version of the Hulk! Sam was only a few words into his pitch when I interrupted him, saying, 'Sam, that's brilliant! Let's do it!'

"What intrigued me about introducing the Maestro was not only the shock, but the thought that Sam put into his function in the story and how authentic it felt to the character. In a fresh twist on Maestro's saga, he would leave his future timeline and journey to The Contest as part of his never-ending quest of conquest. This alternate reality Hulk, having defeated all who stood before him, would make the bold move of traveling to the ultimate arena in order to sake his unquenchable thirst for domination!

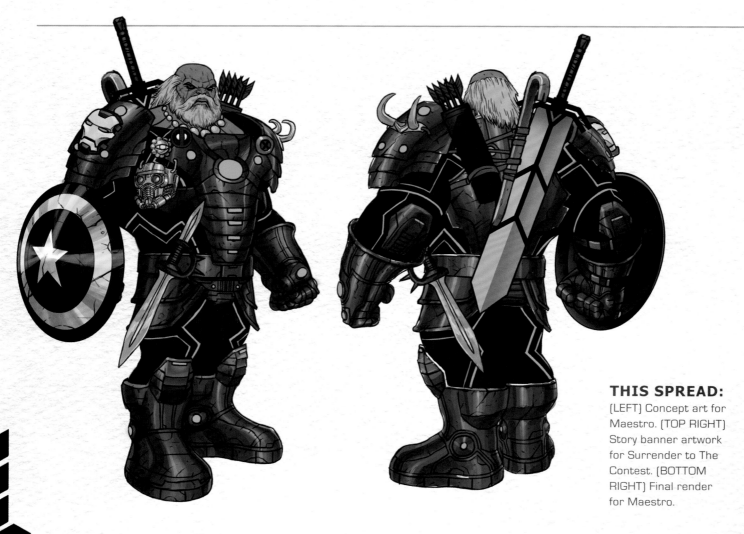

THIS SPREAD:
[LEFT] Concept art for Maestro. [TOP RIGHT] Story banner artwork for Surrender to The Contest. [BOTTOM RIGHT] Final render for Maestro.

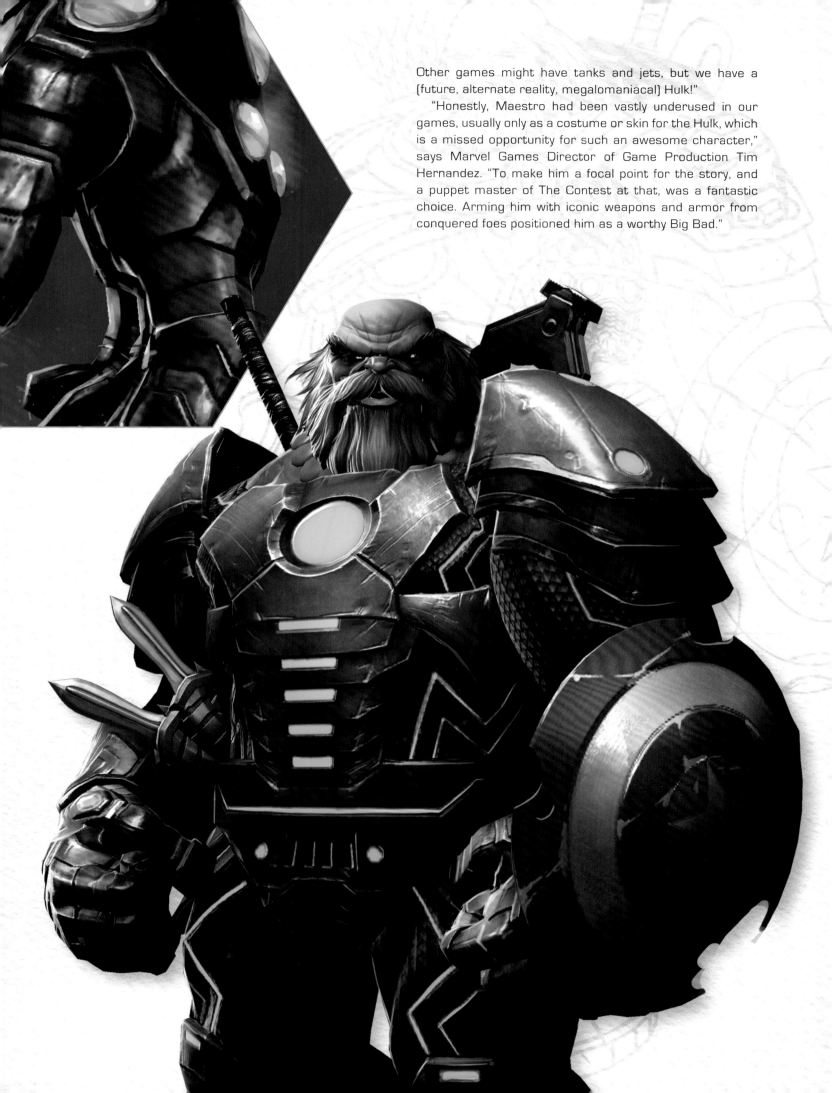

Other games might have tanks and jets, but we have a (future, alternate reality, megalomaniacal) Hulk!"

"Honestly, Maestro had been vastly underused in our games, usually only as a costume or skin for the Hulk, which is a missed opportunity for such an awesome character," says Marvel Games Director of Game Production Tim Hernandez. "To make him a focal point for the story, and a puppet master of The Contest at that, was a fantastic choice. Arming him with iconic weapons and armor from conquered foes positioned him as a worthy Big Bad."

MAESTRO

The future Hulk, true creator of The Contest of Champions, possesses all the powers of his younger self, greatly enhanced owing to radiation absorbed during a nuclear war that all but eradicated the majority of Earth's superhumans. He describes himself as "inevitable Hulk," and "the final product of natural selection."

Maestro designed and built the city of Dystopia, over which he ruled from a mighty throne. This would have been impressive were it not for his avarice born of over-confidence. Rebels found a way to bring Hulk from the past in hopes of defeating his malevolent self, but sadly, Maestro's cruelty prevailed.

Now, Maestro's lust for power has made him seek the ISO-Sphere—"the power primordial"—in order to become the God-King of the Battleworld.

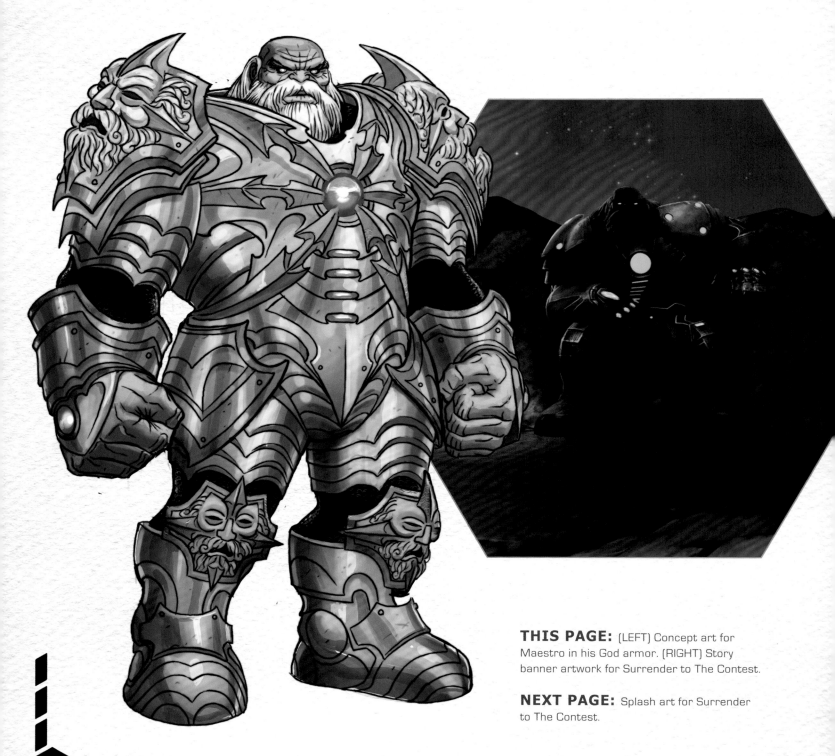

THIS PAGE: [LEFT] Concept art for Maestro in his God armor. [RIGHT] Story banner artwork for Surrender to The Contest.

NEXT PAGE: Splash art for Surrender to The Contest.

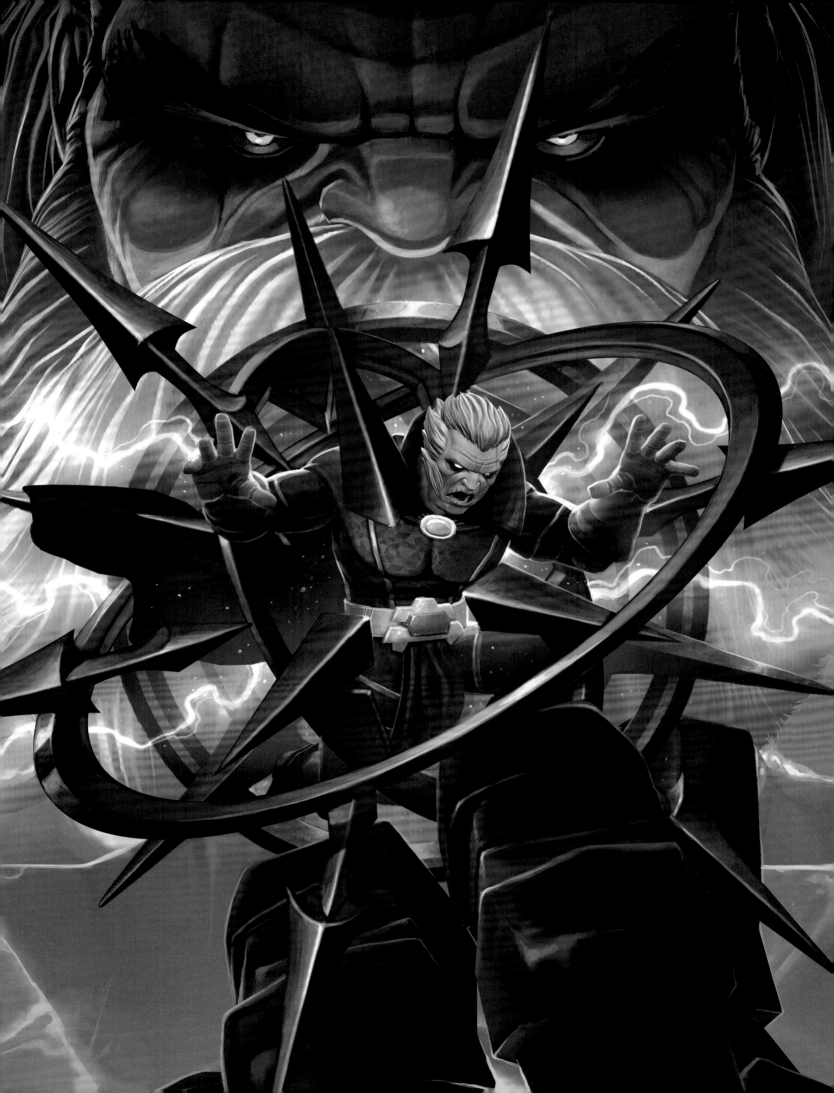

AGE OF ULTRON
CHAPTER FOUR

With a new team at Marvel Games supporting Kabam, one of the earliest challenges was to launch an ambitious promotional event based on Marvel Studios' *Avengers: Age of Ultron.*

"*Avengers: Age of Ultron* was the first of many movie tie-in events in *Contest*," says Tim Hernandez. "Ultron, Hulkbuster, and Vision set the bar high for how accurate the team would get with movie inspired character designs. Our goal was for Marvel fans to be walking out of a theater blown away, immediately wanting to play *Marvel Contest of Champions* to create their own experience with the same awesome

characters the movie presented on screen. We shared Kabam's concepts with our Studios team and filmmakers, and they were amazed by the level of detail and realism the team was able to achieve. The team crushed it!"

At Kabam, with the gauntlet thrown down, the next challenge was how to link the Battlerealm to the films in a meaningful way. "Act 3 had to close off a multitude of story threads kicked off throughout Acts 1 and 2," explains Kabam Lead Quest Designer, Dominic O'Grady. "We always intended to continue to carry the story forward, but it would be some time before we could return to releasing story content, so we

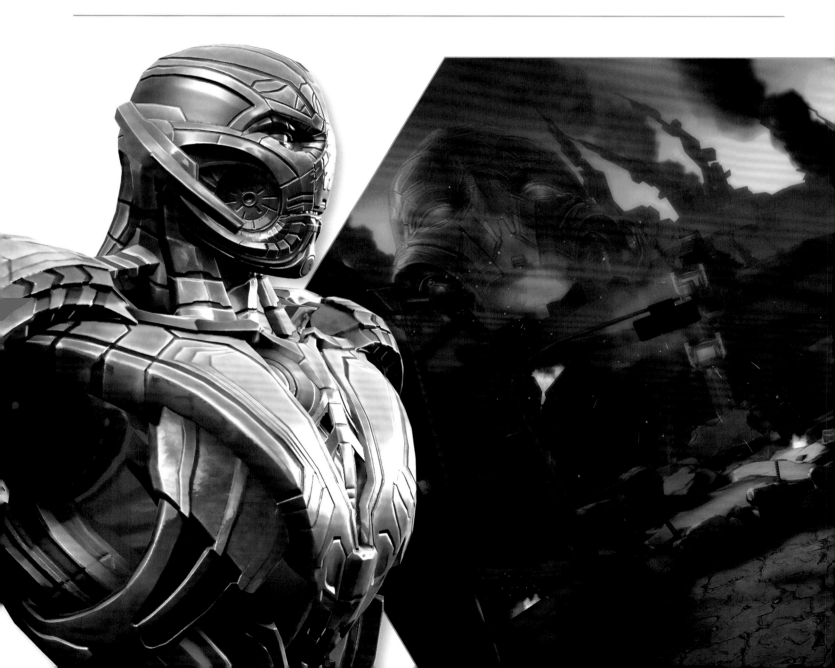

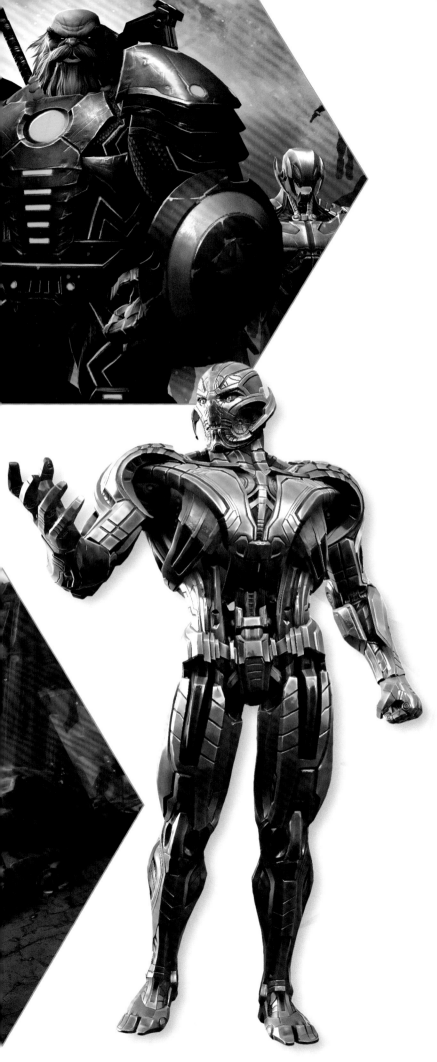

The Collector unleashes the mighty Ultron into the Battlerealm, in the hopes of increasing the danger in The Contest to foster greater power for the ISO-Sphere. Unfortunately his actions come with unexpected consequences. As Ultron's systematic corruption spreads throughout The Contest, the Collector seeks assistance from the Summoners and the Avengers to stop the maniacal machine's plan.

didn't want to leave too many details hanging. Act 3 briefly introduced Ultron, but players wouldn't see him really take action until he returned as the final boss in our new Alliance Quest mode. This was the first of many major film tie-ins we would do with Marvel, and also the first game-transforming event we ran."

"The Ultron invasion, our first event inspired by a Marvel Studios' film, was tremendously successful on several layers," says Bill Rosemann. "First, along with the introduction of heroes leaping from the pages of current comic books, it emphasized how *Marvel Contest of Champions* was moving in synch with everything happening across Marvel as a whole. You could walk out of the theater and then continue the battle with Ultron in *Contest*! Secondly, it proved to the rest of the company that the Marvel Games team could work with them to help amplify the excitement of their own projects. Finally, players loved it, which is our number one goal."

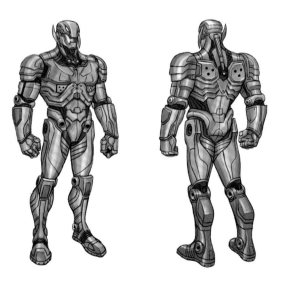

THIS SPREAD: (LEFT) Final render of Ultron, (MIDDLE) Artwork for Age of Ultron movie tie-in, (RIGHT) Concept art for Ultron (Classic).

THIS PAGE: Splash art for Age of Ultron.

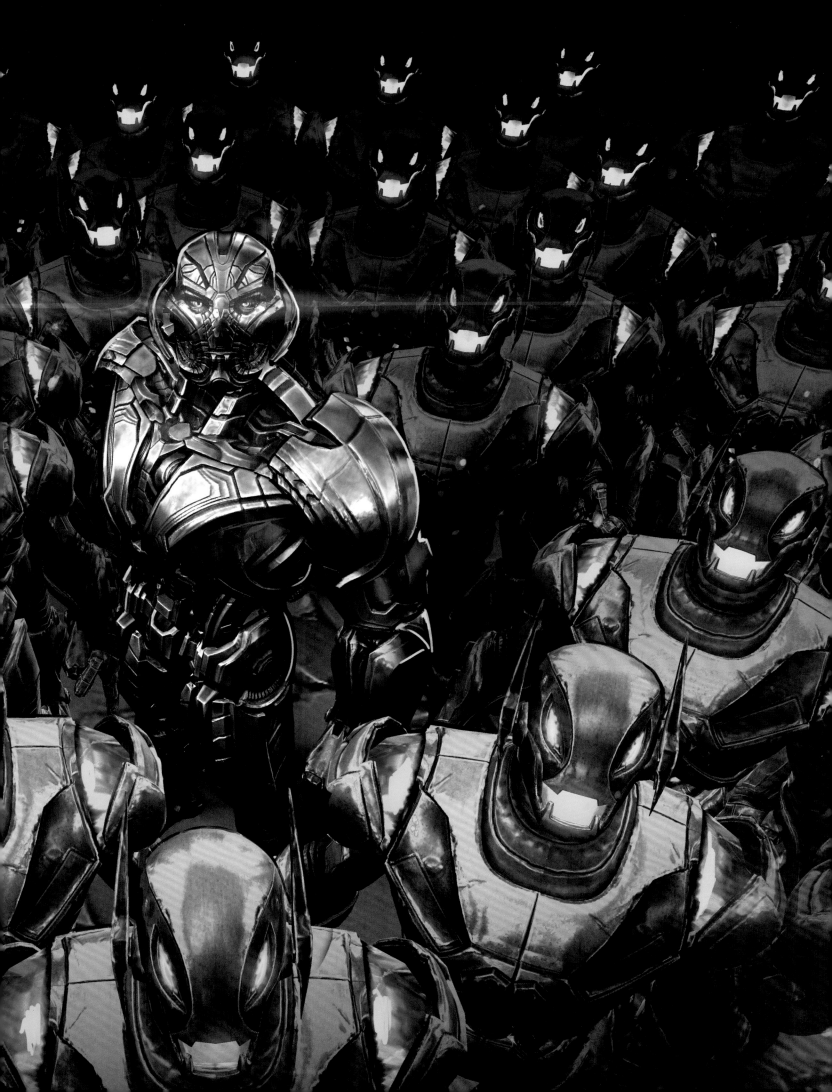

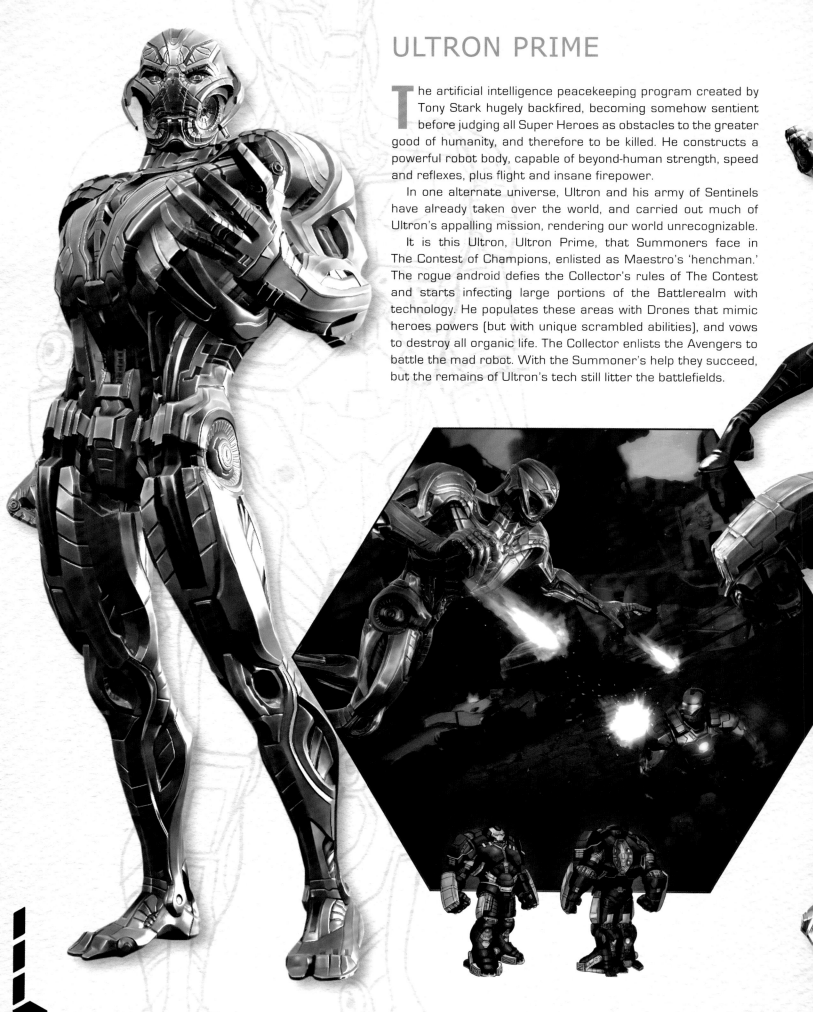

ULTRON PRIME

The artificial intelligence peacekeeping program created by Tony Stark hugely backfired, becoming somehow sentient before judging all Super Heroes as obstacles to the greater good of humanity, and therefore to be killed. He constructs a powerful robot body, capable of beyond-human strength, speed and reflexes, plus flight and insane firepower.

In one alternate universe, Ultron and his army of Sentinels have already taken over the world, and carried out much of Ultron's appalling mission, rendering our world unrecognizable.

It is this Ultron, Ultron Prime, that Summoners face in The Contest of Champions, enlisted as Maestro's 'henchman.' The rogue android defies the Collector's rules of The Contest and starts infecting large portions of the Battlerealm with technology. He populates these areas with Drones that mimic heroes powers (but with unique scrambled abilities), and vows to destroy all organic life. The Collector enlists the Avengers to battle the mad robot. With the Summoner's help they succeed, but the remains of Ultron's tech still litter the battlefields.

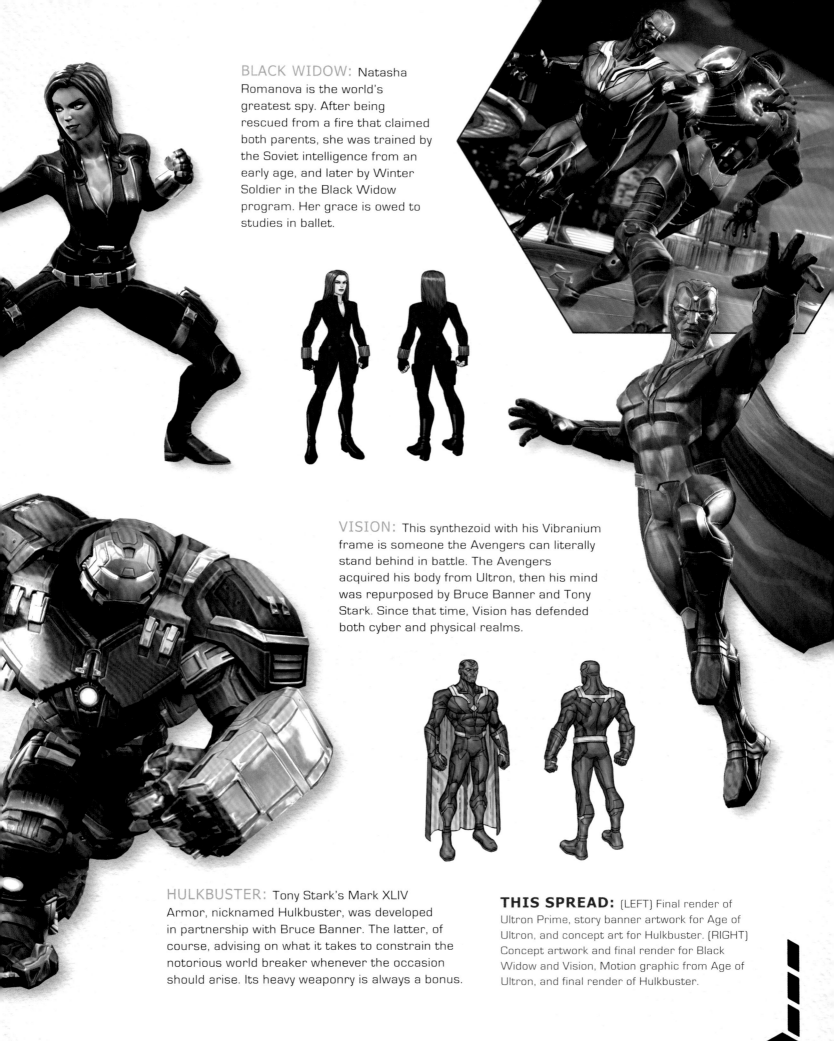

BLACK WIDOW: Natasha Romanova is the world's greatest spy. After being rescued from a fire that claimed both parents, she was trained by the Soviet intelligence from an early age, and later by Winter Soldier in the Black Widow program. Her grace is owed to studies in ballet.

VISION: This synthezoid with his Vibranium frame is someone the Avengers can literally stand behind in battle. The Avengers acquired his body from Ultron, then his mind was repurposed by Bruce Banner and Tony Stark. Since that time, Vision has defended both cyber and physical realms.

HULKBUSTER: Tony Stark's Mark XLIV Armor, nicknamed Hulkbuster, was developed in partnership with Bruce Banner. The latter, of course, advising on what it takes to constrain the notorious world breaker whenever the occasion should arise. Its heavy weaponry is always a bonus.

THIS SPREAD: [LEFT] Final render of Ultron Prime, story banner artwork for Age of Ultron, and concept art for Hulkbuster. [RIGHT] Concept artwork and final render for Black Widow and Vision, Motion graphic from Age of Ultron, and final render of Hulkbuster.

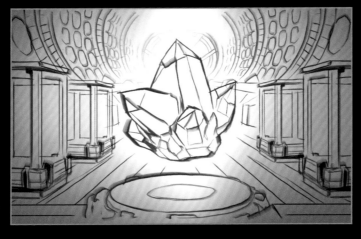

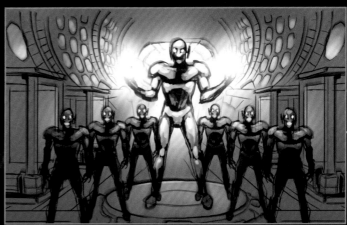

THIS PAGE: Storyboard for Age of Ultron.

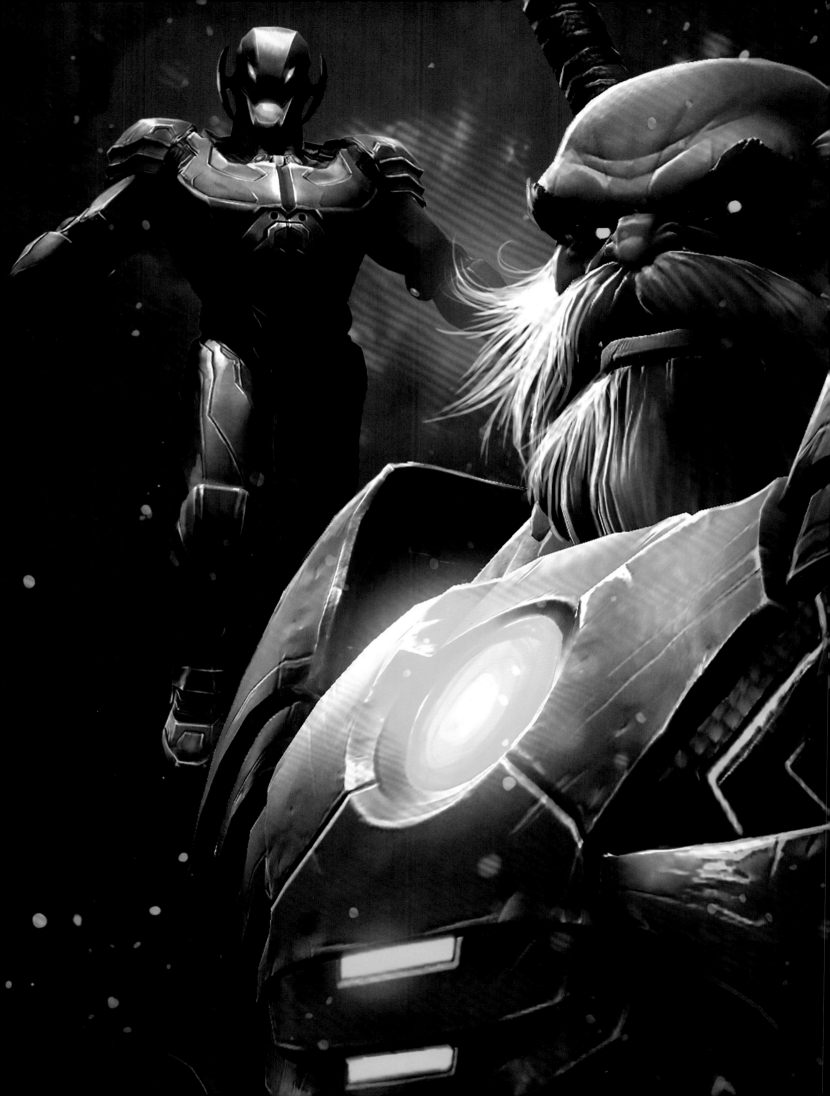

MYSTERY IN THE MICRO-REALM
CHAPTER FIVE

It has been essential from the beginning for narrative and gameplay to evolve hand-in-hand throughout *Marvel Contest of Champions*. The very distinctive, high-definition art style of Contest was becoming established and increasingly recognizable. Movie characters were adapted to belong with the entire roster, without losing their essence. But while *Avengers: Age of Ultron* stood as a mighty milestone in development, it was the second story event, Mystery in the Micro-Realm, that afforded Gabriel Frizzera and the writing team a chance to show how such occasions were being seamlessly worked across the update strategy overall.

The rivalry between Ant-Man and Yellowjacket was a longstanding component that Kabam understood very well, and their subplot fed into the Battlerealm mystery at large. A new ant-sized realm was introduced to The Contest, promising future developments in that area that Summoners could look forward to in Act 4.

"We really admired how the team wove Ant-Man and Yellowjacket into the larger overarching story of the Battlerealm, while incorporating themes that connected it spiritually to the movie," says Tim Hernandez. "It was a great way to take comic characters that were being newly introduced to larger audiences, and add *Contest*'s own unique spin to them. Plus their Special Attacks are still some of my favorites in the game!"

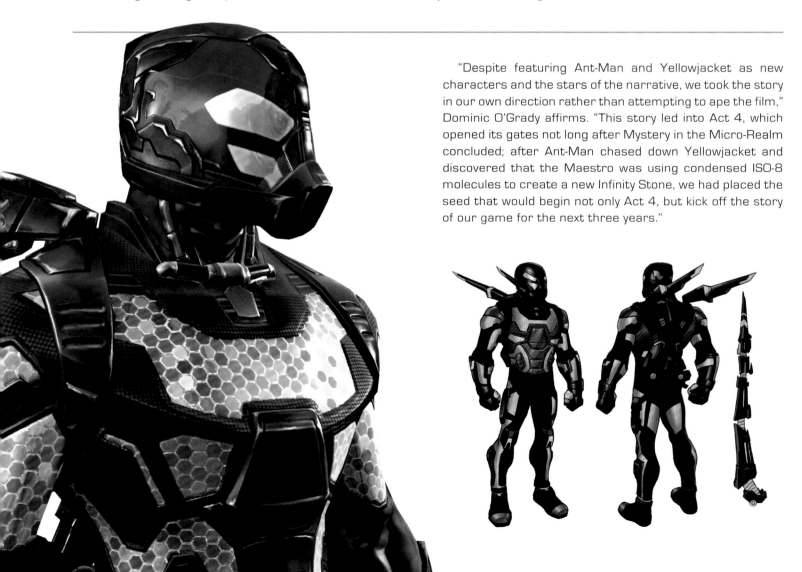

"Despite featuring Ant-Man and Yellowjacket as new characters and the stars of the narrative, we took the story in our own direction rather than attempting to ape the film," Dominic O'Grady affirms. "This story led into Act 4, which opened its gates not long after Mystery in the Micro-Realm concluded; after Ant-Man chased down Yellowjacket and discovered that the Maestro was using condensed ISO-8 molecules to create a new Infinity Stone, we had placed the seed that would begin not only Act 4, but kick off the story of our game for the next three years."

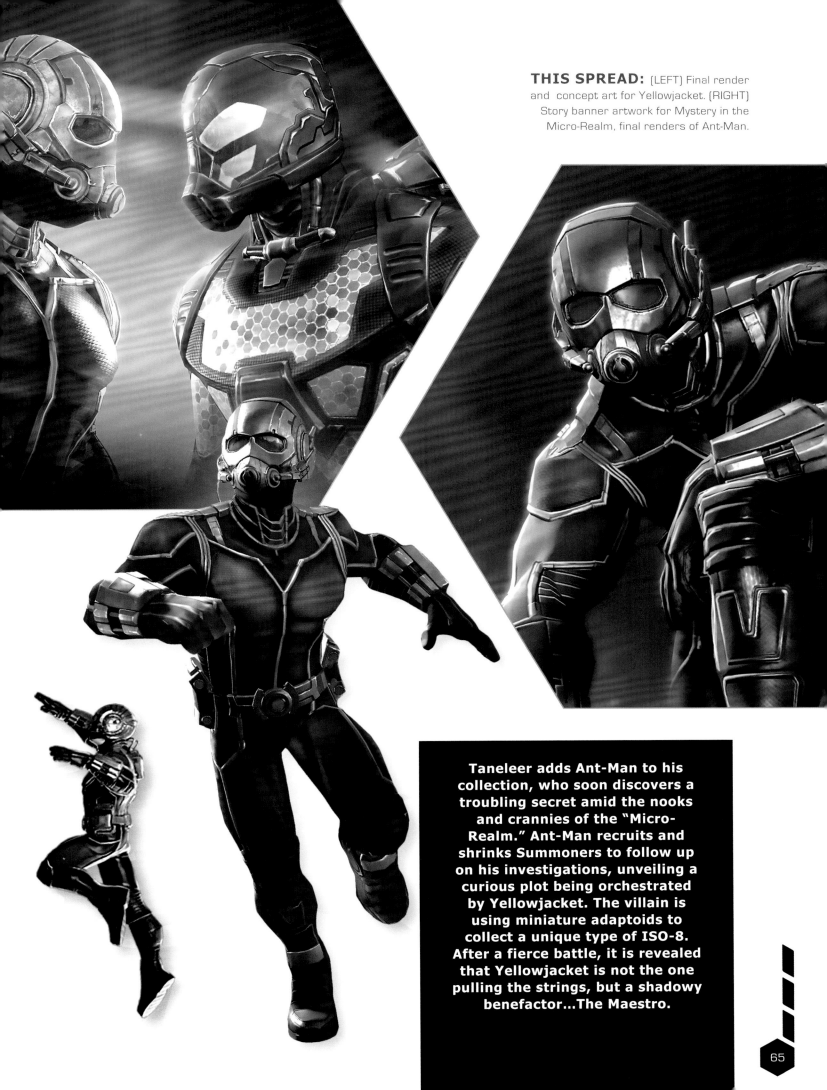

Taneleer adds Ant-Man to his collection, who soon discovers a troubling secret amid the nooks and crannies of the "Micro-Realm." Ant-Man recruits and shrinks Summoners to follow up on his investigations, unveiling a curious plot being orchestrated by Yellowjacket. The villain is using miniature adaptoids to collect a unique type of ISO-8. After a fierce battle, it is revealed that Yellowjacket is not the one pulling the strings, but a shadowy benefactor...The Maestro.

YOU **FAILED ME**, INSECT.

BUT MASTER... I SAVED SOME OF THE **SUBSTANCE**!

AH... **REFINED ISO-8.**

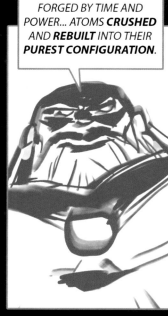

FORGED BY TIME AND POWER... ATOMS **CRUSHED** AND **REBUILT** INTO THEIR **PUREST CONFIGURATION**.

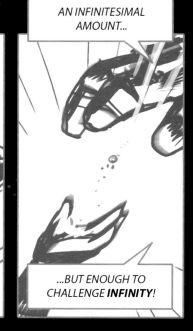

AN INFINITESIMAL AMOUNT...

...BUT ENOUGH TO CHALLENGE **INFINITY**!

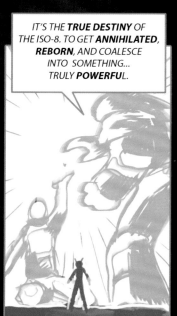

IT'S THE **TRUE DESTINY** OF THE ISO-8. TO GET **ANNIHILATED**, **REBORN**, AND COALESCE INTO SOMETHING... TRULY **POWERFUL**.

GET ME MORE!

OH, **BOY**. THAT SOUNDS **BAD**.

I NEED TO TELL THE **COLLECTOR**!

THIS PAGE: Storyboard for Mystery in the Micro-Realm.

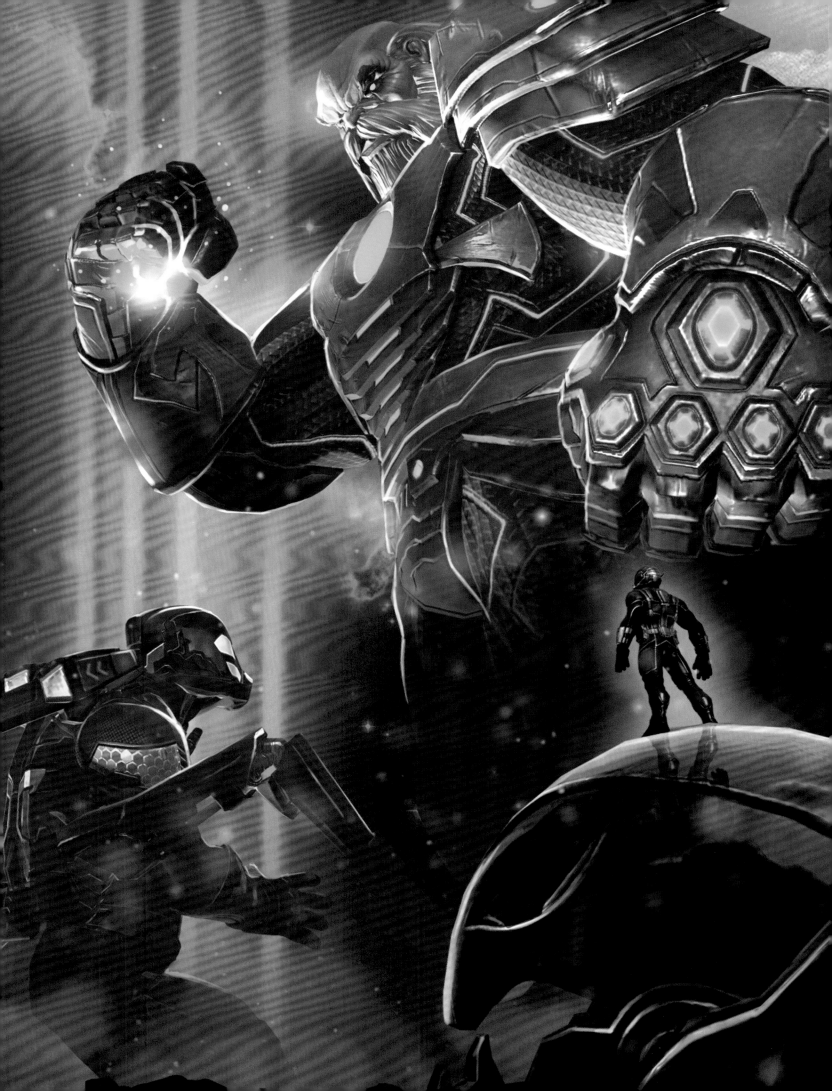

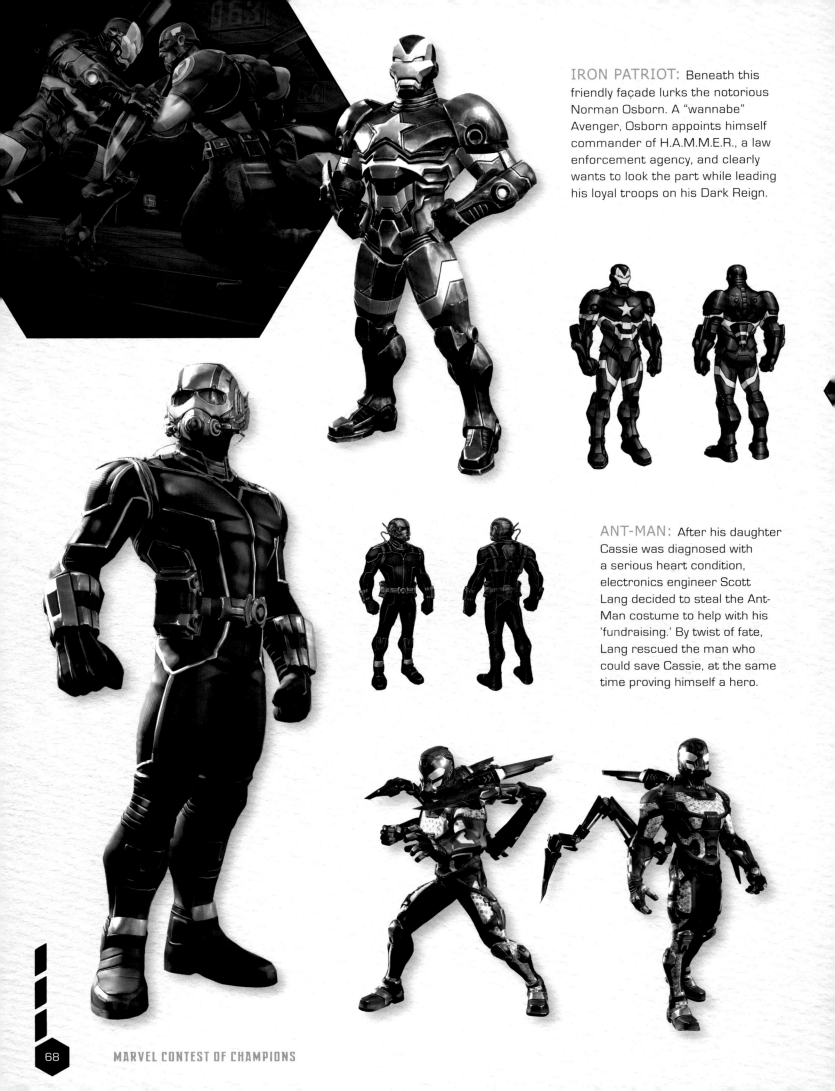

IRON PATRIOT: Beneath this friendly façade lurks the notorious Norman Osborn. A "wannabe" Avenger, Osborn appoints himself commander of H.A.M.M.E.R., a law enforcement agency, and clearly wants to look the part while leading his loyal troops on his Dark Reign.

ANT-MAN: After his daughter Cassie was diagnosed with a serious heart condition, electronics engineer Scott Lang decided to steal the Ant-Man costume to help with his 'fundraising.' By twist of fate, Lang rescued the man who could save Cassie, at the same time proving himself a hero.

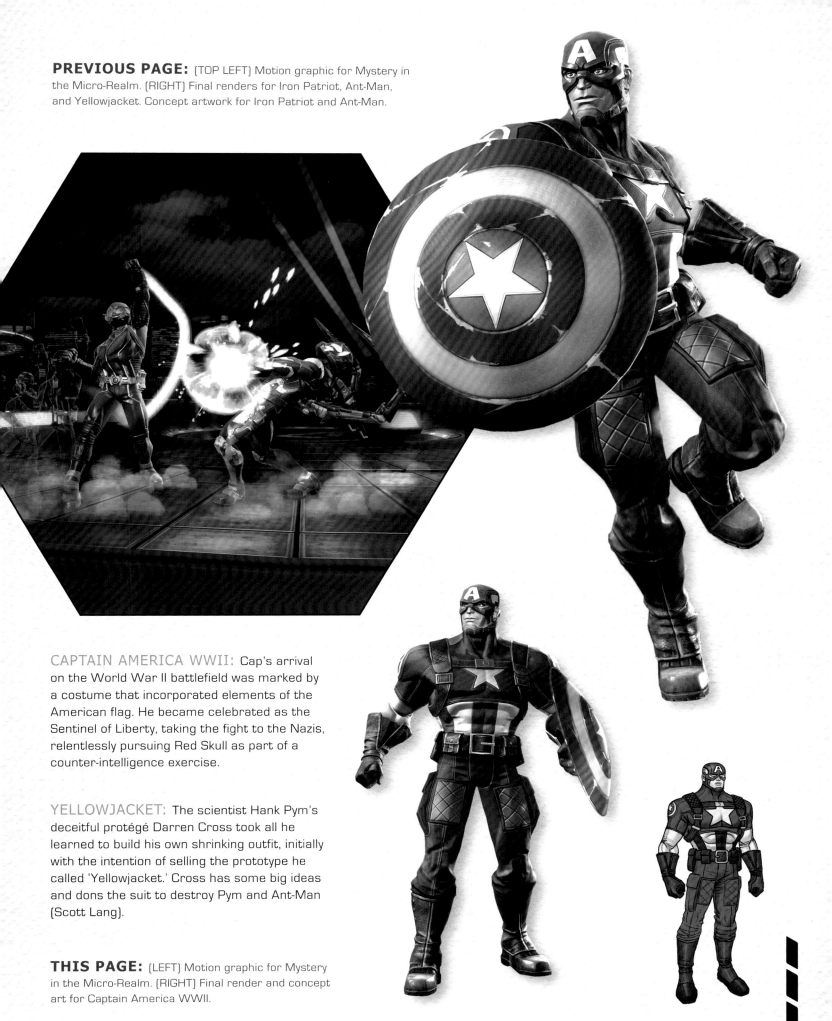

PREVIOUS PAGE: [TOP LEFT] Motion graphic for Mystery in the Micro-Realm. [RIGHT] Final renders for Iron Patriot, Ant-Man, and Yellowjacket. Concept artwork for Iron Patriot and Ant-Man.

CAPTAIN AMERICA WWII: Cap's arrival on the World War II battlefield was marked by a costume that incorporated elements of the American flag. He became celebrated as the Sentinel of Liberty, taking the fight to the Nazis, relentlessly pursuing Red Skull as part of a counter-intelligence exercise.

YELLOWJACKET: The scientist Hank Pym's deceitful protégé Darren Cross took all he learned to build his own shrinking outfit, initially with the intention of selling the prototype he called 'Yellowjacket.' Cross has some big ideas and dons the suit to destroy Pym and Ant-Man (Scott Lang).

THIS PAGE: [LEFT] Motion graphic for Mystery in the Micro-Realm. [RIGHT] Final render and concept art for Captain America WWII.

POLAR OPPOSITES
CHAPTER SIX

The Kabam writing team was getting into its stride, gaining confidence from this wildly successful Marvel partnership. "Following our *Ant-Man* and *Age of Ultron* tie-ins, we had received a lot of positive response on our smaller *à la carte* quests with their bite-size storytelling and self-contained reward sets," says Dominic O'Grady. "We had also noticed it was a great way to highlight new characters, tell some of our own stories in the Marvel Universe, and run some of our own takes on classic Marvel Universe stories.

"In that spirit, Polar Opposites was our first event of this type, something that would become a monthly staple in the future and one of our most common storytelling formats. Once Marvel got wind of our desire to tell unique stories to highlight our characters, they were just as excited as we were. This quest's tale was simple enough: How would two versions of Magneto, drawn from different times in his life, interact with the Battlerealm and the treatment of mutants therein? Turns out they can solve their differences—it just takes a little work."

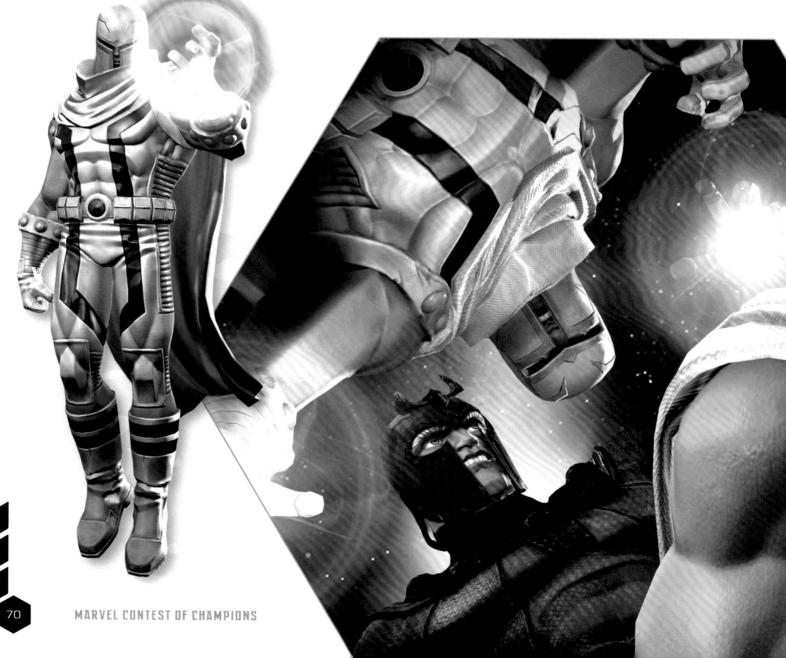

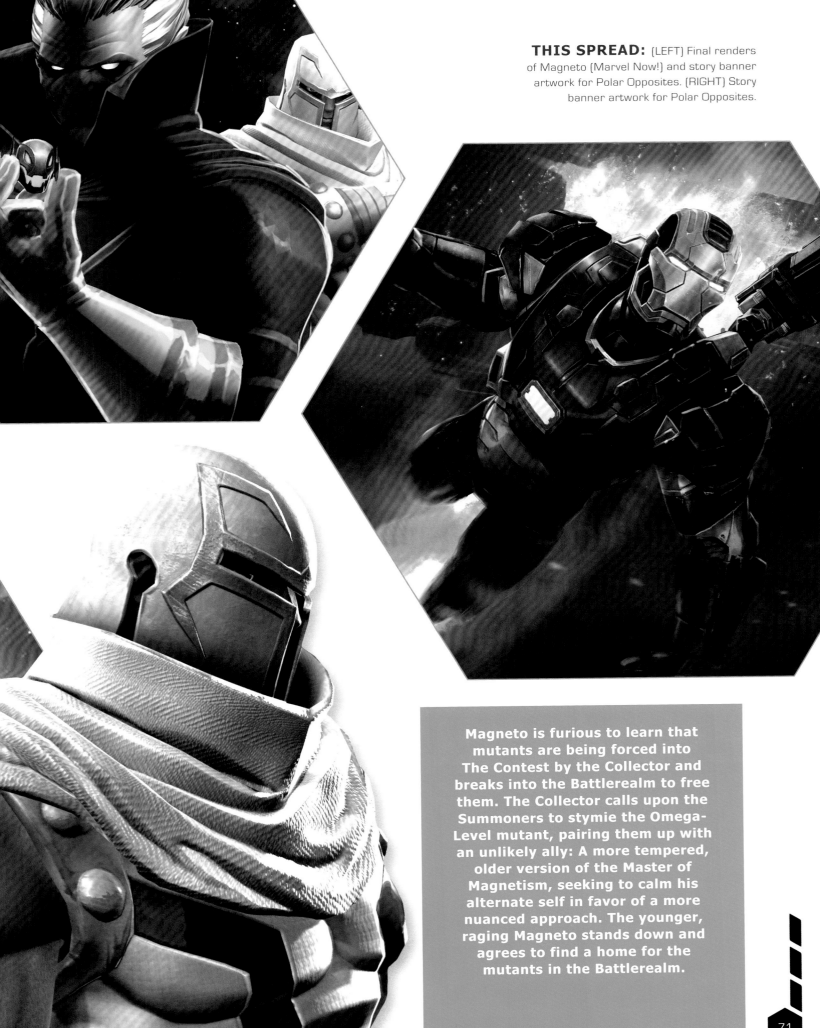

Magneto is furious to learn that mutants are being forced into The Contest by the Collector and breaks into the Battlerealm to free them. The Collector calls upon the Summoners to stymie the Omega-Level mutant, pairing them up with an unlikely ally: A more tempered, older version of the Master of Magnetism, seeking to calm his alternate self in favor of a more nuanced approach. The younger, raging Magneto stands down and agrees to find a home for the mutants in the Battlerealm.

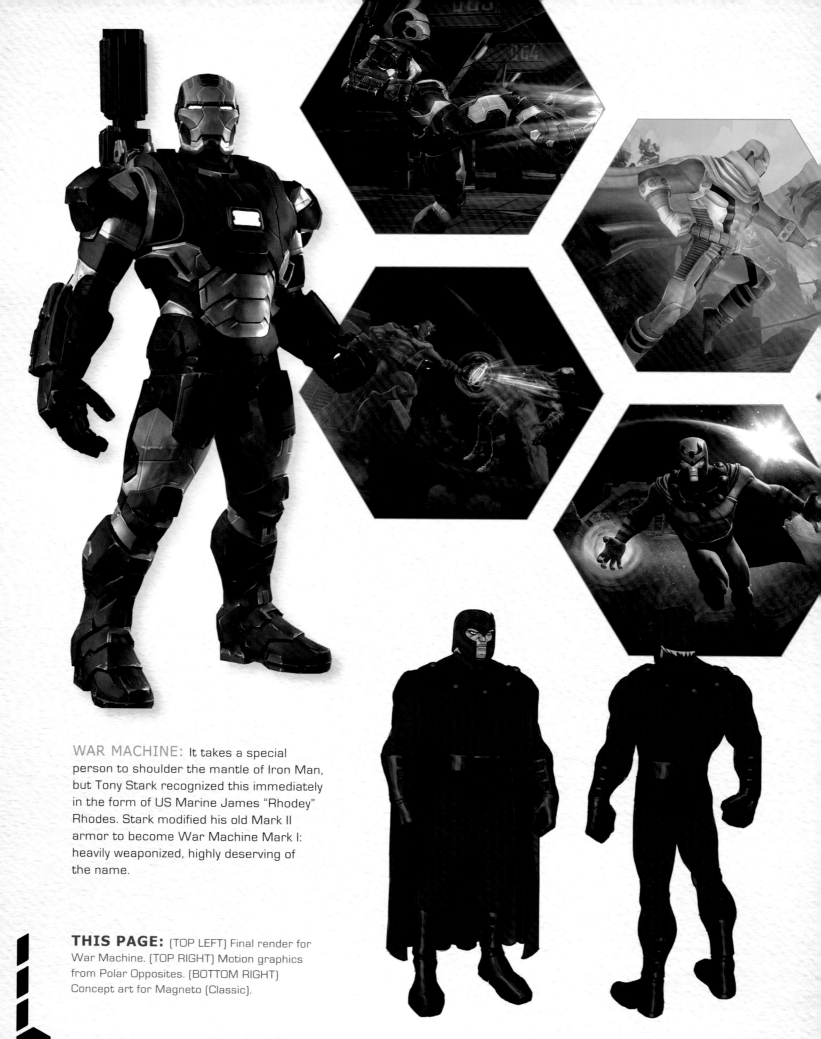

WAR MACHINE: It takes a special person to shoulder the mantle of Iron Man, but Tony Stark recognized this immediately in the form of US Marine James "Rhodey" Rhodes. Stark modified his old Mark II armor to become War Machine Mark I: heavily weaponized, highly deserving of the name.

THIS PAGE: (TOP LEFT) Final render for War Machine. (TOP RIGHT) Motion graphics from Polar Opposites. (BOTTOM RIGHT) Concept art for Magneto (Classic).

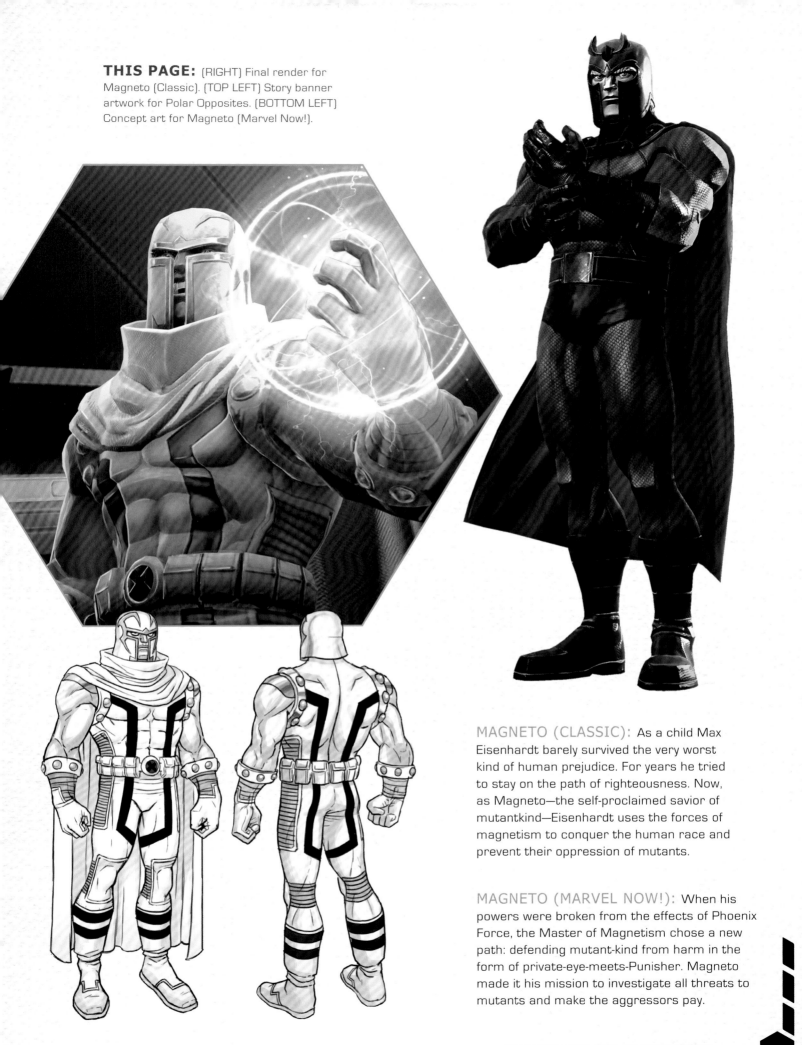

THIS PAGE: (RIGHT) Final render for Magneto (Classic). (TOP LEFT) Story banner artwork for Polar Opposites. (BOTTOM LEFT) Concept art for Magneto (Marvel Now!).

MAGNETO (CLASSIC): As a child Max Eisenhardt barely survived the very worst kind of human prejudice. For years he tried to stay on the path of righteousness. Now, as Magneto—the self-proclaimed savior of mutantkind—Eisenhardt uses the forces of magnetism to conquer the human race and prevent their oppression of mutants.

MAGNETO (MARVEL NOW!): When his powers were broken from the effects of Phoenix Force, the Master of Magnetism chose a new path: defending mutant-kind from harm in the form of private-eye-meets-Punisher. Magneto made it his mission to investigate all threats to mutants and make the aggressors pay.

WANING MOON
CHAPTER SEVEN

"Waning Moon was a fairly unique event for us, in that we had to create a story out of three pretty disparate characters," says Dominic O'Grady. "How do you tie together Spider-Man and Deadpool, who have some history, with a far more esoteric character like Moon Knight?"

"It was a great challenge that really began to open the door for how we delivered these events, and also came with a great surprise: Our players really took to Moon Knight, and went out to acquire him in droves through a variety of means. I believe to this day that it's because we made him a bit of a bully in the final quest of the story; he would constantly ambush players as they approached the finish, and we had slightly over-tuned this encounter, meaning he made quite the impression!"

"Moon Knight is a great example of how Kabam can take a Marvel character that may not be recognizable to all fans and turn him into a massive success through gameplay," says Tim Hernandez. "With his visual design they stayed true to his roots, but made his abilities dependent on the phases of the moon. It was such a fun and clever idea that we were excited to see how players would react to, and they loved it."

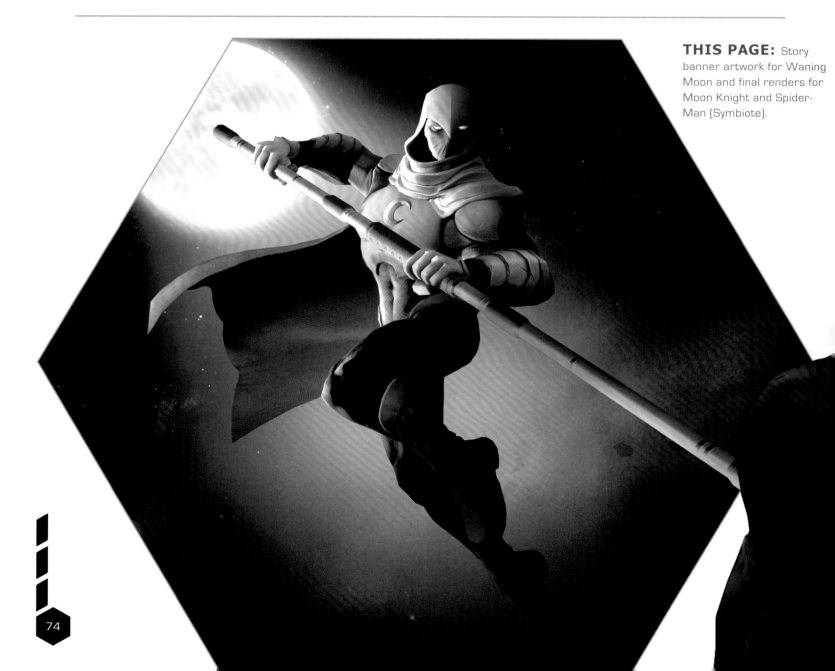

THIS PAGE: Story banner artwork for Waning Moon and final renders for Moon Knight and Spider-Man (Symbiote).

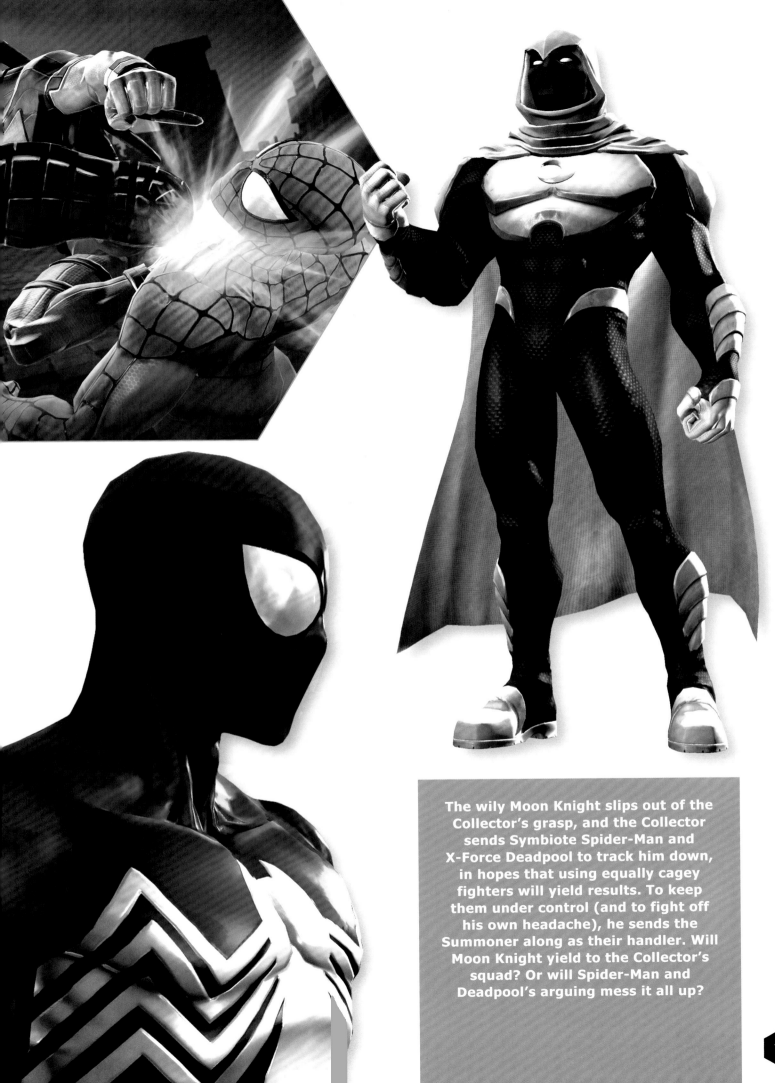

The wily Moon Knight slips out of the Collector's grasp, and the Collector sends Symbiote Spider-Man and X-Force Deadpool to track him down, in hopes that using equally cagey fighters will yield results. To keep them under control (and to fight off his own headache), he sends the Summoner along as their handler. Will Moon Knight yield to the Collector's squad? Or will Spider-Man and Deadpool's arguing mess it all up?

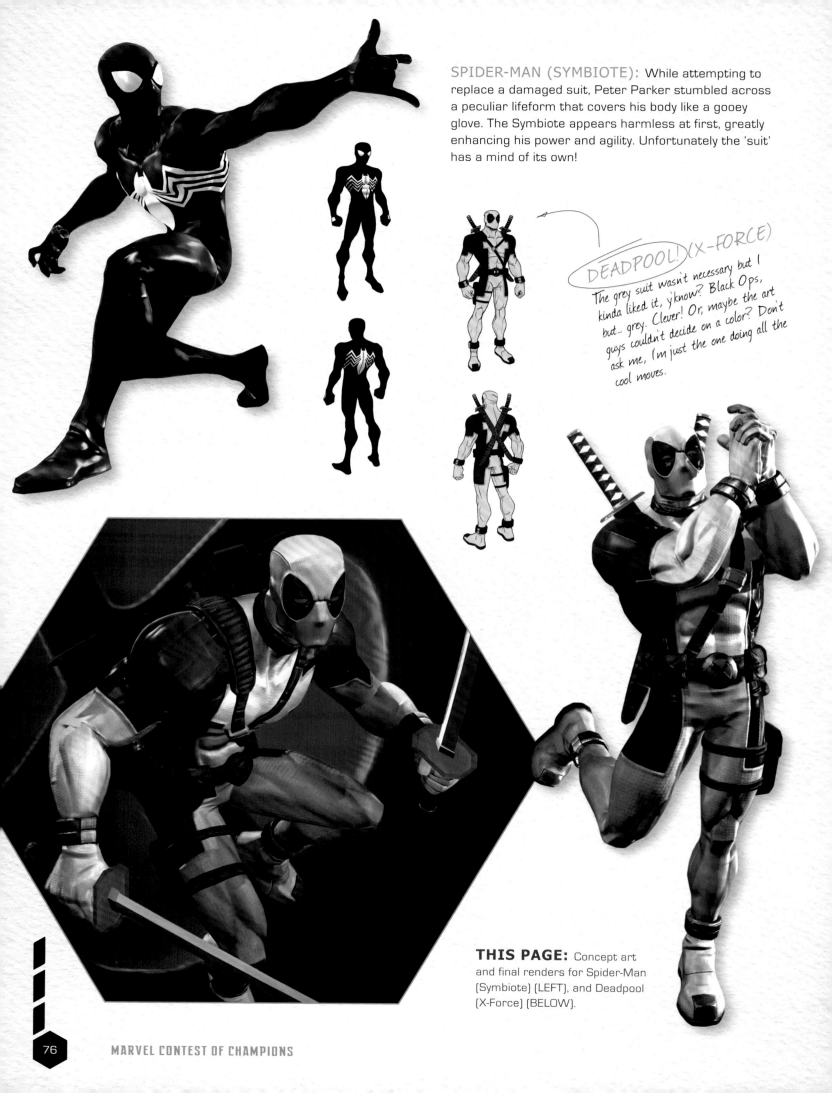

SPIDER-MAN (SYMBIOTE): While attempting to replace a damaged suit, Peter Parker stumbled across a peculiar lifeform that covers his body like a gooey glove. The Symbiote appears harmless at first, greatly enhancing his power and agility. Unfortunately the 'suit' has a mind of its own!

DEADPOOL! (X-FORCE)
The grey suit wasn't necessary but I kinda liked it, y'know? Black Ops, but... grey. Clever! Or, maybe the art guys couldn't decide on a color? Don't ask me, I'm just the one doing all the cool moves.

THIS PAGE: Concept art and final renders for Spider-Man (Symbiote) [LEFT], and Deadpool (X-Force) [BELOW].

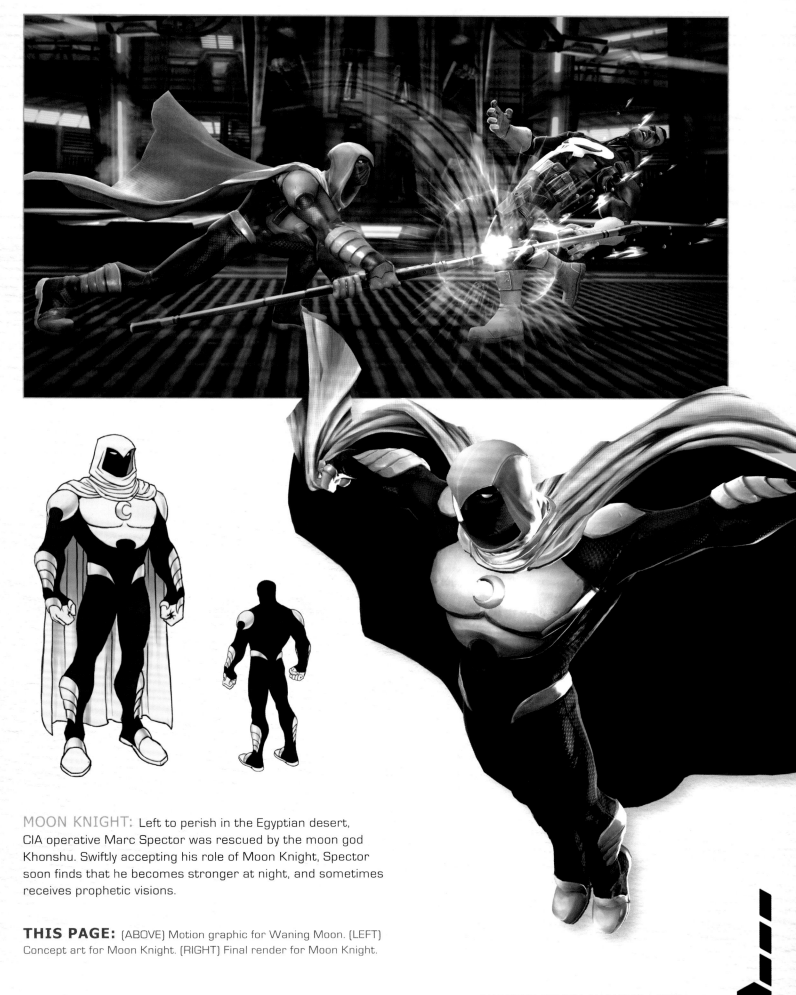

MOON KNIGHT: Left to perish in the Egyptian desert, CIA operative Marc Spector was rescued by the moon god Khonshu. Swiftly accepting his role of Moon Knight, Spector soon finds that he becomes stronger at night, and sometimes receives prophetic visions.

THIS PAGE: [ABOVE] Motion graphic for Waning Moon. [LEFT] Concept art for Moon Knight. [RIGHT] Final render for Moon Knight.

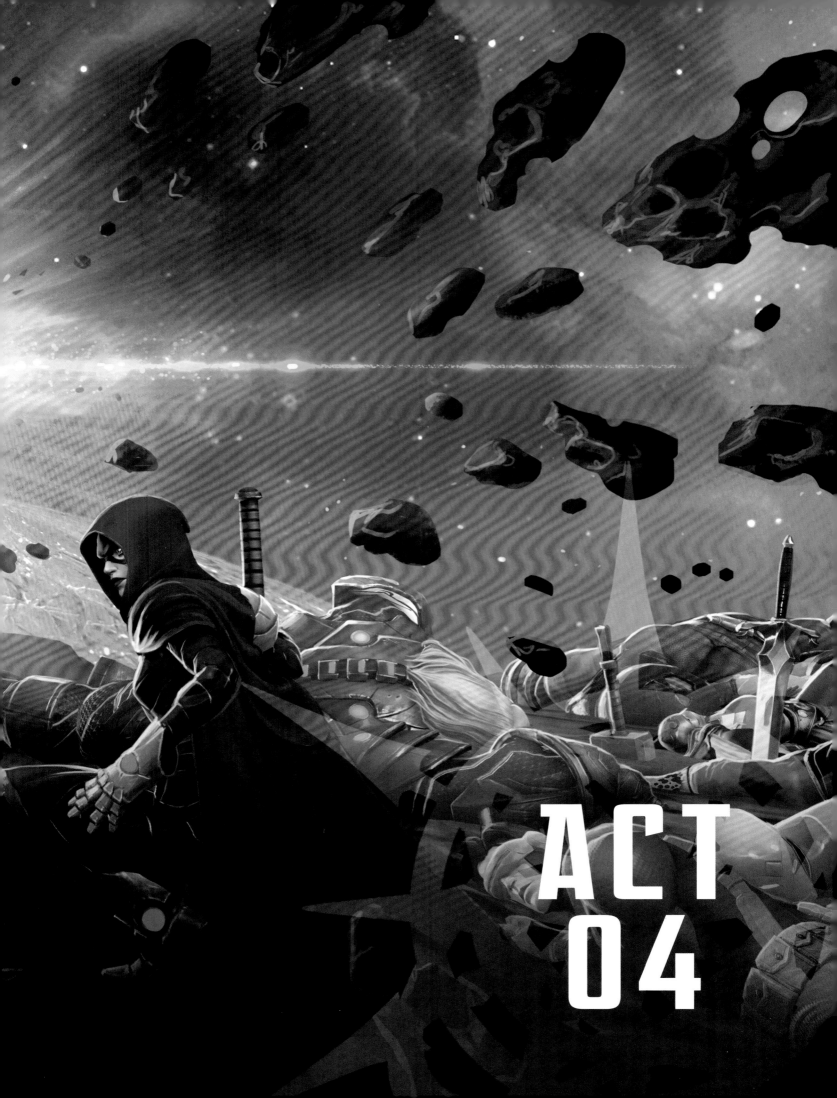

BLOOD & VENOM

CHAPTER EIGHT

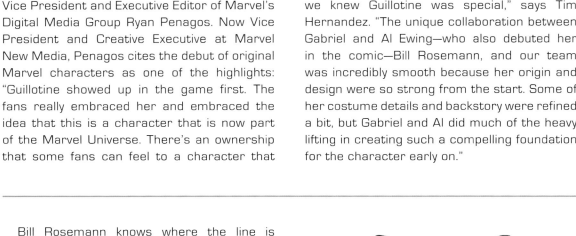

Total downloads for *Marvel Contest of Champions* were climbing beyond forty million toward the end of 2015. The impact on the Marvel Multiverse was not lost on then Vice President and Executive Editor of Marvel's Digital Media Group Ryan Penagos. Now Vice President and Creative Executive at Marvel New Media, Penagos cites the debut of original Marvel characters as one of the highlights: "Guillotine showed up in the game first. The fans really embraced her and embraced the idea that this is a character that is now part of the Marvel Universe. There's an ownership that some fans can feel to a character that they're experiencing before anyone else, which is really neat."

"It's not very often that you get the opportunity to create a brand-new Marvel character, but we knew Guillotine was special," says Tim Hernandez. "The unique collaboration between Gabriel and Al Ewing—who also debuted her in the comic—Bill Rosemann, and our team was incredibly smooth because her origin and design were so strong from the start. Some of her costume details and backstory were refined a bit, but Gabriel and Al did much of the heavy lifting in creating such a compelling foundation for the character early on."

Bill Rosemann knows where the line is drawn with regards to founding original heroes and villains for the Marvel Multiverse. "The Marvel Games team views creating all-new characters for *Marvel Contest of Champions* as, paraphrasing the words of Stan Lee, a great power and a great responsibility," says Rosemann. "We must always strive to prove that what we're creating is worthy of the Marvel name."

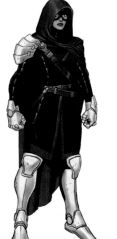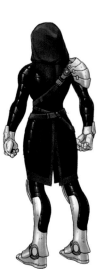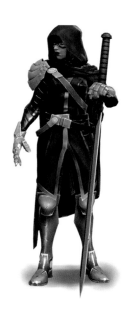

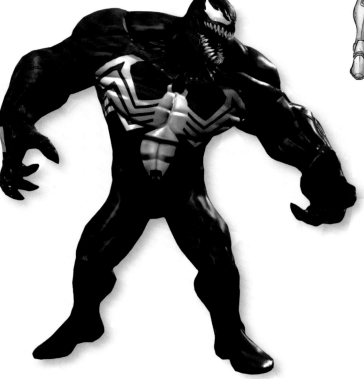

The Collector summons you to a dilapidated part of the Battlerealm, full of broken down asteroids, ghostly apparitions, and an oppressive darkness. As you and Guillotine (revealed as an agent of the Collector) fight towards the core of this nightmarish realm, strange creatures pour from the shadows that even her mighty blade cannot slay. You eventually discover the source of the evil lurking in the shadows: The dangerous alien Symbiote, Venom.

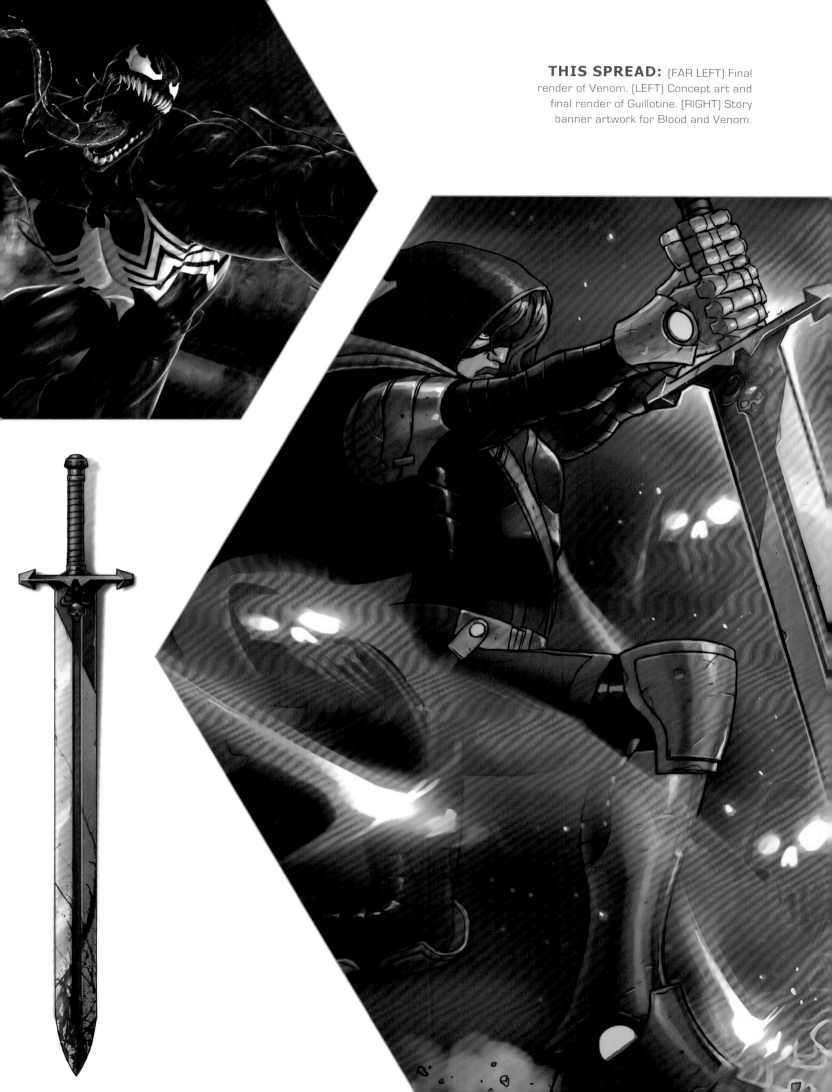

THIS SPREAD: (FAR LEFT) Final render of Venom. (LEFT) Concept art and final render of Guillotine. (RIGHT) Story banner artwork for Blood and Venom.

GUILLOTINE

Does she guide the blade, or does the blade guide her? This is what keeps Jeannine Sauvage awake at night. At age twelve, she followed the faint whisper of her name toward a darkened room in her house, spying a box containing a mighty sword: La Fleur du Mal ('The Flower of Evil'). Something in her French-Algerian bloodline intended for Sauvage to claim this cursed treasure. Sleepily cutting her finger on the blade sealed the deal.

Now grown up and living in Paris, Sauvage has accepted her fate as the latest to inherit the sentient Blood Sword. As the Super Hero Guillotine, Sauvage employs the ornate weapon for good in her role as vigilante, though many of her ancestors—Queen Haasen of Languria in particular (999AD)—used it for pure evil. This "thing of beauty and danger" is said to display a limitless thirst for blood. How long before Guillotine succumbs to this taste for carnage...?

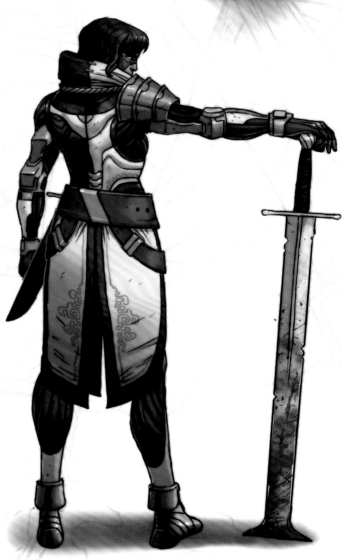

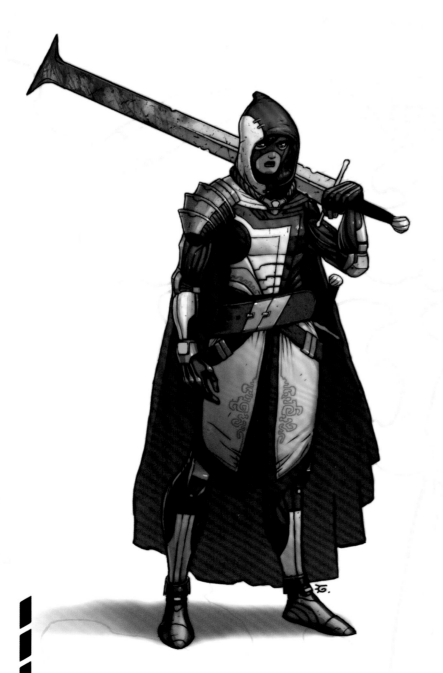

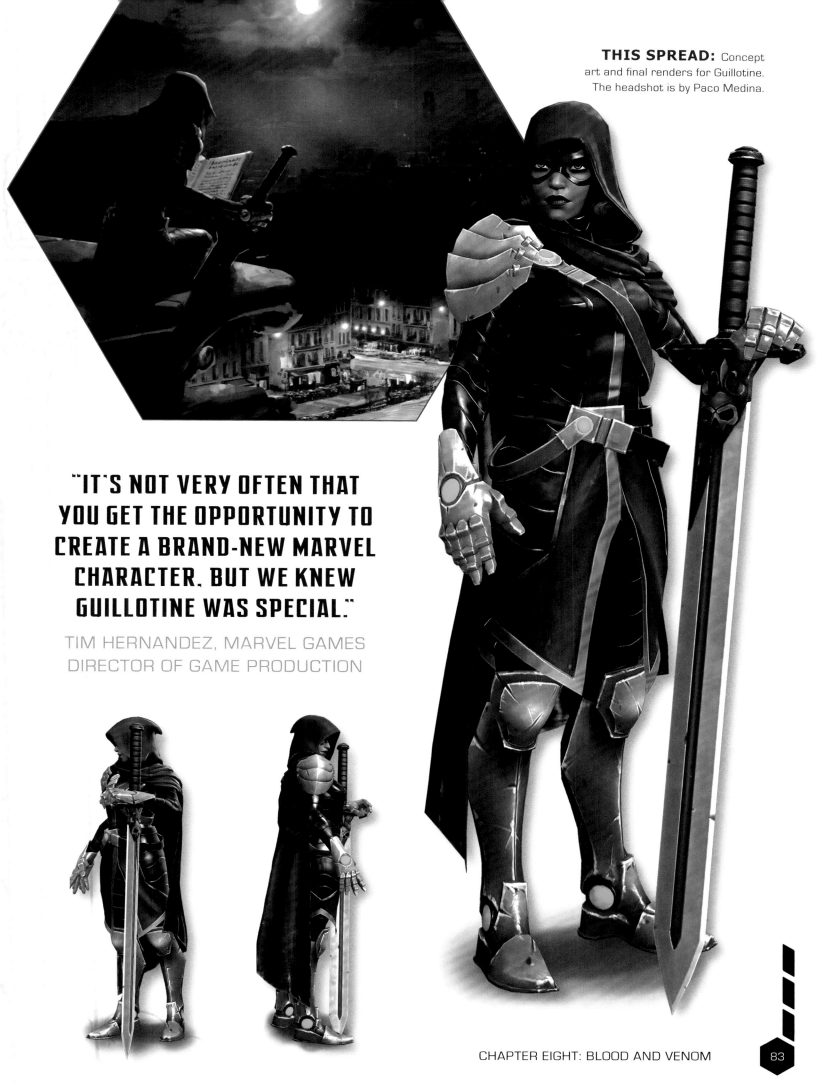

"IT'S NOT VERY OFTEN THAT YOU GET THE OPPORTUNITY TO CREATE A BRAND-NEW MARVEL CHARACTER, BUT WE KNEW GUILLOTINE WAS SPECIAL."

TIM HERNANDEZ, MARVEL GAMES DIRECTOR OF GAME PRODUCTION

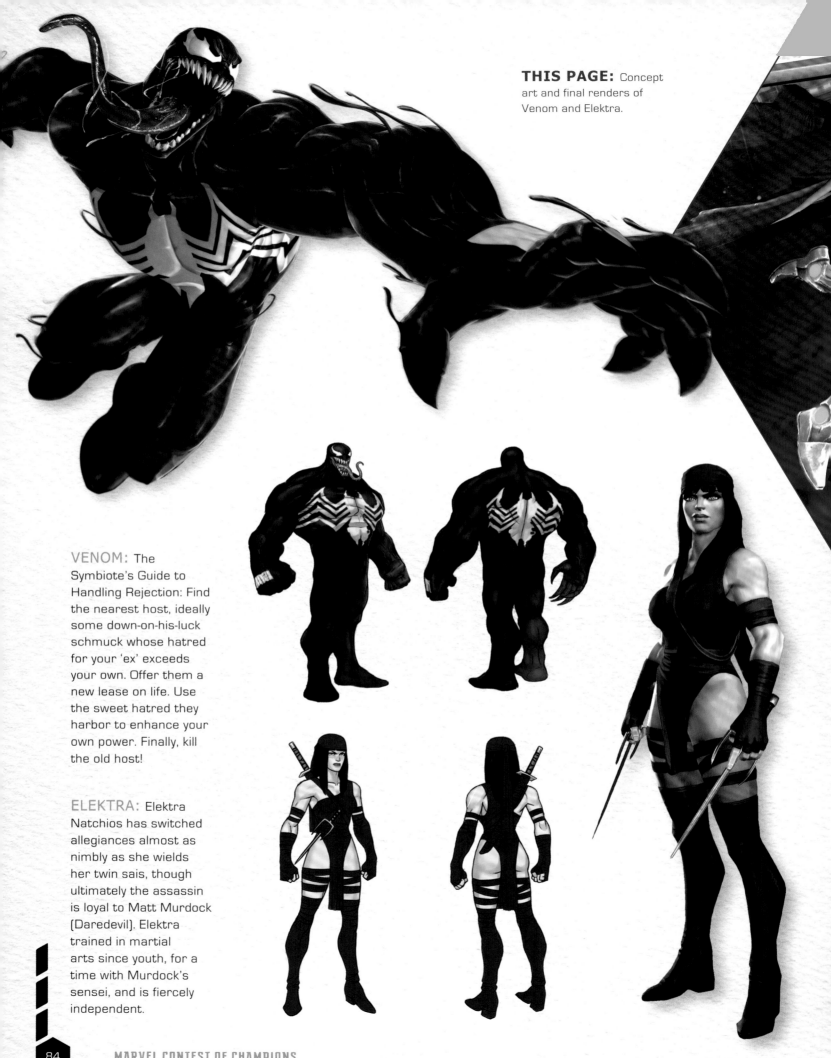

VENOM: The Symbiote's Guide to Handling Rejection: Find the nearest host, ideally some down-on-his-luck schmuck whose hatred for your 'ex' exceeds your own. Offer them a new lease on life. Use the sweet hatred they harbor to enhance your own power. Finally, kill the old host!

ELEKTRA: Elektra Natchios has switched allegiances almost as nimbly as she wields her twin sais, though ultimately the assassin is loyal to Matt Murdock (Daredevil). Elektra trained in martial arts since youth, for a time with Murdock's sensei, and is fiercely independent.

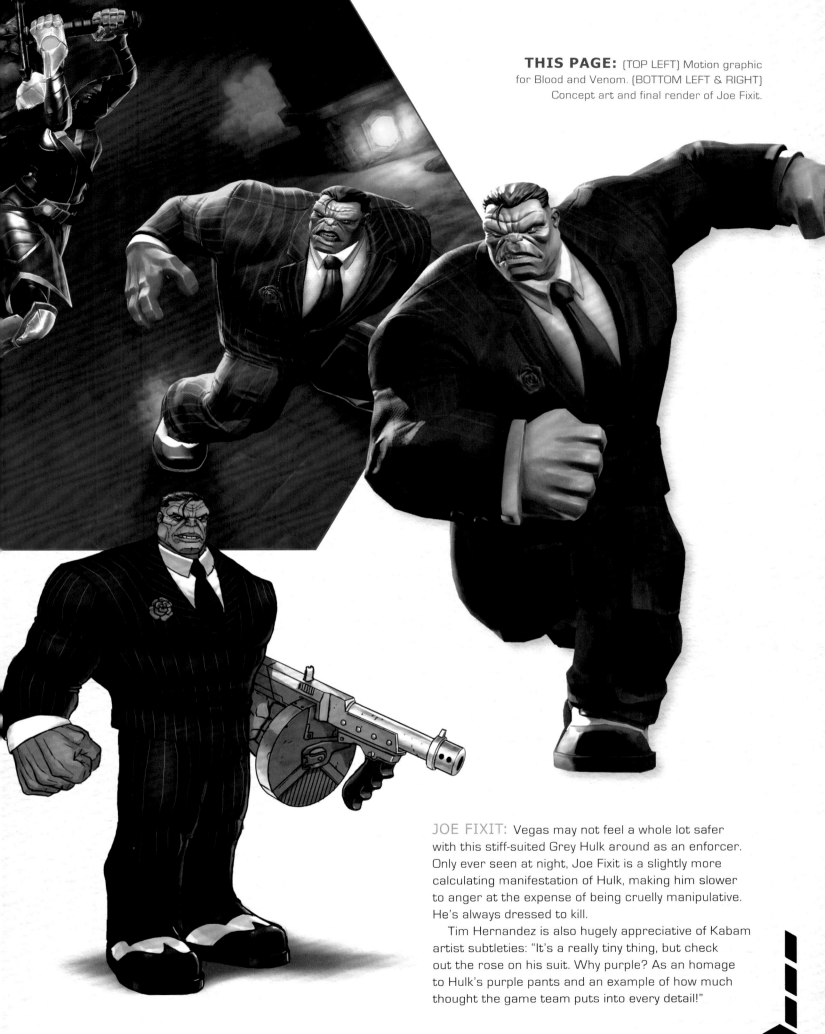

JOE FIXIT: Vegas may not feel a whole lot safer with this stiff-suited Grey Hulk around as an enforcer. Only ever seen at night, Joe Fixit is a slightly more calculating manifestation of Hulk, making him slower to anger at the expense of being cruelly manipulative. He's always dressed to kill.

Tim Hernandez is also hugely appreciative of Kabam artist subtleties: "It's a really tiny thing, but check out the rose on his suit. Why purple? As an homage to Hulk's purple pants and an example of how much thought the game team puts into every detail!"

CHAPTER EIGHT: BLOOD AND VENOM

IT'S OVER, MAESTRO. HAND ME THE ISO DUST, BEFORE IT'S TOO LATE.

IT'S ALREADY TOO LATE, ELDER SCUM. YOUR PRECIOUS CONTEST HAS SERVED ITS PURPOSE!

I HAVE BEEN SATURATING YOUR CHAMPIONS WITH ISO-8... INCUBATING IT IN THEIR BODIES AS THEY BATTLE IN THE ARENA, UNTIL ITS PURE ESSENCE COULD BE EXTRACTED!

AND NOW, THROUGH MY MIGHTY HANDS, THIS CRUDE MATERIAL CAN BE FUSED... INTO ITS FINAL FORM!

NO! I MADE A TERRIBLE MISTAKE....
ARGHHH!

NOW, ONCE MY FULL POWER RE-TURNS I CAN RESUME MY-

POW

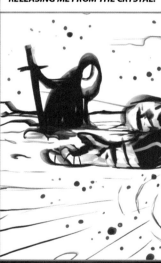

DON'T BE AFRAID, CURSE-BEARER. YOU DID THE RIGHT THING RELEASING ME FROM THE CRYSTAL.

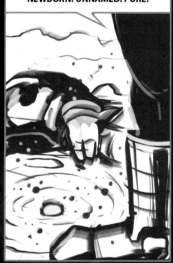

HMM. I HAVE NEVER SEEN A GEM QUITE LIKE YOU BEFORE. NEWBORN. UNNAMED. PURE.

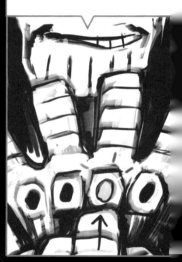

HUSH NOW... LET THANOS OF TITAN INTRODUCE YOU TO THE UNIVERSE.

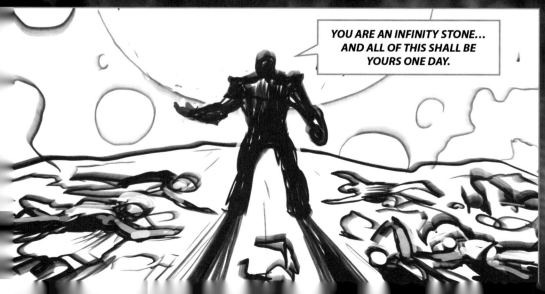

YOU ARE AN INFINITY STONE... AND ALL OF THIS SHALL BE YOURS ONE DAY.

THIS PAGE: Storyboard for Act 4. With the Maestro defeated, the Infinity Stone finds a new owner. The Mad Titan Thanos has been released from his crystal prison by Guillotine.

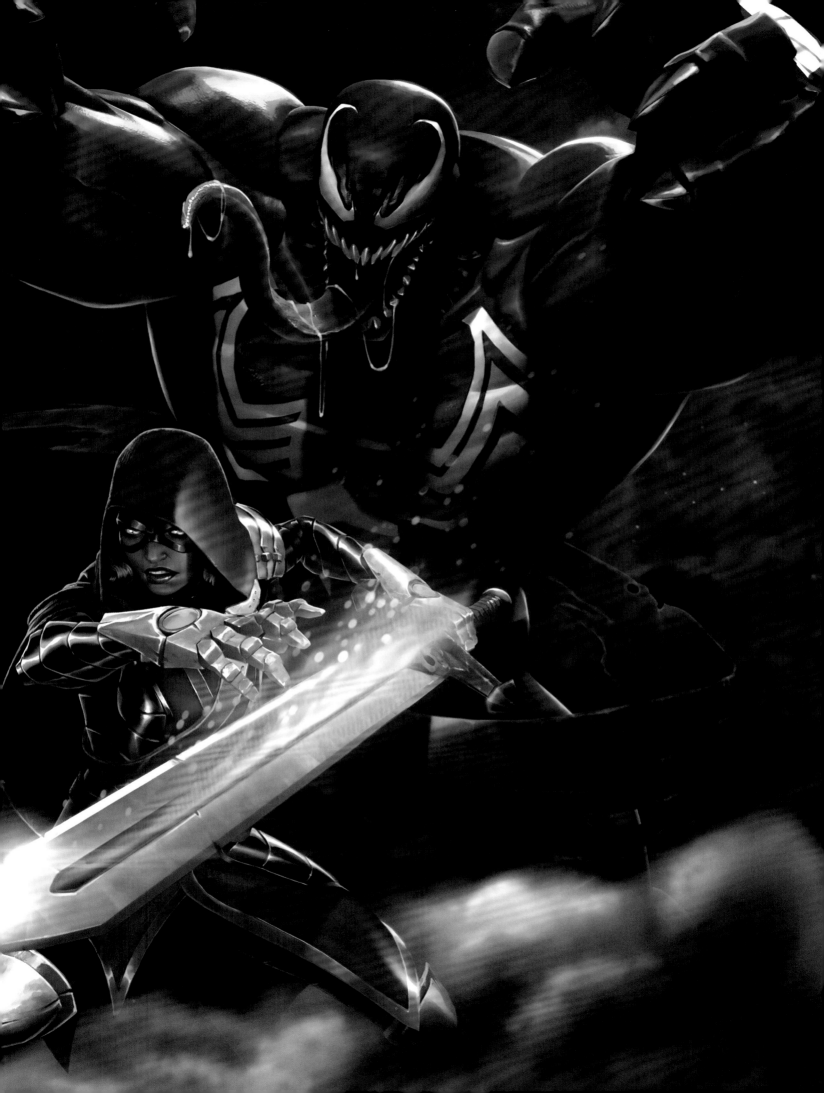

CONTAGION
CHAPTER NINE

▶▶ **I**n November of 2015 we began our first foray into fleshing out the Battlerealm, which would eventually become an expansive story space full of different factions, allies, and enemies," Dominic O'Grady recollects. "With the introduction of the Defenders, our first 'street-level' heroes in the form of Luke Cage and the new Daredevil, we wanted to tell a grittier story about those who hide in the shadows of the Battlerealm and use its many nooks and crannies to avoid justice.

"Joe Fixit, a perfect fit for organized crime villainy, is an alternate-universe Hulk who became one of our mainstays for telling stories about the 'Black-ISO Mafia,' a gradually expanding organized crime family that initially traded in the powerful but dubious Black-ISO that empowered but poisoned its users. In the next month we ran a fun and relaxed anniversary event to celebrate the release of Groot, and also look back on one year of *Marvel Contest of Champions*, reviewing all of our major story beats and the Champions added to the game!"

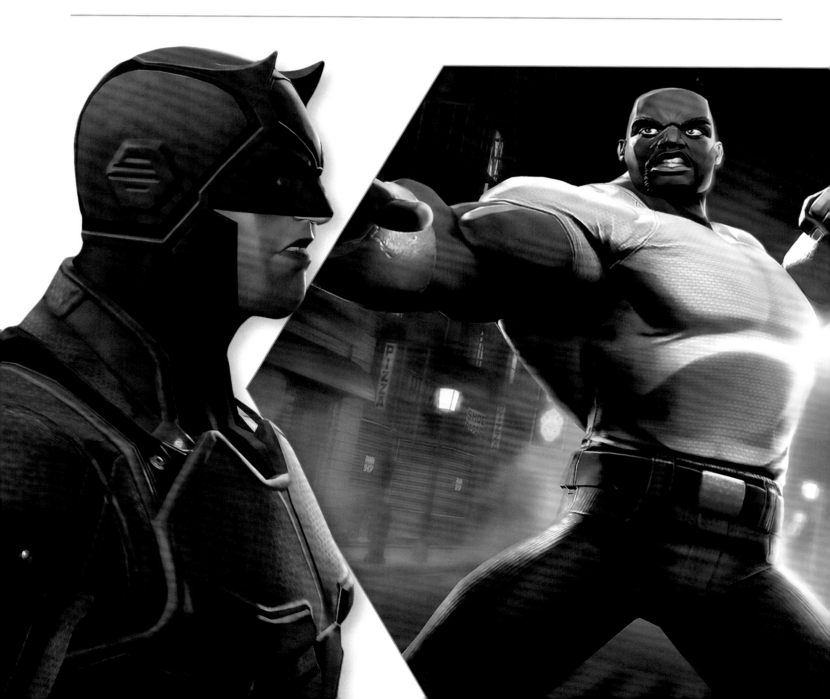

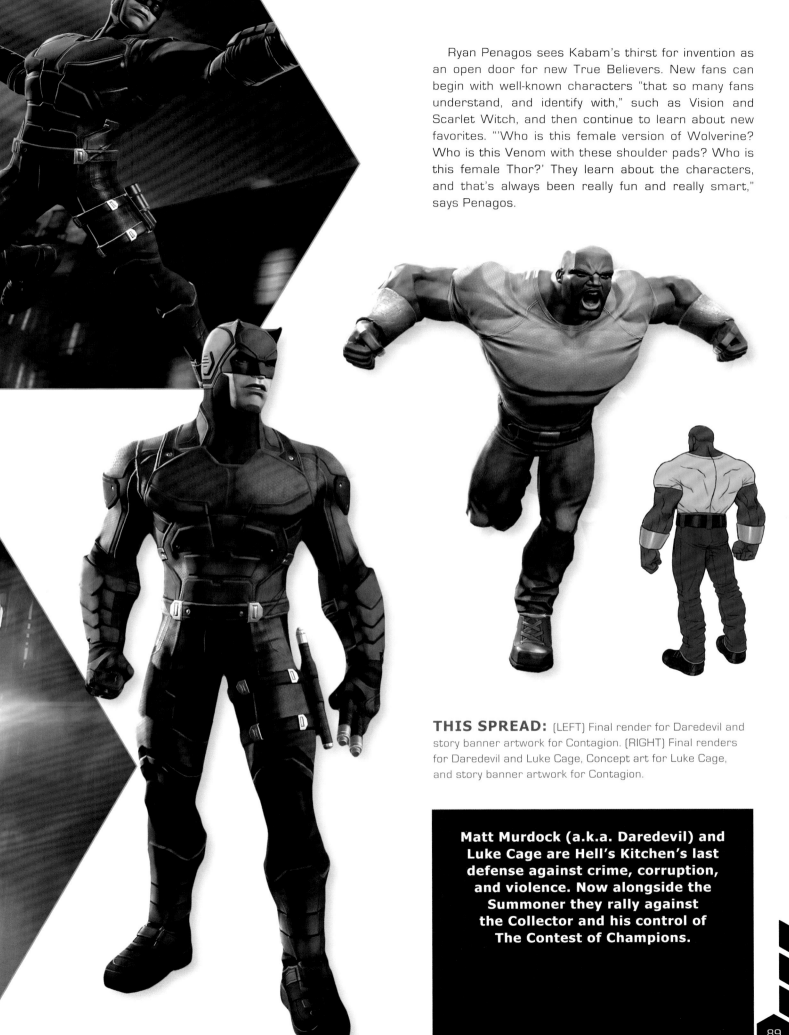

Ryan Penagos sees Kabam's thirst for invention as an open door for new True Believers. New fans can begin with well-known characters "that so many fans understand, and identify with," such as Vision and Scarlet Witch, and then continue to learn about new favorites. "'Who is this female version of Wolverine? Who is this Venom with these shoulder pads? Who is this female Thor?' They learn about the characters, and that's always been really fun and really smart," says Penagos.

THIS SPREAD: [LEFT] Final render for Daredevil and story banner artwork for Contagion. [RIGHT] Final renders for Daredevil and Luke Cage, Concept art for Luke Cage, and story banner artwork for Contagion.

Matt Murdock (a.k.a. Daredevil) and Luke Cage are Hell's Kitchen's last defense against crime, corruption, and violence. Now alongside the Summoner they rally against the Collector and his control of The Contest of Champions.

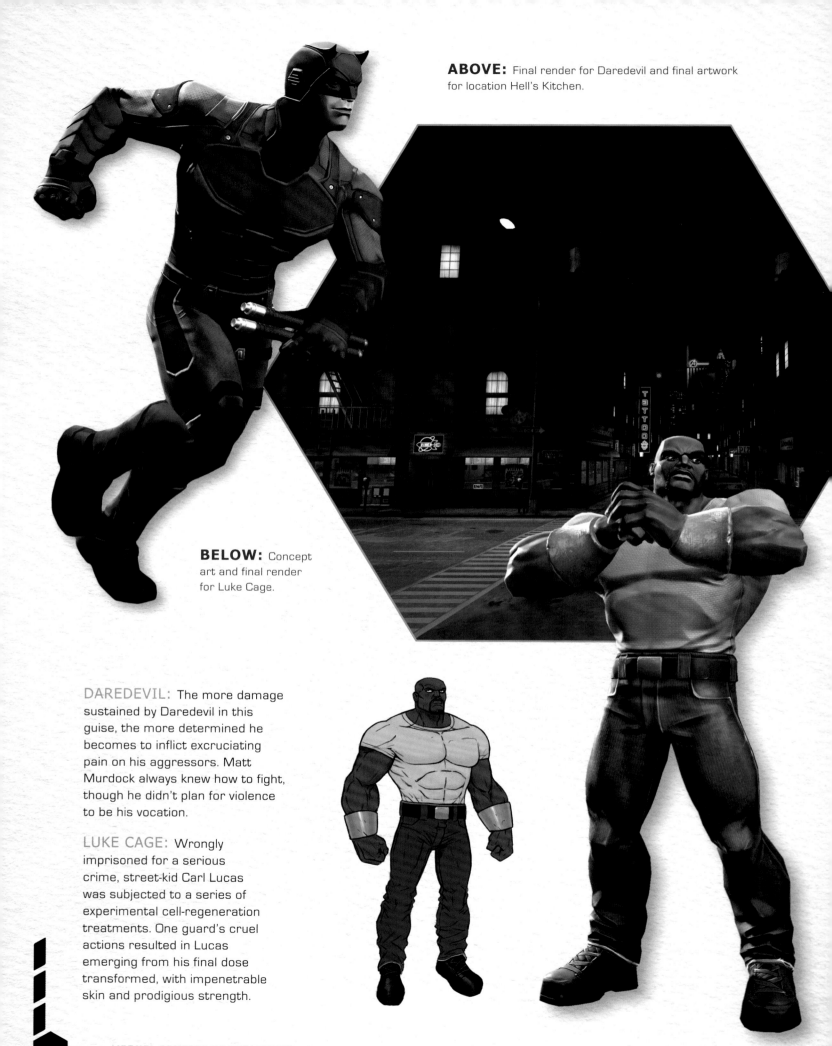

ABOVE: Final render for Daredevil and final artwork for location Hell's Kitchen.

BELOW: Concept art and final render for Luke Cage.

DAREDEVIL: The more damage sustained by Daredevil in this guise, the more determined he becomes to inflict excruciating pain on his aggressors. Matt Murdock always knew how to fight, though he didn't plan for violence to be his vocation.

LUKE CAGE: Wrongly imprisoned for a serious crime, street-kid Carl Lucas was subjected to a series of experimental cell-regeneration treatments. One guard's cruel actions resulted in Lucas emerging from his final dose transformed, with impenetrable skin and prodigious strength.

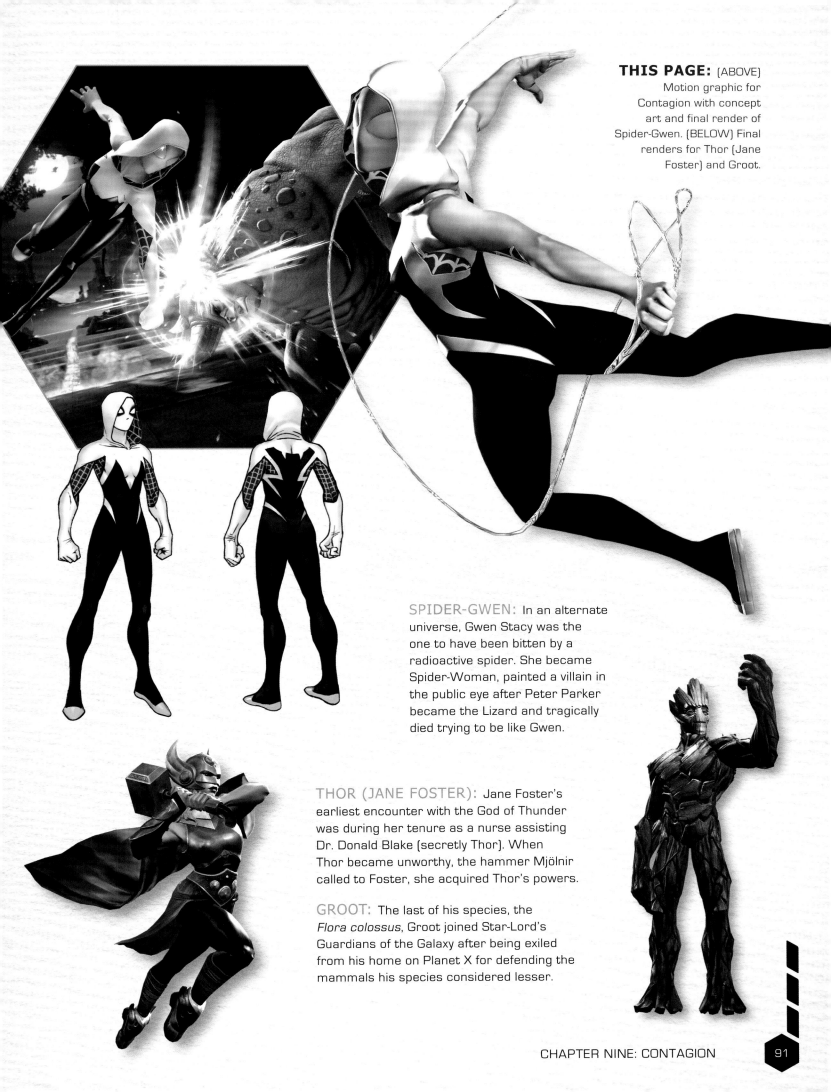

SPIDER-GWEN: In an alternate universe, Gwen Stacy was the one to have been bitten by a radioactive spider. She became Spider-Woman, painted a villain in the public eye after Peter Parker became the Lizard and tragically died trying to be like Gwen.

THOR (JANE FOSTER): Jane Foster's earliest encounter with the God of Thunder was during her tenure as a nurse assisting Dr. Donald Blake (secretly Thor). When Thor became unworthy, the hammer Mjölnir called to Foster, she acquired Thor's powers.

GROOT: The last of his species, the *Flora colossus*, Groot joined Star-Lord's Guardians of the Galaxy after being exiled from his home on Planet X for defending the mammals his species considered lesser.

ARACHNID ACTION
CHAPTER TEN

It's difficult to imagine the pressures involved in handling such beloved properties as Spider-Man and the X-Men, but it is obvious how the Kabam team delighted in the process. Miles Morales and Cyclops aren't the most obvious Marvel duo, but Kabam came up with a new and exciting story that could legitimately involve the two characters being introduced.

"Sometimes, a pair of character releases just don't really jive from a story point, even if they're both great Champions," says Dominic O'Grady. "Such was the case in January of 2016, when we released Miles Morales and the classic 90s variant of Cyclops. Rather than

trying to buddy-cop the two, as we had with Symbiote Spider-Man and X-Force Deadpool, we decided to focus on telling a coming-of-age story with Miles, who would be coached by the other Spiders—Spider-Man, Spider-Gwen, and a little bit of Symbiote Spidey—while on a task from the Collector to wrangle a disoriented Cyclops.

"Bringing together the Spider family is always a lot of fun, both due to their timeless nature in the Marvel series and their positive, occasionally corny energy. This wouldn't be the last time we'd partner all of them up to work together!"

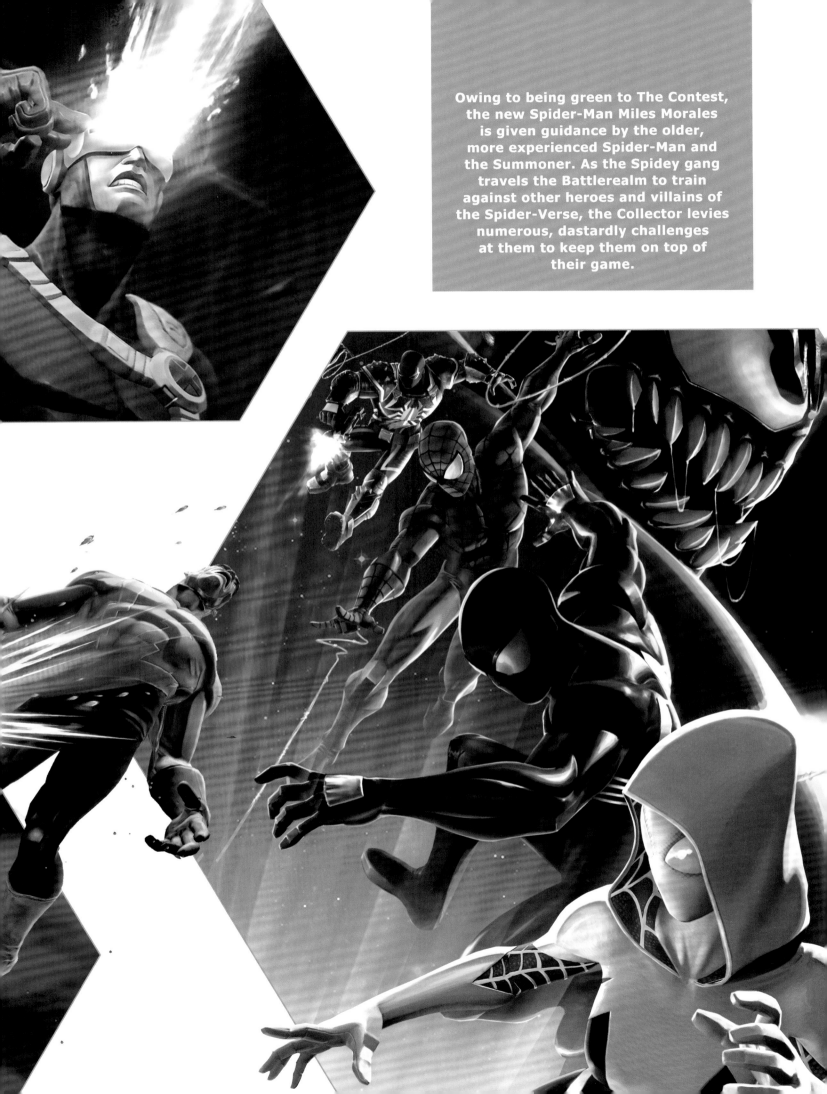

Owing to being green to The Contest, the new Spider-Man Miles Morales is given guidance by the older, more experienced Spider-Man and the Summoner. As the Spidey gang travels the Battlerealm to train against other heroes and villains of the Spider-Verse, the Collector levies numerous, dastardly challenges at them to keep them on top of their game.

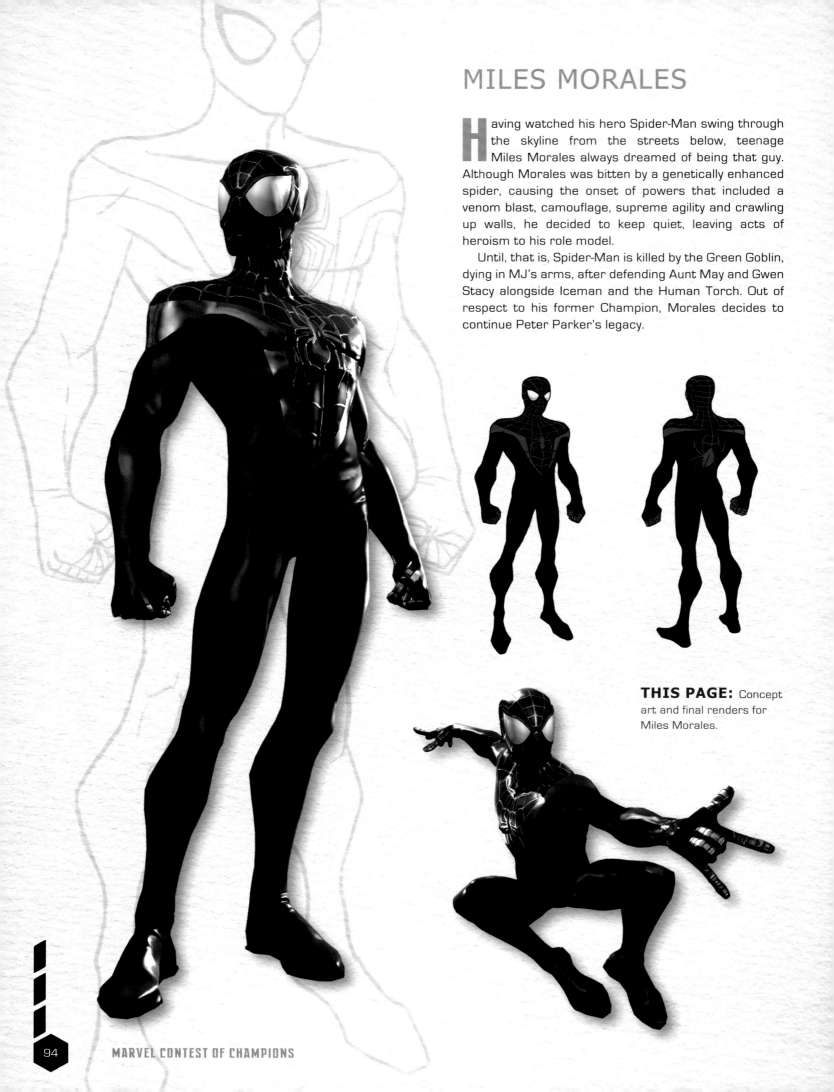

MILES MORALES

Having watched his hero Spider-Man swing through the skyline from the streets below, teenage Miles Morales always dreamed of being that guy. Although Morales was bitten by a genetically enhanced spider, causing the onset of powers that included a venom blast, camouflage, supreme agility and crawling up walls, he decided to keep quiet, leaving acts of heroism to his role model.

Until, that is, Spider-Man is killed by the Green Goblin, dying in MJ's arms, after defending Aunt May and Gwen Stacy alongside Iceman and the Human Torch. Out of respect to his former Champion, Morales decides to continue Peter Parker's legacy.

THIS PAGE: Concept art and final renders for Miles Morales.

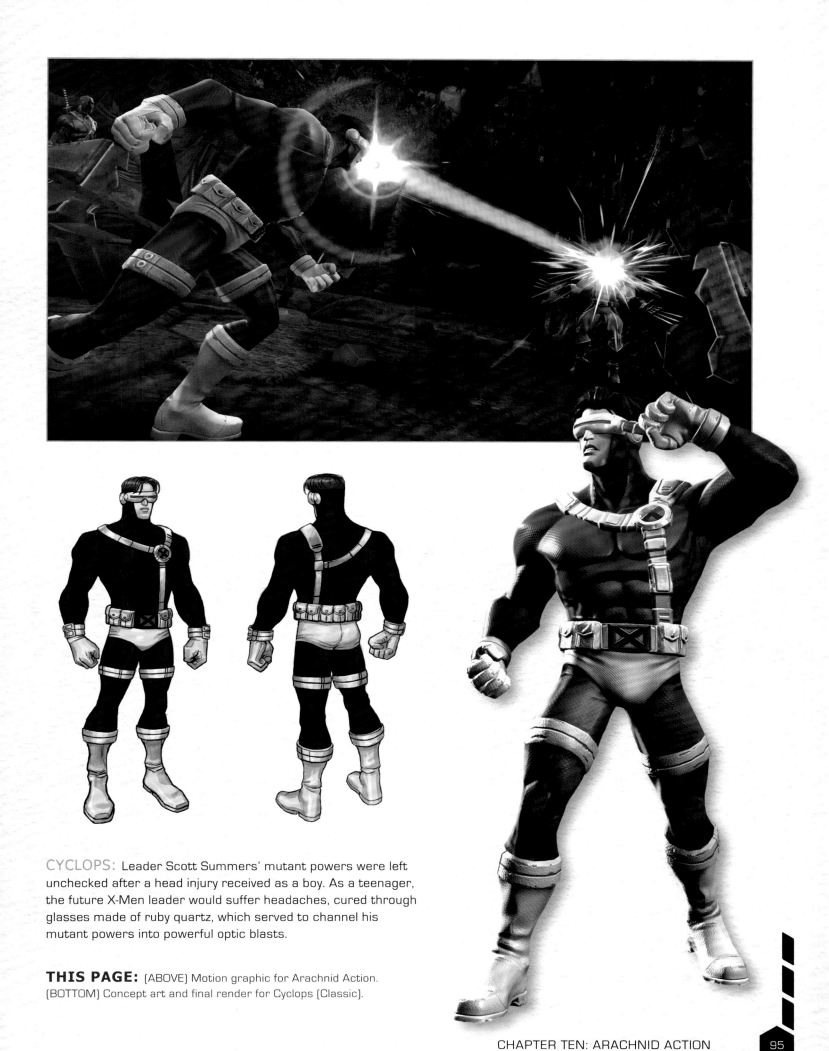

CYCLOPS: Leader Scott Summers' mutant powers were left unchecked after a head injury received as a boy. As a teenager, the future X-Men leader would suffer headaches, cured through glasses made of ruby quartz, which served to channel his mutant powers into powerful optic blasts.

THIS PAGE: [ABOVE] Motion graphic for Arachnid Action. [BOTTOM] Concept art and final render for Cyclops [Classic].

DEADPOOLOOZA
CHAPTER ELEVEN

"We had been itching to tell a story focused on Deadpool since the very beginning, as his irreverent and fourth-wall-breaking humor is a perfect fit for video games in general, and the live nature of our game in particular," says Dominic O'Grady. "From the quest names ('I Forgot to Name This One,' 'BFF <3') to the banner messages ('I Made a Quest and It's The Best') we allowed Deadpool to take over the game for the month and reveled in ditching our usually semi-serious tone. This update also came with one of our original characters, Venompool!"

"While fusing Marvel characters with Symbiotes isn't exactly untrodden territory in the Marvel Universe, our take on Venompool was the first to see release in a video game and had a fun animatic introduce him," says Gabriel Frizzera.

"We were a little hesitant with the idea of Venompool at first," says Tim Hernandez. "While there was no denying the appeal of splicing Venom with Deadpool, two massively popular characters in their own right, was it right for the game? The first design quickly convinced us he'd look awesome, and it was a stroke of genius to let Deadpool take over The Contest (even if temporarily), which allowed for such an over the top character like Venompool to fit right in."

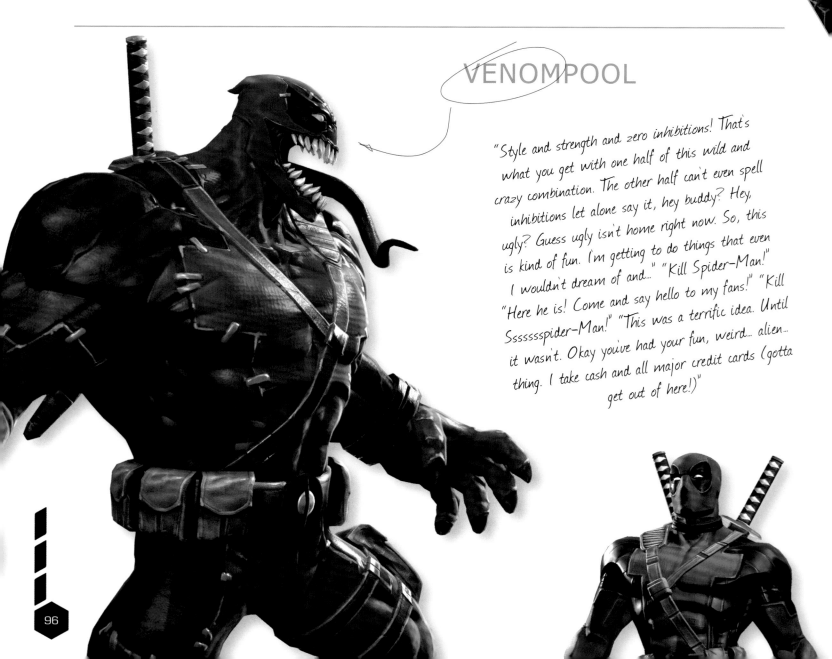

VENOMPOOL

"Style and strength and zero inhibitions! That's what you get with one half of this wild and crazy combination. The other half can't even spell inhibitions let alone say it, hey buddy? Hey, ugly? Guess ugly isn't home right now. So, this is kind of fun. I'm getting to do things that even I wouldn't dream of and..." "Kill Spider-Man!" "Here he is! Come and say hello to my fans!" "Kill Sssssspider-Man!" "This was a terrific idea. Until it wasn't. Okay you've had your fun, weird... alien... thing. I take cash and all major credit cards (gotta get out of here!)"

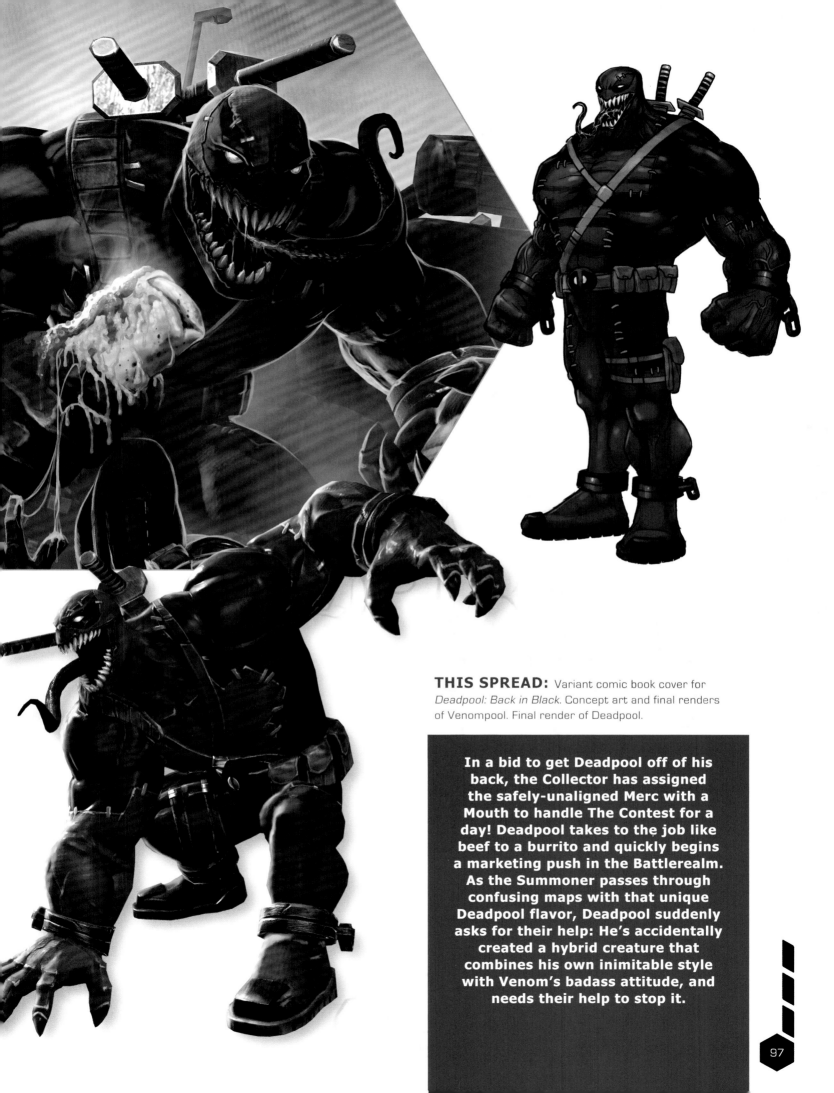

THIS SPREAD: Variant comic book cover for *Deadpool: Back in Black*. Concept art and final renders of Venompool. Final render of Deadpool.

In a bid to get Deadpool off of his back, the Collector has assigned the safely-unaligned Merc with a Mouth to handle The Contest for a day! Deadpool takes to the job like beef to a burrito and quickly begins a marketing push in the Battlerealm. As the Summoner passes through confusing maps with that unique Deadpool flavor, Deadpool suddenly asks for their help: He's accidentally created a hybrid creature that combines his own inimitable style with Venom's badass attitude, and needs their help to stop it.

OLD MAN LOGAN

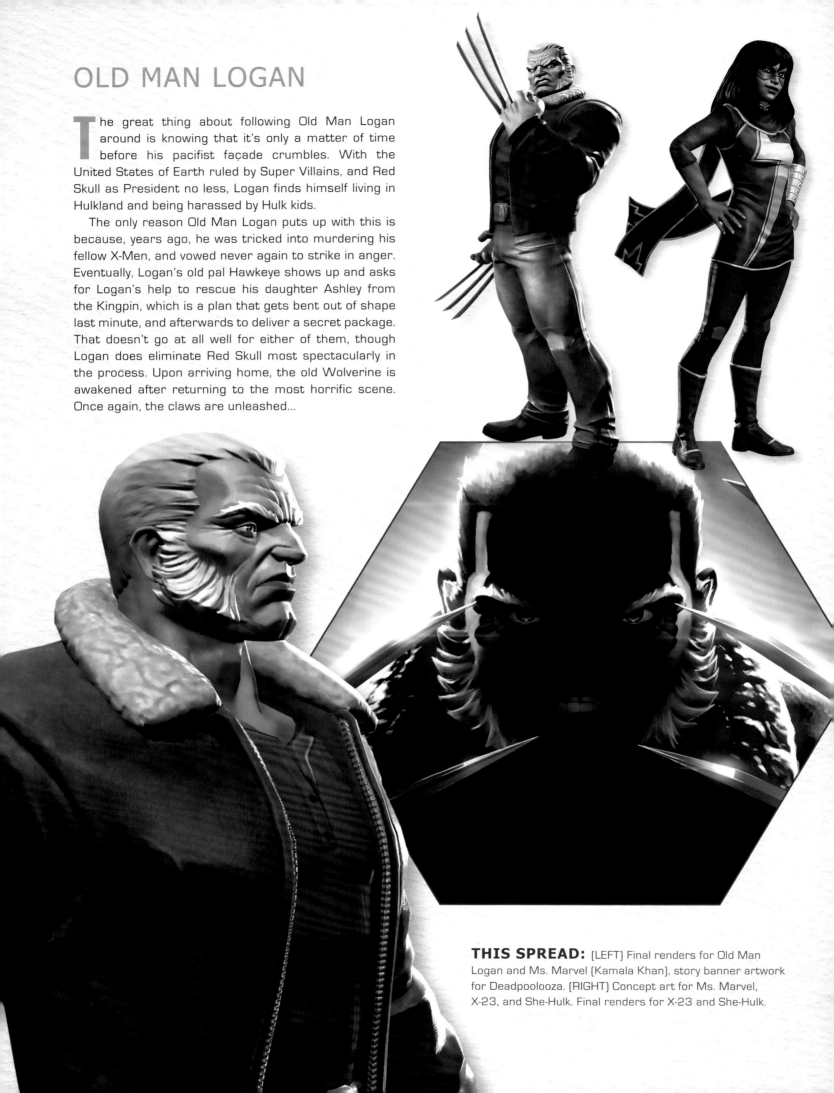

The great thing about following Old Man Logan around is knowing that it's only a matter of time before his pacifist façade crumbles. With the United States of Earth ruled by Super Villains, and Red Skull as President no less, Logan finds himself living in Hulkland and being harassed by Hulk kids.

The only reason Old Man Logan puts up with this is because, years ago, he was tricked into murdering his fellow X-Men, and vowed never again to strike in anger. Eventually, Logan's old pal Hawkeye shows up and asks for Logan's help to rescue his daughter Ashley from the Kingpin, which is a plan that gets bent out of shape last minute, and afterwards to deliver a secret package. That doesn't go at all well for either of them, though Logan does eliminate Red Skull most spectacularly in the process. Upon arriving home, the old Wolverine is awakened after returning to the most horrific scene. Once again, the claws are unleashed...

THIS SPREAD: [LEFT] Final renders for Old Man Logan and Ms. Marvel (Kamala Khan), story banner artwork for Deadpoolooza. [RIGHT] Concept art for Ms. Marvel, X-23, and She-Hulk. Final renders for X-23 and She-Hulk.

WOMEN OF POWER

We celebrated the women of Marvel in a quest introducing Kamala Khan, the new Ms. Marvel, to the Battlerealm," says Hernandez. "In addition to telling Kamala's tale, we further celebrated International Women's Day with a Champion Challenge featuring Chloe Bennet (who plays Quake on *Marvel's Agents of S.H.I.E.L.D.*), where players could face off against a team of Champions she hand-picked."

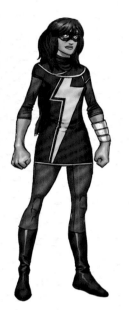

MS. MARVEL (KAMALA KHAN): The Inhuman Kamala Khan, a teenager from Jersey City, was overjoyed upon receiving her shapeshifting abilities, after breathing in Terrigen Mist. She'd always dreamt of becoming Ms. Marvel, just like Carol Danvers, and goes all out to be just as "beautiful and awesome and butt-kicking."

WOLVERINE X-23: Laura Kinney is a female clone of Wolverine who survived the painful bonding process of Adamantium to her skeleton. Known as test subject X-23, Kinney was weaponized then ordered to complete numerous covert missions before being asked by her surrogate mother to destroy her kin.

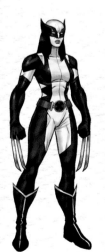
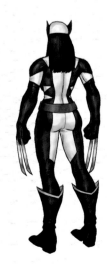
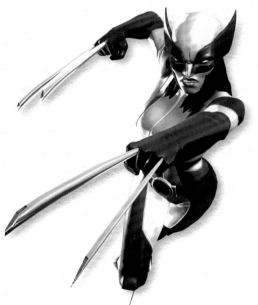

SHE-HULK: Timid lawyer Jennifer Walters saw her life change dramatically the day she was accidentally shot. Only a blood transfusion from Walters' close relative Bruce Banner could save her, but it also transformed her into She-Hulk, leading to exploits with the Avengers and Fantastic Four.

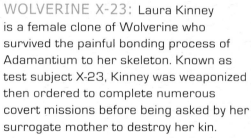

M.O.D.O.K., MO' PROBLEMS

CHAPTER TWELVE

Gabriel Frizzera always felt that M.O.D.O.K. deserved more exposure, and was keen to include him in *Marvel Contest of Champions*. To make him viable as a playable Champion, however, some suitably ingenious modifications were required. Fortunately, the partnership between Marvel and Kabam was now such that those modifications could be made.

Bill Rosemann has been at Marvel for more than twenty years and uses his experience to help transition characters from movies and comics to games. "Redesigning a character comes down to a few questions: Do they need to be adapted to fit the game's visual style? Does the character's look now feel a bit dated and need some modern updates? Or, as in many cases, are there any elements of their classic design that we can embrace? How can we make sure that we deliver the key design elements—from their colors to their symbols and silhouette—in order to authentically present them? There's no set of rules carved in granite, so it's up to all of us at Marvel Games and Kabam to trust our creative instincts, respect Marvel's rich history, and also have the conviction to surprise players with the shock of the new."

M.O.D.O.K. is such a recognizable character in the Marvel Universe. "Those lips, that hair, that ride. How could you resist such a stunning creature?" says Tim Hernandez. It was important to ensure that this grotesque mastermind was correctly portrayed in the game. One key element that helped enhance M.O.D.O.K.'s unique character was the introduction of alternate Marvel Super Heroes and Villains. "Helping come up with a few of M.O.D.O.K.'s hybrid Champions was so much fun," says Hernandez. "It gave us a taste of how a mad scientist thinks!"

RED HULK: General Thaddeus E. "Thunderbolt" Ross was a proud military man before a lifetime of pursuing the Hulk turned into obsession, leading to his own monstrous transformation. Thunderbolt once demonized Hulk, but now understands what it means to lose control.

THIS SPREAD: Final renders for M.O.D.O.K., Agent Venom, and Red Hulk, and concept art for M.O.D.O.K.

Having grown tired of being relegated to the Collector's rejected Champion warehouse, M.O.D.O.K. decides to take matter into his own hands. He recruits other rejects and weird alternate versions of well-known Champions to prove they can dominate The Contest. In the end, the Collector is so impressed with M.O.D.O.K.'s efforts that he decides to make the Big Head his Chief Technology Officer.

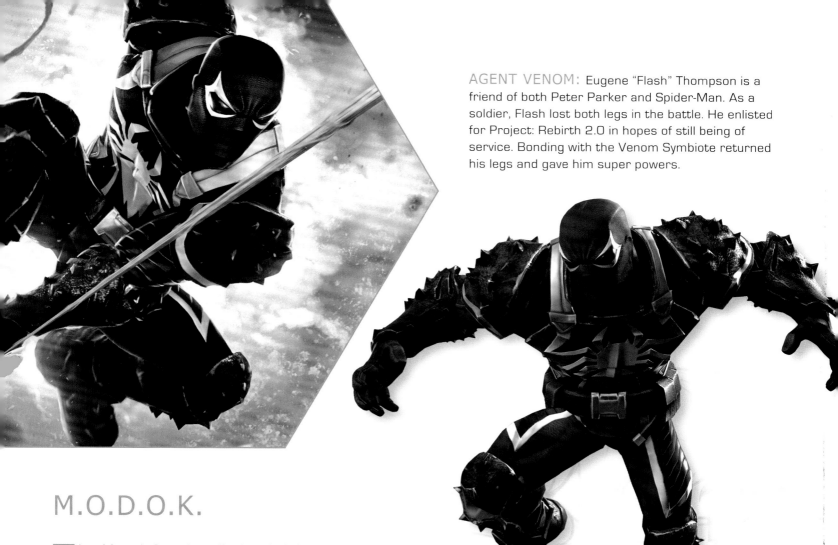

Eugene "Flash" Thompson is a friend of both Peter Parker and Spider-Man. As a soldier, Flash lost both legs in the battle. He enlisted for Project: Rebirth 2.0 in hopes of still being of service. Bonding with the Venom Symbiote returned his legs and gave him super powers.

M.O.D.O.K.

The Mental Organism Designed Only for Killing (M.O.D.O.K.) was once lab technician George Tarleton, selected to become a living computer by the Scientist Supreme of A.I.M. Upon his completion—a process that mutated Tarleton's head to grotesque proportions—the new supreme being operated under the codename M.O.D.O.C., standing for "Mobile Organism Designed Only for Computing." Tarleton quickly modified this to more accurately suit his purpose.

The M.O.D.O.K. encountered in The Contest of Champions is still licking his wounds after an unsuccessful revolt against the Collector. M.O.D.O.K. has, however, convinced his new boss, the Grandmaster, to allow him control over a small portion of the Battlerealm. This area is a kind of Hotel/Spa/Bootcamp for experiments on discarded Champions, disguised as the five star resort of their dreams: "The most luxurious destination this side of the Quantumverse."

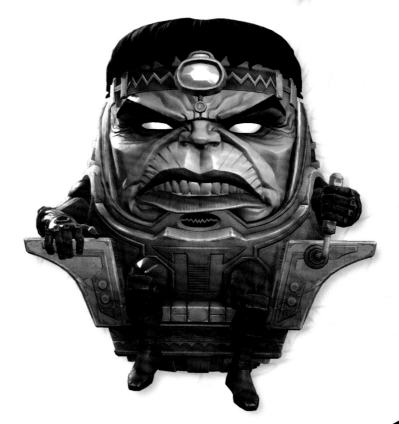

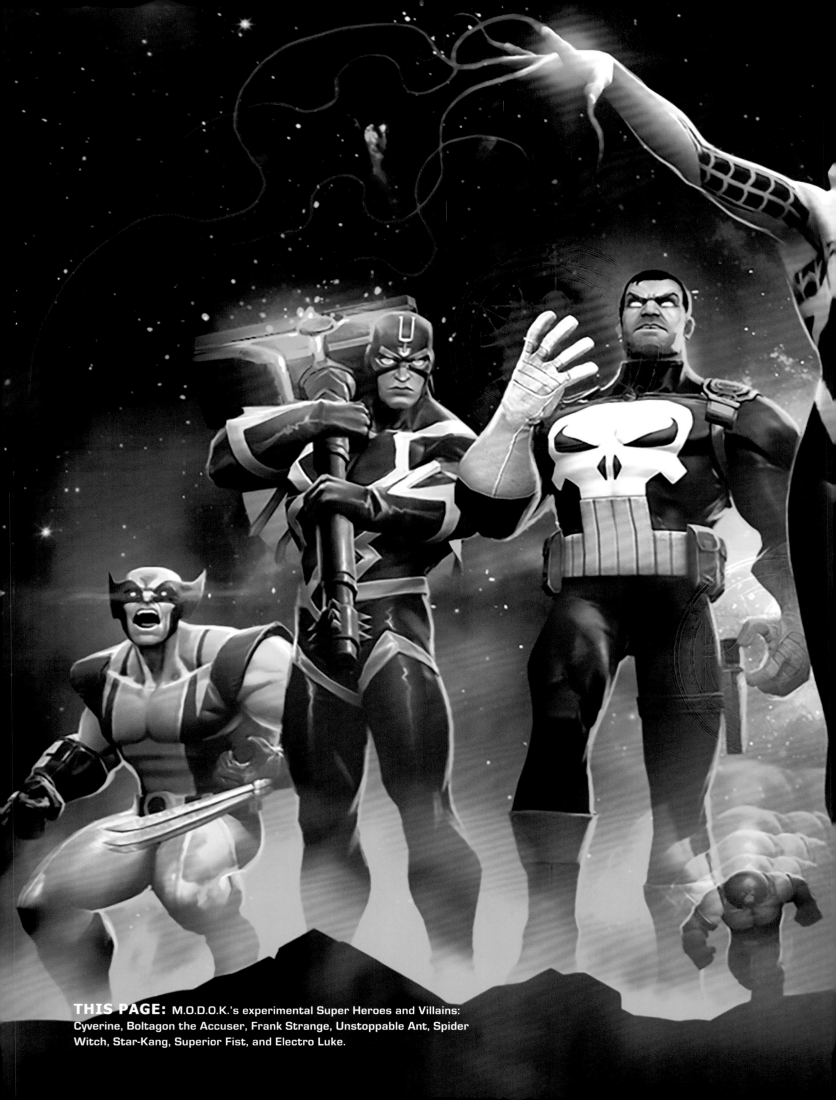

THIS PAGE: M.O.D.O.K.'s experimental Super Heroes and Villains: Cyverine, Boltagon the Accuser, Frank Strange, Unstoppable Ant, Spider Witch, Star-Kang, Superior Fist, and Electro Luke.

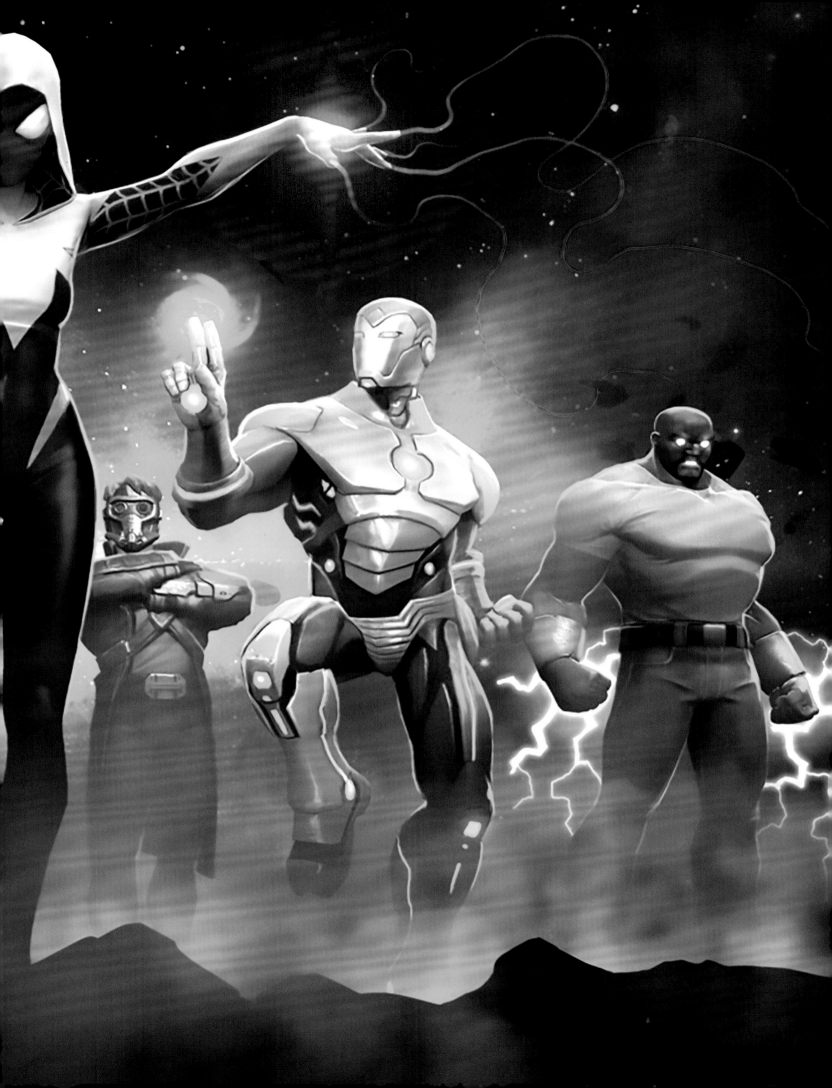

COSMIC CIVIL WAR
CHAPTER THIRTEEN

"After the incredible response to Guillotine, we presented Kabam and our other games a chance to create their own exclusive version of Captain America in honor of the character's 75th Anniversary," says Tim Hernandez. "Kabam rose to the challenge and took it a step further by making this new iteration the lynchpin of their *Captain America: Civil War* event.

"In terms of design, it was fitting that he'd be a mix of Cap and Iron Man, but our main creative feedback was to make sure that visually he read as Cap. Iron Patriot was already in the game, and red, white, and blue themed Iron Man armors had been done in comics before. It was important to drive home that this was Steve Rogers making his own suit to honor Tony."

The reaction to Civil Warrior was enormously positive, with Kabam successfully bringing together two of Marvel's most famous heroes. Civil Warrior is a fitting embodiment of the 'Civil War' event that split the Marvel Universe. In the dark depths of the Battlerealm, Civil Warrior stands as a beacon of strength and unity, calling for friends and foes to work together to defeat a greater evil.

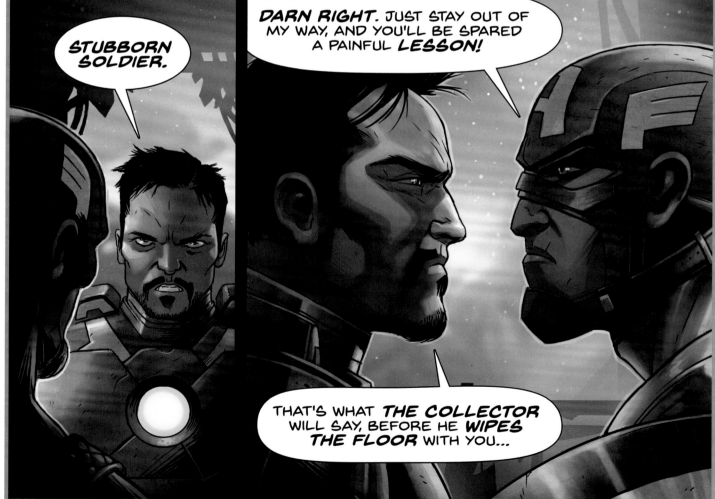

THIS PAGE: Panels from the *Road to Civil War* comic.

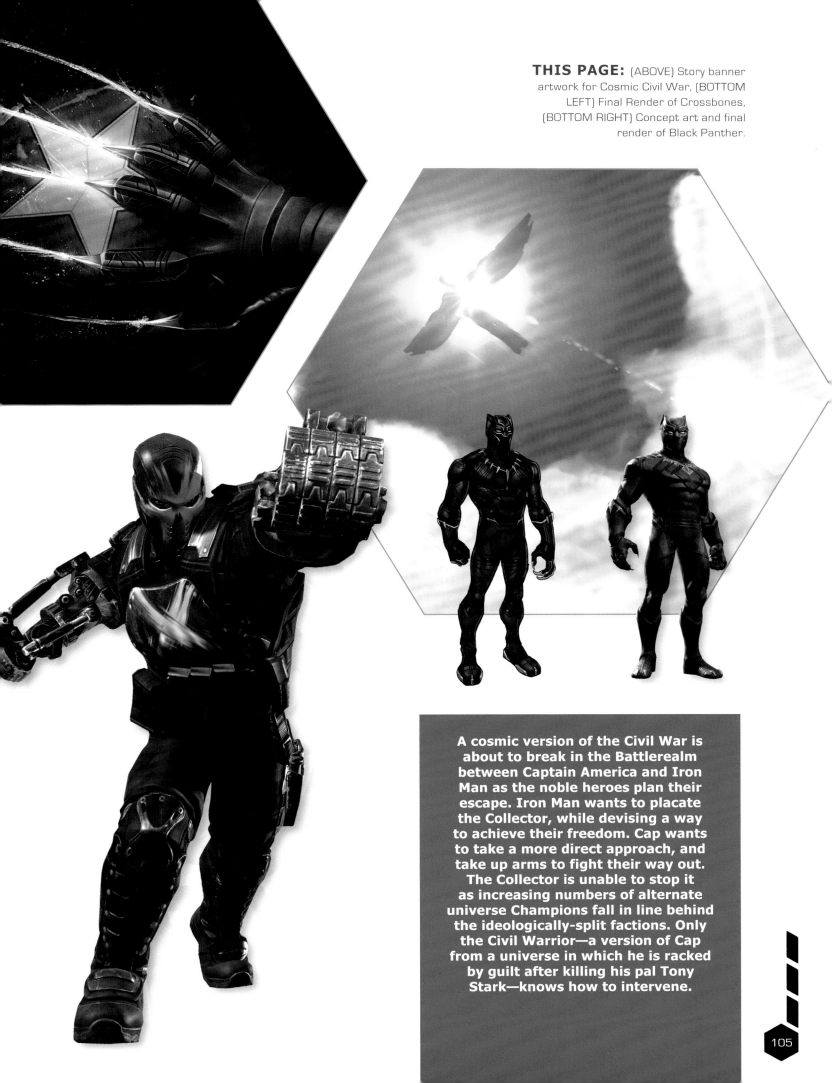

A cosmic version of the Civil War is about to break in the Battlerealm between Captain America and Iron Man as the noble heroes plan their escape. Iron Man wants to placate the Collector, while devising a way to achieve their freedom. Cap wants to take a more direct approach, and take up arms to fight their way out. The Collector is unable to stop it as increasing numbers of alternate universe Champions fall in line behind the ideologically-split factions. Only the Civil Warrior—a version of Cap from a universe in which he is racked by guilt after killing his pal Tony Stark—knows how to intervene.

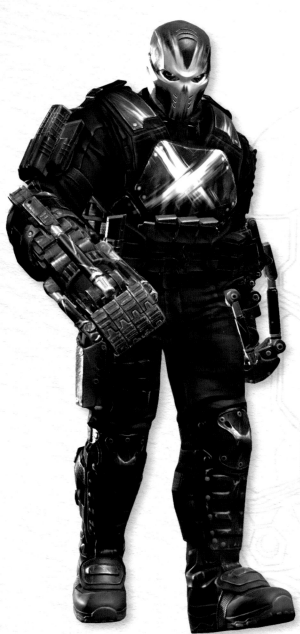

CROSSBONES: This former S.H.I.E.L.D. agent turned terrorist seeks bloody revenge for the death of his old Hydra commander, Alexander Pierce. Under his new identity as Crossbones, Brock Rumlow wants to make sure that the Avengers pay for their role in all the hardship he has suffered.

THIS SPREAD:

(LEFT) Final renders for Crossbones, Falcon and Black Panther. (RIGHT) Motion graphic for Cosmic Civil War, final render and, concept art for Civil Warrior.

FALCON: After his own experiences of war, Samuel Thomas Wilson returned home to help his fellow veterans cope with Post-Traumatic Stress Disorder. A chance meeting with Captain America led to Wilson's involvement in the Avengers, taking to the skies as the winged hero, Falcon.

BLACK PANTHER: T'Challa was trained his whole life to take his father's place as monarch of Wakanda. Though he admired his father's strength and agility, he took no interest in politics. After his father's murder, T'Challa took the mantle of Black Panther and soon proved himself worthy of the name.

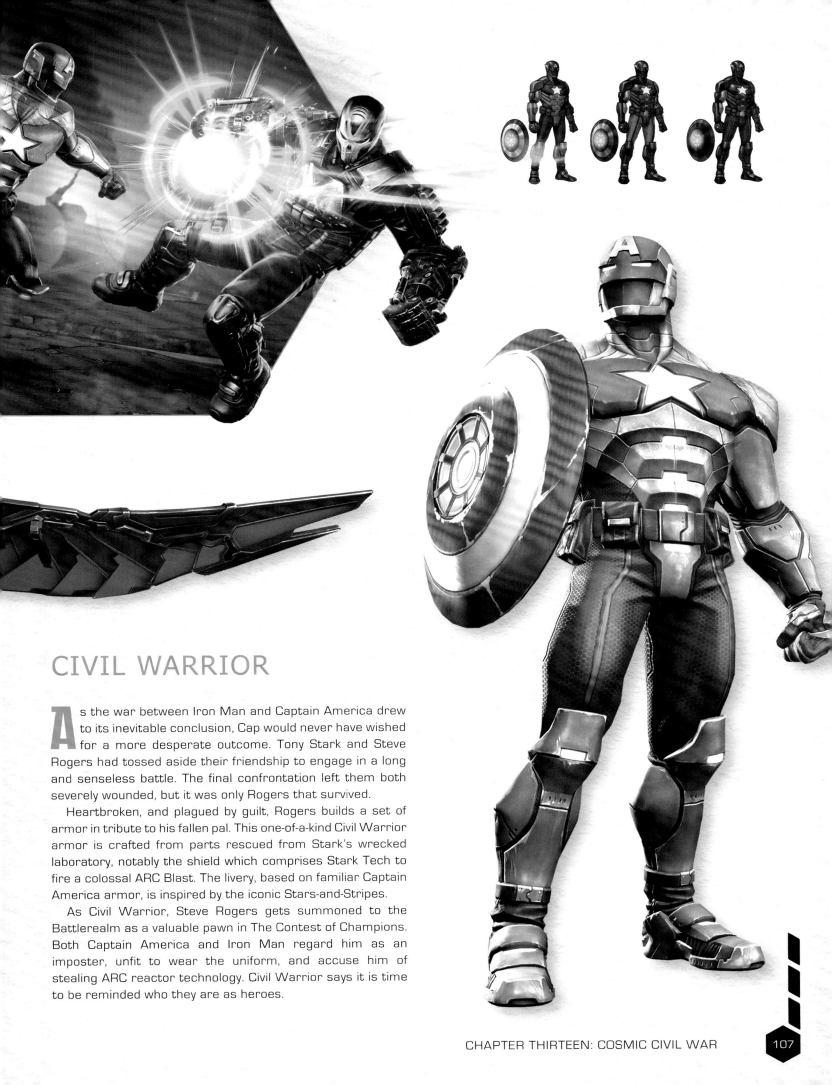

CIVIL WARRIOR

As the war between Iron Man and Captain America drew to its inevitable conclusion, Cap would never have wished for a more desperate outcome. Tony Stark and Steve Rogers had tossed aside their friendship to engage in a long and senseless battle. The final confrontation left them both severely wounded, but it was only Rogers that survived.

Heartbroken, and plagued by guilt, Rogers builds a set of armor in tribute to his fallen pal. This one-of-a-kind Civil Warrior armor is crafted from parts rescued from Stark's wrecked laboratory, notably the shield which comprises Stark Tech to fire a colossal ARC Blast. The livery, based on familiar Captain America armor, is inspired by the iconic Stars-and-Stripes.

As Civil Warrior, Steve Rogers gets summoned to the Battlerealm as a valuable pawn in The Contest of Champions. Both Captain America and Iron Man regard him as an imposter, unfit to wear the uniform, and accuse him of stealing ARC reactor technology. Civil Warrior says it is time to be reminded who they are as heroes.

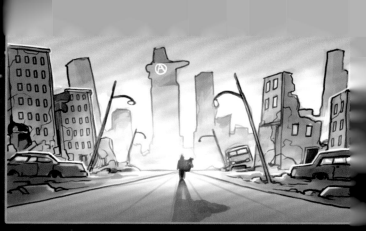

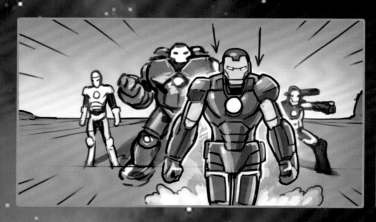
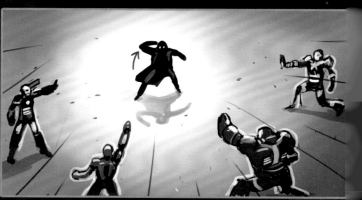

CRUNCH

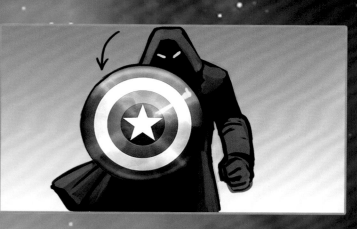
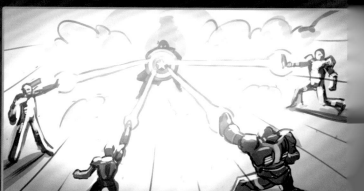

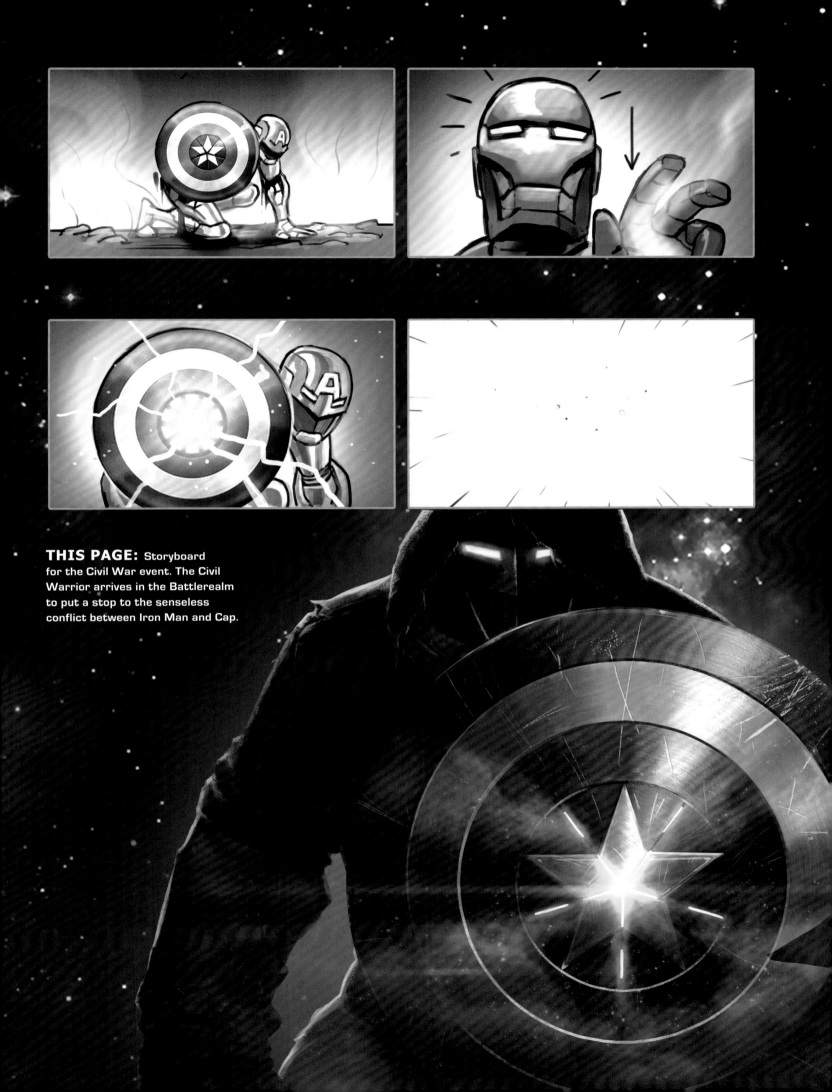

THIS PAGE: Storyboard for the Civil War event. The Civil Warrior arrives in the Battlerealm to put a stop to the senseless conflict between Iron Man and Cap.

X-MEN TERRIGENOCIDE

CHAPTER FOURTEEN

Considering the enormity of Jean Grey and Phoenix Force, it is not only remarkable how loyal Kabam's writers and artists have remained to the subject matter; it is astonishing how confidently the team molds these epic tales to suit their own purpose.

"The Terrigenesis saga was really all about showing that the internal conflicts mutants always seem to find themselves in are helpful to no-one, least of all themselves," says Scott Bradford. "Things start off nicely enough, with Magneto

and Beast working together to stop M.O.D.O.K.'s experiments on mutants. Unfortunately, their disagreement on how to handle Jean Grey's transition into the Phoenix and her newfound power distracts them from the true threat, and Thanos claims another Infinity Stone as Phoenix is encased in a cocoon of pure ISO-8. This was the first Infinity Stone we'd shown since the conclusion of Act 4, and it telegraphed that *Infinity War* was coming. The end point was known, and this was in a way the beginning of our march towards it."

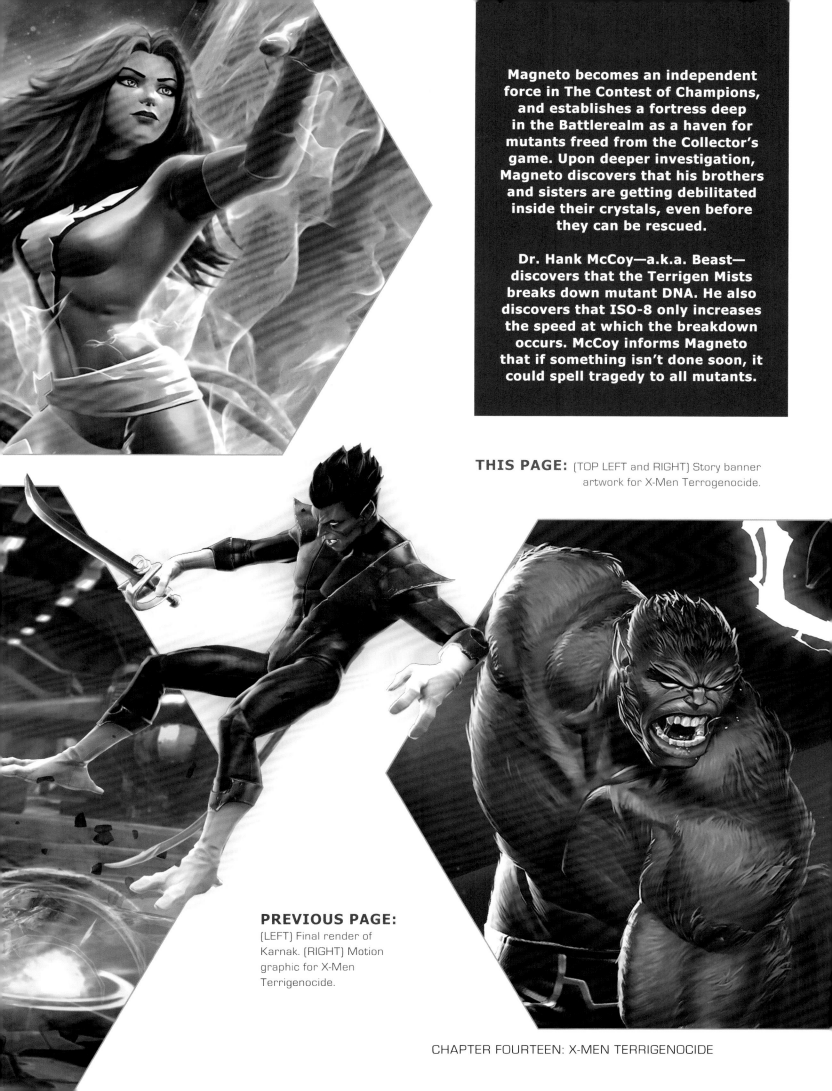

Magneto becomes an independent force in The Contest of Champions, and establishes a fortress deep in the Battlerealm as a haven for mutants freed from the Collector's game. Upon deeper investigation, Magneto discovers that his brothers and sisters are getting debilitated inside their crystals, even before they can be rescued.

Dr. Hank McCoy—a.k.a. Beast—discovers that the Terrigen Mists breaks down mutant DNA. He also discovers that ISO-8 only increases the speed at which the breakdown occurs. McCoy informs Magneto that if something isn't done soon, it could spell tragedy to all mutants.

THIS PAGE: [TOP LEFT and RIGHT] Story banner artwork for X-Men Terrogenocide.

PREVIOUS PAGE:
[LEFT] Final render of Karnak. [RIGHT] Motion graphic for X-Men Terrigenocide.

Hoping to develop a cure for the Terrigen Mists, Beast entreats the Summoner to help him find more X-Men, and to discover the secret to perfecting his cure.

Meanwhile, Magneto grows tired of waiting for Beast to perfect his cure, and so sets off to find and destroy the Collector's ship, the Ghost Orchid. The Summoner and several X-Men leave Beast in order to seek out Quake, who may hold the key to discovering the ship's location and thus the key to ending the Terrigenocide, but Jean Grey grows more unstable by the hour...

THIS PAGE: (LEFT) Concept art and final render for Phoenix. (TOP RIGHT) Concept art for Rogue. (BOTTOM RIGHT) Story banner artwork for X-Men Terrigenocide.

PHOENIX: Jean Grey not only took the name of Phoenix, she merged with the Phoenix Force. Through the Phoenix Force, Grey wields powers of cosmic pyrokinesis, resurrection, and immortality.

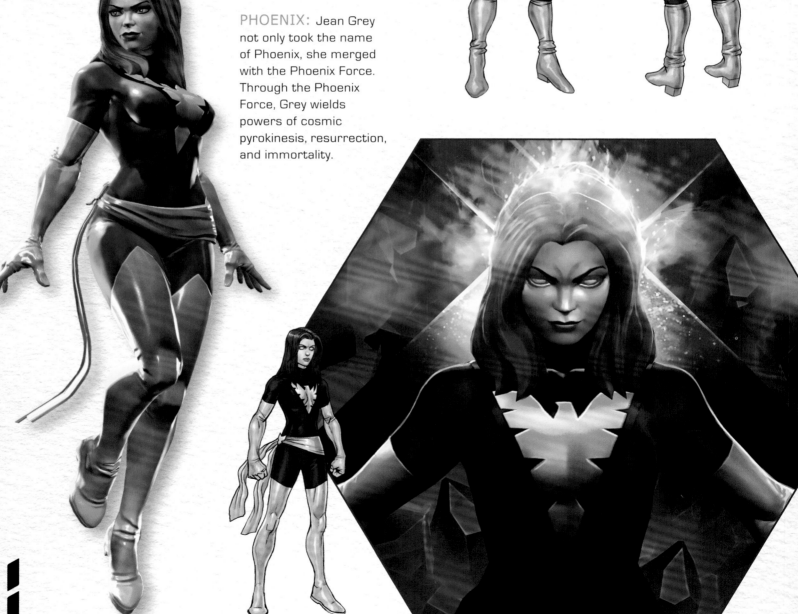

ROGUE: It's the perfect handle for a Super Hero, but Rogue has been Anna Marie's nickname since she was a teenager (when she ran away from home). She has the power to absorb the life energy of another person simply via touch and is invaluable to the X-Men.

GAMBIT: Remy LeBeau has been passed around like a deck of cards since birth. Raised by thieves, he combines light fingers with his ability to charge objects with kinetic energy; playing cards are his weapon of choice. Like Rogue, LeBeau can sense others' thoughts.

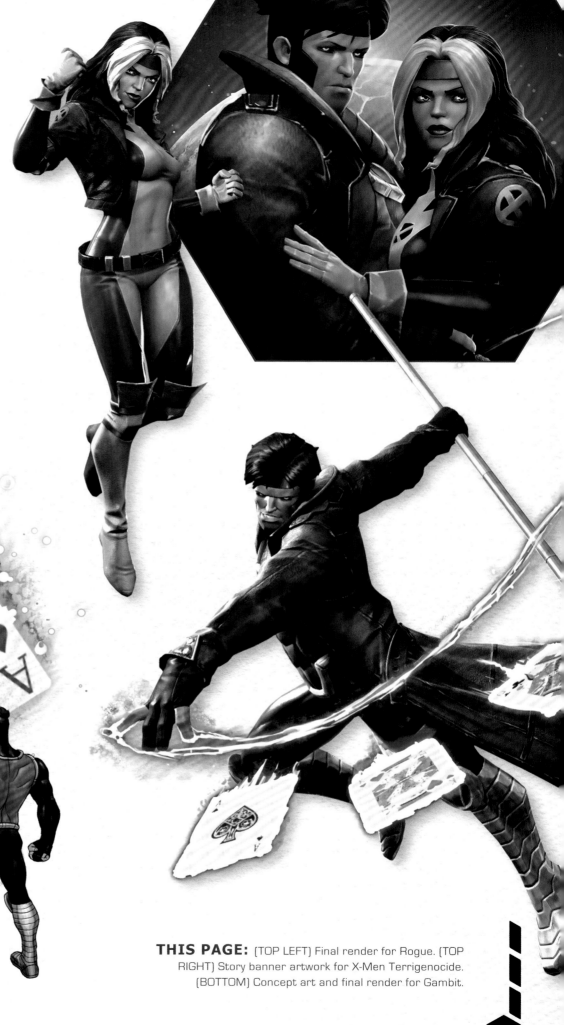

THIS PAGE: (TOP LEFT) Final render for Rogue. (TOP RIGHT) Story banner artwork for X-Men Terrigenocide. (BOTTOM) Concept art and final render for Gambit.

CHAPTER FOURTEEN: X-MEN TERRIGENOCIDE 113

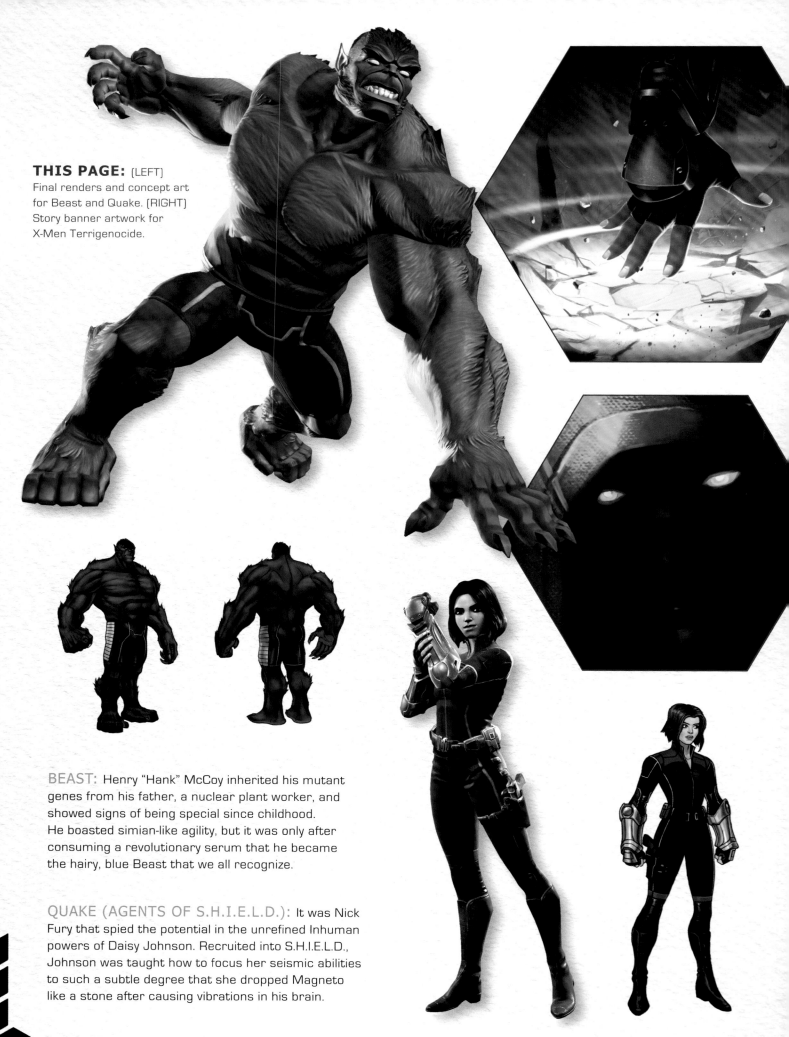

THIS PAGE: [LEFT]
Final renders and concept art
for Beast and Quake. [RIGHT]
Story banner artwork for
X-Men Terrigenocide.

BEAST: Henry "Hank" McCoy inherited his mutant
genes from his father, a nuclear plant worker, and
showed signs of being special since childhood.
He boasted simian-like agility, but it was only after
consuming a revolutionary serum that he became
the hairy, blue Beast that we all recognize.

QUAKE (AGENTS OF S.H.I.E.L.D.): It was Nick
Fury that spied the potential in the unrefined Inhuman
powers of Daisy Johnson. Recruited into S.H.I.E.L.D.,
Johnson was taught how to focus her seismic abilities
to such a subtle degree that she dropped Magneto
like a stone after causing vibrations in his brain.

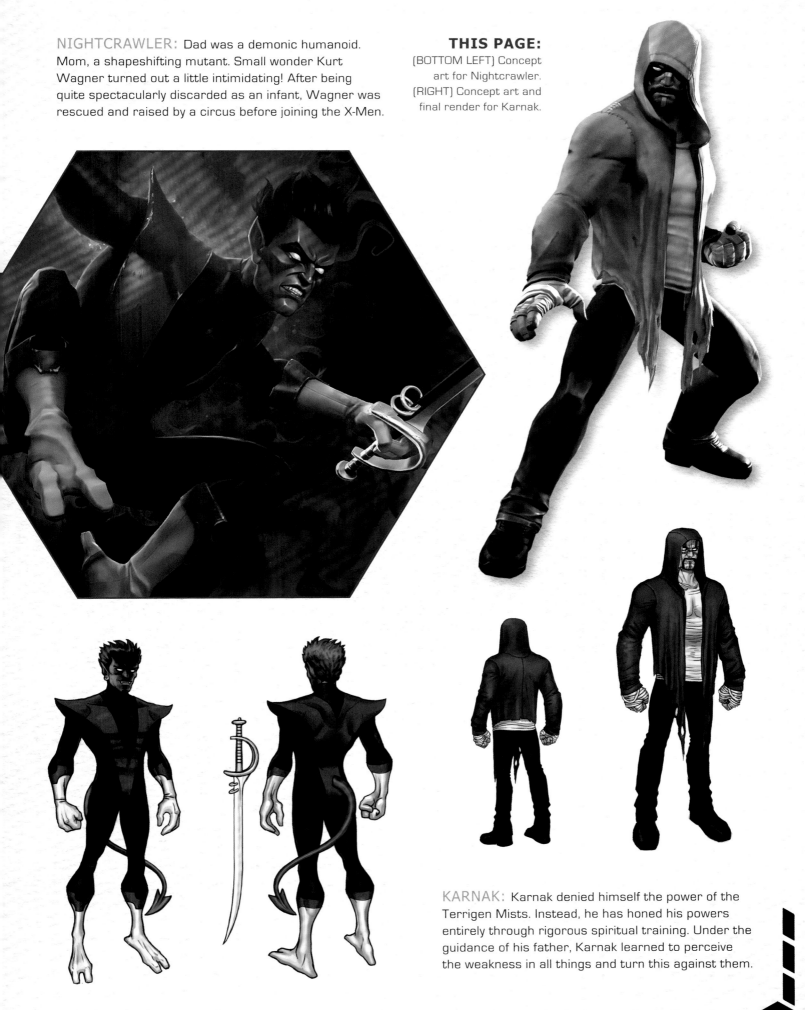

NIGHTCRAWLER: Dad was a demonic humanoid. Mom, a shapeshifting mutant. Small wonder Kurt Wagner turned out a little intimidating! After being quite spectacularly discarded as an infant, Wagner was rescued and raised by a circus before joining the X-Men.

THIS PAGE:
(BOTTOM LEFT) Concept art for Nightcrawler.
(RIGHT) Concept art and final render for Karnak.

KARNAK: Karnak denied himself the power of the Terrigen Mists. Instead, he has honed his powers entirely through rigorous spiritual training. Under the guidance of his father, Karnak learned to perceive the weakness in all things and turn this against them.

CHAPTER FOURTEEN: X-MEN TERRIGENOCIDE

TITANOMACHY
CHAPTER FIFTEEN

The games truly began when Kabam introduced Loki, the God of Mischief to the Battlerealm. Inevitably Loki's tricks and schemes would wreak havoc with the Collector's plans. But the real game changer would be the return of the Grandmaster to The Contest of Champions.

"We had started doing our One-Shots and Spotlights; every month we created these special events," explains Cuz Parry. "Sometimes they would augment the story or offer their own side-stories in the Battlerealm. Adding Deadpool just makes it fun, for example. Sometimes there's a two-month arc, and those are the ones that link in with the movies."

"I think one of the reasons that Marvel Games as a group is so smart in what they're doing is that they look at what's happening in the comics, and they look at how that feeds into the games," Ryan Penagos says. "They feed back and forth into each other in a really great, totally organic way. There's no one saying 'You need to use this!' They're great characters, and great ideas, so it's easy for all the creators to jump in with ideas and say 'this is a cool thing that I want to do.'"

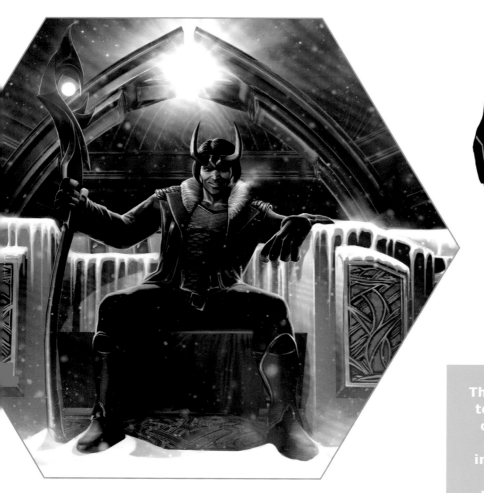

THIS SPREAD: [FAR LEFT & ABOVE] Story banner artwork for Titanomachy. [LEFT & RIGHT] Concept art and final renders for Loki.

The Collector plans to host a grand tournament to reboot The Contest of Champions in the aftermath of the Civil War. Unfortunately for those involved, the Collector's Elder brother, the Grandmaster, crashes the party with the aid of Loki, God of Mischief. The Grandmaster issues a challenge for nothing more than the ownership of The Contest that was once his.

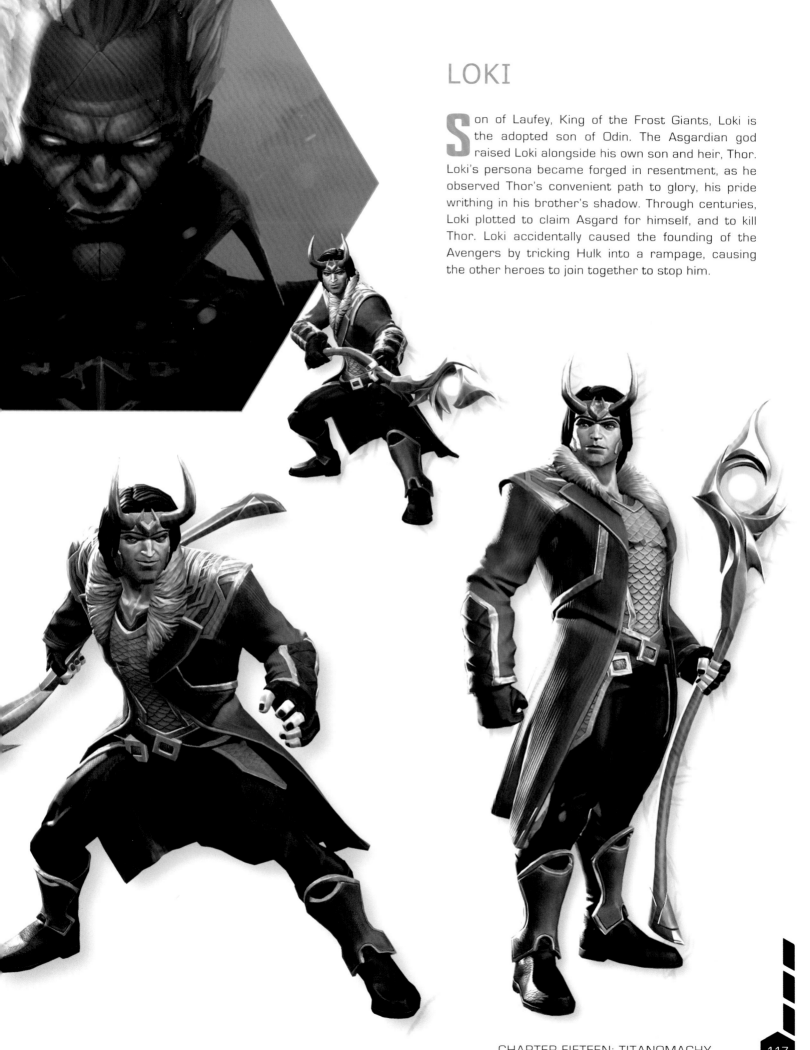

LOKI

Son of Laufey, King of the Frost Giants, Loki is the adopted son of Odin. The Asgardian god raised Loki alongside his own son and heir, Thor. Loki's persona became forged in resentment, as he observed Thor's convenient path to glory, his pride writhing in his brother's shadow. Through centuries, Loki plotted to claim Asgard for himself, and to kill Thor. Loki accidentally caused the founding of the Avengers by tricking Hulk into a rampage, causing the other heroes to join together to stop him.

PANDEMONIUM RISING

CHAPTER SIXTEEN

The Johnny Blaze summoned by the Grandmaster in The Contest is everything that any Marvel fan could wish for and more. Ghost Rider is one of the most recognizable characters to have stepped off the pages of any comic book. He's so scary-looking that you'd swear he would be one of the bad guys—all part of that anti-hero charm.

With Pandemonium Rising, fans mainly wanted to know if they could ram Ghost Rider's Hellcycle into opponents (which they could). But to conquer him, Summoners needed to contend with his special abilities that included a Penance Stare with its severe debilitating effects, and a power-draining Hellfire Blast.

"Though we definitely took our spiritual cue from the *Marvel vs. Capcom* series—fast-paced, big specials, big *everything*—we also thought it would be more BCG (Battle Card Game), more RPG," says Cuz Parry. "Leveling up your character was going to be the deciding factor. Four years later, there is so much skill involved with the high-end players. We didn't expect Contest to become this skill-based fighting game at all."

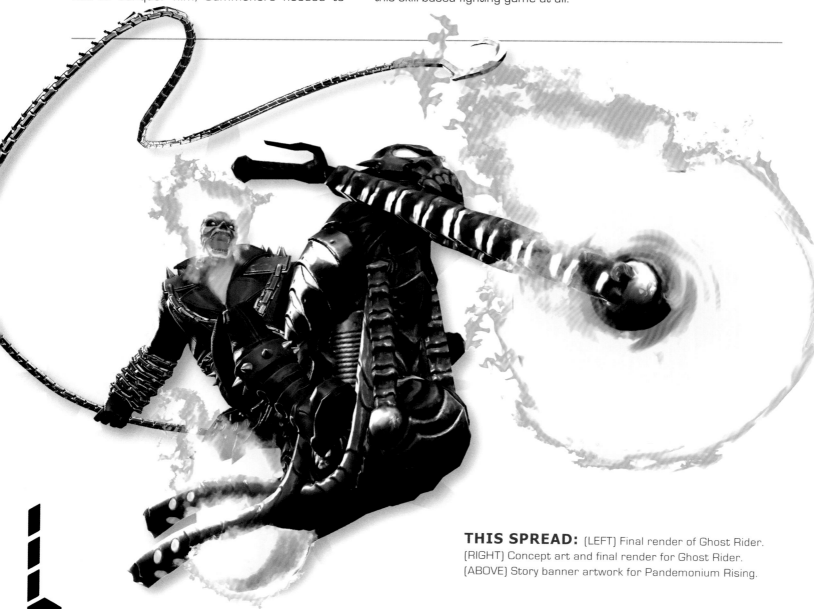

THIS SPREAD: (LEFT) Final render of Ghost Rider. (RIGHT) Concept art and final render for Ghost Rider. (ABOVE) Story banner artwork for Pandemonium Rising.

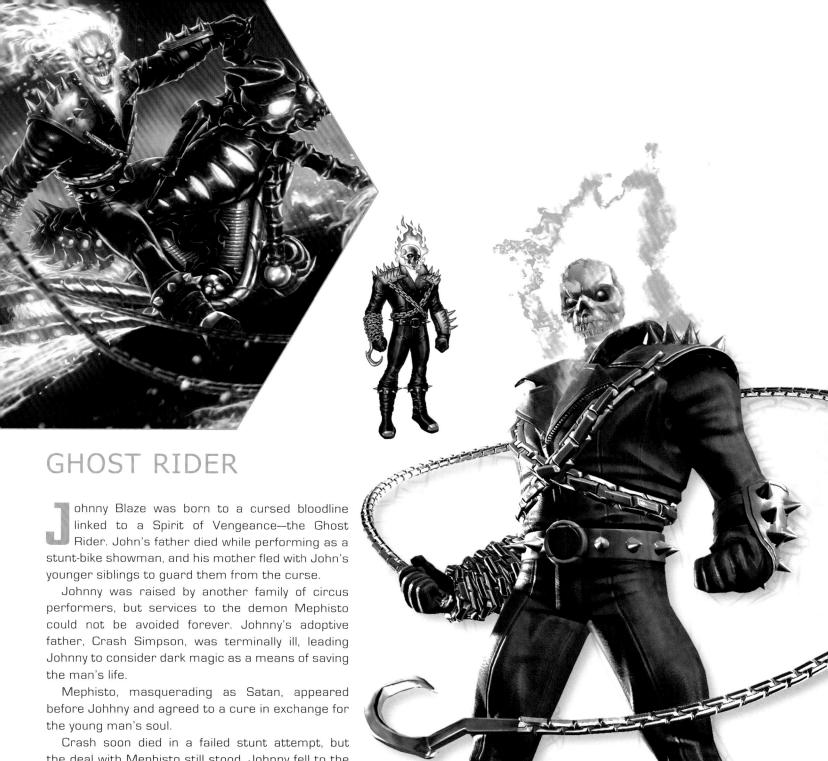

GHOST RIDER

Johnny Blaze was born to a cursed bloodline linked to a Spirit of Vengeance—the Ghost Rider. John's father died while performing as a stunt-bike showman, and his mother fled with John's younger siblings to guard them from the curse.

Johnny was raised by another family of circus performers, but services to the demon Mephisto could not be avoided forever. Johnny's adoptive father, Crash Simpson, was terminally ill, leading Johnny to consider dark magic as a means of saving the man's life.

Mephisto, masquerading as Satan, appeared before Johnny and agreed to a cure in exchange for the young man's soul.

Crash soon died in a failed stunt attempt, but the deal with Mephisto still stood. Johnny fell to the family curse and became Ghost Rider, though a twist of fate allowed him to fight against evil.

Black Widow asks for help from fellow Champion Ghost Rider. He needs to travel to hell to rescue the soul of a little boy trapped by a demon. During his search, Ghost Rider battles his way through strange creatures and shapeshifters posing as heroes. Until he realizes he's been tricked by the Grandmaster to fight real heroes—not in hell but in the Battlerealm!

SORCERER'S CONCLAVE

CHAPTER SEVENTEEN

Kabam is always careful to have a story reason behind every new character's introduction to The Contest. One great example is Mordo, whose guise was influenced by his appearance in Marvel Studios' *Doctor Strange*. The reason the Collector found Mordo appealing is that this ally to the Ancient One posed a serious challenge to Strange.

As Scott Bradford says, "Originally, our monthly Event Quests were a way to continue introducing fresh new content for players and highlight our new characters in interesting ways every month. From a story perspective, they also let us reveal unique aspects about the Battlerealm and The Contest, or set up concurrent narratives throughout the game that pay off in larger events.

"Sorcerer's Conclave is very much the latter, and is all about Doctor Strange's plan to collect Infinity Stones faster than Thanos. Obviously, this is another instance of our *Infinity War* storyline bubbling to the surface, which we would do more frequently as we barrelled towards the Infinity Event. Sorcerer's Conclave was especially important because it established Doctor Strange as the leader of the Illuminati, who would go on to be one of the main opposing forces to Thanos in the *Infinity War* story."

While the Collector has made some improvements to The Contest of Champions, and is eager to test them out, the Sorcerer Supreme has learned of the growing forces of the Mad Titan Thanos at the fringes of the Battlerealm. Doctor Strange enlists the help of the most powerful sorcerers in the Battlerealm to locate Guillotine (who had been kidnapped by Thanos) to uncover his plans. But a traitor among their midst could lead them into a trap.

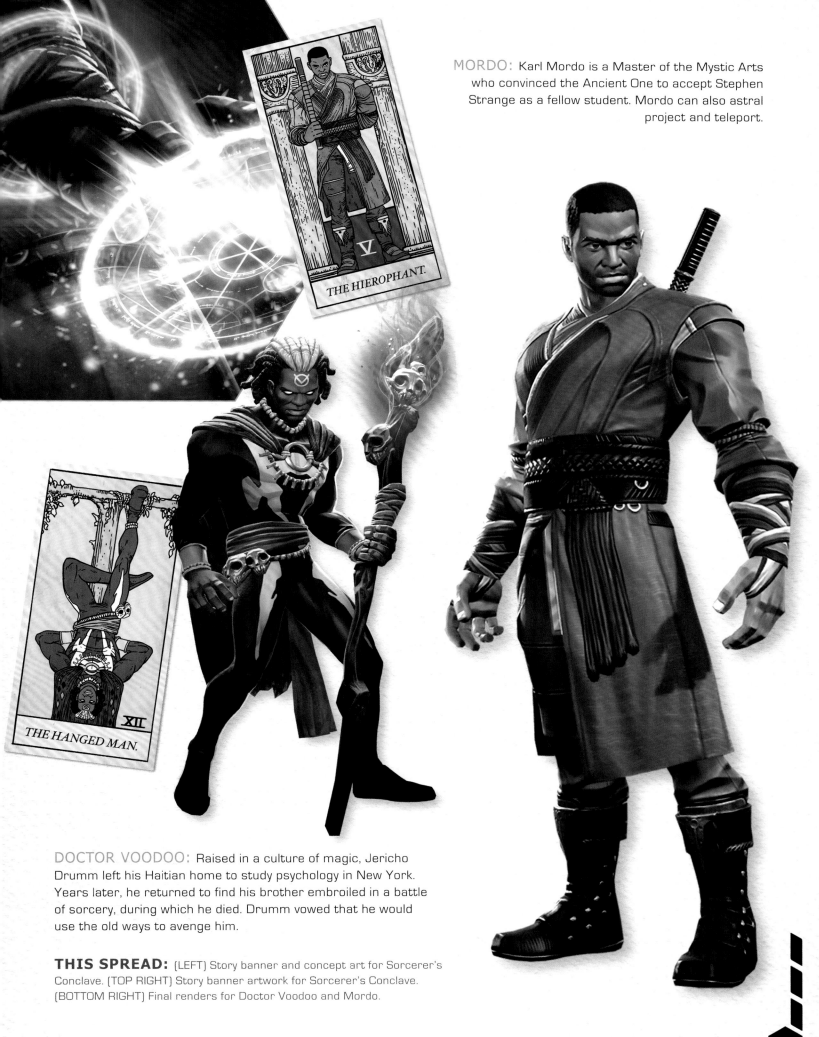

MORDO: Karl Mordo is a Master of the Mystic Arts who convinced the Ancient One to accept Stephen Strange as a fellow student. Mordo can also astral project and teleport.

THE HIEROPHANT.

V

THE HANGED MAN.

XII

DOCTOR VOODOO: Raised in a culture of magic, Jericho Drumm left his Haitian home to study psychology in New York. Years later, he returned to find his brother embroiled in a battle of sorcery, during which he died. Drumm vowed that he would use the old ways to avenge him.

THIS SPREAD: (LEFT) Story banner and concept art for Sorcerer's Conclave. (TOP RIGHT) Story banner artwork for Sorcerer's Conclave. (BOTTOM RIGHT) Final renders for Doctor Voodoo and Mordo.

HOWARD & HYPERION'S HIJINKS

CHAPTER EIGHTEEN

"Ah, Howard the Duck... He's an office favorite for sure; many of us have figures of him adorning our desks," says Scott Bradford. "With Holiday Hijinks, we wanted to tell a story about finding a home for the holidays. This led us to have Howard the Duck (in a mech suit, mind you) and Hyperion romp around the Battlerealm looking for Hyperion's lost home, which they find all but destroyed.

"Not wanting Hyperion to be alone, Howard invites him to enjoy the holidays with him, and they learn that home isn't where your stuff is, it's where your friends are. Isn't that nice? Very often, our holiday quests also try something a little outside the box, and Holiday Hijinks was no different. For example, a couple of quests were completely empty maps, only populated by enemies waiting to ambush the player and Howard. The idea was that everybody had gone home for the holidays, leaving only those who wanted to capture Howard behind."

"I'm pretty sure our initial reaction was something along the lines of, 'Howard in a fighting game?!' to which the reply was, 'just wait and see,'" Tim Hernandez says. "As with Venompool, once we saw the first look at the duck-mech we were reminded never to doubt the creativity and absurd sense of humor of the team. Pairing him with the overpowered Hyperion—who has a much more classic and traditional design—as an odd couple with a touching connection alleviated our skepticism."

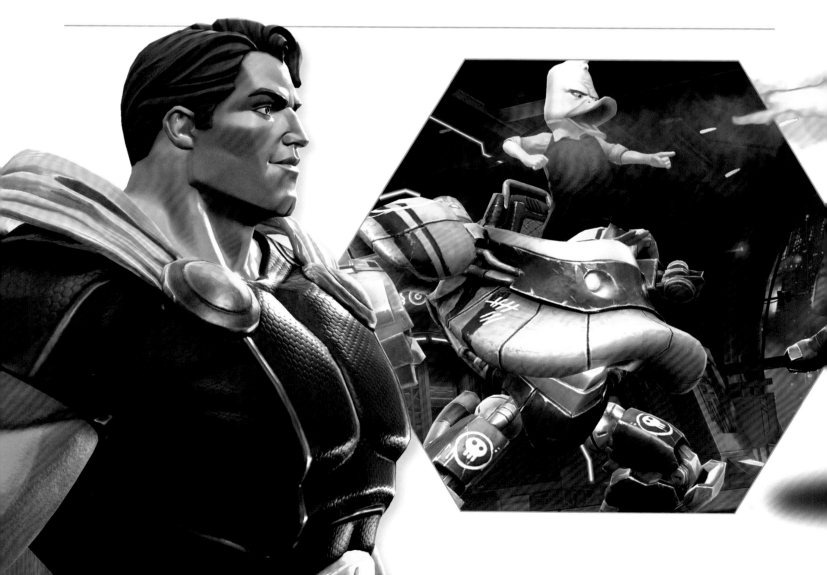

The Holidays have come to The Contest, and all the Champions have been given the month off by the Collector. Well, all the Champions except for Howard the Duck, who's stuck in the Battlerealm without a friend in sight, organizing Crystals all day long. But nobody should be alone during the holidays! A friendly face has come to Howard in need of his indispensable investigative intuition: Hyperion needs Howard's help to go home! It's time to hit the road and help Howard and Hyperion get to the bottom of this cross-dimensional conundrum!

THIS PAGE: (FAR LEFT) Final render of Hyperion. (LEFT & ABOVE) Motion graphic for Howard and Hyperion's Hijinks. (RIGHT) Final render for Howard and his ISO-Loader.

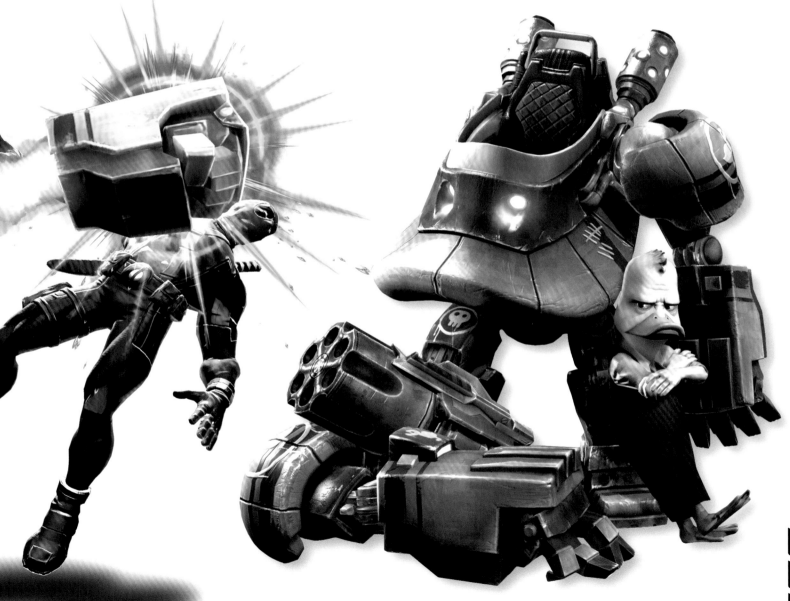

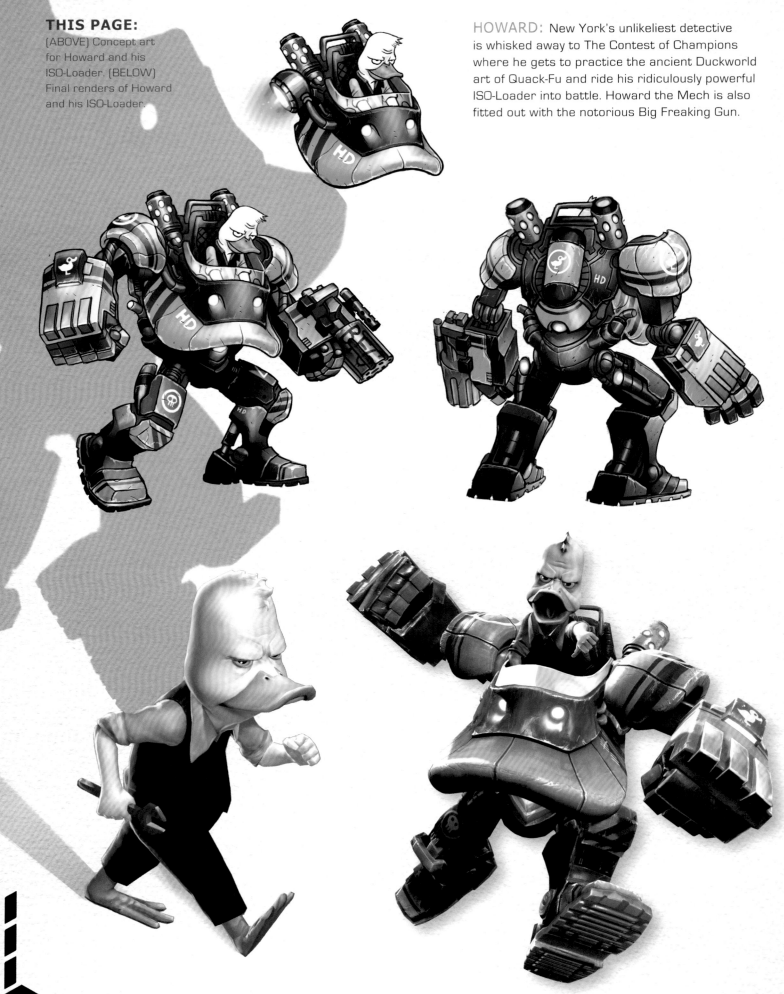

THIS PAGE:
[ABOVE] Concept art for Howard and his ISO-Loader. [BELOW] Final renders of Howard and his ISO-Loader.

HOWARD: New York's unlikeliest detective is whisked away to The Contest of Champions where he gets to practice the ancient Duckworld art of Quack-Fu and ride his ridiculously powerful ISO-Loader into battle. Howard the Mech is also fitted out with the notorious Big Freaking Gun.

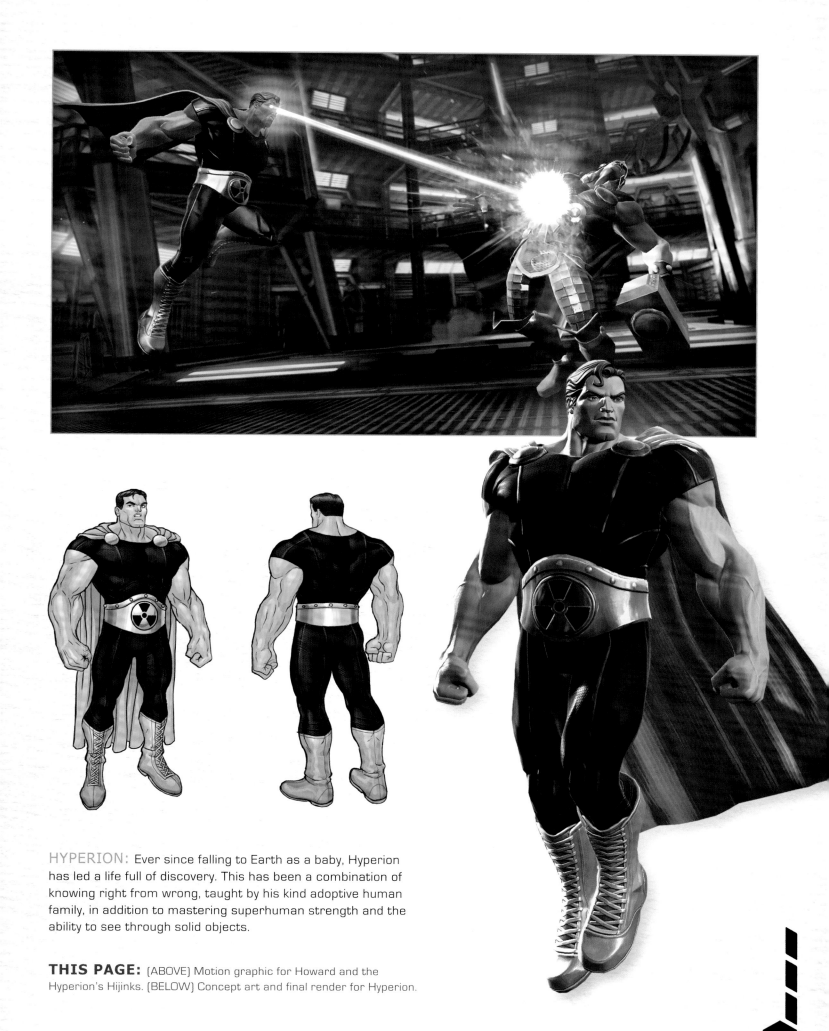

HYPERION: Ever since falling to Earth as a baby, Hyperion has led a life full of discovery. This has been a combination of knowing right from wrong, taught by his kind adoptive human family, in addition to mastering superhuman strength and the ability to see through solid objects.

THIS PAGE: (ABOVE) Motion graphic for Howard and the Hyperion's Hijinks. (BELOW) Concept art and final render for Hyperion.

GWENPOOL: AGENT OF C.A.B.L.E.

CHAPTER NINETEEN

"We always love doing something a little...off kilter," says Scott Bradford. "Gwenpool is one of our favorite characters because she's smart, powerful, and kind of sarcastic. In this storyline, she hops between timelines trying to find the right one to tell the Summoner something—until we find out she just misunderstood Cable's instructions.

"The big revelation from all the time-hopping is that The Contest is essentially an endless time-loop. There's no 'future' or 'past' to travel to at all! The 'time travel' element of the story was reinforced by the repeating map layouts and alternate versions of events. Any time we get to use a character that breaks the fourth wall, we have a lot of fun. Sometimes we'll use it to make pop culture references, and other times we'll use it to make little winks at our players to give those who read our stories a little something extra."

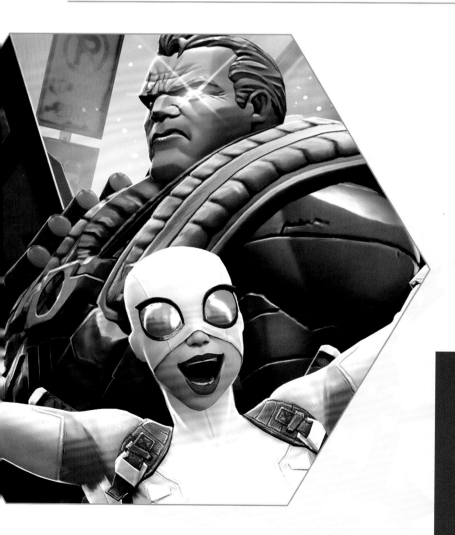

Building on the efforts of Magneto's failed mutant rebellion, a group of humans, mutants, and Inhumans secretly join forces as the Unity Squad to free more heroes from The Contest and find a way home. However, the arrival of time-traveling mutant Cable might drastically change their plans. Deadpool tries to get in there too, but it turns out there's another "Pool" Champion trying to steal his job as Cable's partner: Gwenpool!

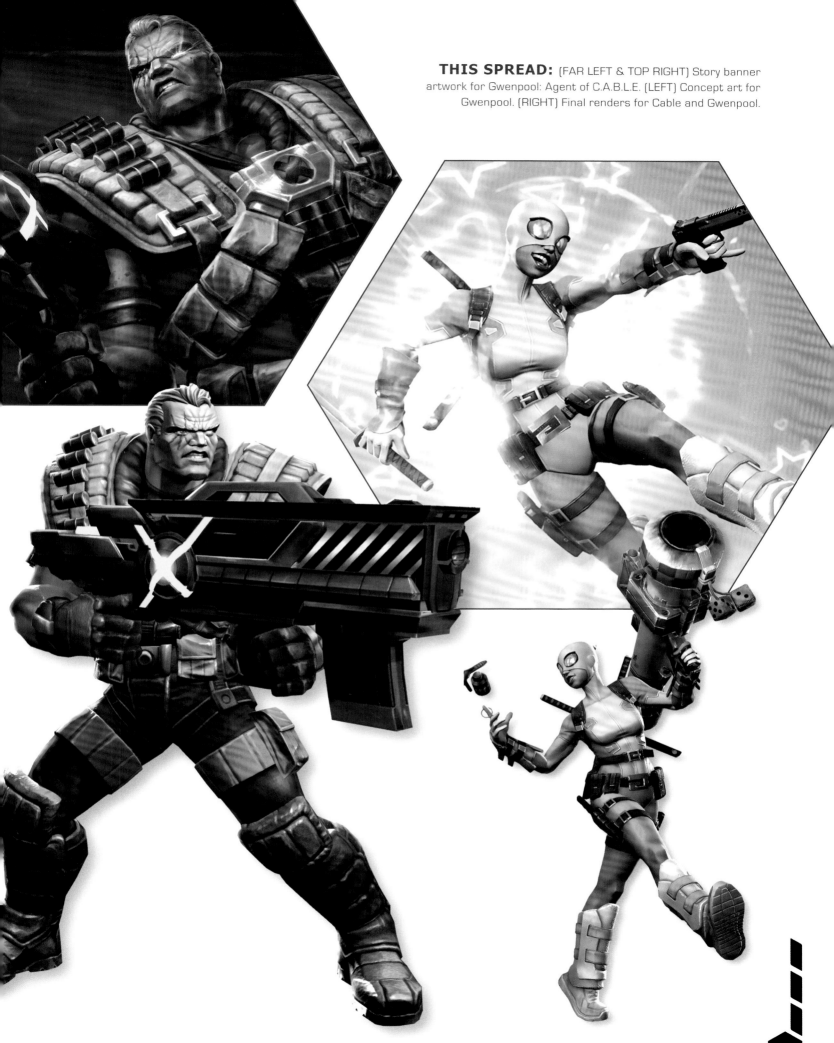

THIS SPREAD: (FAR LEFT & TOP RIGHT) Story banner artwork for Gwenpool: Agent of C.A.B.L.E. (LEFT) Concept art for Gwenpool. (RIGHT) Final renders for Cable and Gwenpool.

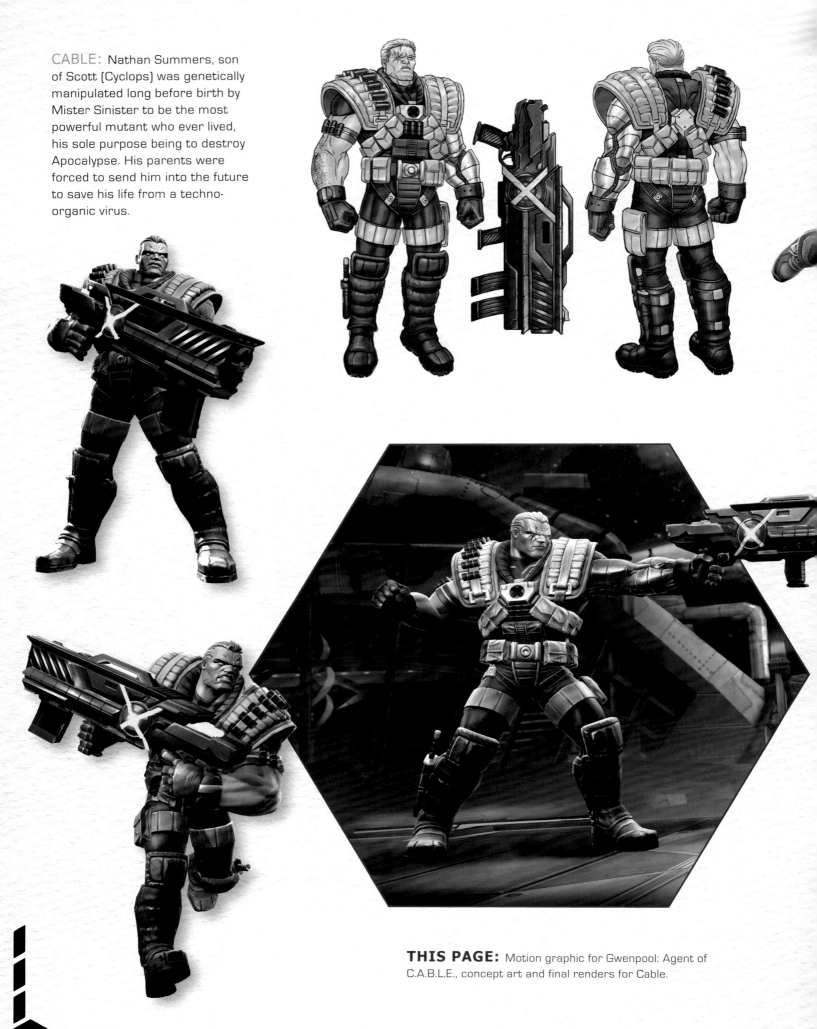

CABLE: Nathan Summers, son of Scott (Cyclops) was genetically manipulated long before birth by Mister Sinister to be the most powerful mutant who ever lived, his sole purpose being to destroy Apocalypse. His parents were forced to send him into the future to save his life from a techno-organic virus.

THIS PAGE: Motion graphic for Gwenpool: Agent of C.A.B.L.E., concept art and final renders for Cable.

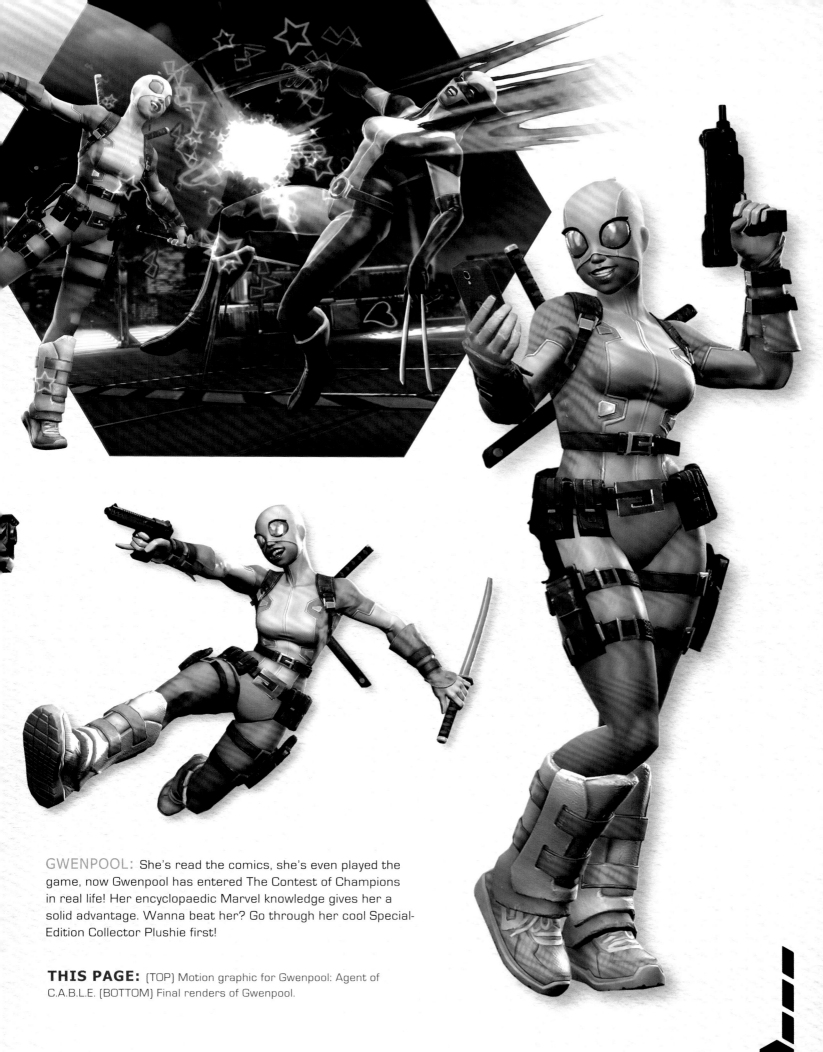

GWENPOOL: She's read the comics, she's even played the game, now Gwenpool has entered The Contest of Champions in real life! Her encyclopaedic Marvel knowledge gives her a solid advantage. Wanna beat her? Go through her cool Special-Edition Collector Plushie first!

THIS PAGE: (TOP) Motion graphic for Gwenpool: Agent of C.A.B.L.E. (BOTTOM) Final renders of Gwenpool.

DAWN OF DARKNESS
CHAPTER TWENTY

Following on from Sorcerer's Conclave a few months earlier at the tail end of 2016, Dawn of Darkness arrived in early 2017 as another mystic event with Doctor Strange. This time, it involved the Illuminati rallying against Thanos in their own enigmatic ways. To achieve this, Strange's most troublesome foes are brought into play: Parker "The Hood" Robbins and Dormammu.

Doctor Strange versus The Hood is a classic Marvel pairing that Kabam ingeniously wove into the Thanos story arc. The Hood is not summoned by the Collector on this occasion, but instead is answering the call of his master Dormammu, which of course cannot work out too well for The Hood in the long term. There are similarities here to when Dormammu granted Baron Mordo superior power in order to confront Strange on the entity's behalf.

The set-up in *Marvel Contest of Champions* is especially interesting, since Dormammu has sworn never to menace planet Earth, but such restrictions do not apply to the Battlerealm. And to make things harder for Doctor Strange, Dormammu can resurrect non-robot villain Champions after they have been knocked out of a fight. As a player, we sense Doctor Strange's mounting frustration throughout combat.

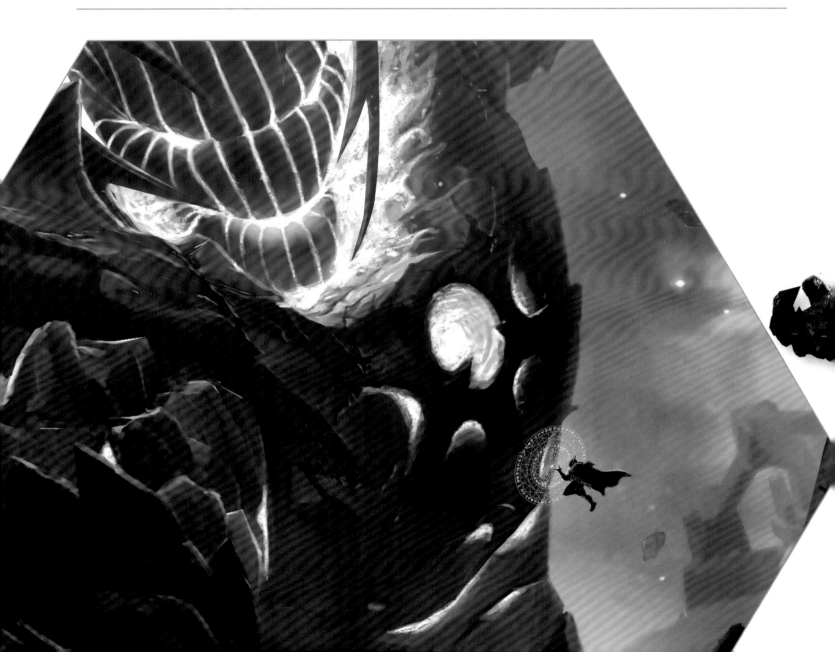

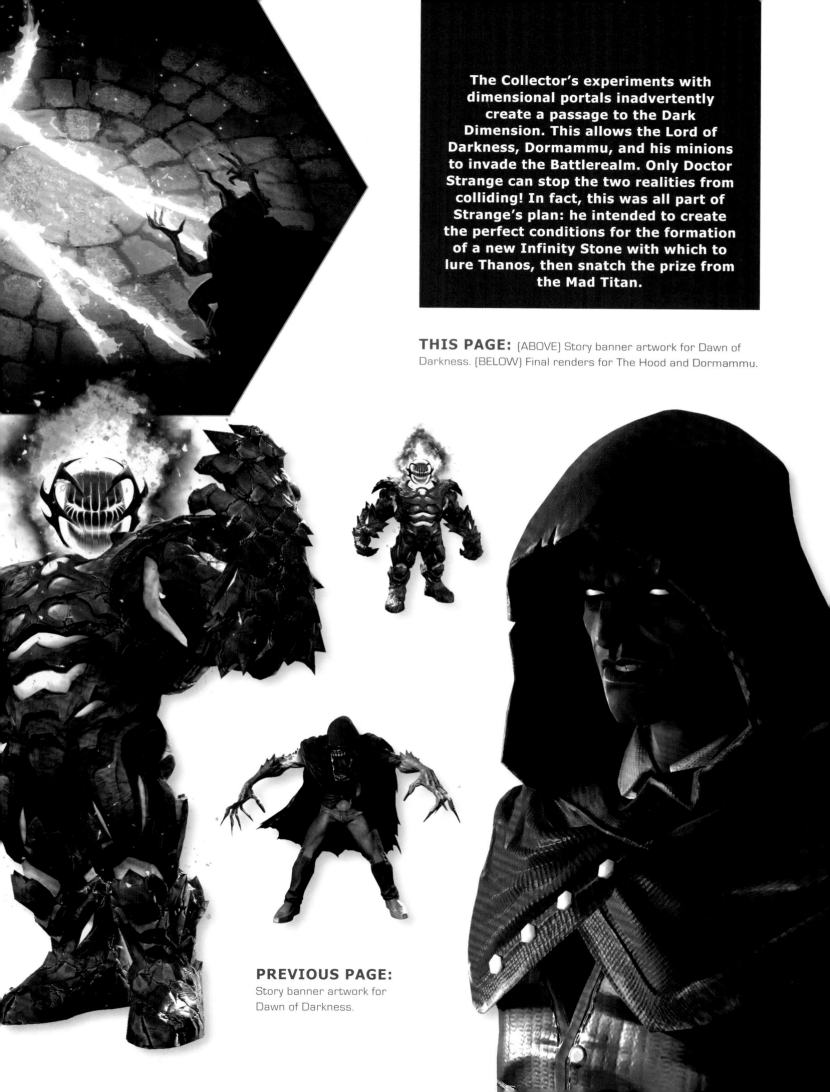

The Collector's experiments with dimensional portals inadvertently create a passage to the Dark Dimension. This allows the Lord of Darkness, Dormammu, and his minions to invade the Battlerealm. Only Doctor Strange can stop the two realities from colliding! In fact, this was all part of Strange's plan: he intended to create the perfect conditions for the formation of a new Infinity Stone with which to lure Thanos, then snatch the prize from the Mad Titan.

THIS PAGE: [ABOVE] Story banner artwork for Dawn of Darkness. [BELOW] Final renders for The Hood and Dormammu.

PREVIOUS PAGE:
Story banner artwork for Dawn of Darkness.

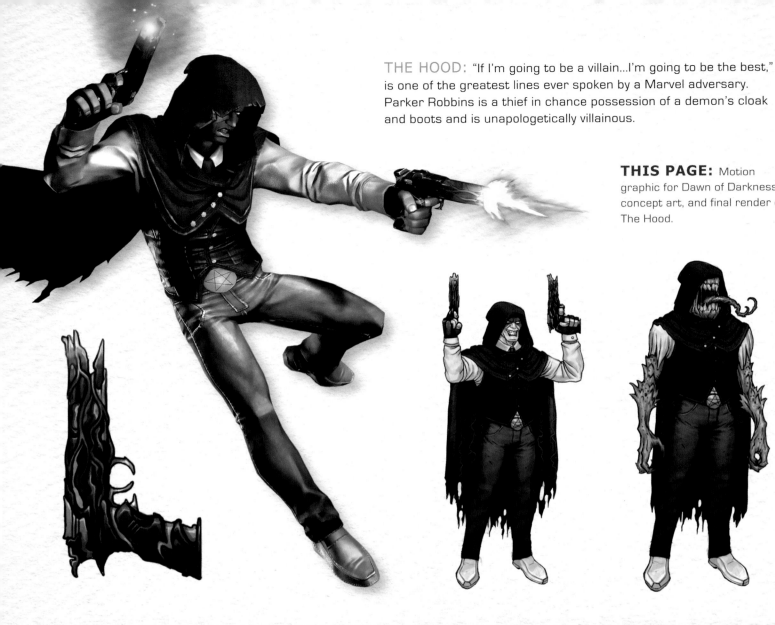

THE HOOD: "If I'm going to be a villain...I'm going to be the best," is one of the greatest lines ever spoken by a Marvel adversary. Parker Robbins is a thief in chance possession of a demon's cloak and boots and is unapologetically villainous.

THIS PAGE: Motion graphic for Dawn of Darkness, concept art, and final render of The Hood.

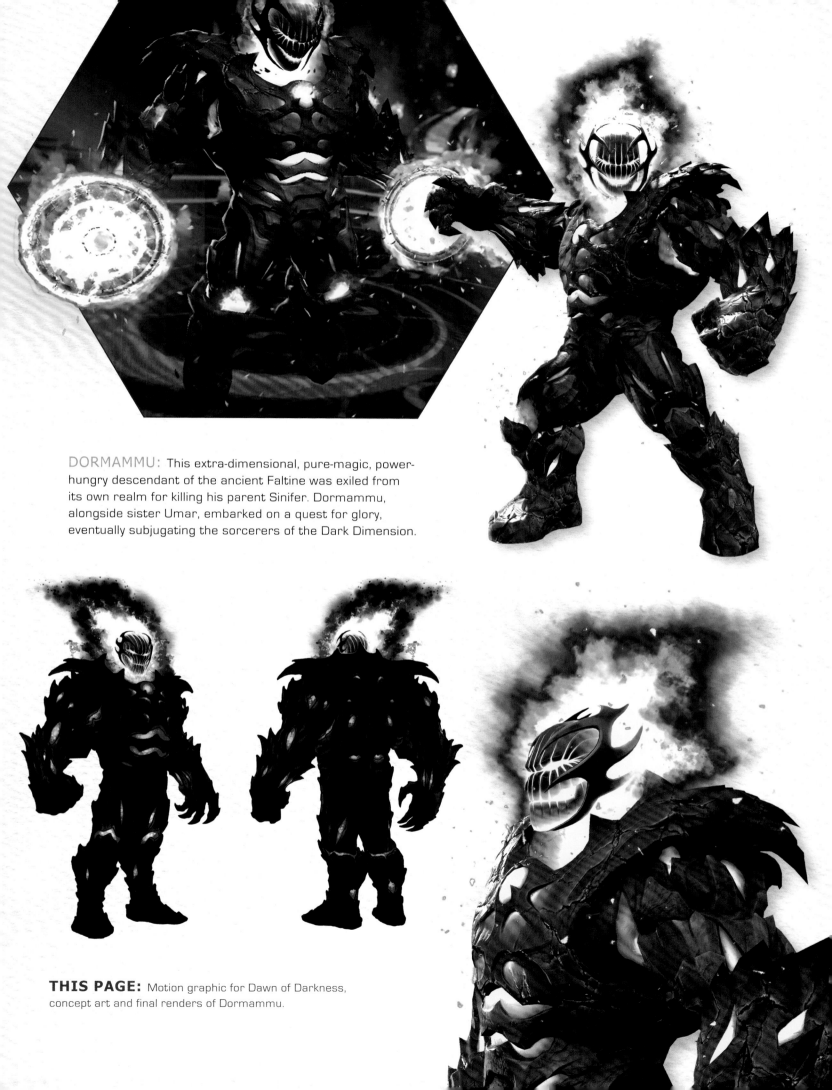

DORMAMMU: This extra-dimensional, pure-magic, power-hungry descendant of the ancient Faltine was exiled from its own realm for killing his parent Sinifer. Dormammu, alongside sister Umar, embarked on a quest for glory, eventually subjugating the sorcerers of the Dark Dimension.

THIS PAGE: Motion graphic for Dawn of Darkness, concept art and final renders of Dormammu.

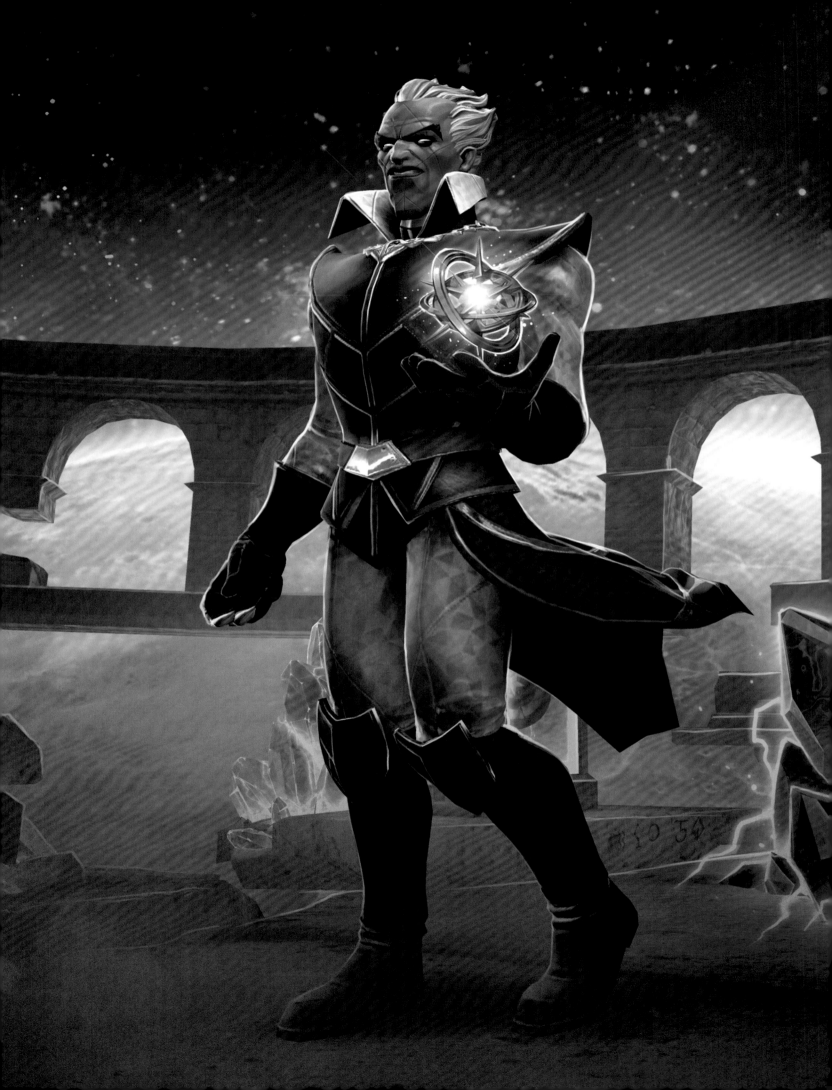

ACT
05

ELDER'S WAR
CHAPTER TWENTY-ONE

In Act 5, the Grandmaster returns to the Battlerealm, intent on destroying his 'brother,' the Collector. True to form, the Grandmaster makes a game out of this duel, suggesting a contest within The Contest—to create the best Summoner's Quest.

Humor has been an important part of the Kabam team's stories throughout The Contest, but The Elder's War takes a surprisingly darker turn. Summoners truly feel as though they are being played somehow, suspicious of the Grandmaster's gambit to discredit the Collector. With loyalties torn, it appears as if the Battlerealm is equally unsettled, providing a visual theme to support the narrative.

In truth, the shift in perception is due to the Grandmaster siphoning power from the ISO-Sphere. Summoners are forced to tread a deceitful path, climaxing in the Collector's defeat. For the audience, this has been a momentous ride, bringing their own morals into question.

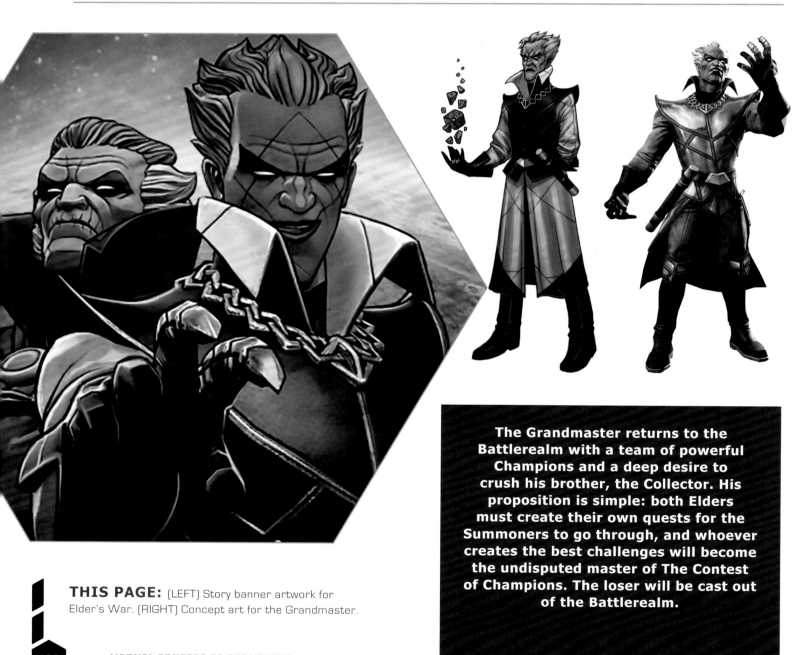

> The Grandmaster returns to the Battlerealm with a team of powerful Champions and a deep desire to crush his brother, the Collector. His proposition is simple: both Elders must create their own quests for the Summoners to go through, and whoever creates the best challenges will become the undisputed master of The Contest of Champions. The loser will be cast out of the Battlerealm.

THIS PAGE: (LEFT) Story banner artwork for Elder's War. (RIGHT) Concept art for the Grandmaster.

THE GRANDMASTER

Before *Marvel Contest of Champions*, the relationship between the Collector and his estranged brother, the Grandmaster was largely unexplored. What we did know about the Grandmaster, however, is that he adores games of all kinds, scouring the known universe for any form of amusement from countless civilizations across untold millennia.

As an Elder of the Universe—a descendant of the most ancient race in all creation—the cosmic gamesman is virtually immortal. Since his ancestors no longer exist, with all traces of them vanished after his native galaxy died, the Grandmaster became obsessed with mastering seemingly trivial pastimes that he evolved into his own aggrandized, high-stakes tournaments.

Inspiration for *Contest of Champions* surely came from the Grandmaster's early forays into competition, included pitching an alternate universe Squadron Supreme against the Scarlet Centurion's Institute of Evil. This led to the formation of the Squadron Sinister, which the Grandmaster took to fight Kang the Conqueror and his (superior) Champions, the Avengers.

The Grandmaster's greatest trial was the game against Death, to earn back the life of the Collector, unable to perform this compassionate act himself. He sacrificed himself to win.

THIS PAGE: [ABOVE] Elders' Language. (RIGHT) Final render of the Grandmaster.

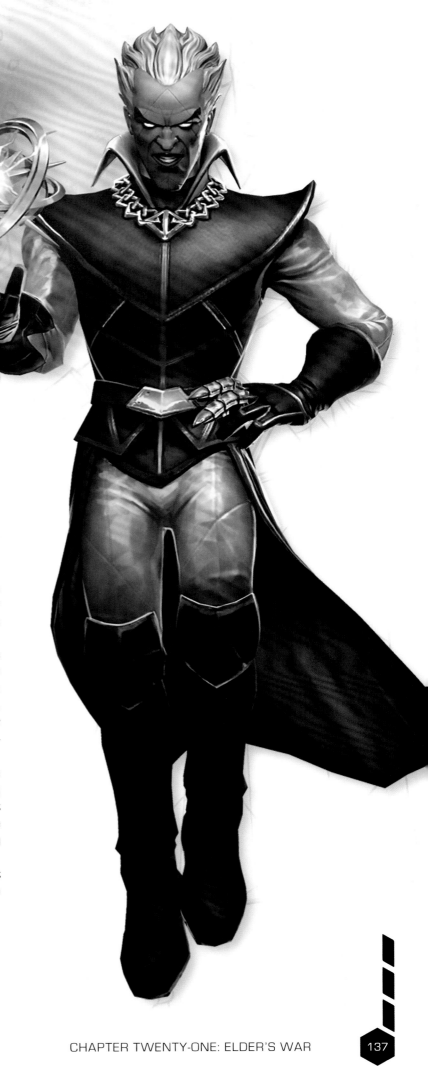

X-ENFORCERS
CHAPTER TWENTY-TWO

Many factors contribute to the introduction of a new Champion. In the case of Psylocke, she was arguably long overdue an appearance in the eyes of *Marvel Contest of Champions* fans and was also the ideal tactical choice for the Grandmaster, who was seeking to get inside his brother's thoughts. That Psylocke was not currently linked to anything from Marvel Studios or TV gave the artists freedom to generate an original, though classic, look.

"After the events of the Terrigenesis Saga, the threat of Omega-Level mutants subsided, but the tension that the mutant conflict created was never really resolved," says Scott Bradford. "Unlike a lot of other stories, this event was a little more contained, which can often be a blessing. Because the X-Enforcers didn't need to set any other event up, or make explicit references to other storylines, we were able to really focus on the emergence of Iceman and the dynamic between the X-Men and a new mutant team: the X-Enforcers, led by Magneto. Having Iceman as the point around which a philosophical debate about mutantkind's future and purpose was a useful framing device for us. Plus, having Iceman and Deadpool in the same event let us make some cheeky references to a popular animated film..."

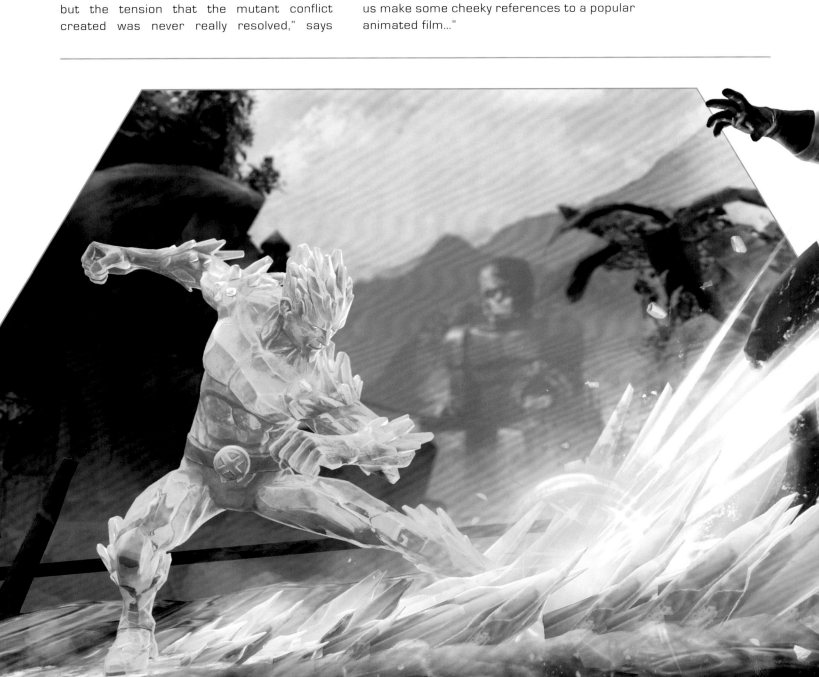

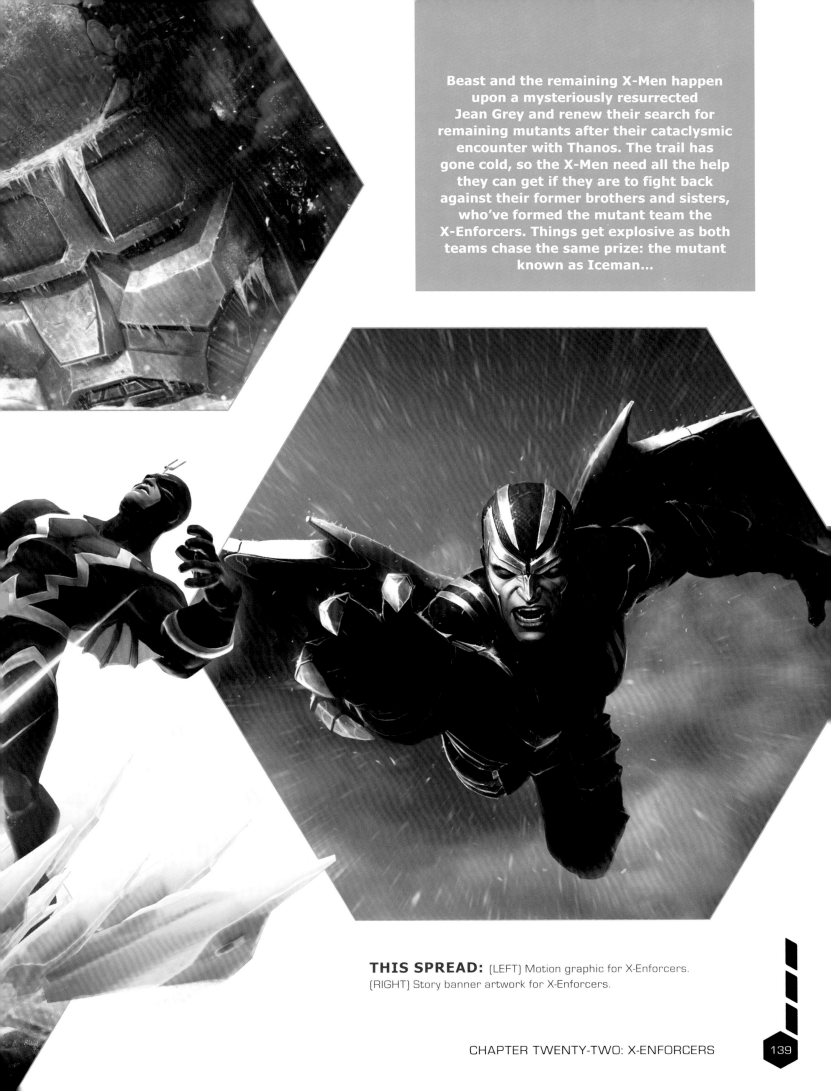

Beast and the remaining X-Men happen upon a mysteriously resurrected Jean Grey and renew their search for remaining mutants after their cataclysmic encounter with Thanos. The trail has gone cold, so the X-Men need all the help they can get if they are to fight back against their former brothers and sisters, who've formed the mutant team the X-Enforcers. Things get explosive as both teams chase the same prize: the mutant known as Iceman...

THIS SPREAD: [LEFT] Motion graphic for X-Enforcers. [RIGHT] Story banner artwork for X-Enforcers.

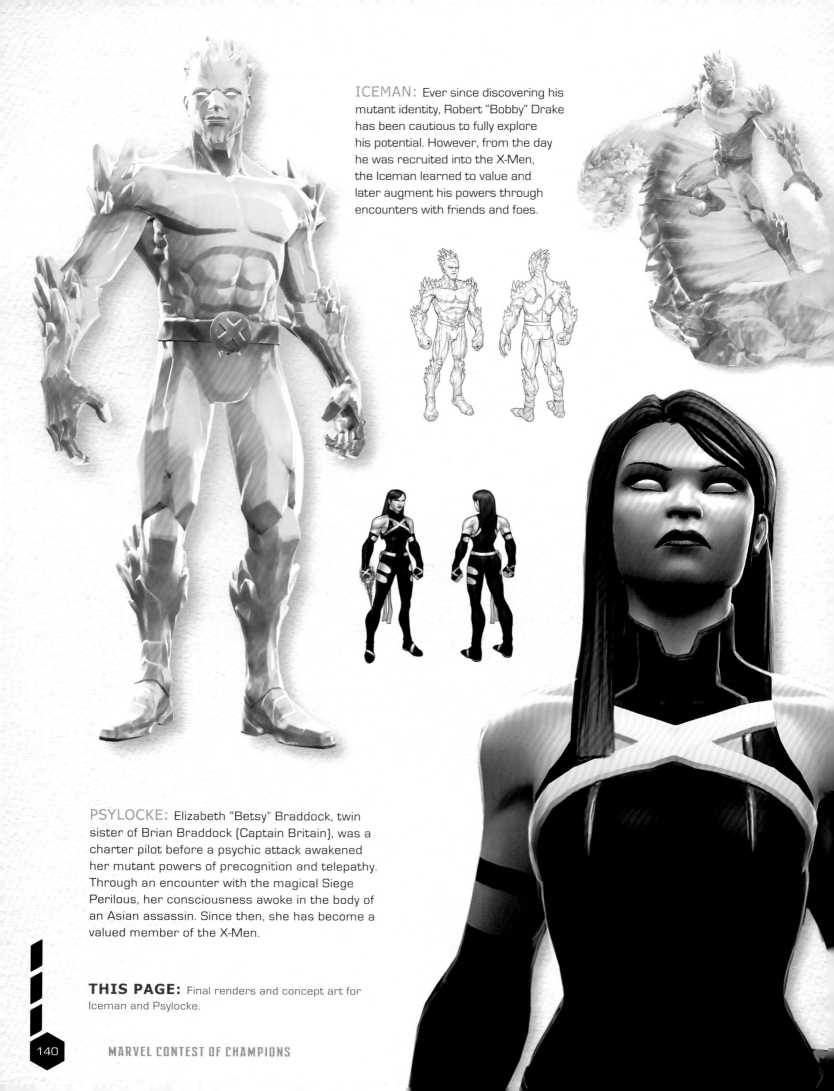

ICEMAN: Ever since discovering his mutant identity, Robert "Bobby" Drake has been cautious to fully explore his potential. However, from the day he was recruited into the X-Men, the Iceman learned to value and later augment his powers through encounters with friends and foes.

PSYLOCKE: Elizabeth "Betsy" Braddock, twin sister of Brian Braddock (Captain Britain), was a charter pilot before a psychic attack awakened her mutant powers of precognition and telepathy. Through an encounter with the magical Siege Perilous, her consciousness awoke in the body of an Asian assassin. Since then, she has become a valued member of the X-Men.

THIS PAGE: Final renders and concept art for Iceman and Psylocke.

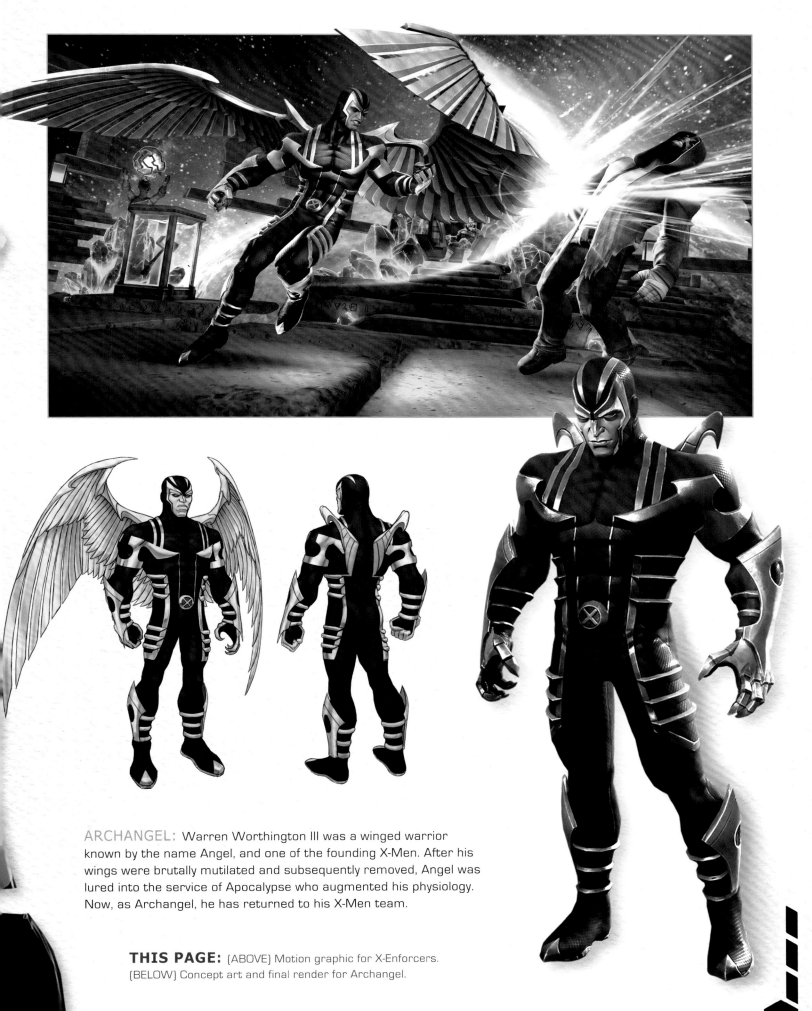

ARCHANGEL: Warren Worthington III was a winged warrior known by the name Angel, and one of the founding X-Men. After his wings were brutally mutilated and subsequently removed, Angel was lured into the service of Apocalypse who augmented his physiology. Now, as Archangel, he has returned to his X-Men team.

THIS PAGE: (ABOVE) Motion graphic for X-Enforcers. (BELOW) Concept art and final render for Archangel.

KING GROOT'S LOOT
CHAPTER TWENTY-THREE

Tim Hernandez took a special shine to King Groot. "Gabriel and the team know their Marvel history inside and out, and honoring Groot's origin—as the monster from Planet X in *Tales to Astonish* from the 60s—was a fantastic homage to Stan Lee, Jack Kirby, and Larry Lieber. They gave him a bit of a modern day makeover so he could compete with other Champions and play differently from the more familiar Groot. This Groot is all about causing damage!"

The King Groot's Loot event is a classic fantasy-style dungeon quest set in the Battlerealm. Scott Bradford elaborates on what makes the storytelling element of *Marvel Contest of Champions* so important. "Working with people at Marvel like Bill Rosemann or Tim Hernandez is incredible. They have such a deep knowledge and respect for Marvel characters, and part of their job is to make sure we do right by them, but that also manifests through the freedom they give us to experiment and add to the Marvel mythos in our own unique way. Really, that's the most important part: character.

"There's so many people who play our game that want to experience a story set within this strange patchwork of Marvel Universes, and people like Bill and Tim give us the support to tell these stories with new and existing characters in interesting ways. We're a Marvel game through and through, but we also have our own unique voice."

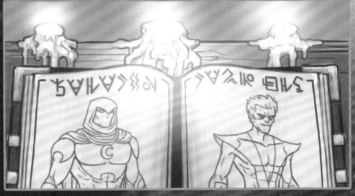
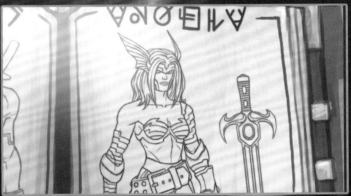

THIS SPREAD: (LEFT) Story banner artwork for King Groot, final render of Angela. (RIGHT) Storyboard for King Groot's Loot.

Groot is being blamed for the evil actions of a mysterious tree monster, so Rocket Raccoon gathers a team of companions (including the Angel Without Wings, Angela) to embark on a journey to uncover the monster's identity, clear his buddy's name, and collect some sweet loot in the process.

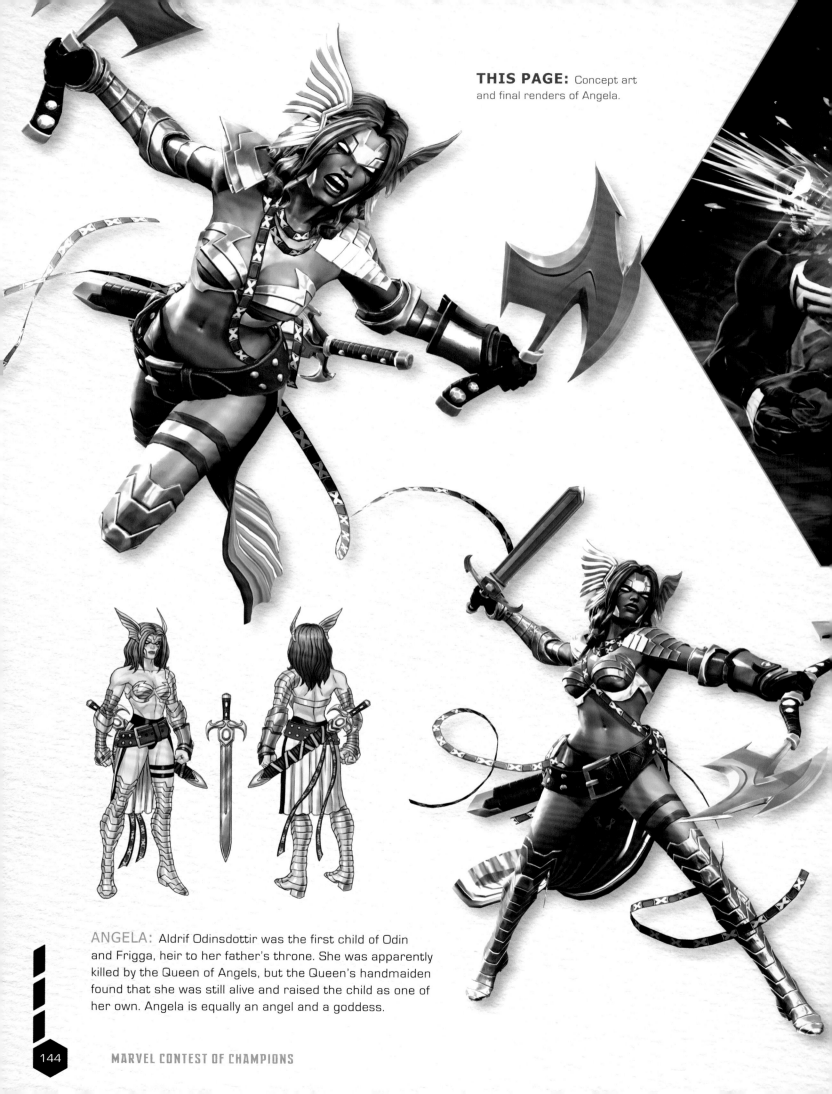

ANGELA: Aldrif Odinsdottir was the first child of Odin and Frigga, heir to her father's throne. She was apparently killed by the Queen of Angels, but the Queen's handmaiden found that she was still alive and raised the child as one of her own. Angela is equally an angel and a goddess.

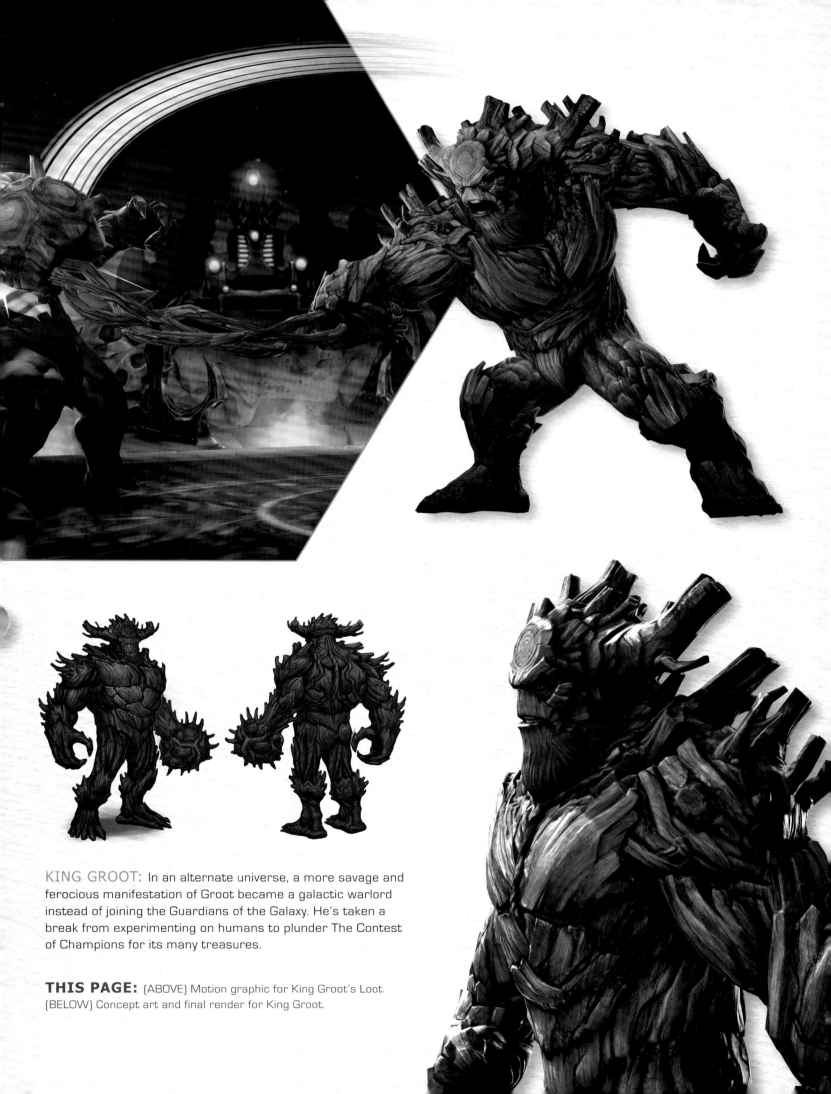

KING GROOT: In an alternate universe, a more savage and ferocious manifestation of Groot became a galactic warlord instead of joining the Guardians of the Galaxy. He's taken a break from experimenting on humans to plunder The Contest of Champions for its many treasures.

THIS PAGE: (ABOVE) Motion graphic for King Groot's Loot. (BELOW) Concept art and final render for King Groot.

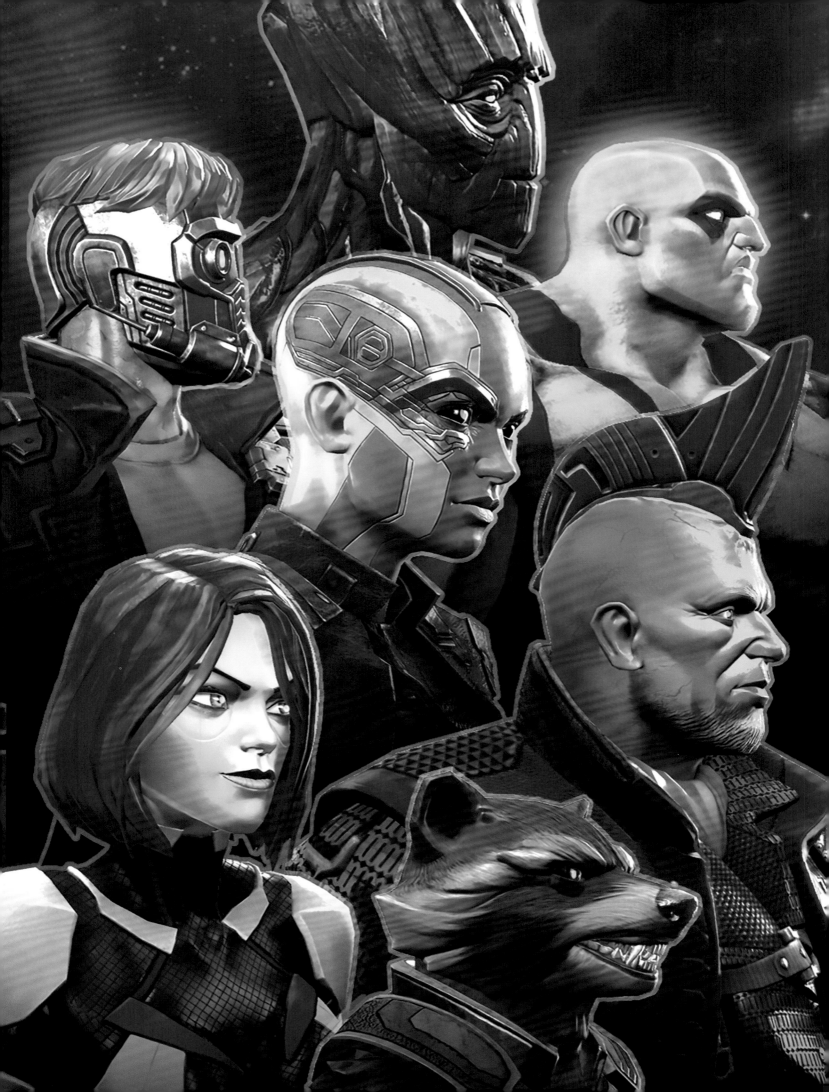

GUARDIANS: VOL. ZERO
CHAPTER TWENTY-FOUR

I n a clip reminiscent of the awesome Nova Corps prison suspects scene from the 2014 *Guardians of the Galaxy* movie, the Guardians: Vol. Zero motion comic sets the tone for the event to come. This, together with the equally irreverent King Groot's Loot, demonstrated how synergy between Kabam and Marvel Games had reached a new peak.

Dominic O'Grady and Scott Bradford are pleased with Kabam's mildly off-kilter Guardians affairs. "We really love the irreverence of Guardians of the Galaxy in the office, so we were super excited to write something like Guardians: Vol. Zero. Like the Guardians films, this Event Quest had a playful attitude that belies the more significant story implications. It continues to set up the events of Infinity War by ending with the Guardians failing to stop the summoning of Thanos. Along the way, we reference other storylines to flesh out their interconnectedness, something we try to do as much as possible to give a sense of cohesion and continuity to our monthly storylines."

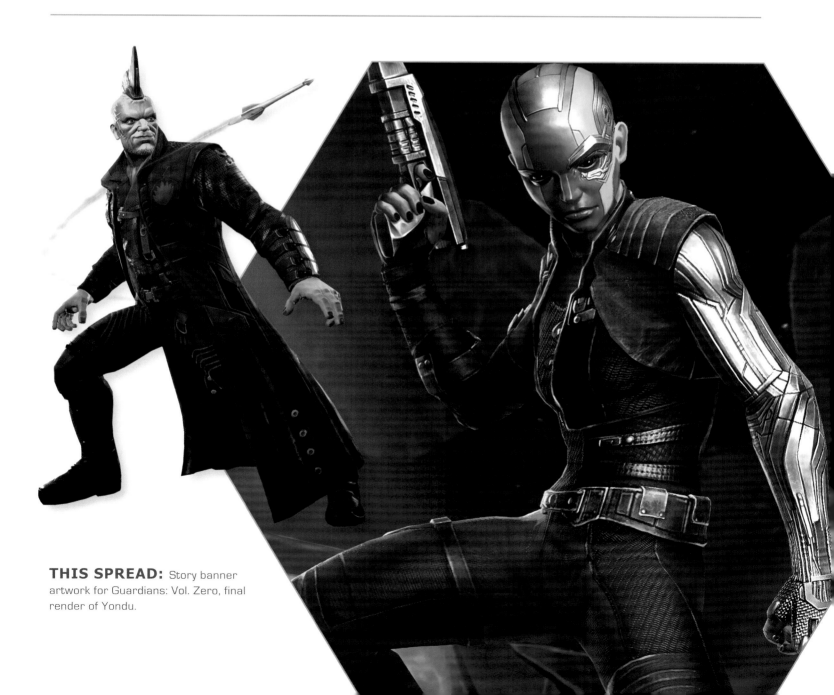

THIS SPREAD: Story banner artwork for Guardians: Vol. Zero, final render of Yondu.

Hired by none other than Kang the Conqueror to locate the wreckage of his ship, the Guardians of the Galaxy end up being transported to the distant year of... 2014. Seeing a chance to alter the past and save The Contest of Champions from the coming of Thanos, they enlist the help of Yondu and Nebula to complete their mission, before they get trapped forever.

NEBULA: Together with her adoptive sister Gamora, the Luphomoid assassin Nebula is one of Thanos' forcibly acquired daughters. She has lost many fights to her sister, and each time Thanos has cybernetically upgraded her to improve superhuman strength, enhanced senses, and auto-repair.

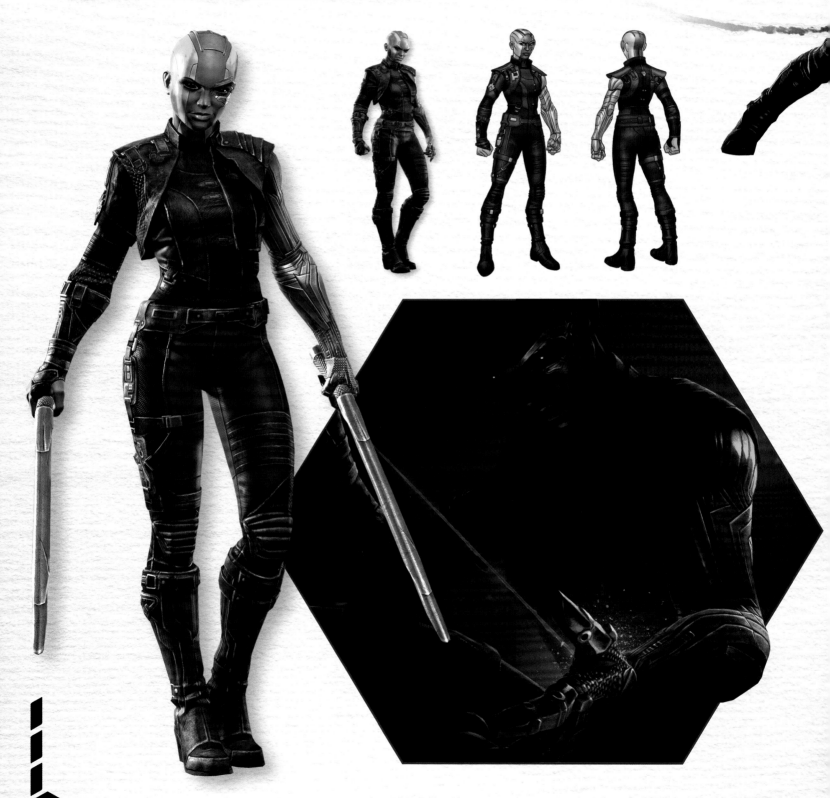

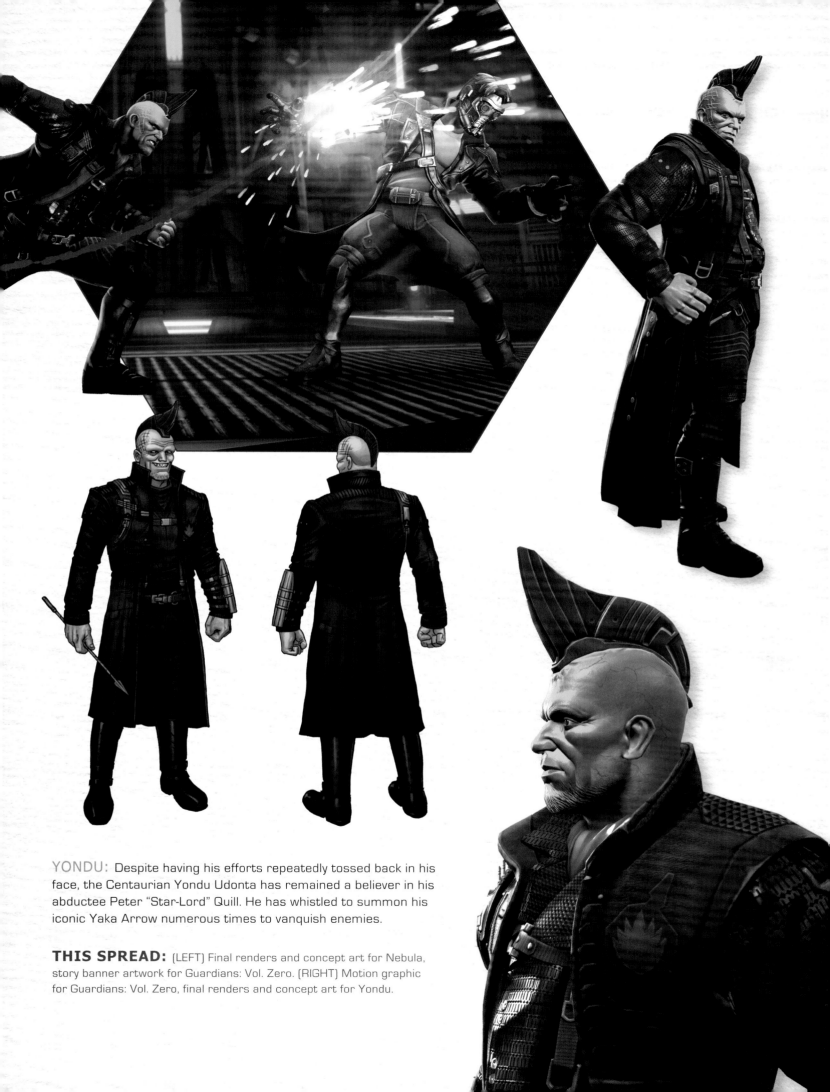

YONDU: Despite having his efforts repeatedly tossed back in his face, the Centaurian Yondu Udonta has remained a believer in his abductee Peter "Star-Lord" Quill. He has whistled to summon his iconic Yaka Arrow numerous times to vanquish enemies.

THIS SPREAD: [LEFT] Final renders and concept art for Nebula, story banner artwork for Guardians: Vol. Zero. [RIGHT] Motion graphic for Guardians: Vol. Zero, final renders and concept art for Yondu.

SECRET EMPIRE FOREVER

CHAPTER TWENTY-FIVE

As the game grew and evolved, designers with many artistic backgrounds began joining the team. This varied experience showed in the arrival of the smoldering duo of Carnage and Punisher 2099. Marvel aficionados knew to expect trouble from these two characters. It was down to Gabriel Frizzera and the studio to deliver on that promise of fireworks.

"The selection of characters has evolved somewhat, we're getting better at it. We have far more designers with far more expertise," explains Cuz Parry. "This comes back to the community discussions: our highest-end meta players found this exploit, or this character is overpowered, or we've found that this combination of characters are unstoppable,

so let's introduce a character that can counter-balance that.

In order to offset the seemingly limitless destruction of Carnage, Kabam needed to produce a suitable adversary. Punisher 2099 was introduced as the final boss in the Carnage-themed event. With psychotic tendencies and a penchant for committing acts of depravity, Carnage and Punisher 2099 became the perfect pair.

As one of the main villains in the *Contest* comic book series it was important for Punisher 2099 to be a force to be reckoned with. Unlike other bosses in the game, fans would be able to play as Punisher 2099, and the ruthless mercenary became the game's 100th playable character.

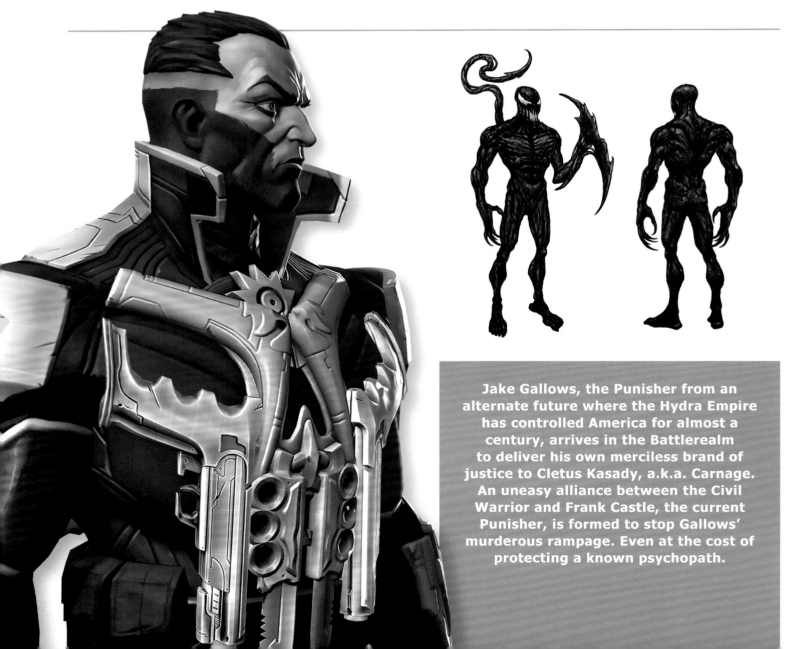

Jake Gallows, the Punisher from an alternate future where the Hydra Empire has controlled America for almost a century, arrives in the Battlerealm to deliver his own merciless brand of justice to Cletus Kasady, a.k.a. Carnage. An uneasy alliance between the Civil Warrior and Frank Castle, the current Punisher, is formed to stop Gallows' murderous rampage. Even at the cost of protecting a known psychopath.

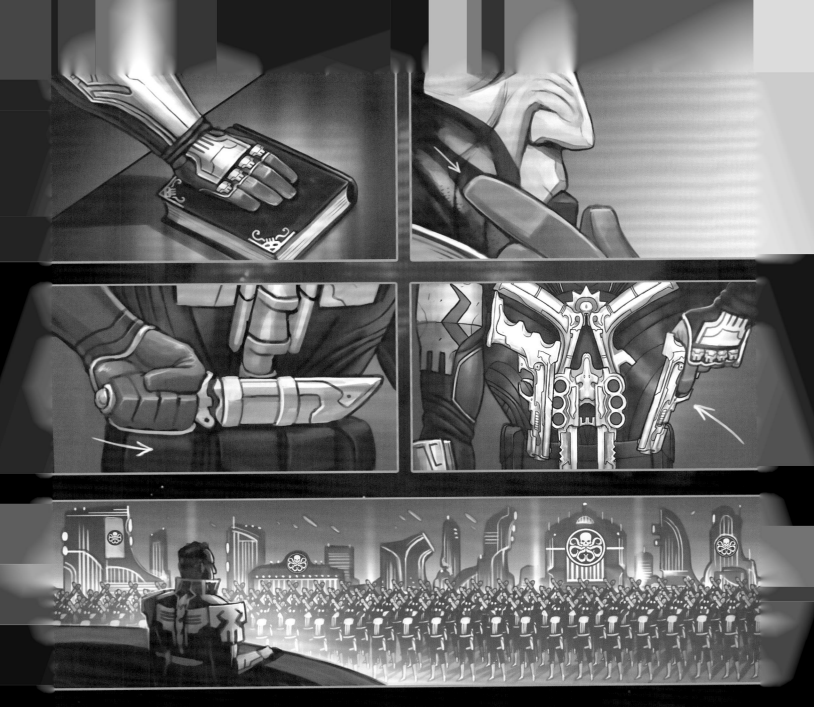

THIS PAGE: Storyboard for Secret Empire Forever.

PREVIOUS PAGE: Final render for the Punisher, concept art for Carnage.

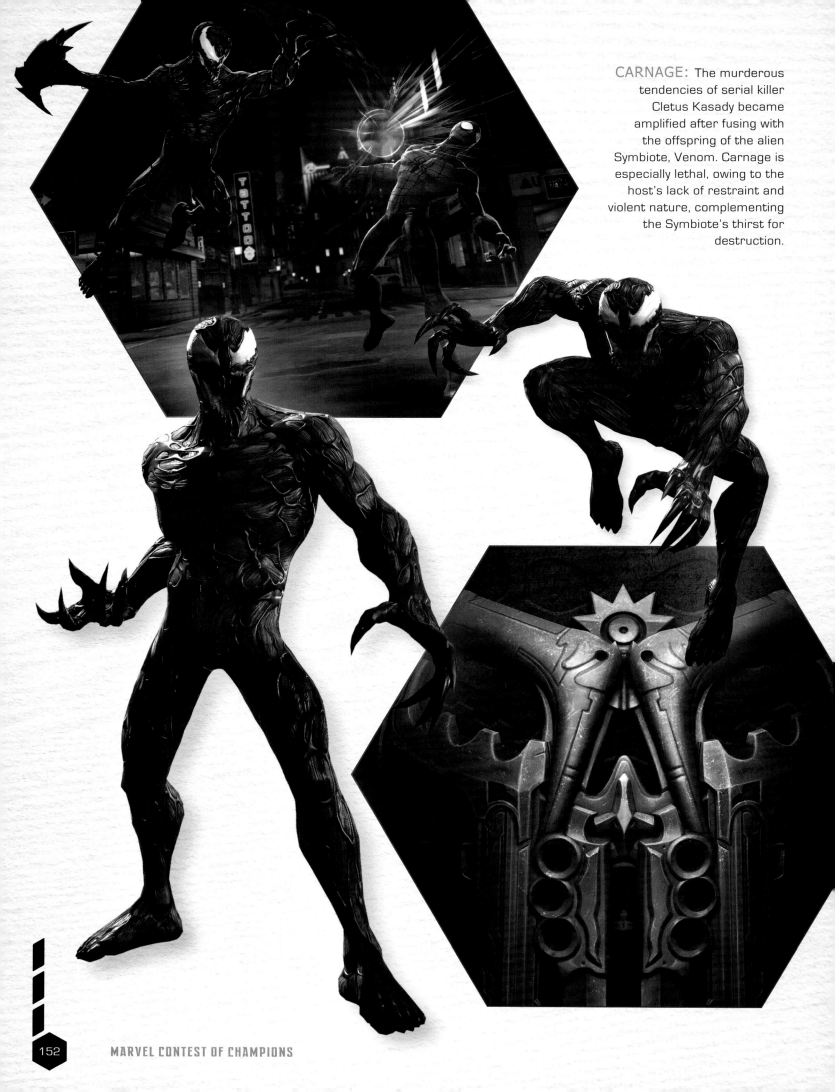

CARNAGE: The murderous tendencies of serial killer Cletus Kasady became amplified after fusing with the offspring of the alien Symbiote, Venom. Carnage is especially lethal, owing to the host's lack of restraint and violent nature, complementing the Symbiote's thirst for destruction.

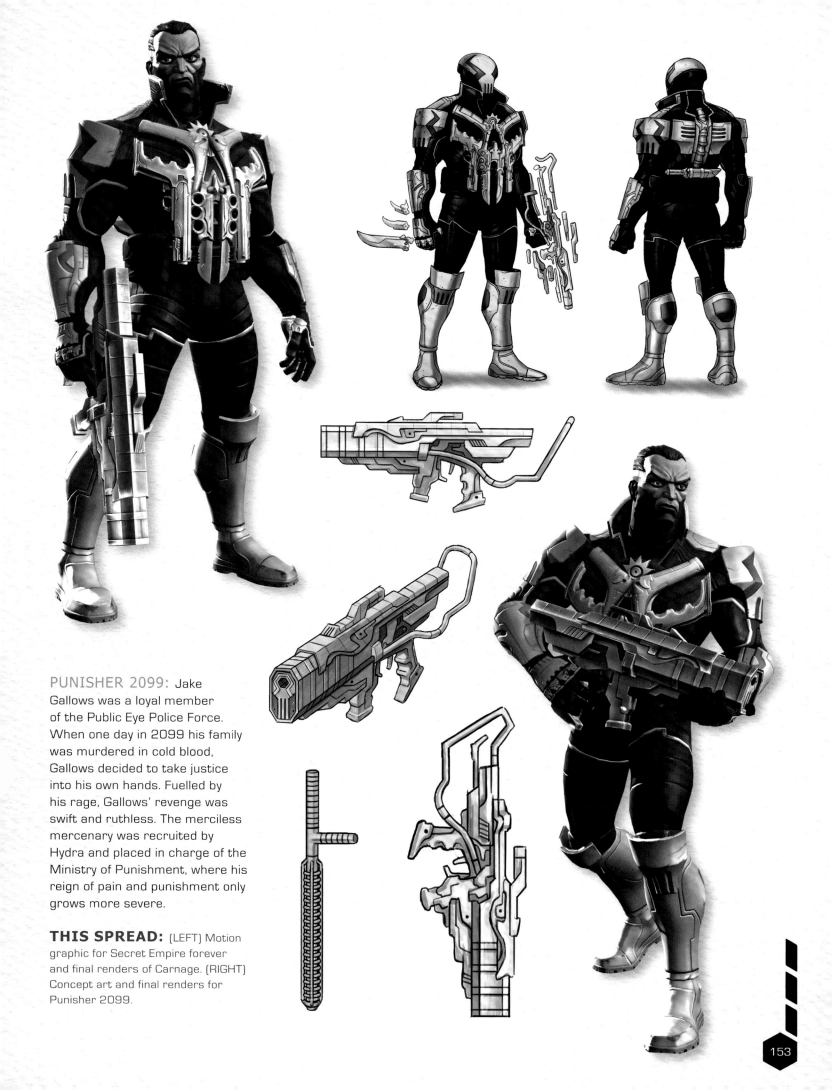

PUNISHER 2099: Jake Gallows was a loyal member of the Public Eye Police Force. When one day in 2099 his family was murdered in cold blood, Gallows decided to take justice into his own hands. Fuelled by his rage, Gallows' revenge was swift and ruthless. The merciless mercenary was recruited by Hydra and placed in charge of the Ministry of Punishment, where his reign of pain and punishment only grows more severe.

THIS SPREAD: (LEFT) Motion graphic for Secret Empire forever and final renders of Carnage. (RIGHT) Concept art and final renders for Punisher 2099.

BATTLEREALM HOMECOMING

CHAPTER TWENTY-SIX

With *Spider-Man: Homecoming* in movie theaters from July 2017, it wasn't hard to predict that everyone would want to road test Peter Parker's new Stark Tech-enhanced suit. Sure enough, it followed that Vulture, with his Chitauri energy core, would be Spidey's adversary. And with Iron Man in his new mentoring role, we were in familiar territory from the get go.

Unlike *Spider-Man: Homecoming*, however, Summoners encountered Joe Fixit as the main source of trouble, working with the Black-ISO Mafia to smuggle something highly suspicious through the Battlerealm. Kabam had captured the essence of the Spidey-Stark relationship without resorting to Battlerealm Homecoming as a straight-up homage to the big screen.

Summoners were tasked with impressing Stark enough to credit Parker with a place among the Avengers; the difference was that we'd need to put a stop to Fixit's shenanigans, whose gang proved more than Spidey bargained for. Vulture, meanwhile, became a Champion that impressed upon first arrival owing to his incredible winged costume that Kabam was able to replicate owing to reference material from Marvel Studios they had received in advance.

To top it all off, everything was tidily wrapped up inside The Contest premise. The Collector's favorite Champion is Spider-Man, which means he absolutely had to own the full Spidey set of villains and allies. The Vulture was bound to appear sometime for the Collector's museum, movie or no movie.

A Stark-enhanced Peter Parker is swept up in the nefarious machinations of the Black-ISO Mafia, the Battlerealm's notorious gang of villains. The villains begin to amass a mysterious power source with the help of the Vulture, leading this new Spider-Man to foil their plans, against the urging of his mentor, Iron Man. With the help of the Summoner, Parker fights to prove his worth to the Avengers and make the Battlerealm safer for everyone.

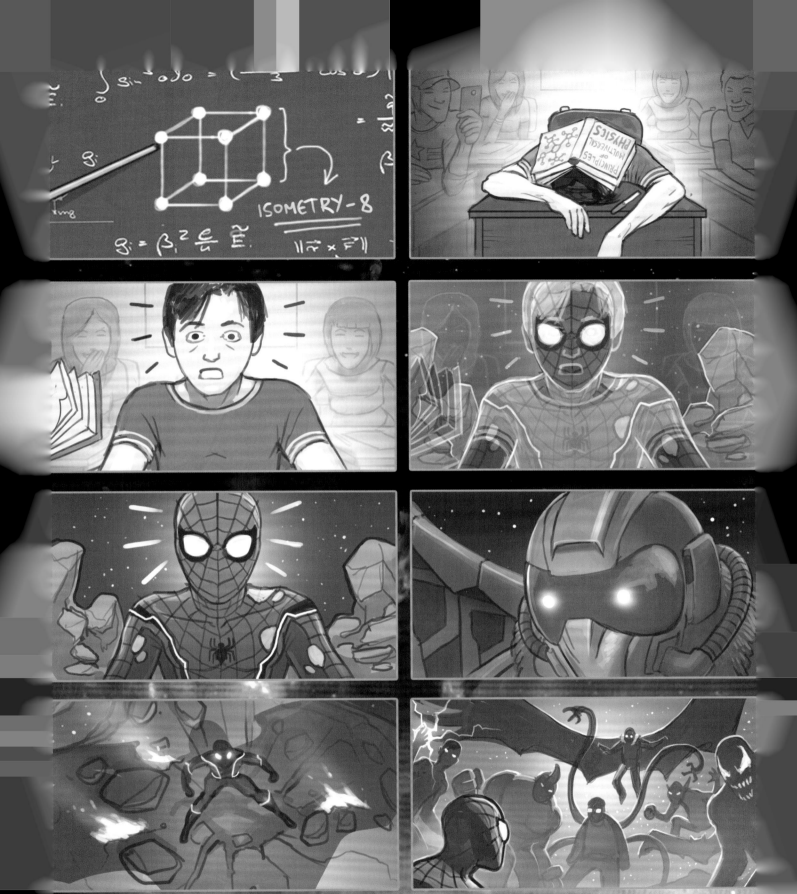

THIS SPREAD: (LEFT) Final artwork for Battlerealm Homecoming. (RIGHT) Storyboard for Battlerealm Homecoming.

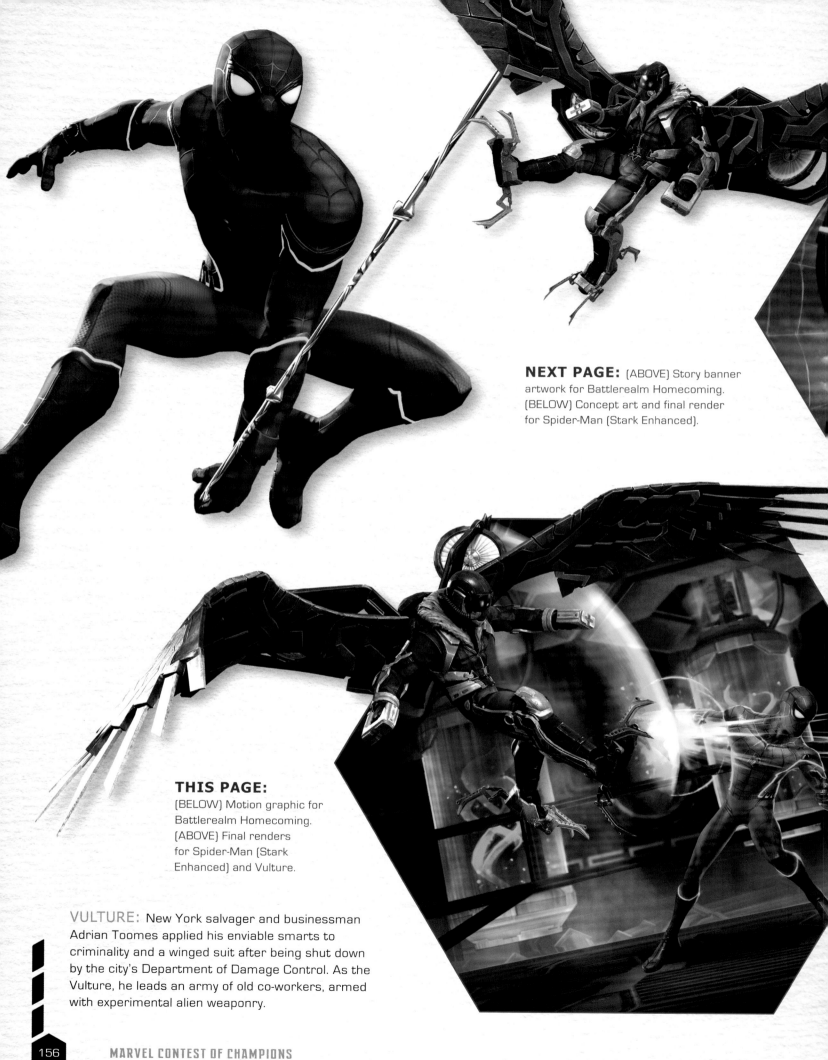

NEXT PAGE: [ABOVE] Story banner artwork for Battlerealm Homecoming. [BELOW] Concept art and final render for Spider-Man (Stark Enhanced).

THIS PAGE:
[BELOW] Motion graphic for Battlerealm Homecoming. [ABOVE] Final renders for Spider-Man (Stark Enhanced) and Vulture.

VULTURE: New York salvager and businessman Adrian Toomes applied his enviable smarts to criminality and a winged suit after being shut down by the city's Department of Damage Control. As the Vulture, he leads an army of old co-workers, armed with experimental alien weaponry.

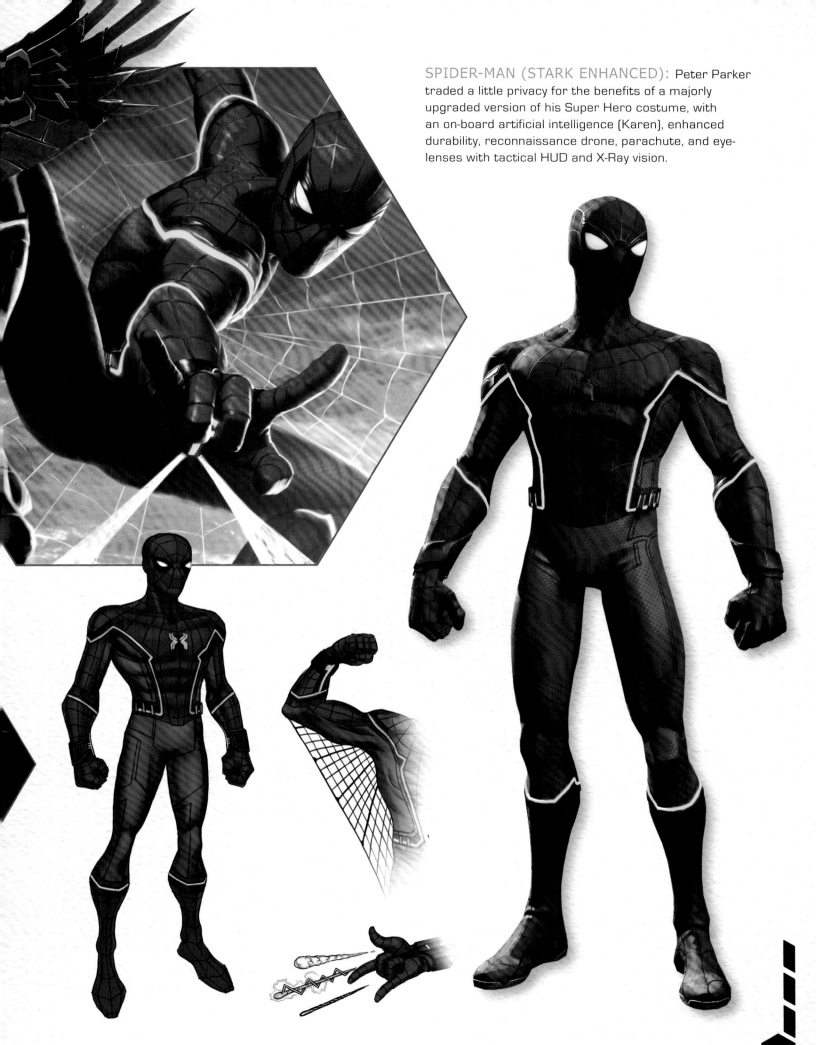

SPIDER-MAN (STARK ENHANCED): Peter Parker traded a little privacy for the benefits of a majorly upgraded version of his Super Hero costume, with an on-board artificial intelligence (Karen), enhanced durability, reconnaissance drone, parachute, and eye-lenses with tactical HUD and X-Ray vision.

SINISTER FOES OF SPIDER-MAN

CHAPTER TWENTY-SEVEN

From the 1960s Silver Age styling of Doctor Octopus to the classic Halloween-inspired Green Goblin, the Sinister Foes update drew from a wide range of influences and passions. Dominic O'Grady and Gabriel Frizzera set about presenting versions of Spider-Man's most feared adversaries as instantly recognizable, although with little details Marvel fans will especially enjoy, such as Doc Ock's pocket pens.

Green Goblin posed a different challenge across the board too, as an always-airborne foe, purely owing to the Kabam team's collective focus on authenticity. Norman Osborn's alter ego has been so often celebrated throughout the Marvel Universe, including movies and earlier videogames, that there was an abundance of reference sources to consult. There have been some enormous talents at the helm of Marvel stories across the decades, and the Kabam team can utilize the skill of their favorite creators in new ways in the game.

"I grew up in the 80s, the so-called 'comic books renaissance,'" says Frizzera. "My favorites are some of the usual suspects: I would have to say Alan Moore, Frank Miller, Grant Morrison, John Byrne, Walt Simonson... and of course Jack Kirby and Stan Lee and John Buscema and all the classics. I also read a lot of European authors like Moebius and Enki Bilal, and plenty of alternative comics from Brazil, which has a seemingly endless roster of talented comic book writers and authors."

THIS SPREAD:
(LEFT) Story banner artwork for Sinister Foes of Spider-Man.
(RIGHT) Final render for King Pin.

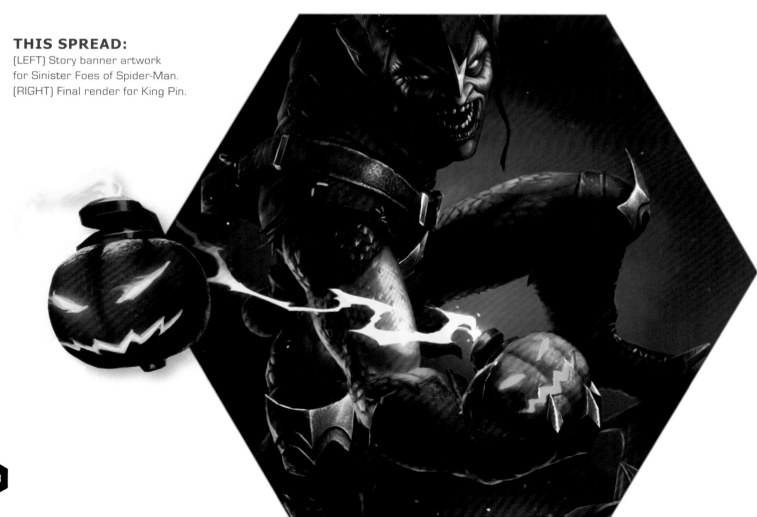

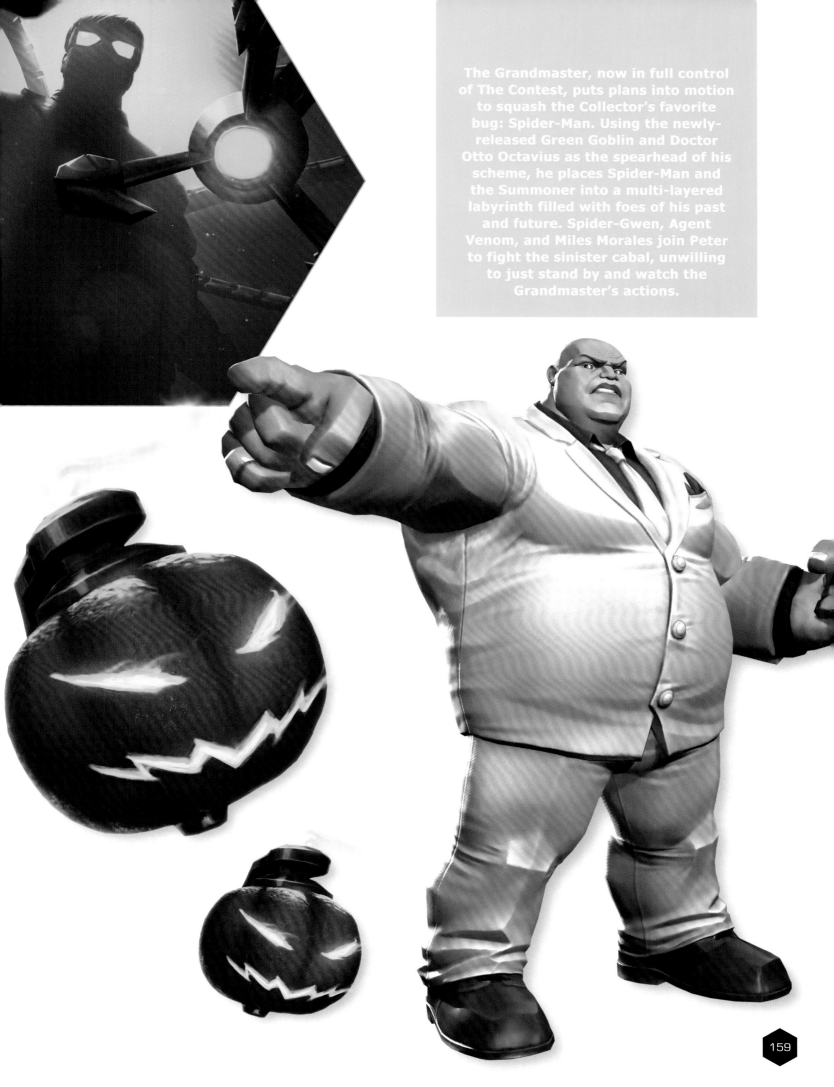

The Grandmaster, now in full control of The Contest, puts plans into motion to squash the Collector's favorite bug: Spider-Man. Using the newly-released Green Goblin and Doctor Otto Octavius as the spearhead of his scheme, he places Spider-Man and the Summoner into a multi-layered labyrinth filled with foes of his past and future. Spider-Gwen, Agent Venom, and Miles Morales join Peter to fight the sinister cabal, unwilling to just stand by and watch the Grandmaster's actions.

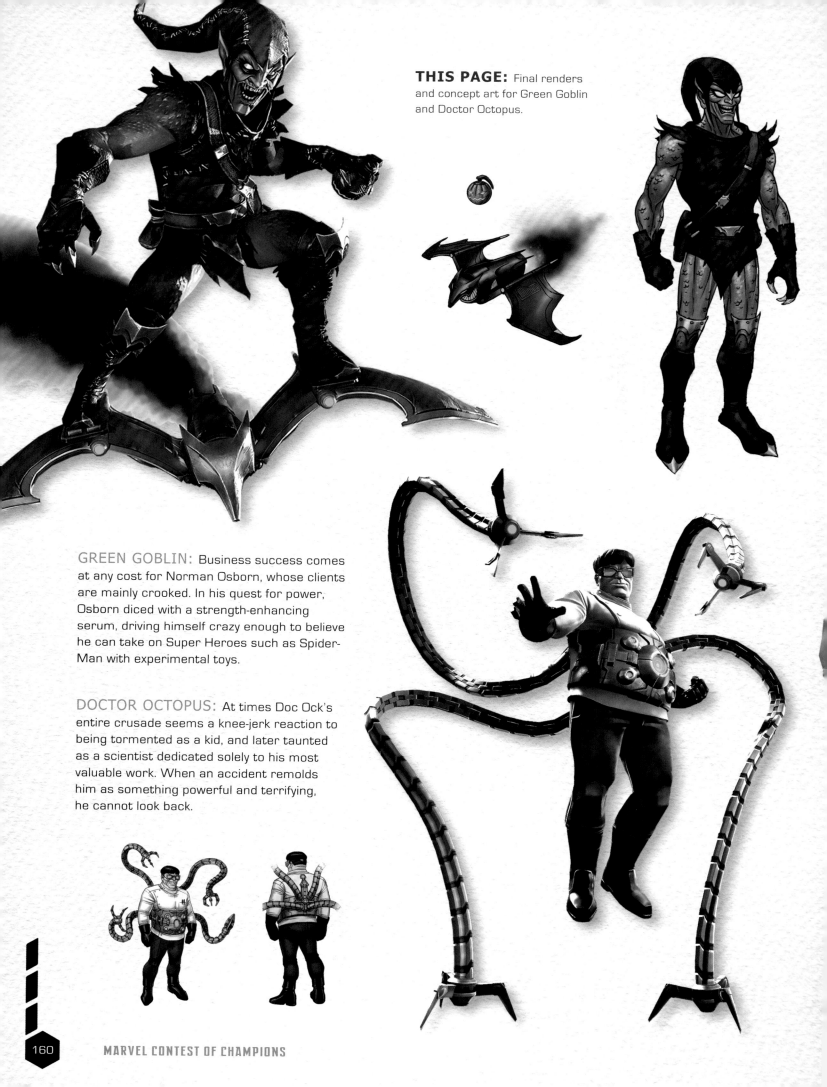

THIS PAGE: Final renders and concept art for Green Goblin and Doctor Octopus.

GREEN GOBLIN: Business success comes at any cost for Norman Osborn, whose clients are mainly crooked. In his quest for power, Osborn diced with a strength-enhancing serum, driving himself crazy enough to believe he can take on Super Heroes such as Spider-Man with experimental toys.

DOCTOR OCTOPUS: At times Doc Ock's entire crusade seems a knee-jerk reaction to being tormented as a kid, and later taunted as a scientist dedicated solely to his most valuable work. When an accident remolds him as something powerful and terrifying, he cannot look back.

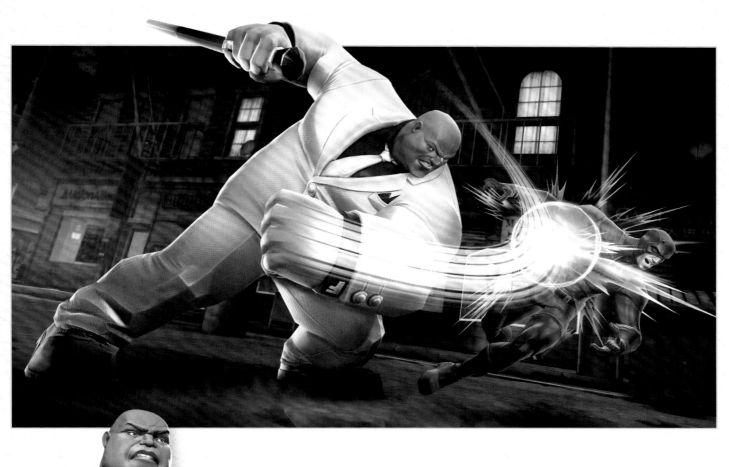

KINGPIN: Wilson Fisk is an elusive target for the Super Heroes of New York and rival groups including Hydra and the Maggia. His imposing size and East Coast criminal activity cast a shadow and leave the kind of footprint that is hard for the likes of Spider-Man and Daredevil to ignore.

THIS PAGE: [ABOVE] Motion graphic for Sinister Foes of Spider-Man. [BELOW] Final render and concept art for Kingpin.

HAVE YOU SEEN THIS DOG?
CHAPTER TWENTY-EIGHT

How do you make Kingpin and Medusa work together in a story? It's something we've talked about before, and that was the challenge once again for this quest," says Scott Bradford. "Kingpin is known for his willingness to do some pretty awful things to get what he wants, so it made sense to us that he might steal a dog that can teleport from a group of superpowered space humans in order to dig up artifacts he thinks are valuable.

On top of this, it was thematically natural for the silent king, Black Bolt, to be keeping a secret about the nature of these artifacts Kingpin stole Lockjaw to find. The art for the missing Lockjaw was so popular, we even printed the flyer off and posted it around the office as a bit of a joke. Kingpin, the Black-ISO Mafia, and other crime in the Battlerealm has been growing for some time now, so this is definitely one of those threads we're not done exploring."

MEDUSA

As a child, she was exposed to the Terrigen Mists resulting in hair she can control. Now, as Queen of the Inhumans, Medusa's steely gaze is only out powered by her fierce, flowing locks.

"Medusa was a character that came up every few months on our wish list for new Champions. As much as we wanted to do her justice in game, her hair was a massive technical challenge and had to be done just right," Tim Hernandez recalls. "The team took her classic design and color scheme but also gave the Queen of the Inhumans more of an edge, quite literally, by giving her some hand-to-hand weapons to balance out the gameplay."

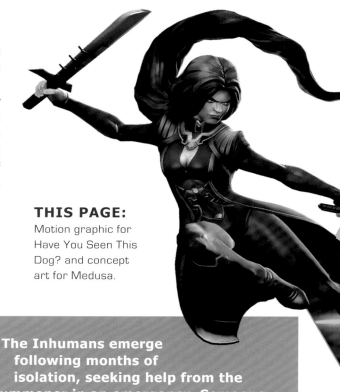

THIS PAGE:
Motion graphic for
Have You Seen This
Dog? and concept
art for Medusa.

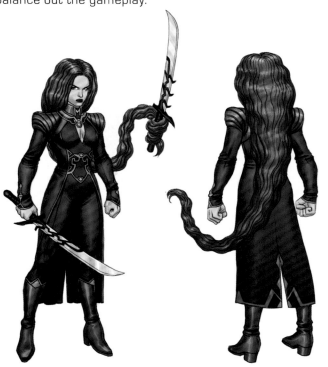

The Inhumans emerge following months of isolation, seeking help from the Summoner in an emergency. Someone has stolen the Royal Family's faithful dog, Lockjaw! The Summoner, alongside the conscripted Howard the Duck and Hyperion, must track down the Inhuman hound using Howard's keen detective senses. Evidence mounts, with all signs pointing to the Black-ISO Mafia. But their new leader, the Kingpin, has a different way of doing business...

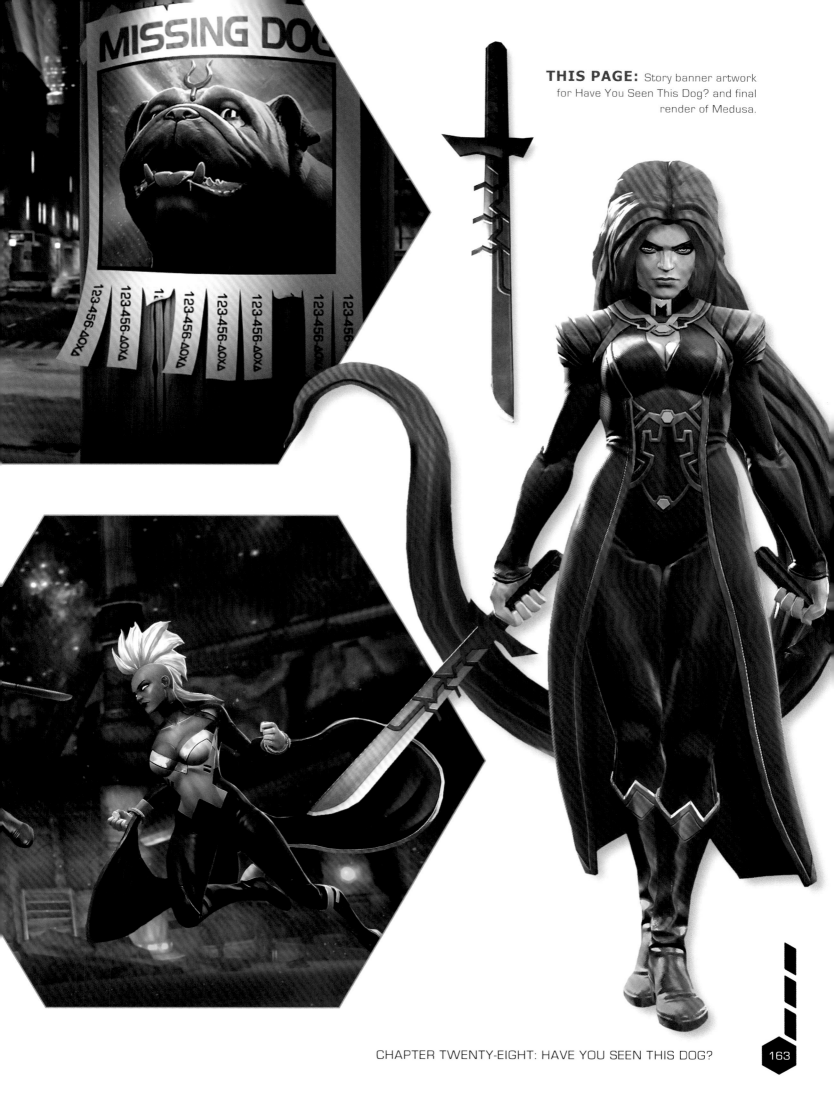

THIS PAGE: Story banner artwork for Have You Seen This Dog? and final render of Medusa.

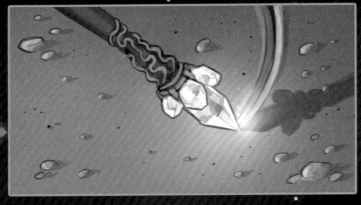

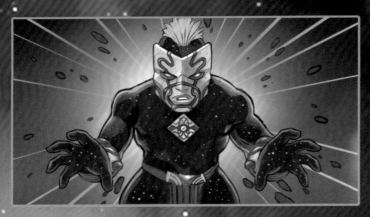

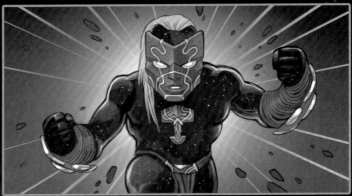

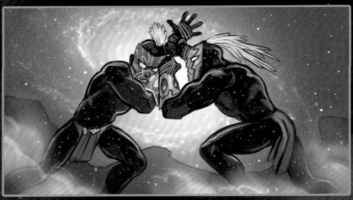

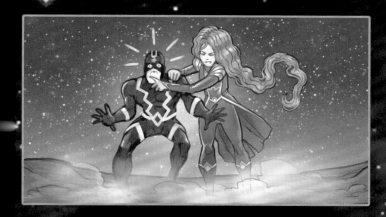

WARRIOR OF THE ISO-PEOPLE

The "ISO-People" was a mysterious civilization native to the Battlerealm whose fate remains unknown. Records describe them as a proud warrior people that were born and lived in the vacuum of space, without any need for breathing apparatus or protective suits. This cosmic culture of Champions forged precious relics capable of enhancing their strength during gladiatorial contests they enacted in honor of their gods.

THIS SPREAD: (LEFT) Storyboard for Have You Seen This Dog?. (RIGHT) Concept art for Warrior of the ISO-People.

BLADES
CHAPTER TWENTY-NINE

"All elements of the character—their powers, personality, visual, name and backstory—must connect into a seamless whole. Each ingredient must complement each other and amplify their core metaphor and purpose," says Bill Rosemann on the principals of creating new Marvel characters. "While I don't want to give away all of our secrets—and also need to restate that there are no 'official' rules written in stone—there are a set of beliefs that we adhere to when it comes to delivering a visual and a backstory that is uniquely and authentically Marvel. A pinch of underdog relatability, a dash of triumph from tragedy, a handful of heroic sacrifice, and a few other secret ingredients... and KA-BOOM! A new Marvel star is born!"

"Morningstar was exactly what we look for in a new character," says Tim Hernandez. "She had an extremely strong visual design, would offer a unique and fun play style with awesome weapons and abilities, a compelling backstory that was both tragic and sympathetic, and even expanded on the legend of Guillotine. The hardest part was waiting for her to make it into the game so we could play as her!"

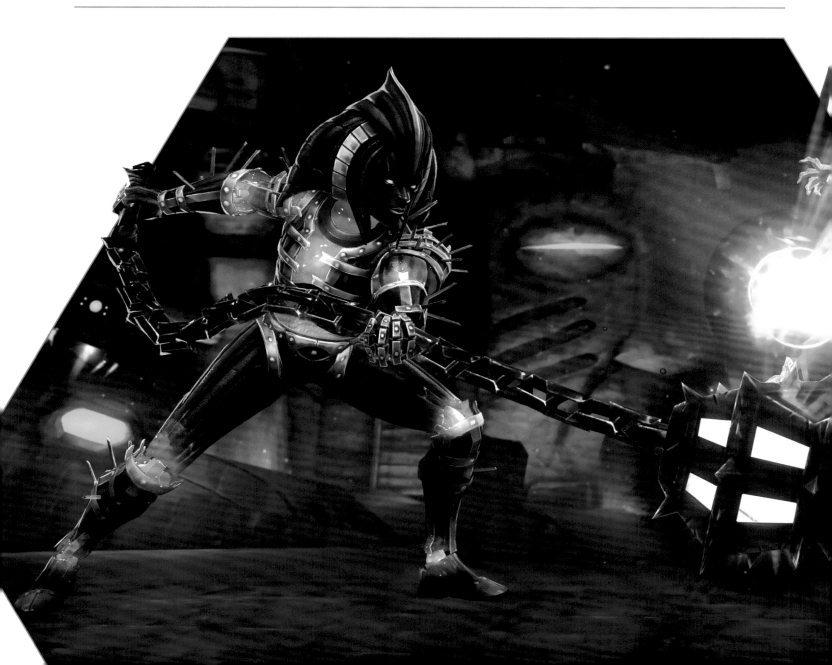

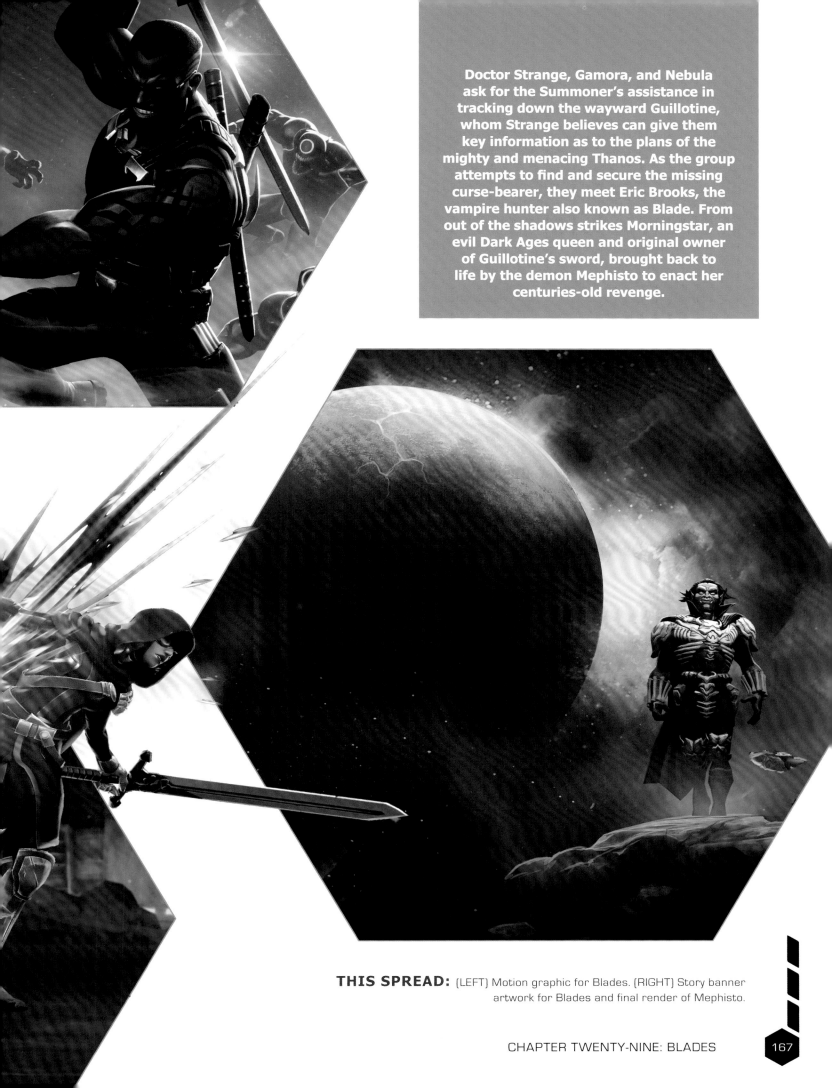

Doctor Strange, Gamora, and Nebula ask for the Summoner's assistance in tracking down the wayward Guillotine, whom Strange believes can give them key information as to the plans of the mighty and menacing Thanos. As the group attempts to find and secure the missing curse-bearer, they meet Eric Brooks, the vampire hunter also known as Blade. From out of the shadows strikes Morningstar, an evil Dark Ages queen and original owner of Guillotine's sword, brought back to life by the demon Mephisto to enact her centuries-old revenge.

THIS SPREAD: [LEFT] Motion graphic for Blades. [RIGHT] Story banner artwork for Blades and final render of Mephisto.

CHAPTER TWENTY-NINE: BLADES

READ CLOSELY, CURSE-BEARER
FOR THIS IS YOUR LEGACY.

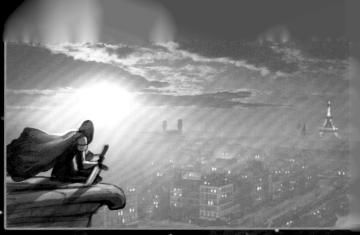

999 AD

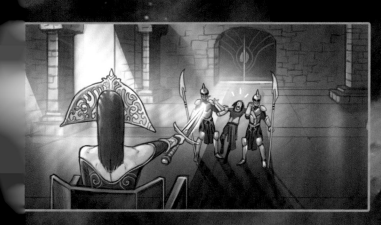

1944 AD

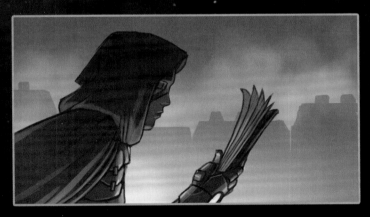
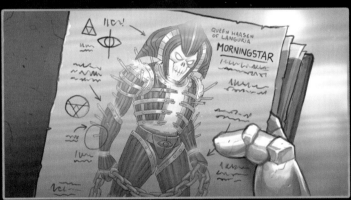

THIS SPREAD: Storyboard for the history of Queen Haasen.

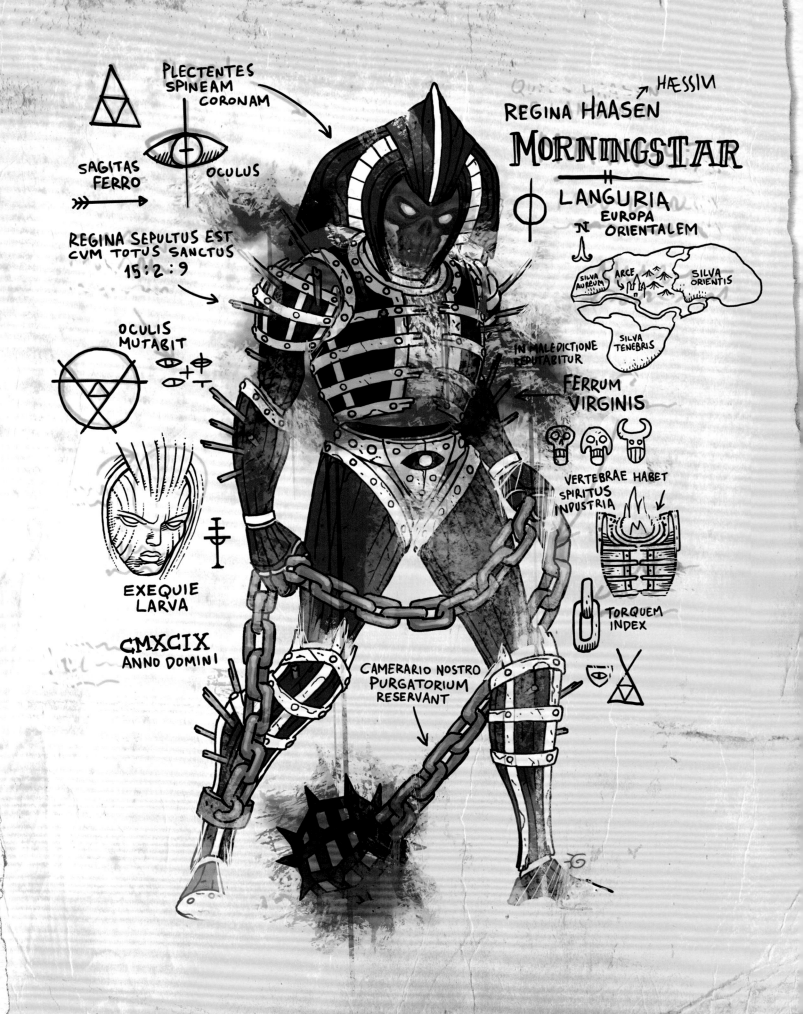

MORNINGSTAR

As Queen Haasen, she ruled with tyranny over Languria, her rage and hatred channelled through the blood sword, La Fleur du Mal. Haasen's angered subjects stormed the castle and sealed her inside one of her own devices, designed to torture the soul beyond death.

Years later, Mephisto, Lord of Lies, brought Haasen back as a monstrous unification of the Queen and the iron maiden that had been her tomb. She wanders the land in search of the demon blade.

THIS PAGE: (FAR LEFT) Concept art and making of Morningstar. (LEFT) Story banner artwork and final render of Morningstar. (RIGHT) Concept art for Queen Haasen.

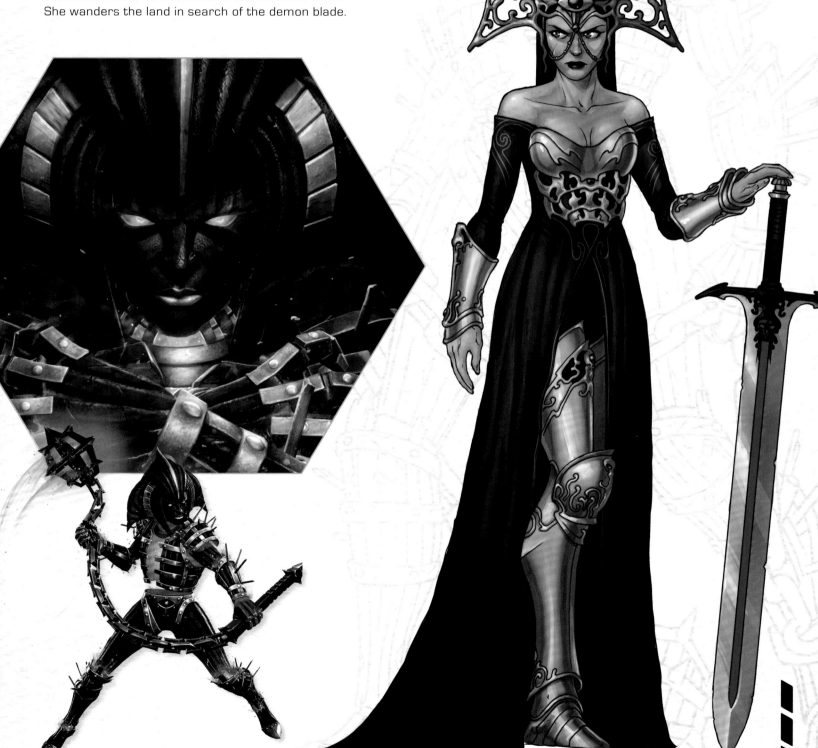

CHAPTER TWENTY-NINE: BLADES

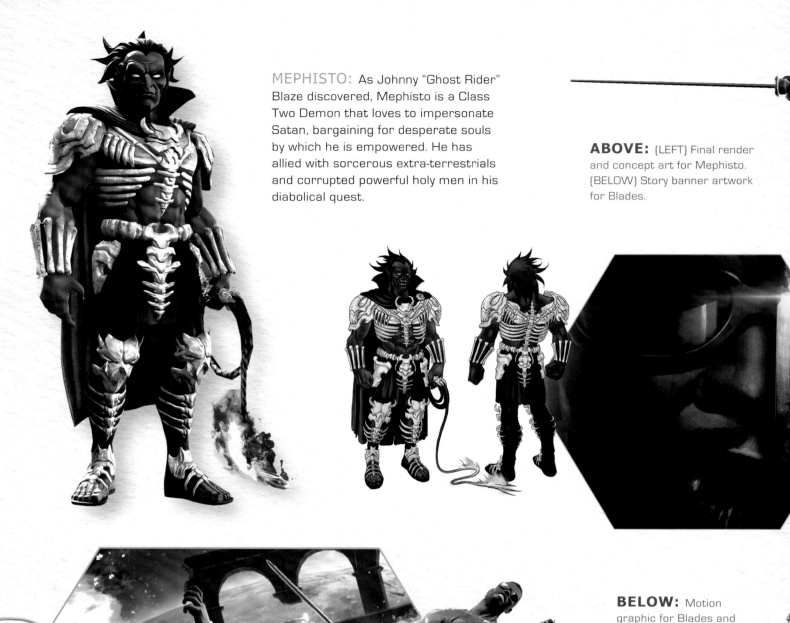

MEPHISTO: As Johnny "Ghost Rider" Blaze discovered, Mephisto is a Class Two Demon that loves to impersonate Satan, bargaining for desperate souls by which he is empowered. He has allied with sorcerous extra-terrestrials and corrupted powerful holy men in his diabolical quest.

ABOVE: (LEFT) Final render and concept art for Mephisto. (BELOW) Story banner artwork for Blades.

BELOW: Motion graphic for Blades and final render of Mephisto.

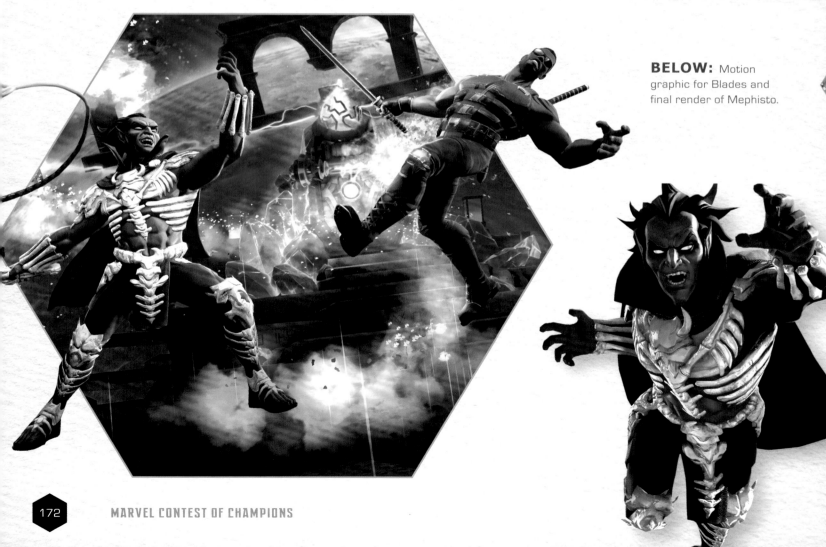

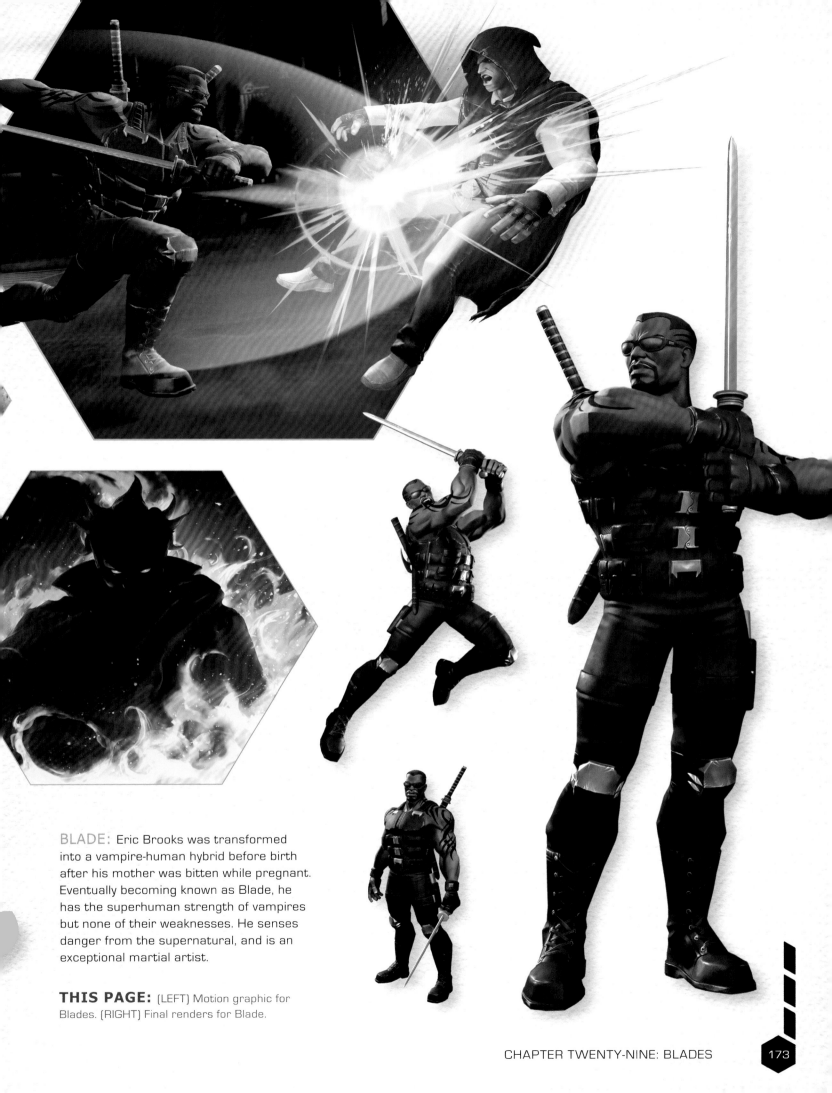

BLADE: Eric Brooks was transformed into a vampire-human hybrid before birth after his mother was bitten while pregnant. Eventually becoming known as Blade, he has the superhuman strength of vampires but none of their weaknesses. He senses danger from the supernatural, and is an exceptional martial artist.

THIS PAGE: (LEFT) Motion graphic for Blades. (RIGHT) Final renders for Blade.

GODS OF THE ARENA
CHAPTER THIRTY

With the release of Marvel Studios' *Thor: Ragnarok* in movie theaters, the Kabam team took the Goddess of Death and disheveled Thor to usher a heightened element of fear and chaos into the arena. Hela is so powerful and spectacularly intimidating that she becomes a threat to the Grandmaster himself.

Gabriel Frizzera's art team received reference materials in advance from Marvel Studios, to ensure that Hela's arrival in Contest captured her movie persona as accurately as possible.

"When the *Thor: Ragnarok* movie came out and we started bringing in characters from that, people went nuts," says Cuz Parry. "We don't tell the story of *Thor: Ragnarok*, though. We tell our own story. We've always been clear: we are not a 'movie game.'

"The fact that Marvel has all of these amazing comic events, and all the movies, all the time, it allows us to bring characters into our world that are famous and that people are clamoring for. But we don't do their event; we don't mimic the movie. We make subtle references here and there, but we do our own story. We take inspiration from the characters, the personalities, and then when new ones are introduced, we bring 'em in."

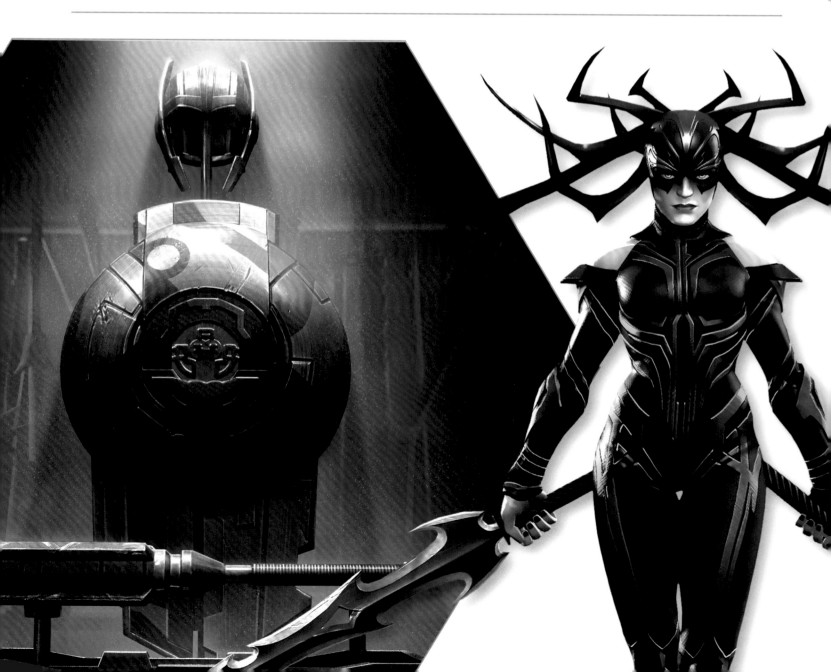

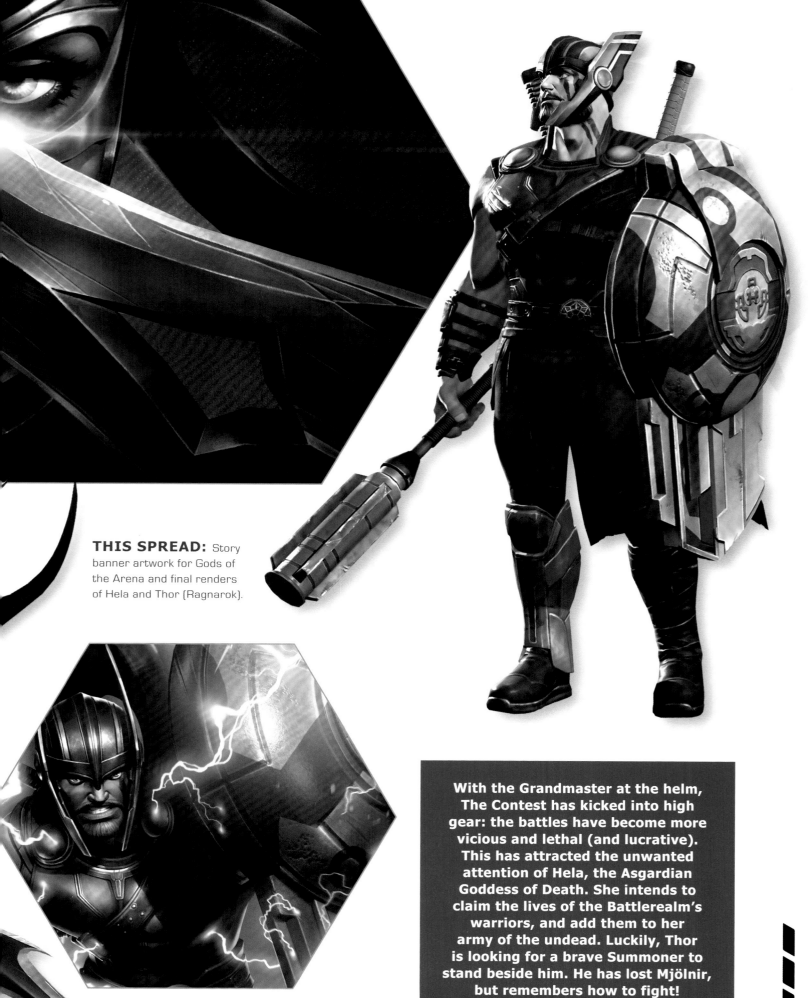

THIS SPREAD: Story banner artwork for Gods of the Arena and final renders of Hela and Thor (Ragnarok).

With the Grandmaster at the helm, The Contest has kicked into high gear: the battles have become more vicious and lethal (and lucrative). This has attracted the unwanted attention of Hela, the Asgardian Goddess of Death. She intends to claim the lives of the Battlerealm's warriors, and add them to her army of the undead. Luckily, Thor is looking for a brave Summoner to stand beside him. He has lost Mjölnir, but remembers how to fight!

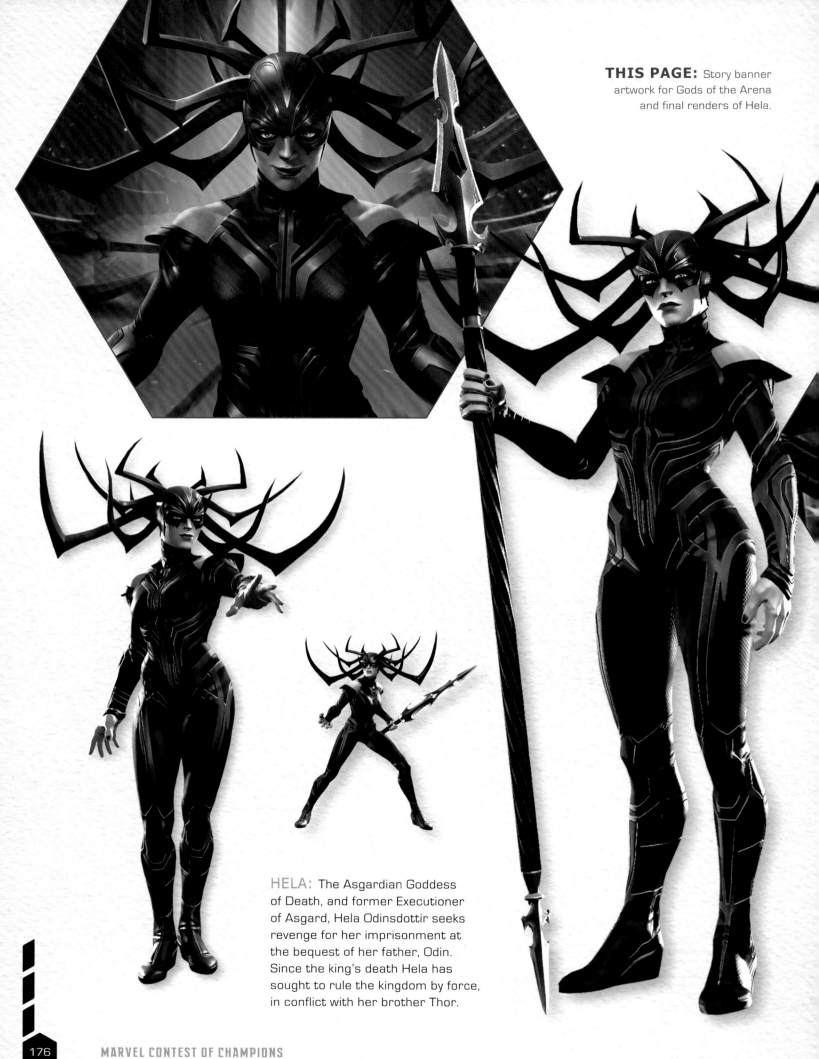

THIS PAGE: Story banner artwork for Gods of the Arena and final renders of Hela.

HELA: The Asgardian Goddess of Death, and former Executioner of Asgard, Hela Odinsdottir seeks revenge for her imprisonment at the bequest of her father, Odin. Since the king's death Hela has sought to rule the kingdom by force, in conflict with her brother Thor.

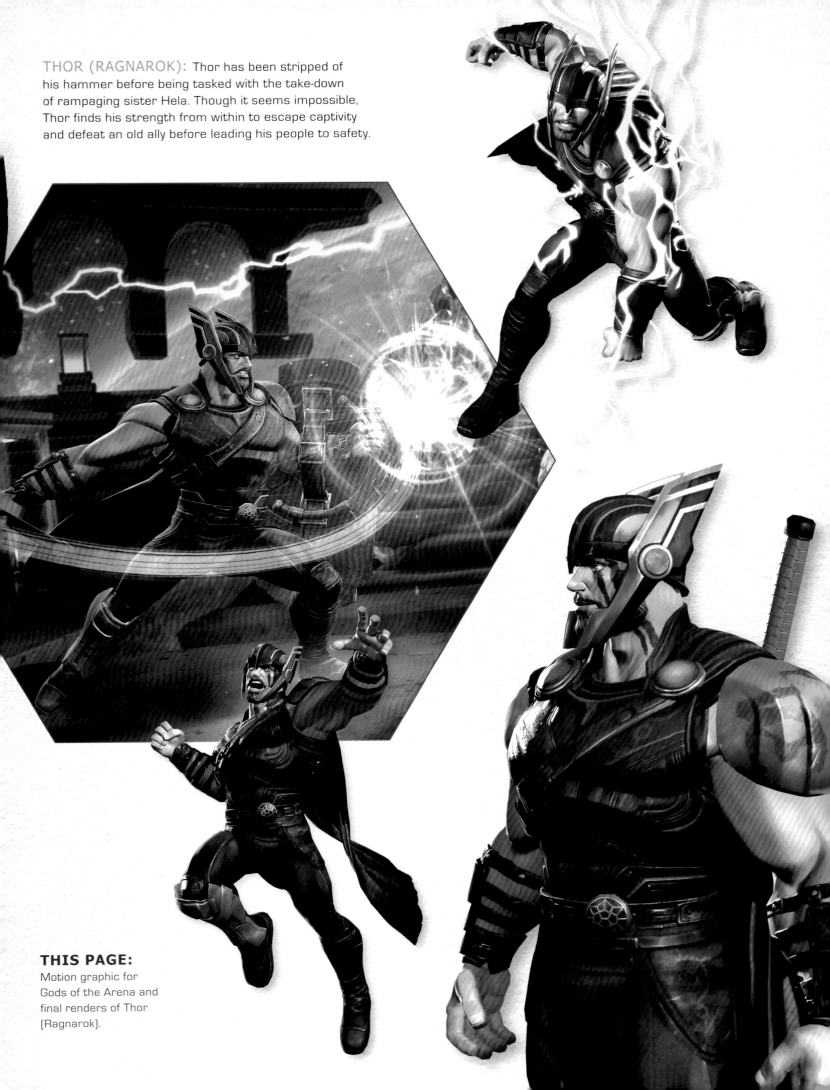

THOR (RAGNAROK): Thor has been stripped of his hammer before being tasked with the take-down of rampaging sister Hela. Though it seems impossible, Thor finds his strength from within to escape captivity and defeat an old ally before leading his people to safety.

THIS PAGE:
Motion graphic for Gods of the Arena and final renders of Thor (Ragnarok).

HOTEL M.O.D.O.K.
CHAPTER THIRTY-ONE

With the Hotel M.O.D.O.K. update, Kabam seized the opportunity to celebrate some of the coolest aspects of all the Champions currently in the game: Taskmaster was now able to use his infamous powers to instantaneously mimic the abilities of others. This became a challenge for the animators more than anyone else, as they were now required to blend the movements of martial arts practitioners and weapons specialists alike...and then add Taskmaster's signature menace.

Taskmaster is also a strong example of the awareness that Kabam demonstrates throughout The Contest, with one eye firmly on what flies in the present day in terms of aesthetic while the other observes the greatest hits of the past. Kabam's iteration streamlines the character model somewhat, with narrative reasoning being that oversized boots would likely obstruct the mercenary's combat prowess.

Gabriel Frizzera's team took into account the more recent stylized versions of the 1980s original, which have presented Tony Masters with a more tactically-armored than figure-hugging costume plus cape. The result is something that retains the classic 80s look and color scheme, but feels entirely modern, and entirely appropriate for a cutting-edge fighting game.

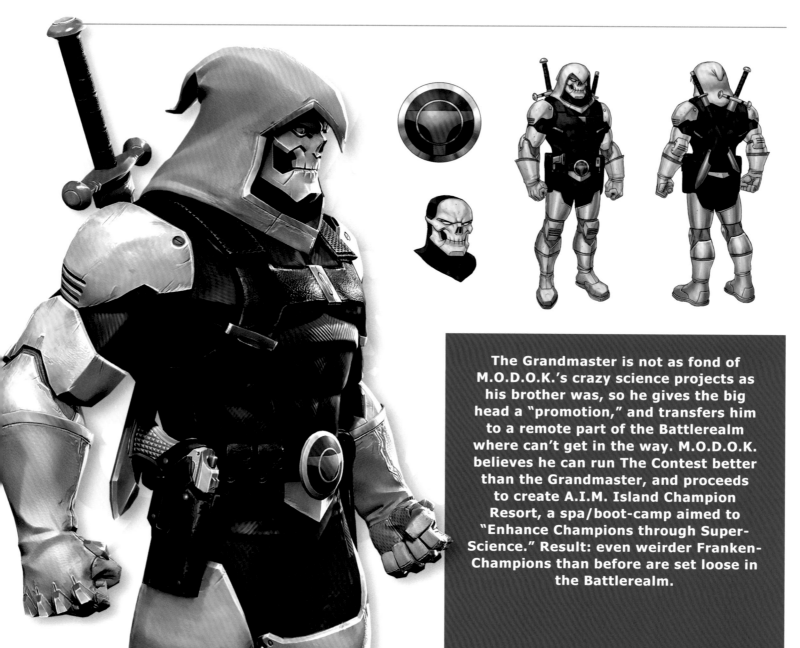

The Grandmaster is not as fond of M.O.D.O.K.'s crazy science projects as his brother was, so he gives the big head a "promotion," and transfers him to a remote part of the Battlerealm where can't get in the way. M.O.D.O.K. believes he can run The Contest better than the Grandmaster, and proceeds to create A.I.M. Island Champion Resort, a spa/boot-camp aimed to "Enhance Champions through Super-Science." Result: even weirder Franken-Champions than before are set loose in the Battlerealm.

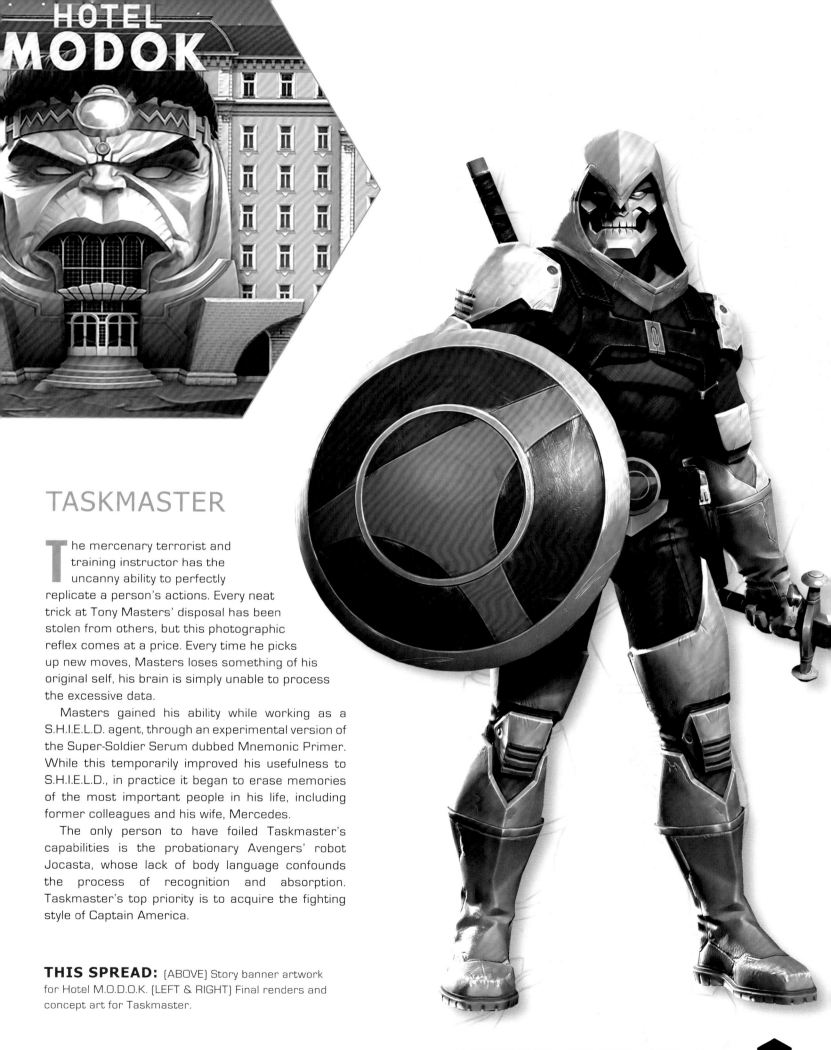

HOTEL MODOK

TASKMASTER

The mercenary terrorist and training instructor has the uncanny ability to perfectly replicate a person's actions. Every neat trick at Tony Masters' disposal has been stolen from others, but this photographic reflex comes at a price. Every time he picks up new moves, Masters loses something of his original self, his brain is simply unable to process the excessive data.

Masters gained his ability while working as a S.H.I.E.L.D. agent, through an experimental version of the Super-Soldier Serum dubbed Mnemonic Primer. While this temporarily improved his usefulness to S.H.I.E.L.D., in practice it began to erase memories of the most important people in his life, including former colleagues and his wife, Mercedes.

The only person to have foiled Taskmaster's capabilities is the probationary Avengers' robot Jocasta, whose lack of body language confounds the process of recognition and absorption. Taskmaster's top priority is to acquire the fighting style of Captain America.

THIS SPREAD: [ABOVE] Story banner artwork for Hotel M.O.D.O.K. [LEFT & RIGHT] Final renders and concept art for Taskmaster.

AGE OF SENTRY
CHAPTER THIRTY-TWO

Though Marvel fans know all too well the colossal dilemma facing Robert Reynolds, a.k.a. the Sentry—the enormous potential for heroism, a light that casts a dread shadow of equal proportion—casual players may not have been prepared for the depth of tragedy on display in Age of Sentry. The Collector, as we discover through reading Gabriel Frizzera's *The Young Elders Tale*, lost his daughter, Carina, to the Battlerealm. She was somehow crystalized at the threshold to an ancient temple before being scattered across a dying celestial's domain.

It takes somebody as powerful as Reynolds' Sentry alter-ego to brave the outer reaches of the Battlerealm in search of Carina's heart. The Elder is prepared to risk everything for this most precious fragment. He even drops his pompous façade, which is quite shocking in itself, almost a fourth-wall moment. After the Sentry resurfaces from a thirty-five--year absence, the Collector, calling him Robert, outright pleads for his long-awaited prize.

We feel the Collector's sickening horror and despair as Reynolds, in thrall to the Void, refuses to hand over the shard. "I will enjoy ripping it into pieces and devouring it," says the Void.

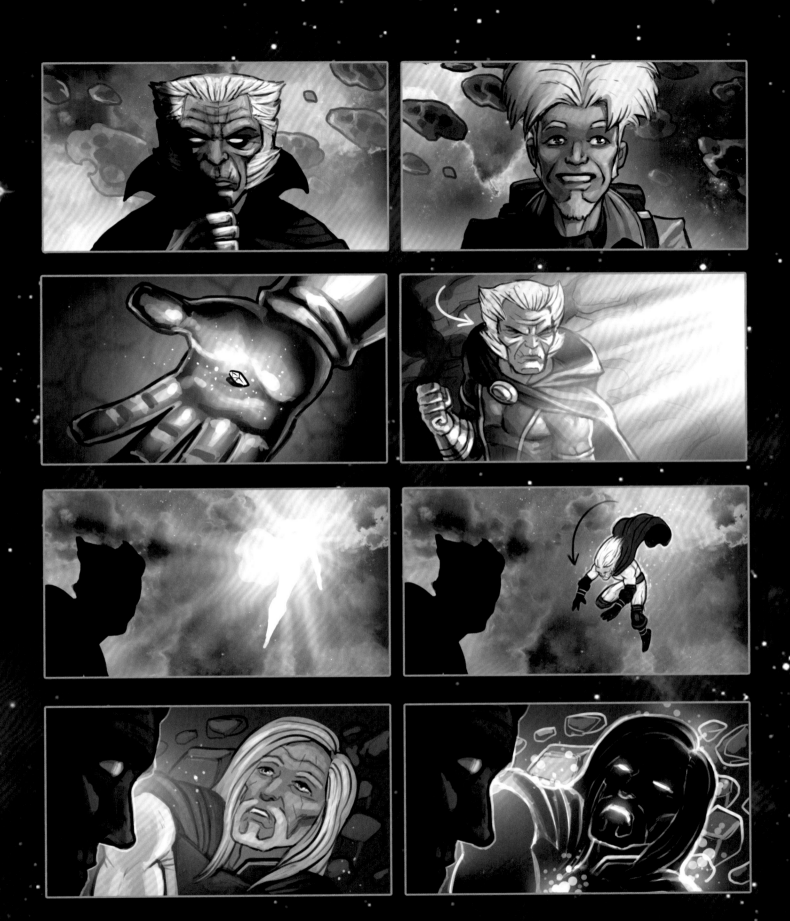

THIS SPREAD: [LEFT] Story banner artwork for Age of Sentry and final render of Void. [RIGHT] Storyboard for Age of Sentry.

Many years ago, the Collector returned to the Battlerealm to build The Contest of Champions with twelve legendary warriors. Among them was Robert Reynolds, also known as the Sentry. Reynolds was over-powered and after he easily defeated all other contestants, the Collector enlisted the Sentry's superhuman senses to track and retrieve the pieces of his daughter's crystal form that are scattered throughout the Battlerealm. But he never returned. Now, thiry-five years after the Sentry went missing, he arrives more unbalanced than usual, and the Collector fears that his dark alter-ego, The Void, is about to be reborn.

SENTRY: Upon drinking an enhanced version of the Super-Soldier Serum, Robert Reynolds gained the power of a million exploding suns and became the most amazing Super Hero who ever lived. As such, Reynolds became a 'poster boy' for costumed liberators. There was just one catch...

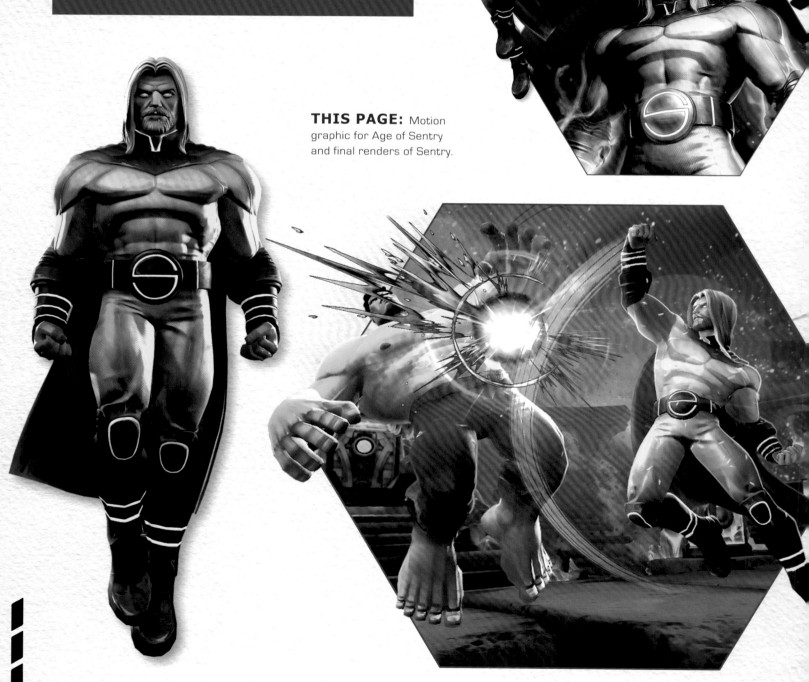

THIS PAGE: Motion graphic for Age of Sentry and final renders of Sentry.

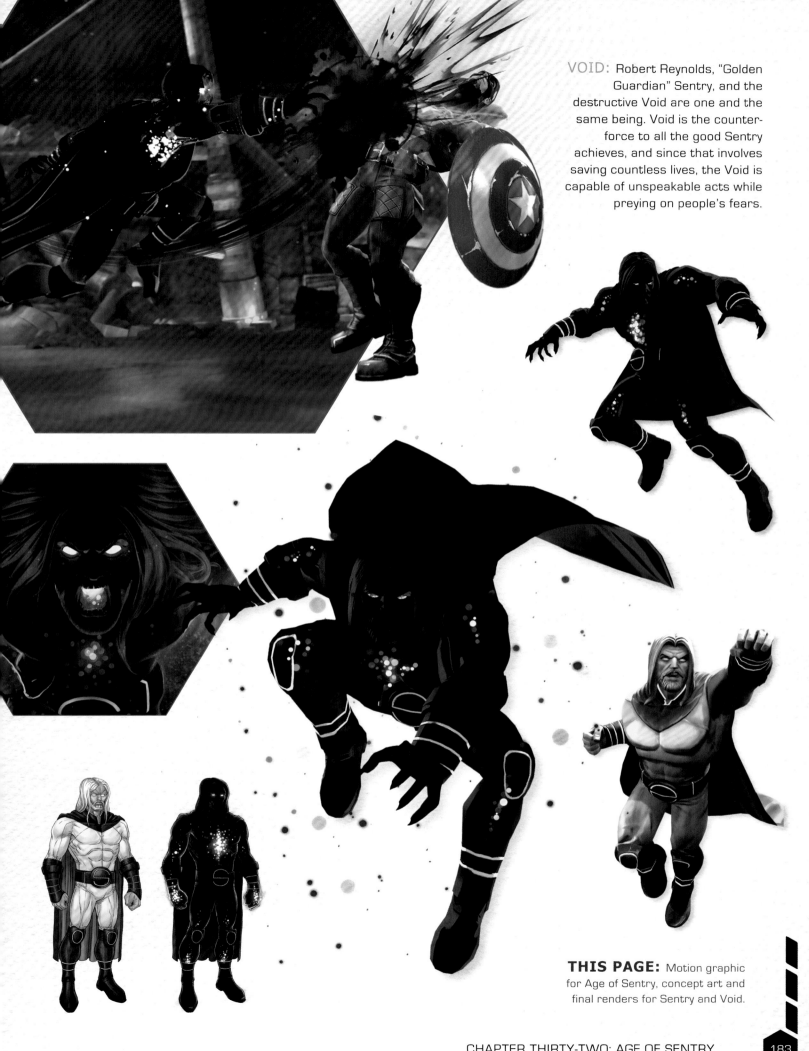

VOID: Robert Reynolds, "Golden Guardian" Sentry, and the destructive Void are one and the same being. Void is the counter-force to all the good Sentry achieves, and since that involves saving countless lives, the Void is capable of unspeakable acts while preying on people's fears.

THIS PAGE: Motion graphic for Age of Sentry, concept art and final renders for Sentry and Void.

RISE OF THE BLACK PANTHER

CHAPTER THIRTY-THREE

Cuz Parry describes Black Panther's introduction to The Contest as "surreal." We find Black Panther "locked in a battle too large for human comprehension" according to Doctor Strange, who's trying to locate T'Challa alongside Iron Man. The script references the disappearance of home-grown Super Hero Guillotine, before uttering an emblematic Doctor Strange line that reads "To find him, one needs to look beyond the traditional concepts of 'place' and 'time,'"

T'Challa, it turns out, has gone in search of an "Infinity Claw" that only exists in an alternate reality, in order to counter Thanos and his Infinity Gauntlet...and we, as Summoners, are invited along to help.

This is some mad videogame theater in play, introducing Killmonger as improbable ruler of Wakanda who fields a corrupted Black Panther as his captain. Later we encounter Hulk (Ragnarok), and ultimately face the arrogant Killmonger himself, whose pride will be his downfall.

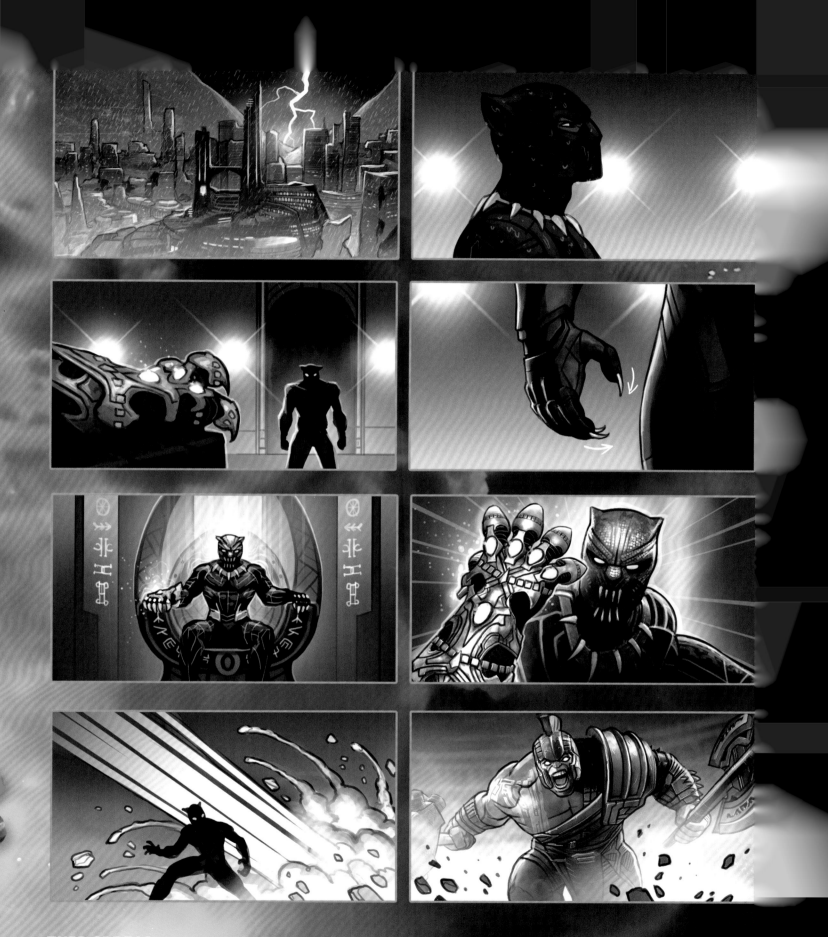

THIS SPREAD: (LEFT) Story banner artwork for Rise of the Black Panther and final render for Hulk (Ragnarok). (RIGHT) Storyboard for Rise of the Black Panther.

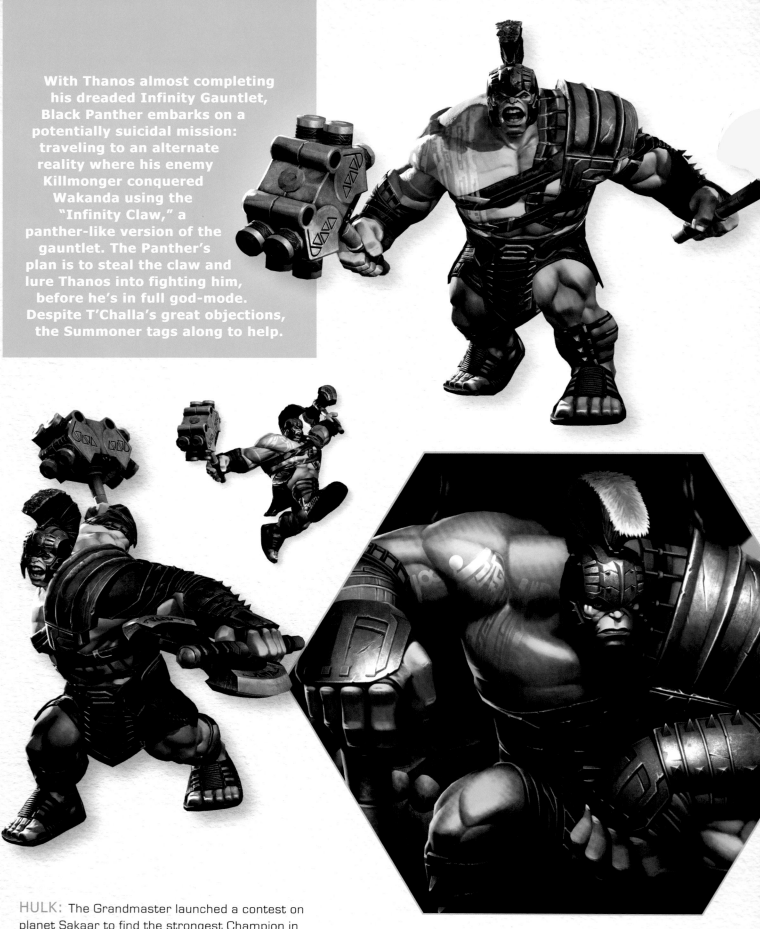

With Thanos almost completing his dreaded Infinity Gauntlet, Black Panther embarks on a potentially suicidal mission: traveling to an alternate reality where his enemy Killmonger conquered Wakanda using the "Infinity Claw," a panther-like version of the gauntlet. The Panther's plan is to steal the claw and lure Thanos into fighting him, before he's in full god-mode. Despite T'Challa's great objections, the Summoner tags along to help.

HULK: The Grandmaster launched a contest on planet Sakaar to find the strongest Champion in the galaxy. In the Grandmaster's corner glowered Hulk, and the green gladiator's most worthy opponent was Thor, resulting in a spectacle eager crowds could never have dreamed of.

THIS PAGE: Story banner artwork for Rise of the Black Panther and final renders of Hulk (Ragnarok).

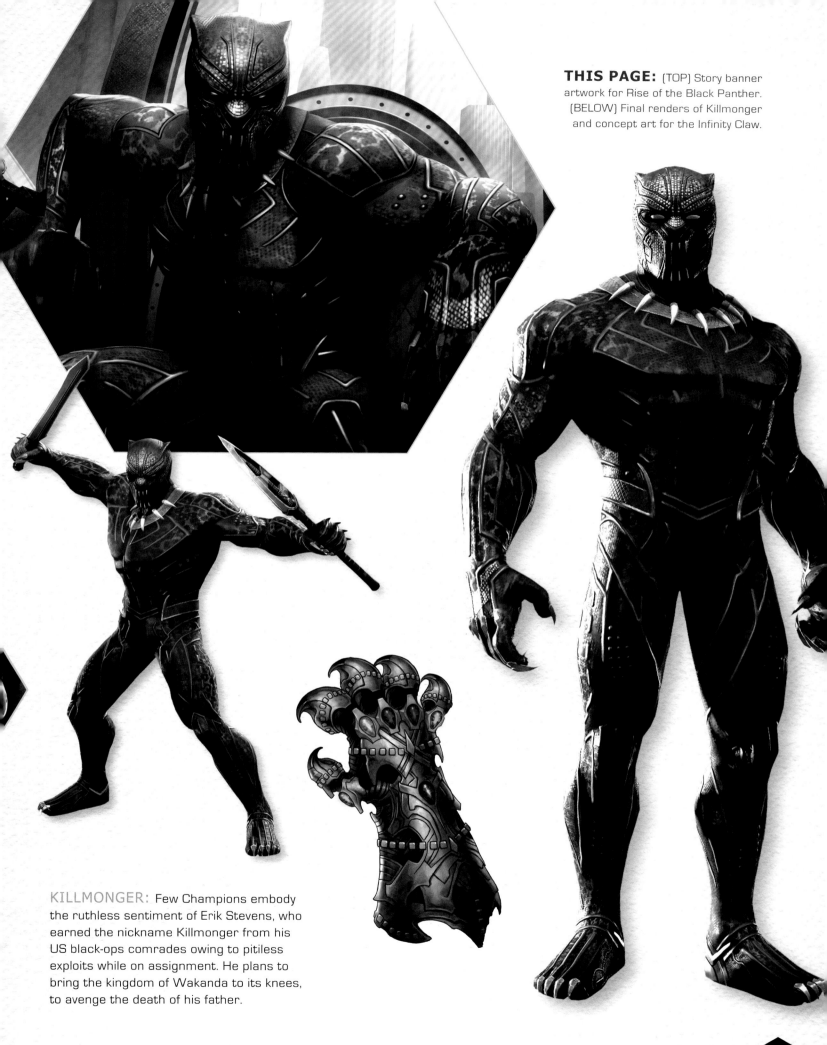

KILLMONGER: Few Champions embody the ruthless sentiment of Erik Stevens, who earned the nickname Killmonger from his US black-ops comrades owing to pitiless exploits while on assignment. He plans to bring the kingdom of Wakanda to its knees, to avenge the death of his father.

SAVAGE FUTURE
CHAPTER THIRTY-FOUR

If fans didn't know any better, they'd think that Kabam's X-Men: Savage Future storyline was lifted straight from the annals of Marvel history. The Sentinels came from a need to shake things up a little with regards to Symbioid (corrupted Adaptoid) cannon fodder, which logically led to the presence of Bishop hunting them down. Summoners got to play as both, which came as a welcome surprise. Plus, the event introduced another newcomer, a literal 'wild' card.

Both the new "Mark-ISO" Sentinels and modernized Bishop hailed from an alternate future, with references to the action-packed scenarios and time traveling twists of fate of 90s comics. Few mutants have a greater score

to settle with Bishop than bestial troublemaker Sabretooth, whose efforts to infect humans with a modified strain of the Legacy Virus were intercepted.

Sabretooth was one of the most requested Champions since The Contest got underway, but Kabam needed to choose the right time for his introduction. There needed to be a gameplay reason to complement the narrative purpose, and one can only sit back and admire how this plan eventually came together. The introduction of Bishop and the Sentinels gave Kabam a chance to bring what it saw as quintessential Sabretooth: "The ferocious, vicious psychopath that was a constant threat to our childhood heroes."

THIS SPREAD: (LEFT) Final render for Sabretooth. (BELOW) Concept art and final render for Bishop. (RIGHT) Story banner artwork for Savage Future and final render of Sentinel.

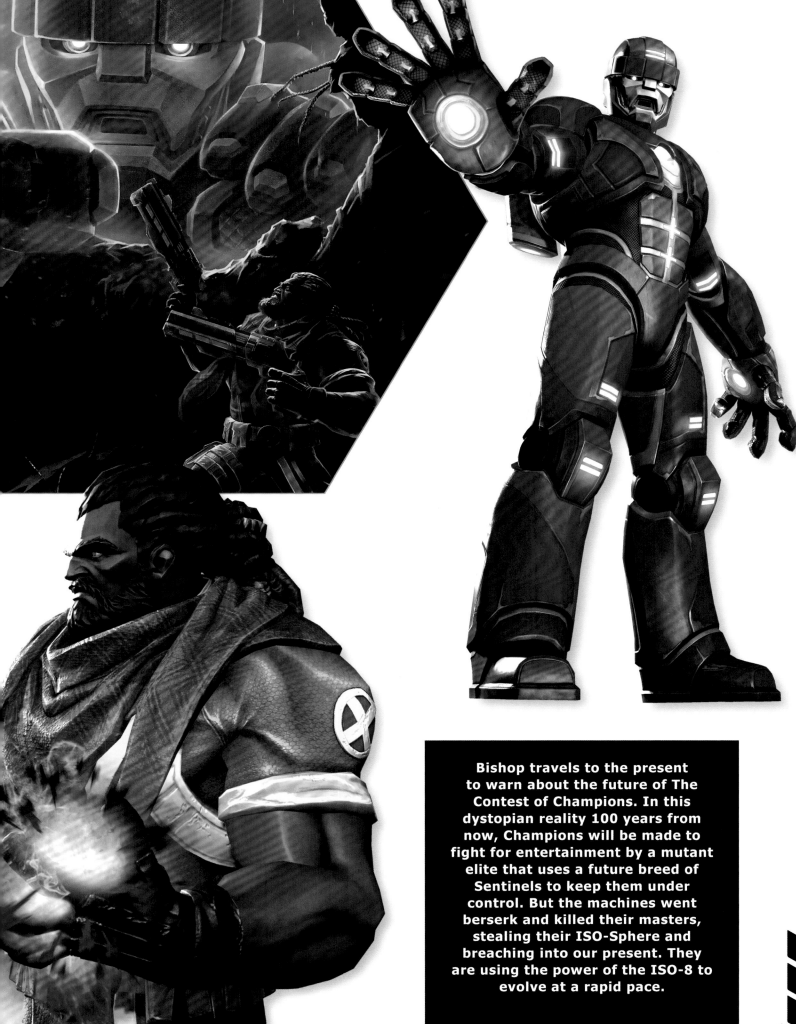

Bishop travels to the present to warn about the future of The Contest of Champions. In this dystopian reality 100 years from now, Champions will be made to fight for entertainment by a mutant elite that uses a future breed of Sentinels to keep them under control. But the machines went berserk and killed their masters, stealing their ISO-Sphere and breaching into our present. They are using the power of the ISO-8 to evolve at a rapid pace.

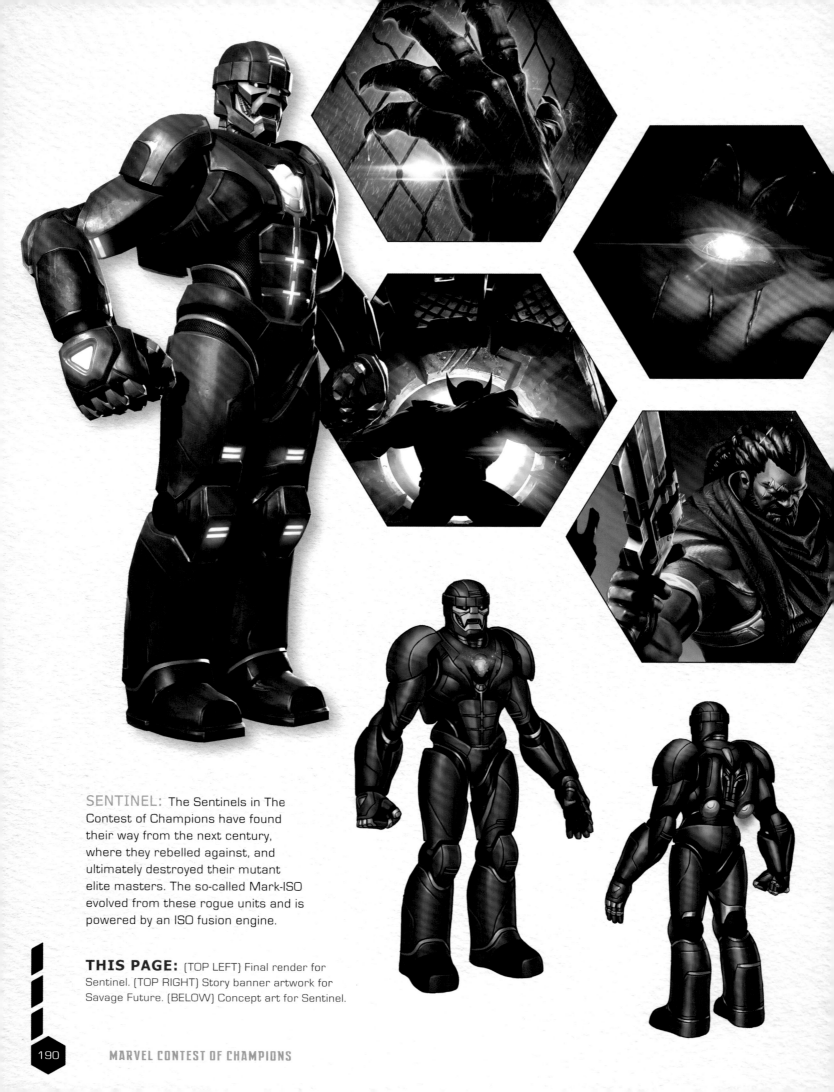

SENTINEL: The Sentinels in The Contest of Champions have found their way from the next century, where they rebelled against, and ultimately destroyed their mutant elite masters. The so-called Mark-ISO evolved from these rogue units and is powered by an ISO fusion engine.

THIS PAGE: (TOP LEFT) Final render for Sentinel. (TOP RIGHT) Story banner artwork for Savage Future. (BELOW) Concept art for Sentinel.

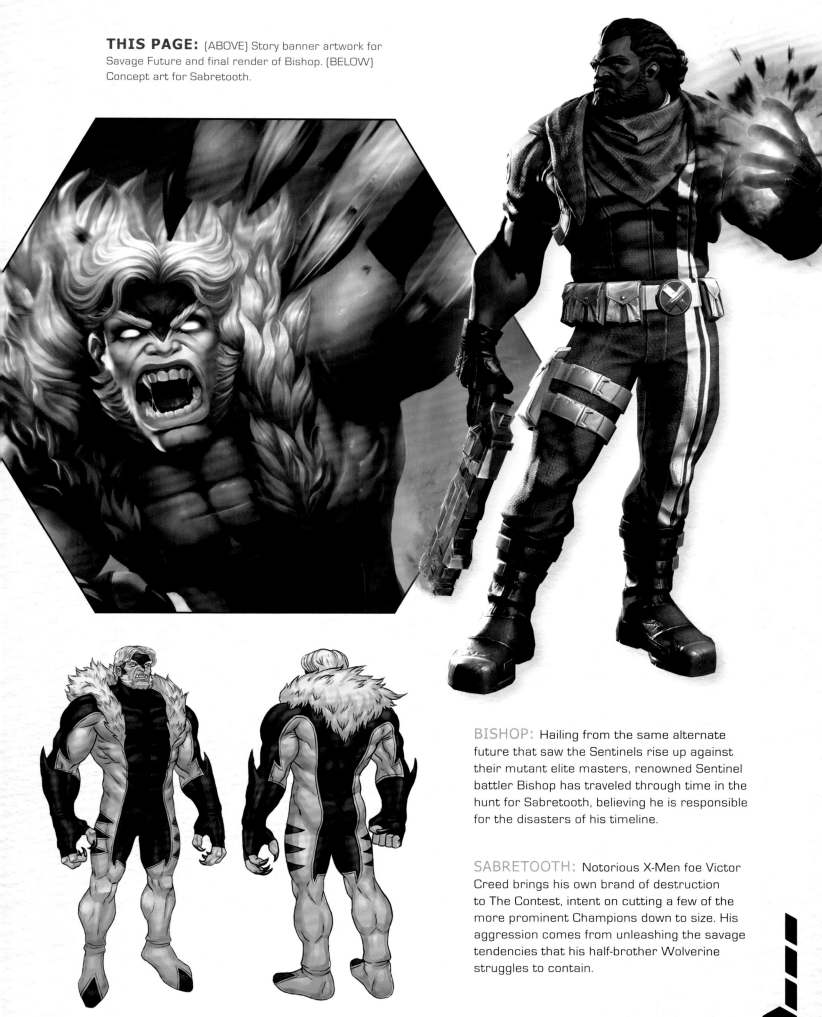

THIS PAGE: (ABOVE) Story banner artwork for Savage Future and final render of Bishop. (BELOW) Concept art for Sabretooth.

BISHOP: Hailing from the same alternate future that saw the Sentinels rise up against their mutant elite masters, renowned Sentinel battler Bishop has traveled through time in the hunt for Sabretooth, believing he is responsible for the disasters of his timeline.

SABRETOOTH: Notorious X-Men foe Victor Creed brings his own brand of destruction to The Contest, intent on cutting a few of the more prominent Champions down to size. His aggression comes from unleashing the savage tendencies that his half-brother Wolverine struggles to contain.

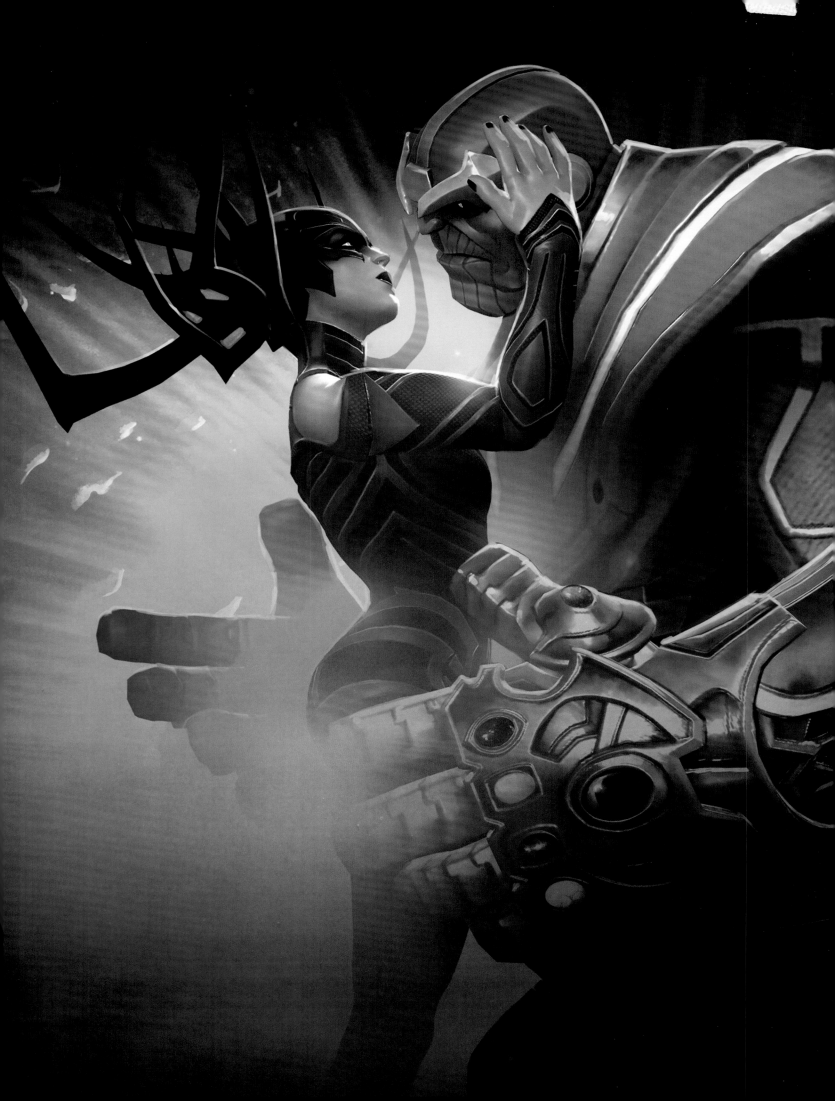

INFINITY
WAR

INFINITY CHAOS
CHAPTER THIRTY-FIVE, PART ONE

"The big one... This storyline was something we knew we would be doing for a long time, so we spent a lot of time (years, in fact) setting things up," says Scott Bradford of the huge efforts involved behind bringing *Infinity War* to *Marvel Contest of Champions.*

"Like the Marvel films, a huge event like this can't put too much effort into fleshing out the myriad protagonists and has to focus in on some central theme, which is why those years of setup were so important. For us, our focal point was exploring Thanos' dilemma in a way that added more dimension to him than just a 'guy who wants to kill stuff.'

"We imagine Thanos as a Mad Titan not for his genocidal tendencies alone. Instead, his madness is derived from a sound premise,

and a false conclusion: He might not be wrong about the question but his answer is absolutely, well, mad.

"Throughout the two-part event, we see Thanos enact his plans to gather the remaining Infinity Stones, but ultimately struggle to decide how best to use them. In the end his internal conflict, represented through Hela and Mephisto whispering in his ear, is what leads to his undoing by giving the heroes an opportunity to stop the madness he created."

In order for Kabam's Infinity War event to link with its Marvel Studios movie counterpart, this necessitated early access to visual materials. Bearing in mind that it can take up to three months to bring new Champions into the game, the lead time is another factor that leans heavily on trust. "At the beginning it was more

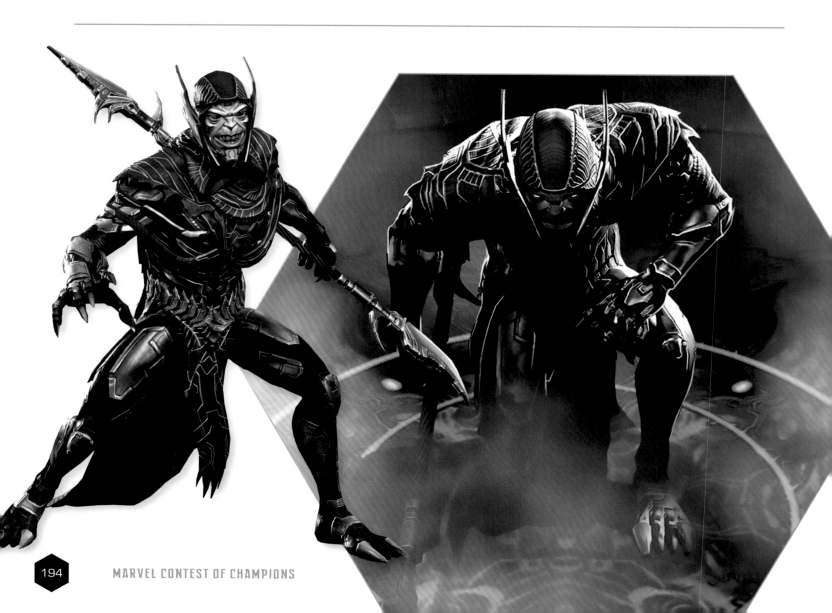

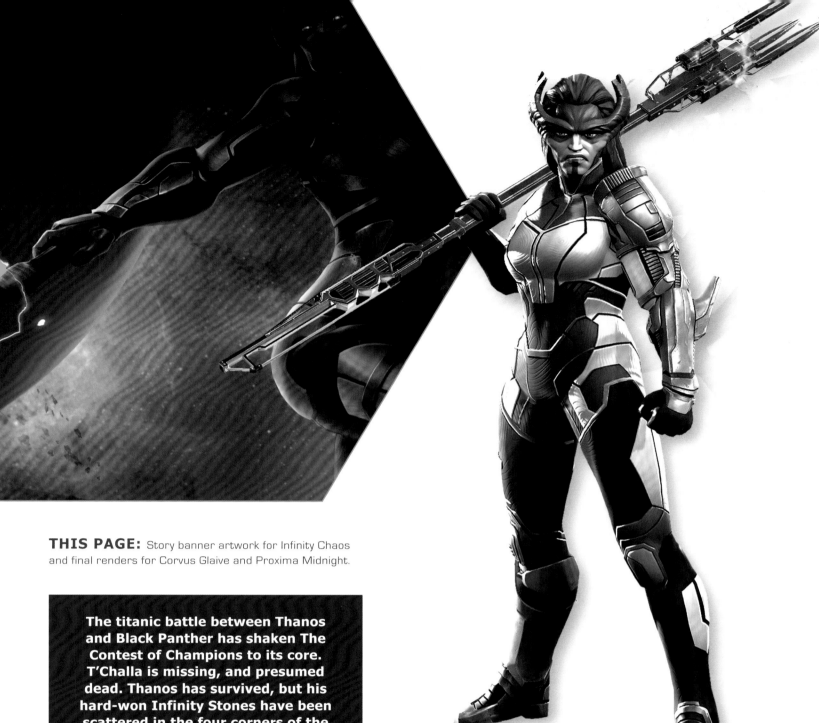

THIS PAGE: Story banner artwork for Infinity Chaos and final renders for Corvus Glaive and Proxima Midnight.

The titanic battle between Thanos and Black Panther has shaken The Contest of Champions to its core. T'Challa is missing, and presumed dead. Thanos has survived, but his hard-won Infinity Stones have been scattered in the four corners of the Battlerealm, buying the heroes some time. The Mad Titan is furious. He breaks into the abandoned Collector's ship and awakens collected versions of his trusted children, Corvus Glaive and Proxima Midnight. The heroes sense Thanos' desperation, and create separate teams to get to the five known Infinity Stones before the Mad Titan and his children. However, the heroes' journey is fraught with danger. In order to retrieve the Infinity Stones they must defeat the Nameless, Thanos' army of deranged heroes, with ashen faces and eyes alight with an otherworldly flame.

challenging because we had to earn that trust," says Cuz Parry. "But now they [Marvel] see the value, they know how popular the game is and it has sunk in that millions of people interact with their world through our game daily.

"It behooves everybody to provide the best service possible to the fans. We have a good idea of the slated movies for the next two years. We guess at the characters as we get closer to finalizing character lists, we work with Marvel, and we ask them: 'Are there going to be any characters that are going to be in that movie while we still have time to build them, that maybe we don't know about?' and they've been really good about it."

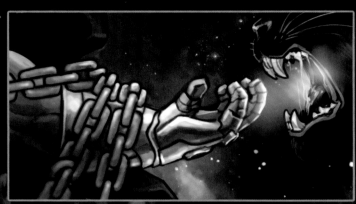

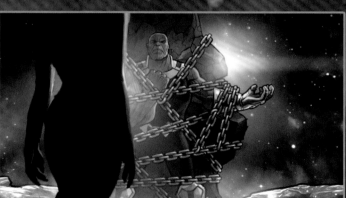

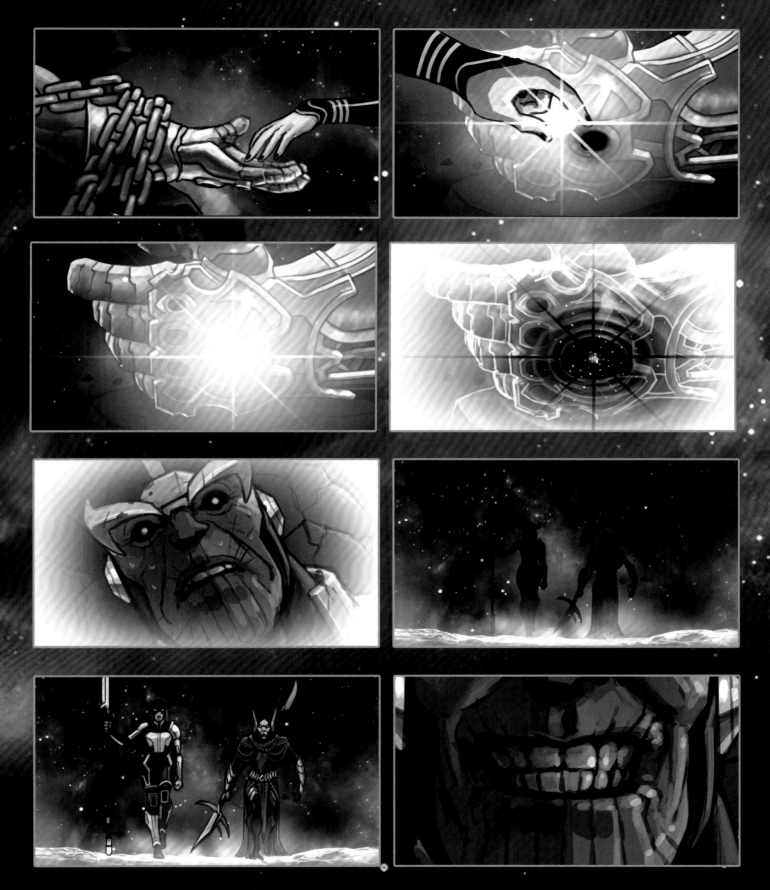

THIS SPREAD: Storyboard for Infinity Chaos.

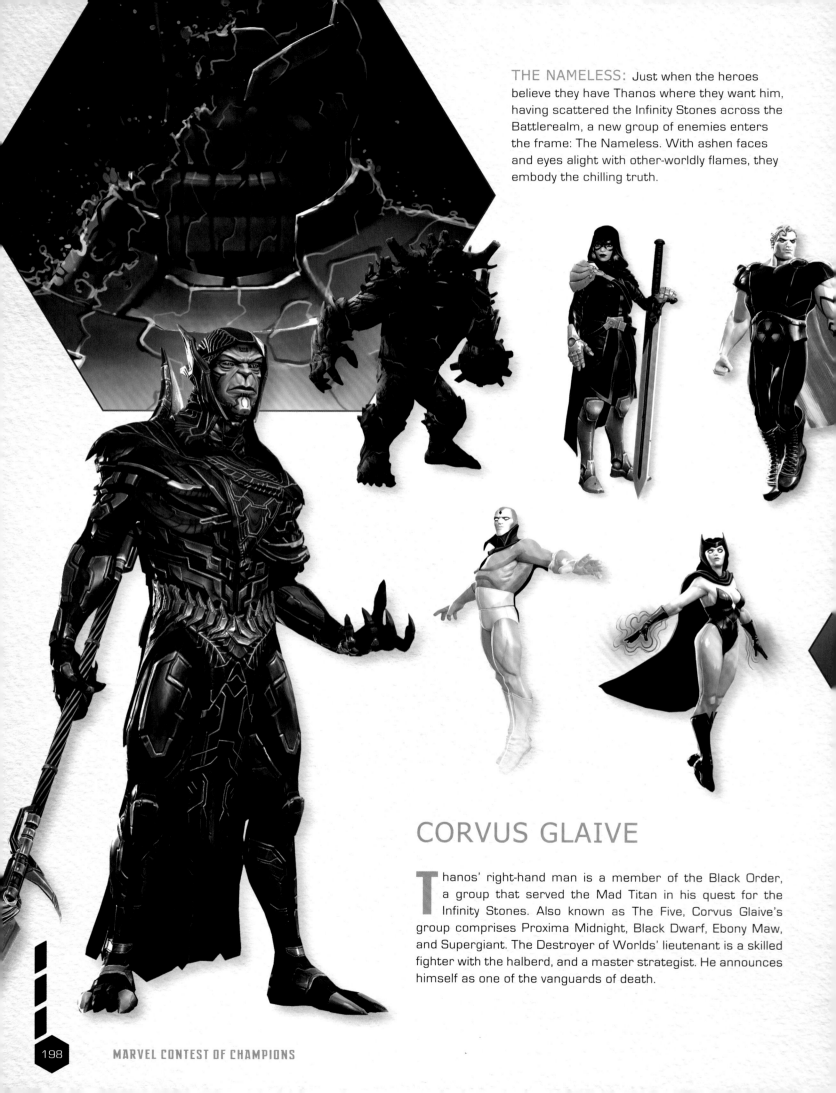

Just when the heroes believe they have Thanos where they want him, having scattered the Infinity Stones across the Battlerealm, a new group of enemies enters the frame: The Nameless. With ashen faces and eyes alight with other-worldly flames, they embody the chilling truth.

CORVUS GLAIVE

Thanos' right-hand man is a member of the Black Order, a group that served the Mad Titan in his quest for the Infinity Stones. Also known as The Five, Corvus Glaive's group comprises Proxima Midnight, Black Dwarf, Ebony Maw, and Supergiant. The Destroyer of Worlds' lieutenant is a skilled fighter with the halberd, and a master strategist. He announces himself as one of the vanguards of death.

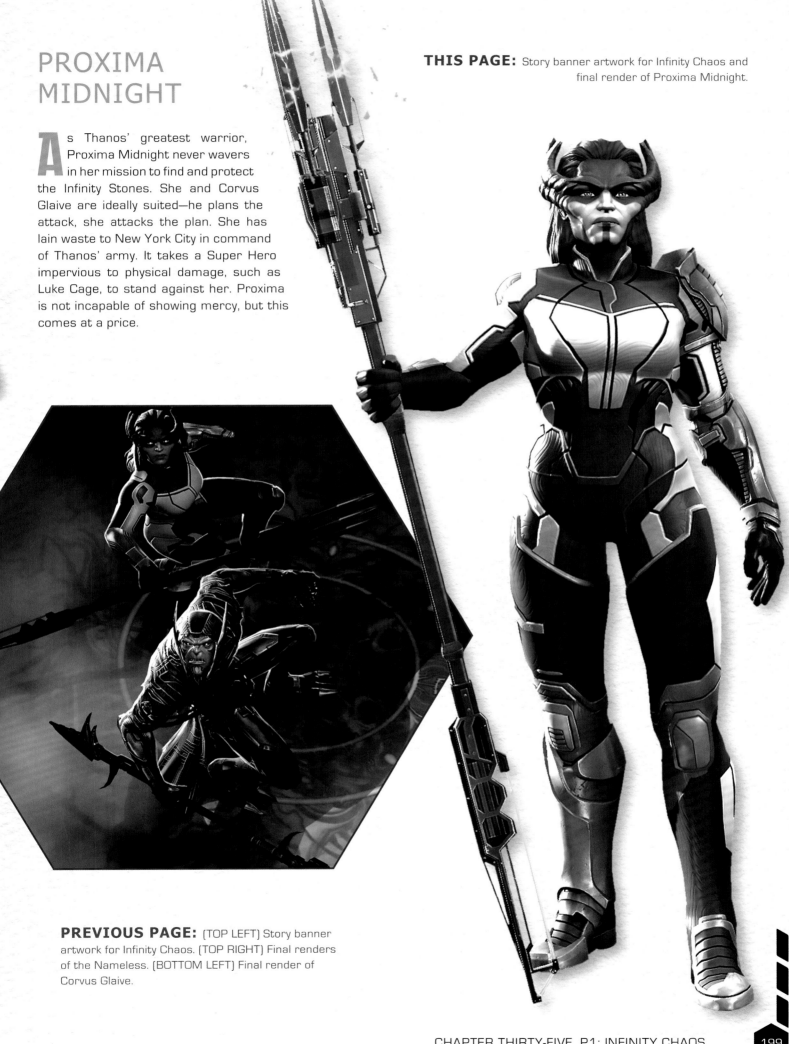

PROXIMA MIDNIGHT

As Thanos' greatest warrior, Proxima Midnight never wavers in her mission to find and protect the Infinity Stones. She and Corvus Glaive are ideally suited—he plans the attack, she attacks the plan. She has lain waste to New York City in command of Thanos' army. It takes a Super Hero impervious to physical damage, such as Luke Cage, to stand against her. Proxima is not incapable of showing mercy, but this comes at a price.

PREVIOUS PAGE: (TOP LEFT) Story banner artwork for Infinity Chaos. (TOP RIGHT) Final renders of the Nameless. (BOTTOM LEFT) Final render of Corvus Glaive.

INFINITY NIGHTMARE
CHAPTER THIRTY-FIVE, PART TWO

Though it was never Kabam's intent to mold its *Infinity War* event on the movie, familiar beats are present, such as the big question of Thanos' true motive in his pursuit of balance throughout the universe. However, as Scott Bradford outlined earlier, *Contest* goes its own inimitable way, drawing on aspects of Champions' personalities and past histories to color a uniquely memorable route to the Mad Titan's downfall.

The exchanges between Doctor Strange and Spider-Man are impeccable, with the Doctor brushing aside something potentially cataclysmic. Spidey becomes "more and more annoyed at being used as a human telephone." Movie-goers are thrilled to encounter Proxima Midnight and Corvus Glaive as bosses. Fans of the game's original characters are also introduced to a deranged Guillotine, who tells players that "Who we are is unimportant, and your nightmare has only just begun."

Every touchstone of the *Infinity War* event is a near perfect vignette that captures the essence of its players so neatly: Thanos, enthroned, with death at his fingertips. Thanos brushing aside the Grandmaster as though he were nothing. Mephisto claiming that the nothingness of death is too boring a way to achieve balance, preferring the chaos of life. This is so well observed by Kabam, as is the petulance of our reluctant ally M.O.D.O.K. Together with a team of hardy heroes (and villains) you can achieve victory.

Above all, when the moment finally comes to drain the Mad Titan of his power, we truly believe that we have found the most magnificent of ways to conquer this would-be god, with one very special vote of confidence from Iron Man before it all goes down.

Thanks to Kabam and *Marvel Contest of Champions*, we are True Believers.

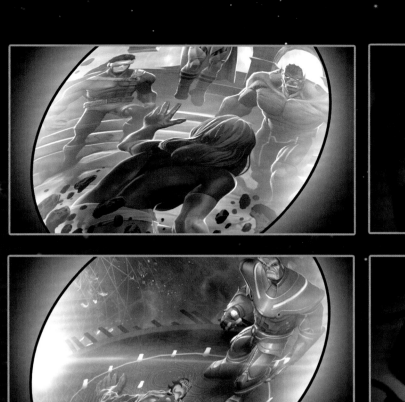

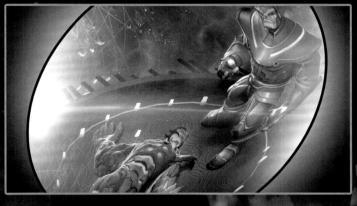

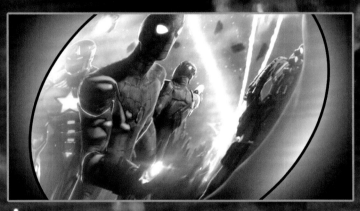

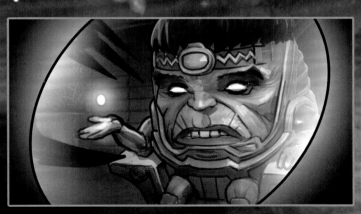
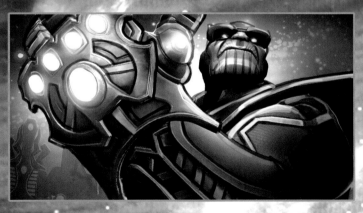

THIS SPREAD: Storyboard for Infinity Nightmare.

With his Infinity Gauntlet complete, it appears as though Thanos has won! The heroes take refuge from Thanos' wrath in the Astral Plane while the Mad Titan informs the Grandmaster that The Contest is now over, and prepares to re-balance the universe in his diabolical way. Hela and Mephisto bicker over the best way to achieve this, while Captain America and Iron Man come to the rescue of the Summoner, enlisting the help of an unlikely ally: M.O.D.O.K.!

IRON MAN (INFINITY WAR)

It appears as though Tony Stark has made significant upgrades to the Iron Man armor since making his choice to co-operate with the American government. However, that painful rift between Stark and his historic super powered allies will need to be crossed, if not healed, as all life in the universe comes under threat. This is no longer just about funding or freedom. It's about ensuring a future for mankind.

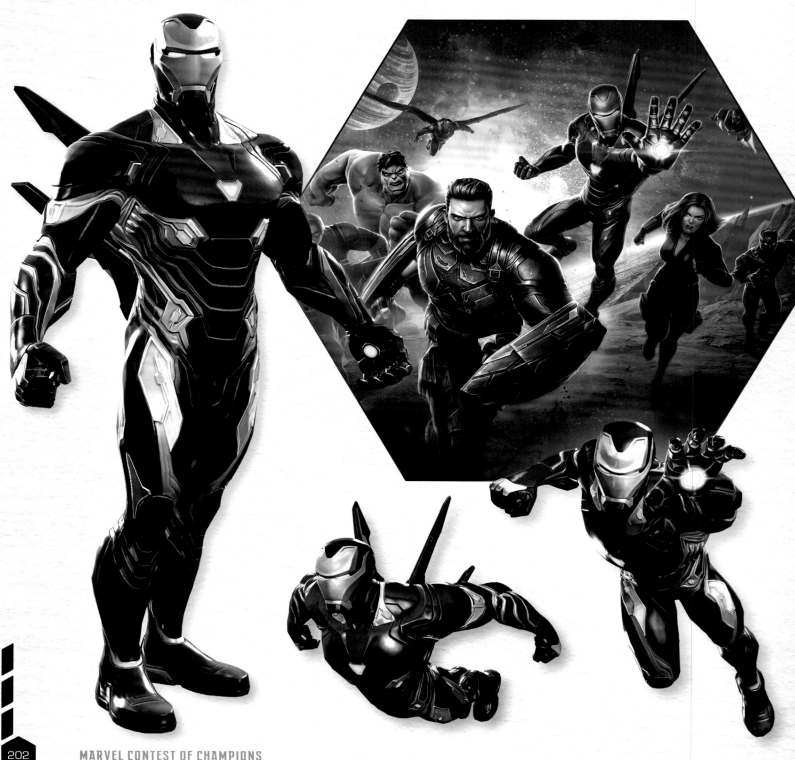

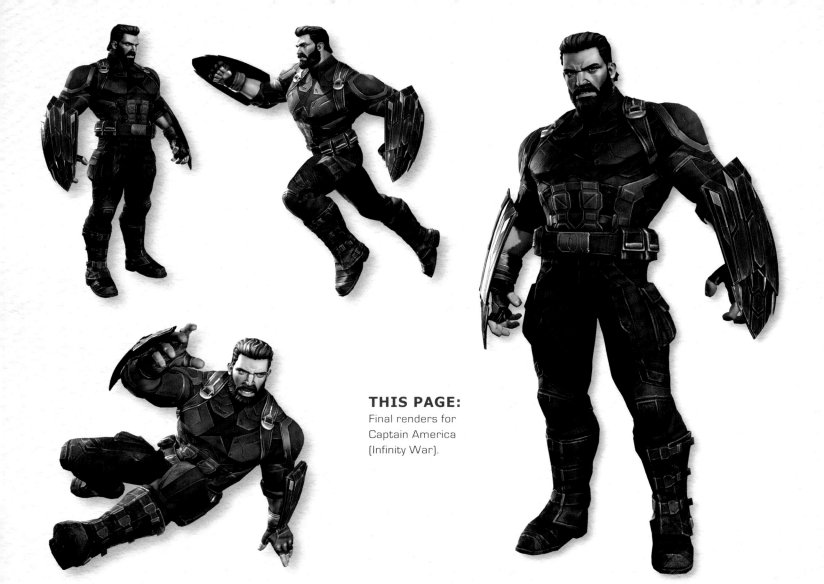

THIS PAGE: Final renders for Captain America (Infinity War).

CAPTAIN AMERICA (INFINITY WAR)

As one of the so-called "US-based enhanced individuals" operating with "unlimited power and no supervision," Captain America stood opposed to the Sokovia Accords, which would have made the Avengers answerable to a United Nations panel, no longer independent.

Consequently Steve Rogers has been forced to retreat and rethink his concept of making the world a safer place. He has sought the help of powerful friends, which includes the Wakandan king T'Challa who provided a pair of gauntlet-style Vibranium shields. Cap will succeed against Thanos through team spirit.

PREVIOUS PAGE: Story banner artwork for Infinity Nightmare and final renders for Iron Man (Infinity War).

M.O.D.O.K. reveals that he conducted secret experiments on the Nightmare Stone before he gave it up to Thanos. The evil genius has created an atomic copy of the Nightmare Stone and it is in a state of quantum entanglement with the real one. With this knowledge, the team of heroes plans to defeat the Mad Titan by creating visions in his head to distract him from their true aim. In a desperate effort to defeat the Summoner, Thanos has drained the War, Genesis, and Chaos Stones in his Infinity Gauntlet. Spurred onward by Iron Man and Captain America, the Summoner battles with Thanos and drains the power from the remaining Evolution, Death, and Nightmare stones. The Mad Titan falls and the Battlerealm is safe from one great evil.

BATTLEREALM INFINITY STONES

A KEY TO THE SIX IMMENSELY POWERFUL GEMS

EVOLUTION

CENTER TOP: Capable of accelerating steps of natural selection, giving the wielder the power to create monsters or grant unnatural abilities to living beings.

GENESIS

TOP LEFT: Capable of creating life from death, and transferring life essence between beings. It can bestow longer life span, or even immortality, to the wielder.

CHAOS

BOTTOM LEFT: Capable of creating deterministic chaos at the wielder's command. A simple thought can cause systemic destruction or disorder at atomic-level.

WAR

TOP RIGHT: Capable of assimilating heterogeneous sections of reality, be it living beings or objects, into a single-minded army tied to the wielder's will.

NIGHTMARE

BOTTOM RIGHT: Capable of blurring the lines between conscious and subconcious, bringing dreams and nightmares into the waking world.

DEATH

BOTTOM CENTER: This one is a mystery. Some say it does nothing, some say it does everything... Or maybe both at the same time. It could be the most powerful stone, if it can be controlled.

CONCLUSION

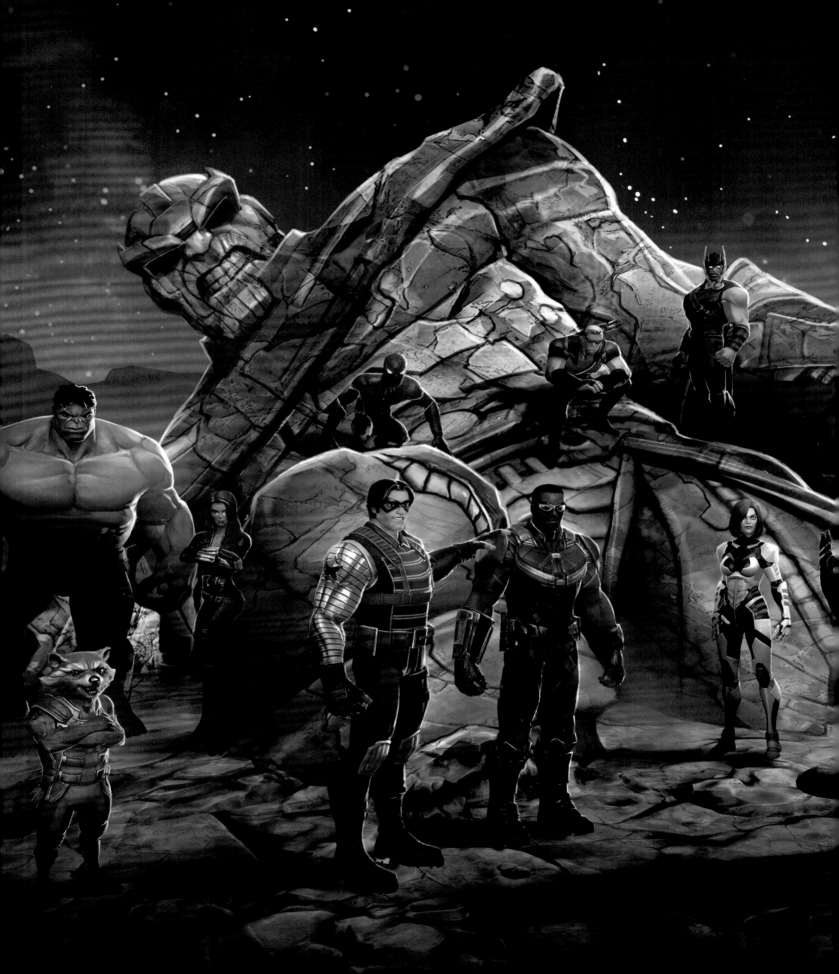

Infinity War brought the first major story arc of *Marvel Contest of Champions* to a stunning climax, though it's clear that Kabam is far from done with the Battlerealm. To say the game has been a success is an understatement of galactic proportions, and a huge part of this has been down to the unwavering passion that Art Director, Gabriel Frizzera instilled into his team.

"So much of this was Gabriel's baby," says Cuz Parry. "He was born to make this Marvel game." We see this in full effect from the authentic narrative to the nitty-gritty detail on each Champion, and every nook and cranny of the awesome Battlerealm.

"*Marvel Contest of Champions* resonates around the world because it delivers everything that today's True Believers want and expect from Marvel: explosive action, epic visuals, an intriguing story, splashes of humor, unexpected surprises, and a constant influx of cool characters, all delivered at the highest level of quality," says Bill Rosemann.

From Frizzera's point of view, the secret is being respectful of what Marvel truly stands for. "When I see some list online saying, 'the 10 most powerful Marvel heroes,' or something like that, I think to myself, 'Man, that's so off the mark,'" says Frizzera. "Marvel is not about

powers or who would beat who. For all its colorful grandeur, the Marvel Universe is about what it means to be human.

"The best Marvel stories (already present in the original stories by Lee and Kirby and Ditko) appeal to people around the world because they speak about universal experiences."

From the Marvel perspective, a team like Frizzera's is a dream scenario. It has allowed the Marvel Multiverse to take shape in ways that appeal to both comic book fans and gamers. *Marvel Contest of Champions* has ushered in millions of newcomers to existing worlds of Super Heroes and Villains, while introducing elements that are new even to Marvel gurus.

"There's elements of both in a lot of what Gabriel thinks about: He's got the Marvel brain; he's got the gaming brain," says Ryan Penagos. "Look at a character like Guillotine, she has such a cool look. Her origin and her powers feels very Marvel, but the way it's expressed, and the way she plays, feels so natural to a videogame.

"The power of what this team is doing is finding those connectivity threads and making something that feels natural, and feels like it's [always] been a part of all this."

Millions of players remain eager to play what Marvel Games and Kabam are planning next.

ACKNOWLEDGEMENTS

Over the past few years, a multitude of people at Kabam helped bring *Marvel Contest of Champions* to life, too many to list here. From artists to programmers to designers to producers to marketers and business people and everyone in between, we have spent countless hours crafting the game and beaming it around the world. The Contest is a labor of love for us, and this book is a celebration of that love.

Kabam would like to thank the Titan Books team and Paul Davies for putting up with our intense scrutiny and demanding attention to detail. You guys believed a mobile game, which are often dismissed simply as commercial ventures, could be treated as art and deserve an awesome book like this, and for that we are grateful.

We'd like to acknowledge the invaluable contribution of the Marvel Games team. These guys and gals are not only our partners, they are an integral part of our crew, living and breathing Marvel daily with us. Every page of this volume is packed with the contributions Bill Rosemann, Tim Hernandez, and team brought to the game. They should be proud of what we have created, and we look forward telling many more stories together in the years to come.

Last but not least, we'd like to thank our families. They have supported us while we were away building this universe, and patched us up after the many battles we fought in The Contest. They are our original Super Team, without which we could never have embarked in this adventure.

Paul Davies would very much like to thank Gabriel Frizzera, Cuz Parry, Tim Hernandez, Bill Rosemann, and Ryan Penagos for dedicating their time and thought to this book. Thanks also to the Titan Books team, including book designer Natasha MacKenzie and editor Charlie Wilson for her rock-solid good humor.

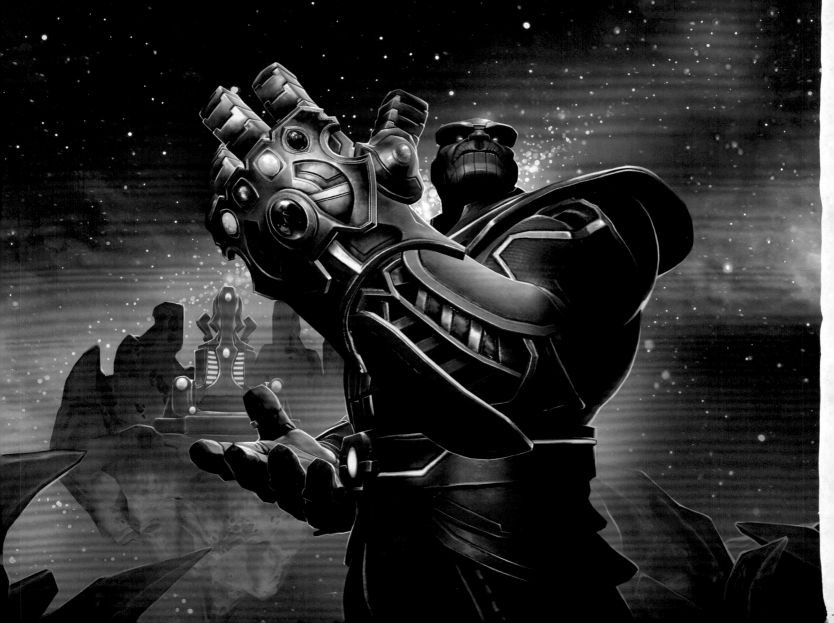